NER **BRITAIN** LARRY BURROWS · JAMES DENIS GILL

HENG HO · KIM SAVATH · KUOY SARUN · LANH DAUNH

AN · SAING HEL · SOU VICHITH · SUN HEANG · TEA KIM

AUDE ARPIN-PONT · FRANCIS BAILLY · GILLES CARON ·

I HUET · PIERRE JAHAN · MICHEL LAURENT · RAYMOND

ANY DIETER BELLENDORF **JAPAN** TAIZO ICHINOSE ·

MOTO **SINGAPORE** CHARLES CHELLAPPAH · SAM KAI FAYE

STATES ROBERT CAPA · SAM CASTAN · DICKEY CHAPELLE

SON · SEAN FLYNN · RONALD D. GALLAGHER · NEIL K.

NT POTTER · EVERETTE DIXIE REESE · TERRY REYNOLDS

EL **SOUTH VIETNAM** HUYNH THANH MY · DO VAN VU ·

REQUIEM

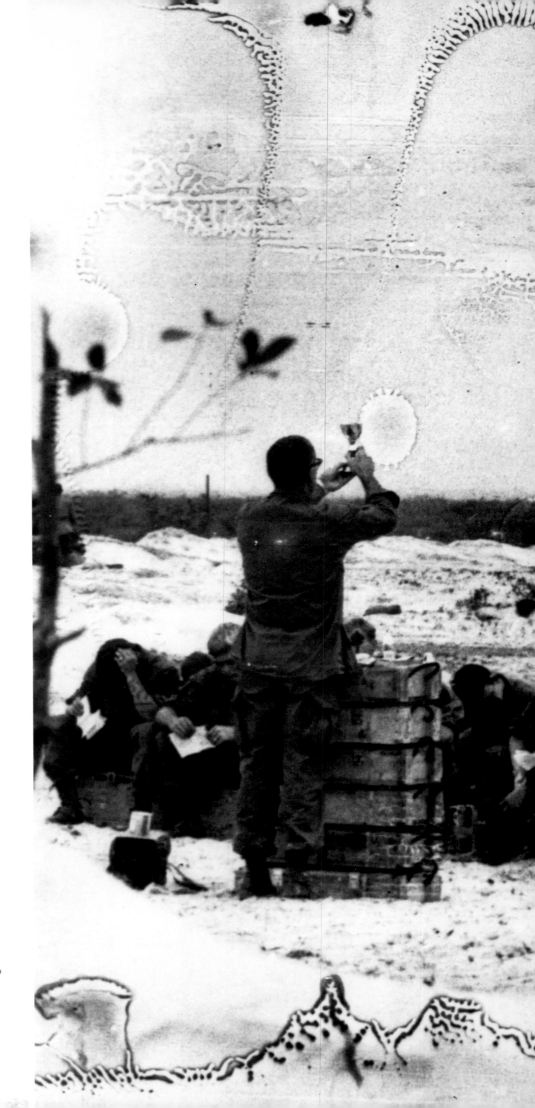

HIROMICHI MINE
Near Hue, Vietnam, 1968.
The fire-and-water-damaged last roll of film from Mine shows an army chaplain celebrating mass for soldiers of the First Cavalry Division. Mine died two days later, on March 6, 1968, when an armored personnel carrier on which he was riding hit a 500-pound bomb.
(UPI)

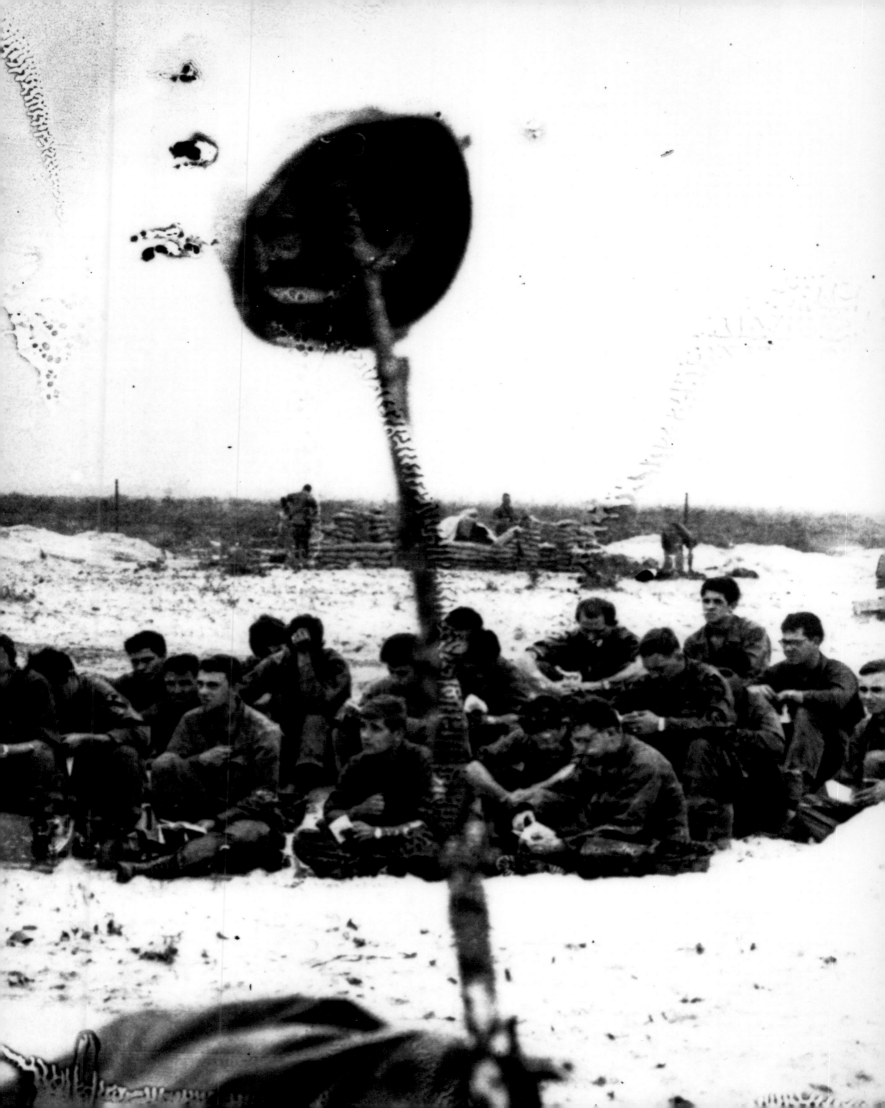

THIS BOOK IS DEDICATED TO THE 135 PHOTOGRAPHERS OF DIFFERENT NATIONS WHO ARE KNOWN TO HAVE DIED OR TO HAVE DISAPPEARED WHILE COVERING THE WARS IN INDOCHINA, VIETNAM, CAMBODIA, AND LAOS. THEIR LIVES ARE REMEMBERED THROUGH THEIR WORK HERE ASSEMBLED.

REQUIEM

BY THE PHOTOGRAPHERS WHO DIED
IN VIETNAM AND INDOCHINA

EDITED BY

HORST FAAS AND TIM PAGE

INTRODUCTION BY

DAVID HALBERSTAM

CONTRIBUTIONS BY

PETER ARNETT, TAD BARTIMUS,

NGUYEN KHUYEN, JOHN LAURENCE, RICHARD PYLE,

PIERRE SCHOENDOERFFER, NEIL SHEEHAN,

JON SWAIN, WILLIAM TUOHY

RANDOM HOUSE NEW YORK

Copyright © 1997 by Indochina Photo Requiem Project, Ltd.
All rights reserved under International and Pan-American Copyright Conventions.
Published in the United States by Random House, Inc., New York, and simultaneously in Canada
by Random House of Canada Limited, Toronto.

Published in Great Britain by Jonathan Cape, Random House, London.

Library of Congress Cataloging-in-Publication Data

Faas, Horst.
Requiem: by the photographers who died in Vietnam and Indochina
p. cm.
ISBN 0-679-45657-0
1. Vietnamese Conflict, 1961–1975—Pictorial works. I. Page, Tim. II. Title.
DS557.72.F33 1997
959.704'3 – dc21 97–8106

Random House website address: http://www.randomhouse.com/
Printed by Arnoldo Mondadori Editore, S.p.A., Verona, Italy, on acid-free paper
24689753
First Edition

Editor and designer: Mark Holborn
with Pascale Hutton and Sheridan Wall

CONTENTS

INTRODUCTION

David Halberstam

The title says that this is a requiem for a war, but as much as anything else, this striking book is a form of homage paid by those who made it back from Vietnam to the memory of those who did not. Looking at these photos now, more than twenty years after the last shots were fired, and well more than thirty years since some of us first went there, I am—like so many others who were part of that story—haunted by these scenes and moved far beyond expectation by them, for the photos in this book evoke dual images. They are not just those of a terrible and violent time and of all the casualties of that war, both civilian and military, but they are, for many of us, images of the faces of the men and women who were there, who were our friends, and who took these very photos. We are reminded of their bravery, of the terrible risks they took, and, of course, constantly, of our own good fortune.

The world has turned many times since the fall of Saigon. The Americans, then newly departed, having been chased off the roof of the U.S. embassy, are now the most welcome of returnees, back now as tourists and potential investors. Vietnam has become a hot new commercial enterprise zone. Young would-be entrepreneurs, some of them born long after many of these photos were taken, talk about the possibilities of economic development there, of a growing tourist market, and of tapping into the same purposeful energy and immense talent and resourcefulness that in their military incarnations were so critical in defeating the French and stalemating the Americans. Those of us who covered the war will not, of course, lightly partake of these expanding economic possibilities: We are left with a different vision of Vietnam; we are too burdened by the past, and we cannot easily conceive of investing in the Four Seasons Nha Trang or the Ramada Can Tho.

Our memories of Vietnam are too mixed, and there is altogether too much sadness in most of them; we have spent much of the last twenty to twenty-five years learning to forget or at least learning to soften those chapters in our lives. Saigon is mercifully distant, a place that belonged to the younger men and women we once were, the young, eager, scared journalists clad in Catinat fatigues, scrambling to get to Tan Son Nhut to get aboard the Hueys going into battle, terrified we might get there too late to get aboard, terrified we might get there in time to get aboard. We are all older now, sedate men and women in our fifties and sixties living in civilized settings, leading ordinary, rather mundane lives. Yet for most of us, the memory is always there, just beneath the surface; when we open a book like *Requiem* and read it now in our handsome apartments in the Western cities in which we live, the past still lurks. And as we read, we are at first flooded by these images of the past, and then we are surrounded by a terrible stillness, a special silence produced by the most relentless of all forces, the power of memory. We are quiet as we turn the pages of this book, as befits a special act of homage to those we knew so well.

The silence stands in sharp contrast to the terrible noise that was a defining part of those days and accompanied so many of these very scenes: the racket of infantry weapons and artillery, the harsh clamor of the helicopters. We read it, of course, now safely distanced from our own terrible fear that was the constant of those days. But in some ways the remembrance of another time is more powerful than ever, not just because of the photos but, more important, because of the memory of the young men and women who took them, since they themselves, in the most terrible and final way, became part of what lay before

them. Looking through *Requiem,* we remember not just what they did, but now we know, as well, the price they paid.

The book is curiously deceptive. Because it is an homage, it makes no attempt to be definitive or even particularly authoritative. Though its aesthetics are at moments overwhelming, it was not born of the idea of being the most artistic of books on Vietnam. And yet the story it tells is curiously complete, and its pages are strikingly, indeed eerily, beautiful. There is a simplicity in the beginning, an almost biblical quality to Dixie Reese's early photos of the landscape in those days before all the soldiers came. Then, as we turn the pages, the level of weaponry gradually escalates, and so, of course, does the carnage. In some way it is all we need to know about Vietnam, this larger truth purchased at a terrible price in human treasure.

I am, like the other writers who have contributed to this book, honored to be part of this special homage to my deceased colleagues. This is for all of us, in the most personal way, a debt long overdue. War correspondents always know who is real and who is not. A war zone is not a good setting for the inauthentic of spirit and heart. We who were print people and who dealt only in words and not in images always knew that the photographers were the brave ones, and in that war, which began in an era of still, black-and-white photography and ended in one of color videotape beamed by satellite to television stations all over the world, they held a special place in our esteem. We deferred to them, reporter to photographer, in that venue as we did in few others.

They were real because they had to be real; they could not, as we print people could, arrive a little late for the action, be briefed, and then, through the skilled use of interviews and journalism, re-create a scene with stunning accuracy, writing a marvelous you-are-there story that reeked of intimacy even though, in truth, we had missed it all. We could miss the fighting and still do our jobs. They could not. There was only one way for them to achieve intimacy: by being eyewitnesses.

That is why *Requiem* is so uniquely poignant. It demonstrates the complete dedication of the men and women whose work is included, and it shows the extreme and ever-present devotion to their jobs. We can look at the photos and think of the violence in front of them even as they pressed the shutter: They were out there alone, had come to the end of civilization as they knew it, were terrified, aware that there is no immunity in situations like this, surely wondering whether this would be the last thing they ever saw.

There is a physiological link here: The mechanical shutter is connected to the human eye, and, more important, the eye is connected to the heart, and the heart, we know, beats wildly at these moments. Our awareness of this link—our knowledge that every person whose work we look at here was at risk and that in some cases the scenes we are viewing were the last that person ever photographed, the last that person ever saw—contributes to the uniqueness of this book.

It was, they all used to say—for it took a certain institutional bravado to work there—a great war for photographers. The war was everywhere, and it was oddly human, not a war in which the machinery, despite the relentless advance of technology, had taken over from the men who had to fight it. It was a war with a measurable scale. The men who fought it still mattered, and the pain and fear and exhaustion still showed in their faces. The war was oddly accessible—you could hire a cab in Saigon for a few dollars and drive to My Tho, go to war if you wanted, and it

was there every day, yours for the mere asking. It was Robert Capa, icon of icons, who, earlier than most, understood that quality of Vietnam, who realized that the remarkable humanity of those who fought there had been produced by the equally remarkable inhumanity of those who had planned the war. He, virtuoso and master of the second great war of modern Europe, his talent and his myth blended together in equal parts, was a veteran of D-day, although most of his great photographs from that day were ruined by a careless technician in London. It would have been easy for him to try to downplay what was taking place in Vietnam; instead, he arrived there in 1954 and ignored those of his contemporaries who claimed that compared to World War II, Vietnam, or Indochina as it was then known, was small stuff, that it lacked grandeur. Capa told a few reporters working with him that those people were wrong, that Vietnam was big enough, and it was real, and intensely human. It was, he said, fierce and dangerous, and it had a genuine face. And then in May 1954, Bob Capa stepped on a land mine. With that his words about the war took on even greater resonance.

For someone like me there is a certain melancholy, looking back at these photos and conjuring up memories of the men who went with the pictures: the elegant Larry Burrows, the most cherished of colleagues; the quiet Henri Huet, his magnificent reputation largely posthumous (we knew how much was stored inside him, how driven and talented he was, only when we saw his photos); François Sully, joyous, full of laughter, undaunted by the irony that came from his having spent some twenty-five years of his life watching a war where white men were on the wrong side, staying on year after year because this was what he knew best, this was where he belonged;

Bernard Fall, the great historian of the war and the beloved teacher of a generation of younger correspondents; the young Jerry Rose, who had left his chosen career of schoolteaching behind because the world of journalism seemed so much more exciting; and, finally, Sam Castan, whom I met on his first day in country and whom I listened to that first night as he talked alternately of his hopes and his fears.

I must mention Larry Burrows in particular. To us younger men who had not yet earned reputations, he was a sainted figure. He was a truly beautiful man, modest, graceful, a star who never behaved like one. He was generous to all, a man who gave lessons to his colleagues not just on how to take photographs but, more important, on how to behave like a human being, how to be both colleague and mentor. Our experience of the star system in photography was, until we met him, not necessarily a happy one; all too often talent and ego seemed to come together in equal amounts. We were touched by Larry: How could someone so talented be so graceful? I remember he once asked the South Vietnamese government for permission to strap himself to the wings of an old World War II plane so he could shoot from outside the cockpit. Others had asked for the same thing and had been turned down. Now Burrows's request was expedited and, in time, approved. When that happened, there was some grumbling on the part of some of the other photographers. Soon word came back from the officials: "Mr. Burrows's request was granted not because he is a photographer, but because he is an artist."

Indeed, he was an artist in every aspect of his life, and as I write these words, I am powerfully drawn to memories of him: In my memory he remains much older and more senior than I; in truth, he was thirty-six in 1962, when we met, only eight years

older than I. Now as I look at the photos of him, he seems so youthful, indeed boyish, as do so many others, so young and talented and brave. I am touched as well by the photo of a group of North Vietnamese photographers about to go south, full of laughter (and, I am sure, fear) because this shot seems almost interchangeable with my memories of the Western photographers, those on the other side, young and eager and audacious. If some of these photographers arrived young and eager and innocent, the innocence did not last long. Horst Faas, whose work was so critical to this book, once said when he was leaving Saigon, "Years later we won't sit around and talk about the good old days in Vietnam because there weren't any good old days." If a common bond unites the photographers represented here, the photographers on both sides, it is the knowledge of the risk, and how total it was with every throw of the dice.

I am glad Horst Faas and Tim Page, among the bravest of the brave, have put this book together. The photographers represented here gave us something special, a remarkable record of that distant war, including many of their photos taken when few people cared about what was happening there. They gave us images that have the power to endure. Now that the war is past, consigned to the negligence normally accorded to history in America, those images remain powerful, a critical part of what constitutes modern memory. We are grateful to those who took the photographs; now, as then, we remain in their debt.

1 A DISTANT WAR

EVERETTE DIXIE REESE
Vietnam, 1950s.
Monsoon season.

The Southern mountains and rivers belong to the Viet people,
It was so clearly written in the Celestial Book.
Those who dare to attack our territory
Will be immediately and pitilessly annihilated.

MARSHAL LY THUONG KIET,
eleventh century

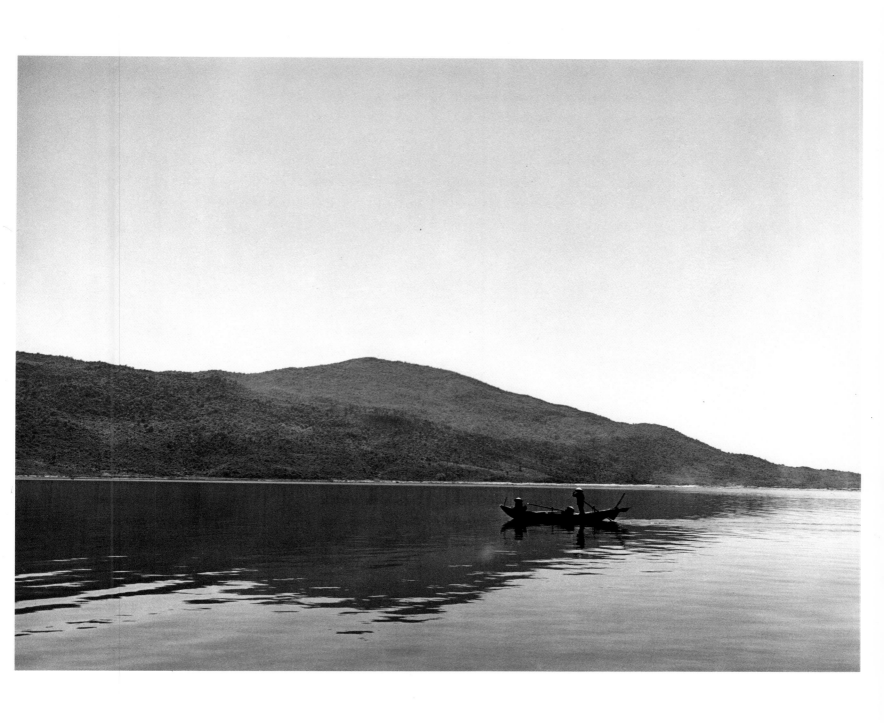

EVERETTE DIXIE REESE
Vietnam, 1950s.

THE LAND AND PEOPLE OF INDOCHINA

Tad Bartimus

In the last half of this century Indochina came to us in snapshots that lodged in our consciousness like hot shrapnel in a wound.

We flinch at remembered images of torment, pain, violence: a woman and her children swim panic-stricken in a canal, looking up at attacking helicopters; a black man, injured, reaches out to a white man, mud-smeared, bleeding; a blinded medic cradles a wounded friend in his lap as battle rages. Always there is blood, soldiers suffering, women crying, babies crying, more blood, old men gazing straight into the lens with that universal survivor's stare: lived too long, seen too much.

Go back. Far back. Back before the celluloid of film, before paintings, before knives for carving stone. Long before Magellan, before Marco Polo or the Great Khan there was the Hoabinhian man, dark-skinned and cave-dwelling, who walked, upright, from Central Asia toward Australia and stopped off in the jungles of Hoa Binh in northern Vietnam. Then came the Bacsonians, who brought double-edged axes to fell ancient hardwoods. More migrants added cattle, irrigation, art for the soul's sake. Huge, intricately decorated bronze drums appeared.

Temples were erected to ancient gods. Wild orchids grew in clay bowls painted blue and white and glazed by fire. Women covered themselves and put on rubies. Men harnessed themselves to the plow. Hinduism, Buddhism, Islam, pagan worship—all emerged as Asia's races mingled. The beauty of Indochina's braided rivers as they spilled across vast deltas, its highlands veiled in mist, its green canopy of rain forest. The heel of Asia became a strategic prize wedged between the great powers of India and China. Which would prevail?

In 111 B.C., China overran Vietnam and stayed more than a thousand years. Today the defining politics of Vietnam, Cambodia, and Laos are still in their relationship with China. How close is too close?

Nearly a millennium after the coming of Christ, when most mapmakers were engraving the void of what would become the Americas with the Latin phrase for "here be monsters," the Champa Empire peaked in southern Vietnam along a shimmering coastal beach. Busy building their artistic heritage, the Chams made a crucial error: They forgot that the spine of Asia sways in the wind and rustles in the night. Rice, life-giver to half the world, was so abundant in the Champa Empire that rich dirt had been allowed to lie fallow. The Viets, packed tight together on mostly hardscrabble land and struggling, then as now, to feed a burgeoning population, burst forth from the Red River delta to overrun the Chams.

Five centuries before Pol Pot committed genocide with his Khmer Rouge in Cambodia, the Chams disappeared. Traces linger only in a few carved ruins and in the DNA of the dwindling montagnard tribes, whose ancestors escaped along the desolate backbone of Vietnam and Laos.

The Chinese were first run off by a peasant army led by an emperor who called his state the Kingdom of the Watchful Hawk. Another great strategist, Tran Hung Dao, used hit-and-run tactics three times to repulse invading Mongols in the thirteenth century. After the last battle a poet-warrior wrote, "This land shall live forever." Emperor Le Loi, whose legend equals that of King Arthur, used Tran's guerrilla model to rout the Chinese once and for all in a battle west of Hanoi in 1426. That triumph ushered in Vietnam's brief golden age of scholarship, art, and peace.

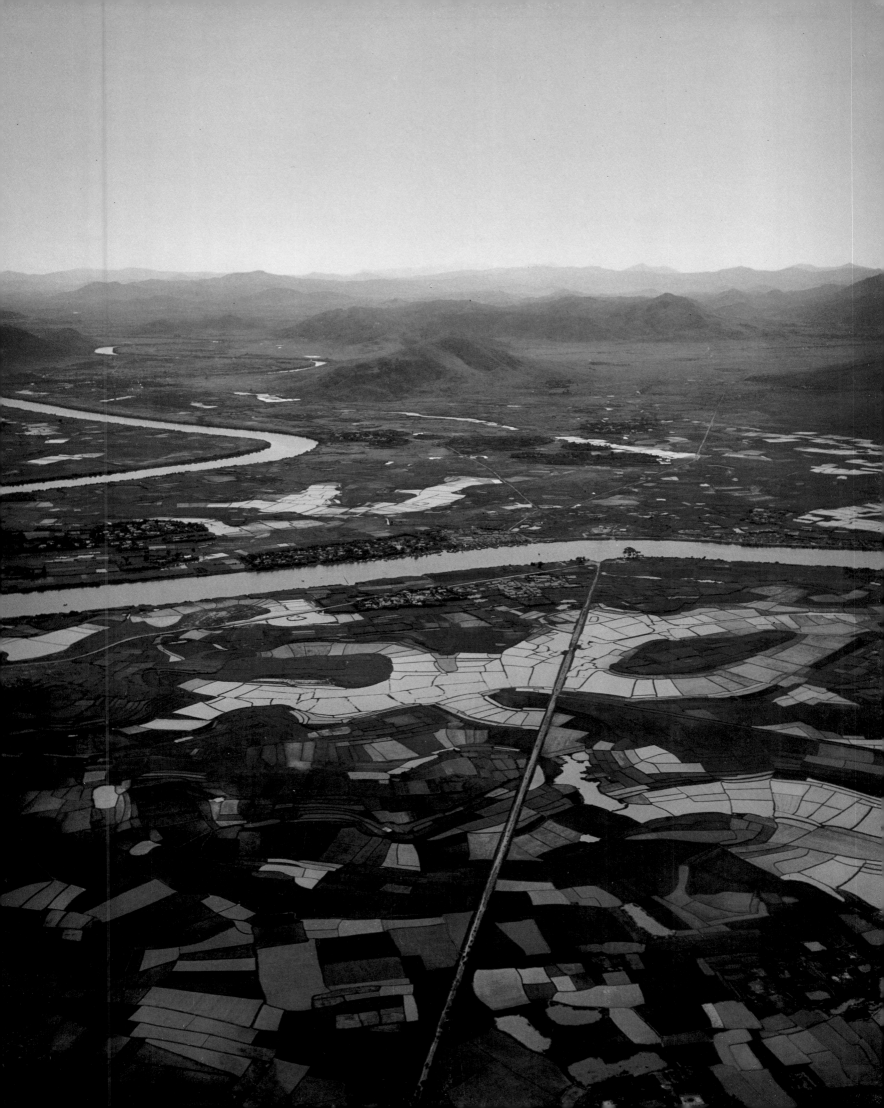

In the sixteenth century ruthless pepper pirates sailing for Portugal tried unsuccessfully to wrest the world spice monopoly from the Dutch and stumbled onto the great stone temple of Angkor, already beginning to crumble in the relentless heat and humidity. They also found a deep harbor along Vietnam's coast, near Da Nang. But their city of Faifo failed to become a traders' mecca like Goa, in India, so the Portuguese stayed only long enough to clutter up the maps with misnomers.

It was left to the French in the seventeenth and eighteenth centuries to mislead cartographers with three distinct geographic divisions of Vietnam: The southern third was labeled Cochin China; the middle was called Annam; and the north, Tonkin. Like God and Mammon, soldiers and missionaries united for the glory of empire vied for power and influence over the Indochinese polyglot. While explorers inventoried vast timber, rubber, and mineral resources, priests counted souls and saw a whole new flock ripe for conversion.

Monsignor Pierre Pigneau de Brehaine dreamed of a Christian empire in Asia's hinterlands and used Prince Canh, the seven-year-old son of Nguyen Anh, a pretender to the Vietnamese throne, as a visual aid when he returned to Versailles in 1787. Marie-Antoinette doted on the little boy, but her ill-starred husband, Louis XVI, dropped the idea of a French expedition to Vietnam shortly before he lost his life to the revolution.

Undeterred by a lack of royal benefactors, de Brehaine finagled help from mercenaries and volunteers, and in 1802 a victorious Nguyen Anh renamed himself Emperor Gia Long and united Vietnam. De Brehaine died of natural causes, a hero mourned with extravagant splendor by his protégé; but just thirty-one years later Nguyen Anh's successor, Minh Mang,

martyred a French priest, ordering six soldiers to strangle him because he had proselytized on behalf of Jesus. Too late, Vietnam's Confucian rulers realized Catholicism would undermine their authority.

By 1887, France had created the Indochinese Union, encompassing Cochin China, Annam, Tonkin, and Cambodia. Laos was soon to be added. The French kept the region on a choke chain, regularly installing puppet emperors to replace those who tried to invoke nationalism among their dispirited subjects. Rogue royalists were either killed, exiled to other distant French "protectorates," or imprisoned. But oppression breeds heroes. Even as the French, in their sweltering white wool uniforms and pith helmets, attempted to "pacify and civilize" the country with fresh-baked baguettes, elaborate ceramic sewer systems in the cities, and lycées to educate the mandarin class, they were paying a high price. Malaria, dysentery, and dissension in Paris in response to the exorbitant cost of maintaining an Indochina colony fueled discontent among the troops. Then there were the violent uprisings, put down with increasing brutality.

"Our side suffered not a single casualty," wrote French colonel Fernand Bernard of one incident, "but without benefit of a trial, sixty-four [Vietnamese] heads rolled."

The French undermined Indochina's social system for the sake of profit. Opium, used only by Chinese residents in Vietnam when the French landed, began to poison the entire population when a refinery was built in Saigon on orders of the governor-general. Rubber-plantation workers were little more than slaves; indentured peasant farmers couldn't feed their families because their bumper crops were being exported for cash.

The old order unraveled. Ancient clan rivalries

EVERETTE DIXIE REESE
Cambodia, 1950s.

(page 17)
EVERETTE DIXIE REESE
Tonkin, Vietnam, 1953.
The Red River Delta.

were set aside by a unifying hatred of the foreign oppressors. Patriots reminded one another of Le Loi's belief that "every man on earth ought to accomplish some great enterprise so that he leaves the sweet scent of his name to later generations. How, then, could he willingly be the slave of foreigners?"

In this caldron of corruption, manipulation, oppression, and inequality was born, in 1890 in central Vietnam, the son of an itinerant medicine man. The child was named Nguyen That Thanh—Nguyen Who Will Be Victorious.

Nguyen That Thanh, who would become a man of many aliases, wrote these words in a Chinese jail:

Neither high, nor very far,
Neither emperor, nor king
You are only a little milestone,
Which stands at the edge of the highway.
To people passing by
You point the right direction,
And stop them from getting lost.
You tell them of the distance
For which they must journey.
Your service is not a small one.
And people will always remember you.

The world remembers him as Ho Chi Minh.

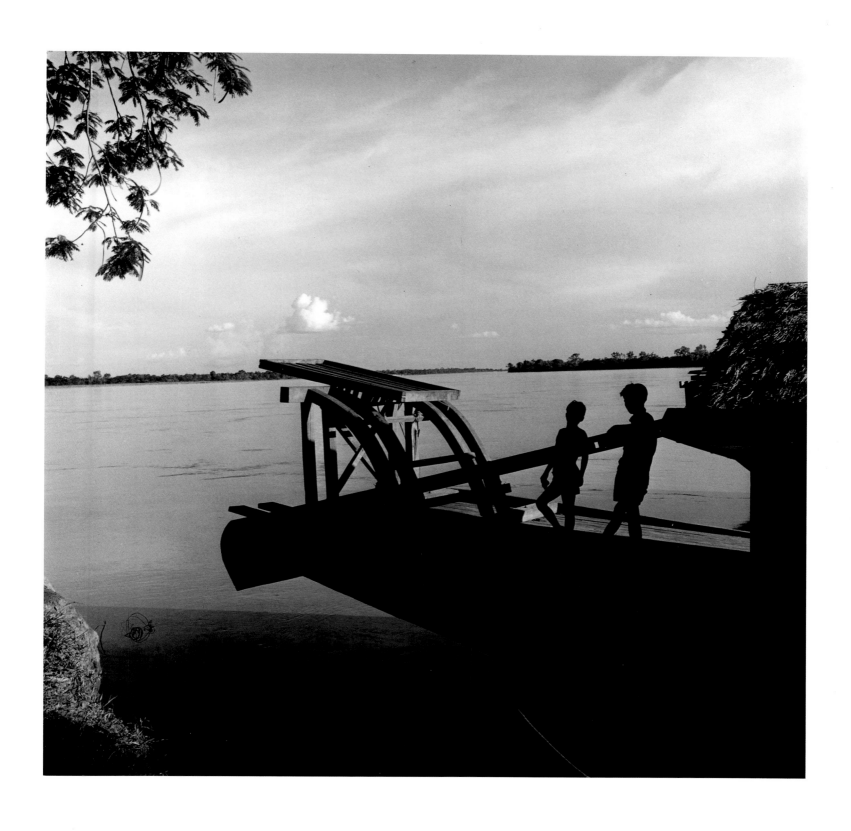

EVERETTE DIXIE REESE
Laos, 1951.
A ferry landing on the Mekong.

EVERETTE DIXIE REESE
Cambodia, 1954.
Terrace on the main temple of Angkor Wat.

EVERETTE DIXIE REESE
Vietnam, 1950s.

EVERETTE DIXIE REESE
Angkor, Cambodia, 1954.
The Bayon, central shrine of Angkor Thom.

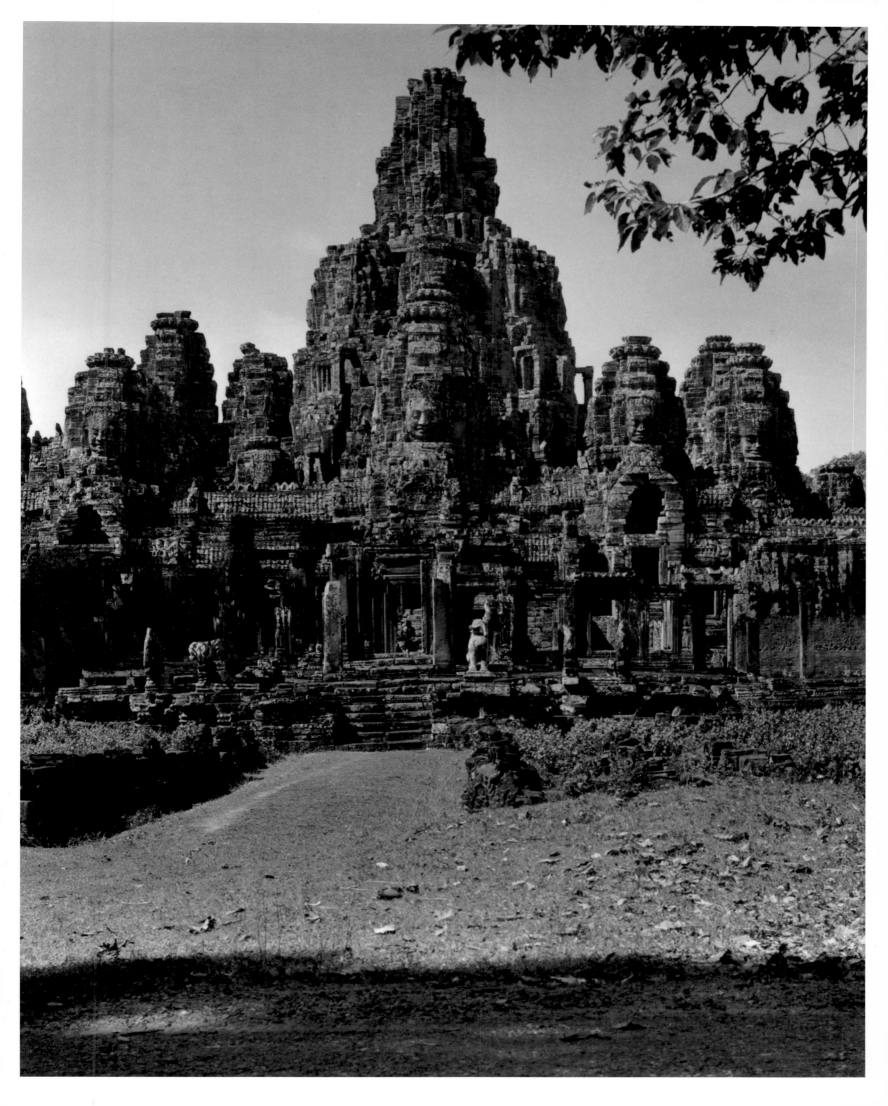

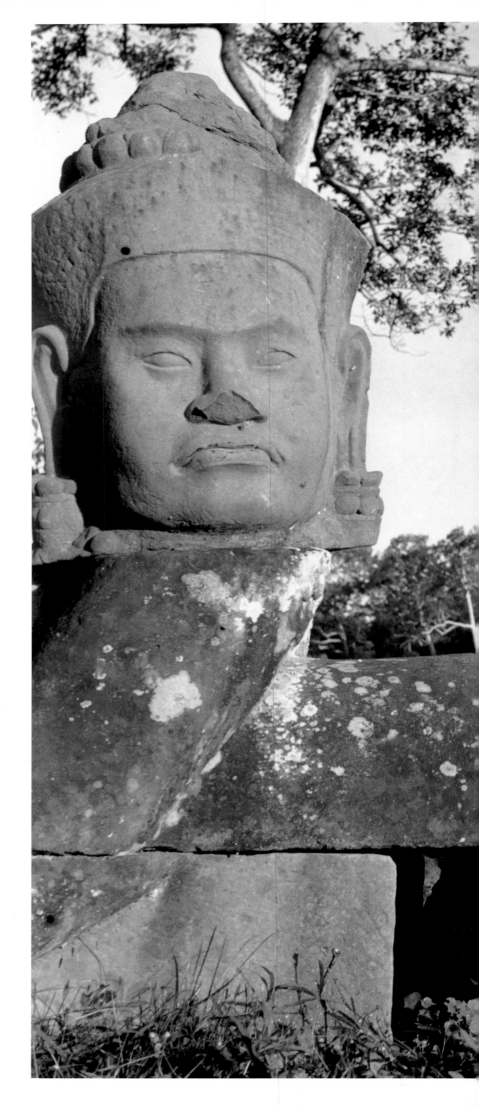

EVERETTE DIXIE REESE
Angkor, Cambodia, 1952.
The Causeway of Gods and Demons, Angkor Thom.

(page 28)
EVERETTE DIXIE REESE
Angkor, Cambodia, 1954.
*A twelfth-century stone relief of the Bayon, the central
shrine of Angkor Thom, showing marching Khmer guards
and officials riding on elephants and shielded by parasols
outside the royal palace gates.*

(page 29)
EVERETTE DIXIE REESE
Angkor, Cambodia, 1954.
*A twelfth-century stone relief showing a battle between
the Khmer and the Cham armies in 1177. The Chams are
distinguished by their helmets adorned with magnolias.*

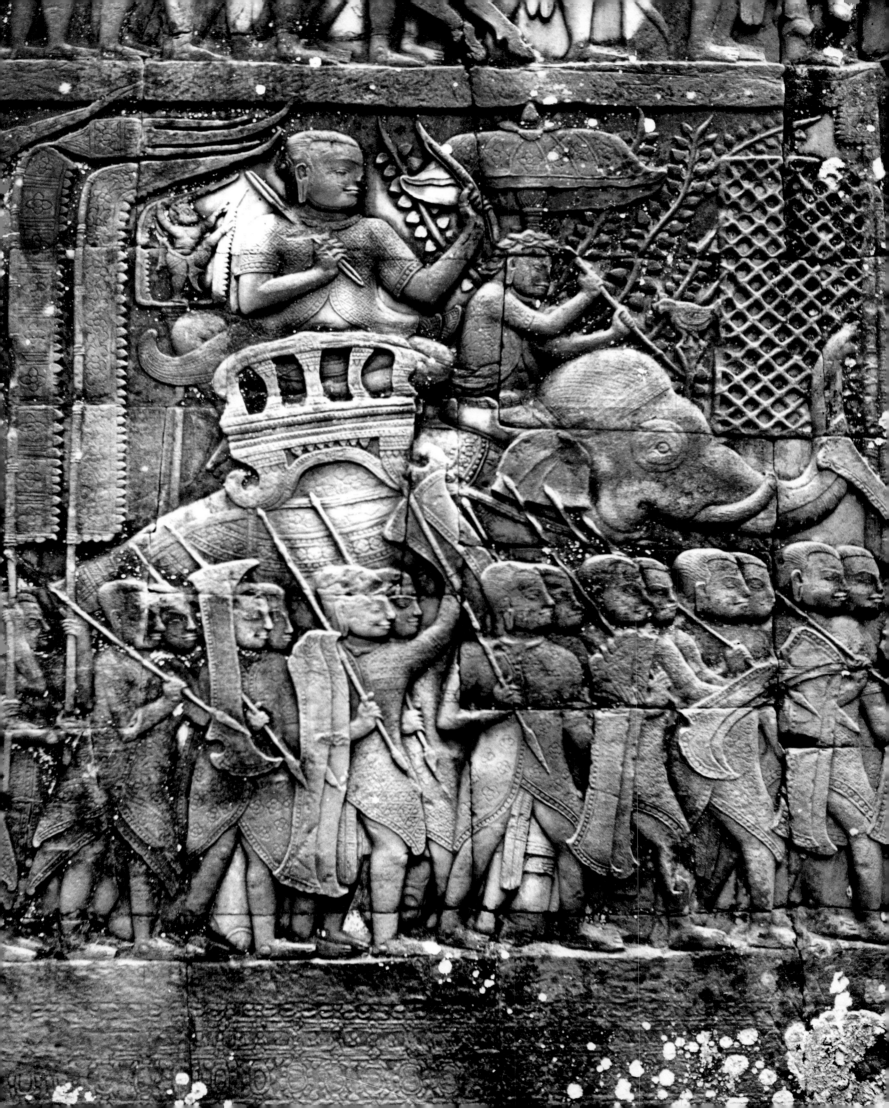

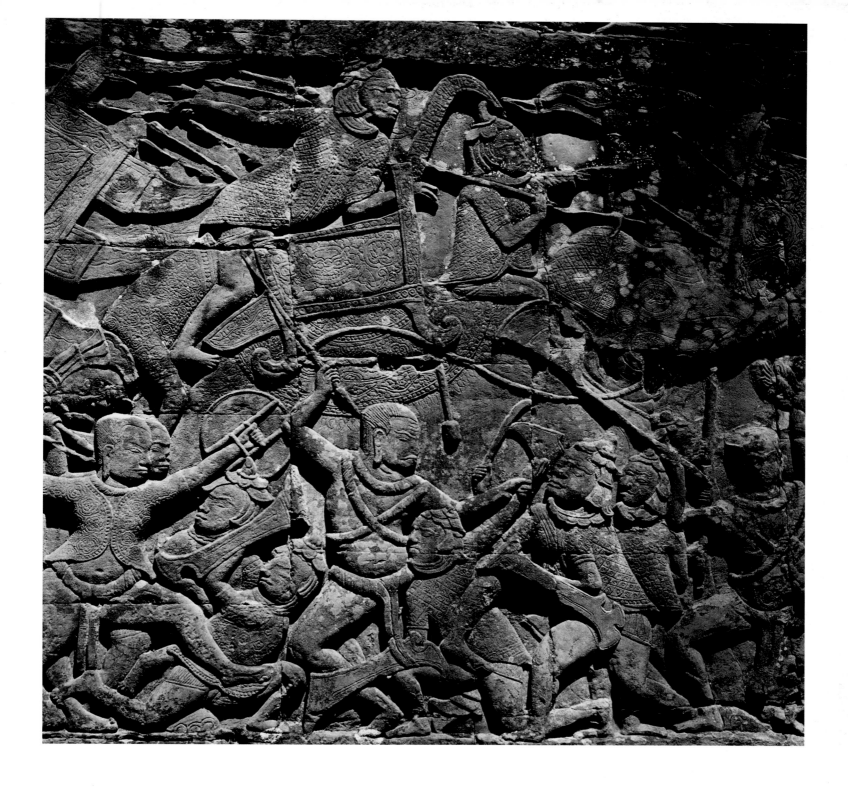

THE SOVEREIGN COMES FORTH

When the king leaves his palace, the procession is headed by soldiery; then come the flags, the banners, the music.
The bodyguards of the palace hold shields and lances.
Finally the sovereign appeared, standing erect on an elephant and holding in his hand the sacred sword.
All around was a bodyguard of elephants, drawn close together, and still more soldiers for complete protection, marching in close order.

From Notes on the Customs of Cambodia *by Chou Ta-kuan, Chinese envoy to the court of Angkor (1296–1297) at the height of Cambodia's prosperity, before the capital was sacked in the fourteenth century.*

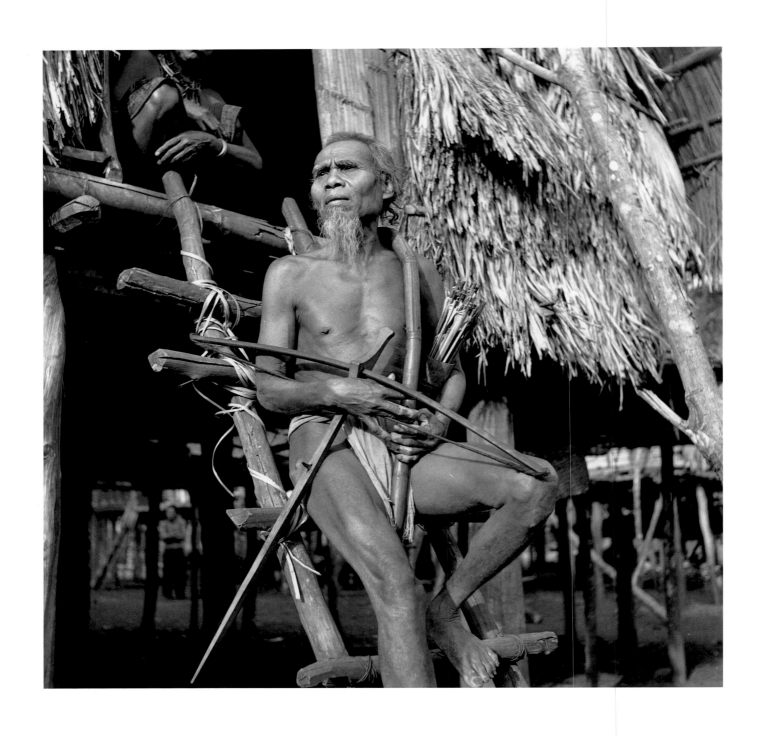

EVERETTE DIXIE REESE
Central Highlands, Vietnam, 1950s.
*The tribespeople of Vietnam's central highlands played an
important role in the guerrilla warfare in Vietnam's
mountain jungles between 1946 and 1975.*

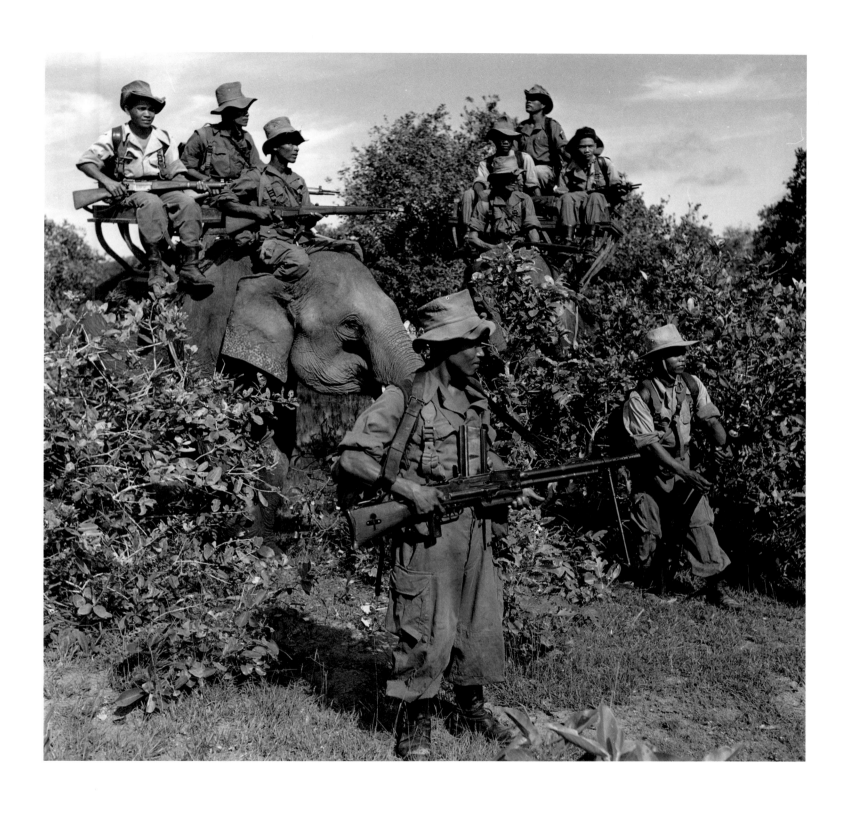

EVERETTE DIXIE REESE
Cambodia, 1950s.
Cambodian troops under French Union command used elephant transport during military operations in north-eastern Cambodia along the border with Vietnam.

WAR IN INDOCHINA

Tad Bartimus

Foreign occupiers always have a vision of what they should do for the conquered. In Indochina, France had, in the words of one prime minister, a mission to civilize "inferior peoples."

"In your eyes, we are savages, dumb brutes, incapable of distinguishing between good and evil," wrote mandarin-turned-nationalist Phan Chau Trinh in an open letter to Vietnam's French governor in the early 1900s. Daringly he added, "Some of us, employed by you, still preserve a certain dignity."

By World War II, dignified natives had been replaced by rebels wanting guns and ammunition. Japan presented Vietnamese nationalists, socialists, and Communists with the rarest of opportunities when it overran Southeast Asia in 1940.

While some Vietnamese hailed an Asian country's overthrow of white colonialism, Ho Chi Minh was wary. He correctly guessed that the United States would prevail and aligned his newly organized Viet Minh forces, operating near the Chinese border, with the Americans' Office of Strategic Services (OSS), which had a base in Kunming, China. Ho bargained for U.S. support by promising to rescue downed pilots, but when the war ended, Harry Truman sided with Charles de Gaulle instead of with a skinny guerrilla leader with close ties to Joseph Stalin's Moscow.

As in Greece, Poland, and Palestine, in Vietnam the end of World War II left a power vacuum. On September 2, 1945, Ho proclaimed the independence of the Democratic Republic of Vietnam with a phrase borrowed from Thomas Jefferson: "All the peoples on earth are equal from birth, all the peoples have a right to life, to be happy and free." Truman ignored him. The opportunity for an American-supported unified Vietnam was being lost.

Lieutenant Colonel A. Peter Dewey, an OSS officer sent to Saigon to look for Allied war prisoners, predicted disaster to come: "Cochin China is burning, the French and the British are finished here, and we [the United States] ought to clear out of Southeast Asia." Then Dewey became the first American to die in Vietnam, when he was caught in a Viet Minh ambush in September 1945.

The French returned. Ignored at the conference table, Ho concluded, "There is nothing left but to fight." Six days before Christmas 1946, the Viet Minh blew up nearly every power plant in the country. The Indochina War began in the dark.

The goal was always unification.

The north had the people and the industry; the south had the rice bowl and the rubber that made the Michelin man fat. The French and, later, Americans would attribute many motives to their Viet Minh, Viet Cong, and North Vietnamese enemies. But the simple fact, rooted in history, was that the Vietnamese had to eat and earn a living. Saigon could go it alone and get by because it could feed itself; Hanoi could not.

The North Vietnamese started south. The French, retaliating with classic warfare tactics, soon floundered against an enemy that played by no rules. Hit and run, ambush, and deadly use of bamboo, poison, and camouflage were enemy weapons. French paratroopers fell back toward the false safety of cities as barefoot guerrillas who lived off bamboo shoots and rice claimed the countryside through fighting and fear.

Washington, baffled by so many French defeats, abandoned neutrality and recognized France's puppet emperor, Bao Dai, who nominally ruled from Saigon but preferred the Riviera. Truman sent advis-

EVERETTE DIXIE REESE
Hanoi, Vietnam, 1954.

ers in 1950. The Americans were in the quagmire. The French fought on: "A year ago none of us could see victory," proclaimed General Henri Navarre; "Now we can see it clearly—like light at the end of a tunnel."

The end came at Dien Bien Phu. The French had tanks, planes, cannon; the Vietnamese had Vo Nguyen Giap. He estimated that he needed fifty thousand troops and six weeks; Ho agreed with the strategy but warned, "Don't begin it unless you are sure of winning."

The day before peace talks opened in Geneva, a Communist soldier raised a red flag over the headquarters of Colonel Christian-Marie-Ferdinand de La Croix de Castries at Dien Bien Phu. It was left to the Chinese strategist Chou En-lai and the hard-line Bolshevik Vyacheslav Molotov to climax seventy-four days of stalemate in Switzerland with a temporary cease-fire, a partition of the country at the seventeenth parallel, and a two-year deadline for elections. No one was happy; Ngo Dinh Diem, the south's prime minister after he and his CIA friends ousted Bao Dai, predicted "another more deadly war."

The first Indochina war ended on July 21, 1954, at 0343 Geneva time. It had cost the French Union forces 172,000 fatal casualties. The Viet Minh's casualties probably ran three times as high, and perhaps another 250,000 Vietnamese civilians were killed during the fighting.

The end triggered the flight of a million northerners, mostly Roman Catholics, to the south and cost the United States $2 billion in aid to the losers.

It was a warm-up act.

Dwight D. Eisenhower, who had become president at the very end of the Korean War, was leery of committing troops to a land war in Asia. But he also worried that, like dominoes, other countries would "go Communist" if there wasn't some U.S. presence in Vietnam after the Geneva Accords were ignored. His successor, who pledged to "pay any price, bear any burden" for liberty, had been beguiled by Vietnam on a brief visit in the 1950s.

As with so many other things, John Kennedy chose to see the country's romance and not its underbelly. Reluctant to become an ugly American, he stalled on committing the Green Berets. But his best and brightest were champing at the bit. Ignoring corruption and Diem's campaign of repression against internal enemies, real and perceived, they urged him to prop up Saigon's teetering regime.

The president was wary: "The troops will march in, the bands will play, the crowds will cheer, and in four days everyone will have forgotten. Then we will be told we have to send in more troops. It's like taking a drink. The effect wears off, and you have to take another."

America fell off the wagon in late 1961. *The New York Times* editorialized that the Vietnam War "is a struggle this country cannot shirk." The Yanks arrived with their can-doism, their gung-ho, more-is-better mentality.

Some called it the "John Wayne syndrome." They sized up the war in strictly military terms and boasted they'd be home by Christmas. Their generals, ignorant of Vietnam's history and ancient political and cultural divisions, believed they could "save" Vietnam by overlaying America's democratic institutions onto it as they would iron a heat-transferred slogan onto a blank T-shirt.

Seizing on the flimsiest of excuses in a phantom threat to two U.S. warships, Lyndon Johnson sealed the fate of his presidency by ramming through Congress the Tonkin Gulf Resolution in 1964, the year of the dragon on the Vietnamese lunar calendar. By then Diem and his brother Nhu had been assassinated—just weeks before Kennedy was killed; a devout Catholic, Nguyen Van Thieu, had become the pliant president; the monk Thich Quang Duc had immolated himself, rallying Buddhists against the government; the Ho Chi Minh Trail, in places little more than a one-man track through the jungle, had been extended nearly to Saigon; Laos and Cambodia had become staging areas for both sides; and a contrarian band of young journalists wouldn't "get on

the team," reporting instead that the war was going from bad to worse for the Americans.

For ten more years the United States remained mired in its longest and most divisive war. Ho died, but Giap fought on. The Chinese and the Russians kept North Vietnam supplied with surface-to-air missiles: those SAMs brought down dozens of American fliers who then spent the war in the "Hanoi Hilton" prison.

The U.S. generals—first Harkins, then Westmoreland, then Abrams—kept predicting that the troops would be home by Christmas, but stopped saying which one. The ambassadors—Nolting, Lodge, Bunker, Taylor, Martin—successively watched the light dim at the tunnel's end.

The grunts, splashing ashore and flying in by the thousands, arrived with conviction and hope. They left in body bags, on stretchers, or aboard charter flights that landed them "back in the world," where their own disillusionment festered. Routinely men who "had to destroy the town in order to save it" were transformed from heroes in Vietnam to pariahs in their hometowns.

Vietnam became the most documented killing field in history. Television and print media delivered images of death and violence as dependably as a milkman: A Shau, An Loc, Khe Sanh, My Lai, Cu Chi, Da Nang, Hue, Tet 1968. Their images are indelible on America's psyche. Abroad they caused French and British antiwar mobs to strike; in Ohio college students were killed by national guardsmen for protesting the war's illegal spread into Cambodia and Laos.

Cambodia, especially, became a sideshow as the United States, attempting to stop traffic on the Ho Chi Minh Trail, conducted clandestine, then overt, B-52 carpet bombings. Like Saigon, the graceful city of Phnom Penh became a refugee camp for thousands of desperate peasants and a bull's-eye for enemy rockets. Brainwashed Khmer Rouge victors eventually turned it into a deserted wasteland.

"No more war!" went from a bumper sticker to a political mandate. When Lyndon Johnson re-treated to Texas to brood about what had gone wrong, Richard Nixon finally achieved the White House in 1968 by promising to end the Vietnam War. He made good his promise in 1973 by doing what the first dead American, Peter Dewey, had advocated. He simply pulled out. Henry Kissinger and Le Duc Tho won the Nobel Peace Prize.

With the Americans out of the way, Hanoi turned into a military Goliath as Giap switched to classic Clausewitz tactics and relentlessly marched north to south, west to east. It wasn't a pincer, it was a steamroller. The speed of conquest shocked even North Vietnamese field commanders, whose tanks often were miles ahead of projections. Panicked South Vietnamese stampeded for the sea. The "boat people" fled in anything that would float and a lot of things that wouldn't. The lucky ones washed up on foreign shores, starving and destitute, only to be quarantined behind barbed wire by hostile hosts. Release came through immigration to another country or repatriation back to Vietnamese prisons or reeducation camps. In the last days South Vietnamese tried to escape by plane, bicycle, car, cart, and foot. The whole world tuned in to witness the disintegration of a society as the North Vietnamese claimed their dream.

There is scant archival record of Cambodia's holocaust. Merciless Khmer Rouge death squads, led by Pol Pot, murdered up to two million people in their purge of the educated class. Their monuments were piles of skulls.

Saigon's final freeze-frame caught terrified evacuees struggling to reach a helicopter perched on a roof in the center of Saigon; millions missed that last flight out.

On April 30, 1975, the second Indochina war came to an ignominious end for the United States. Not until twenty years after the war did the Hanoi government disclose that 1.1 million Communist fighters died and 600,000 were wounded in twenty-one years of conflict, from 1954 to 1975. Missing in action were 300,000 Communist soldiers, compared with 2,211 U.S. soldiers.

Other figures show that nearly two million civilians were killed in the north and the south, and an equal number were injured. From 1959 to 1975, a total of 58,168 Americans died. The war cost the United States more than $150 billion.

When it disintegrated, the South Vietnamese administration had counted 223,748 of its fighters dead. How many soldiers and civilians perished in the confusion of flight and defeat during the final days, when South Vietnam's soldiers faded away or were taken prisoner, was not recorded. Nobody can estimate or is willing to divulge how many Vietnamese did not return from the labor and reeducation camps set up by the winning side after the war. In addition, families in Australia, New Zealand, South Korea, and Thailand mourned the deaths of their sons who fought and died as allies of the South Vietnamese. There are 496 names engraved on Vietnam War memorials in Australia, 37 names in New Zealand, 5,083 in South Korea, and 539 in Thailand. The small Philippine Civic Action Group recorded no dead.

The Vietnamese, north and south, were exhausted, their country devastated. Ho's heirs were excluded from the family of industrialized nations, and a coterie of old, hard men meted out punishment to all who had sided with the Americans. Those left in the fields earned less than $200 a year. It was a bitter peace.

In the two decades since, diplomats at first ignored one another, but mutual interests forced them finally to grope toward an awkward reconciliation. Today the American Express card is accepted in Hanoi as well as in Saigon, Club Med is building a resort near Bao Dai's old palace, and Vo Nguyen Giap takes tea with retired American generals.

C'est la guerre.

EVERETTE DIXIE REESE
Highlands, Vietnam, 1954.
French Foreign Legion soldier.

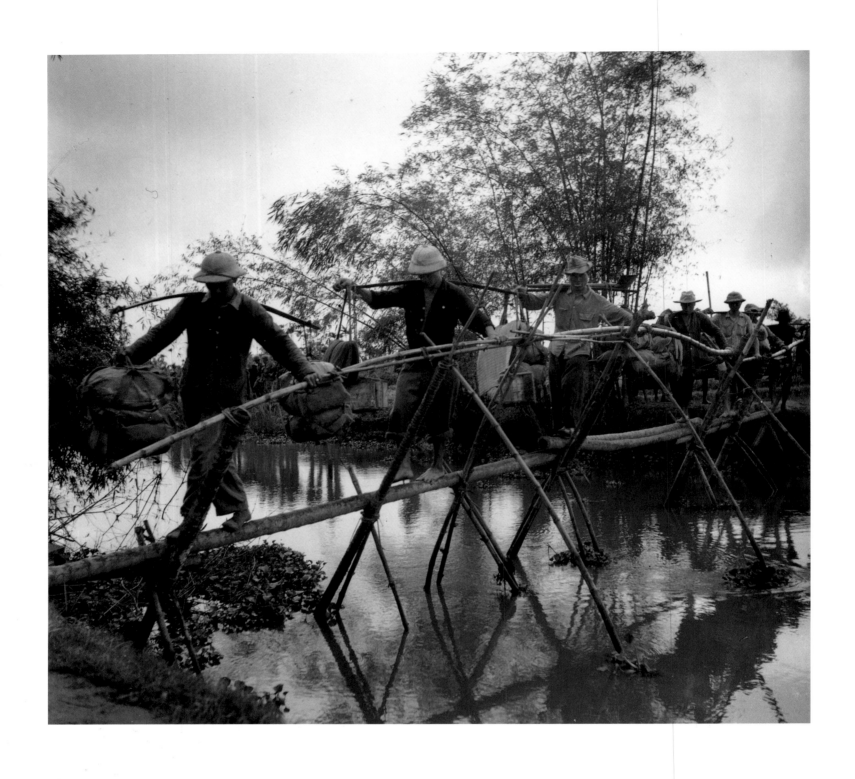

PIERRE JAHAN
Tonkin, Vietnam, 1952.
*Operation Mercure: Civilians drafted into a local
militia carry supplies.*
(SIRPA/ECPA)

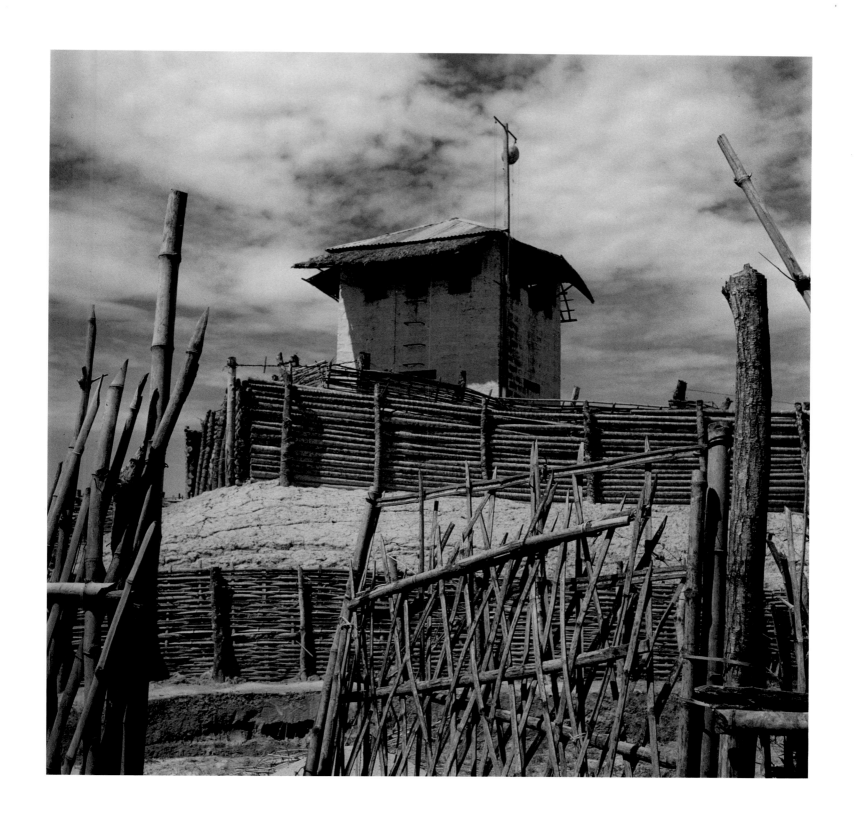

EVERETTE DIXIE REESE
Near Hue, Vietnam, 1951.
Military outpost.

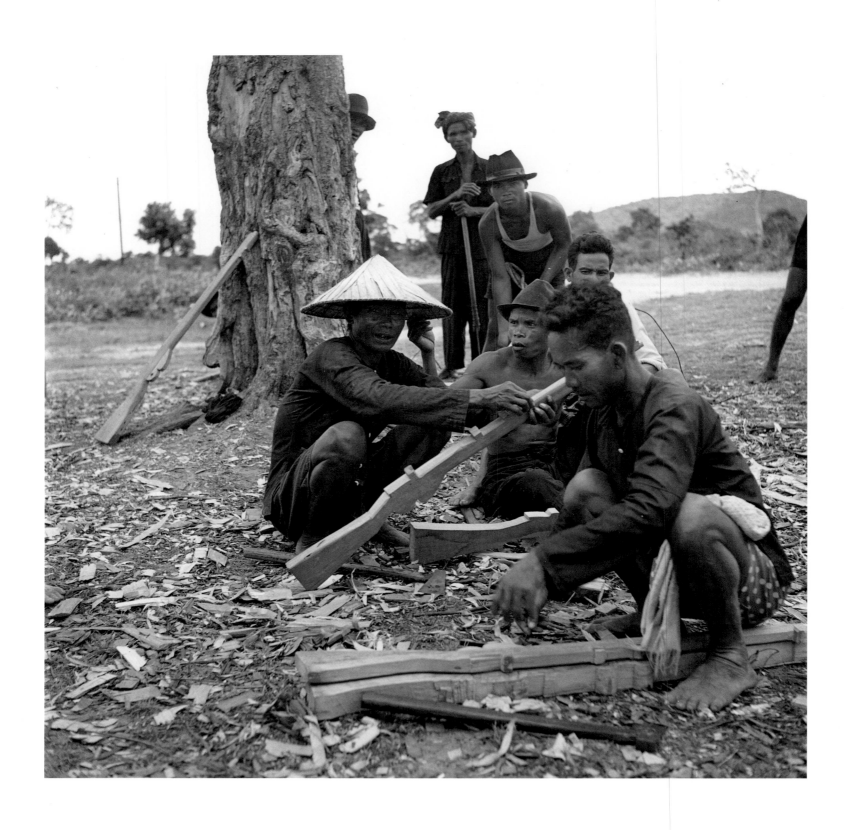

EVERETTE DIXIE REESE
Cambodia, 1950s.
*Local peasants and fishermen manufacture wooden
dummy rifles to be used for exercises by the local militia
formed under French Union command for village and
outpost defense.*

EVERETTE DIXIE REESE
Tonkin, Vietnam, 1953.
A Vietnamese soldier fighting alongside the French.

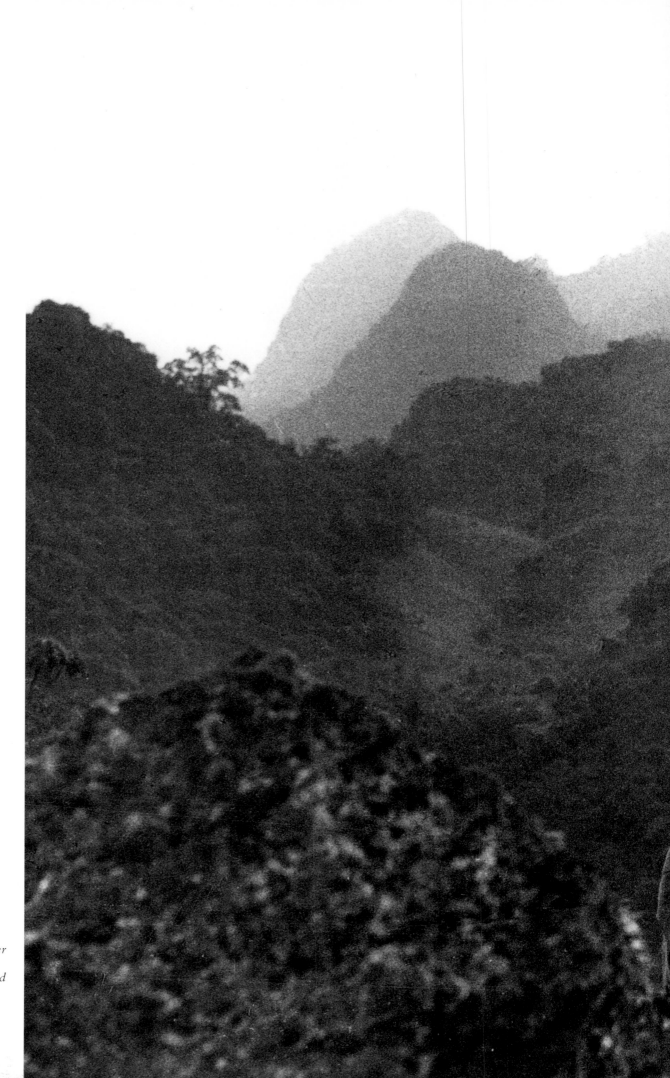

PIERRE JAHAN
Tonkin, Vietnam, 1952.
French sentry in the Black River
military campaign. In 1952,
French Union forces were pitted
against Viet Minh regulars.
(SIRPA/ECPA)

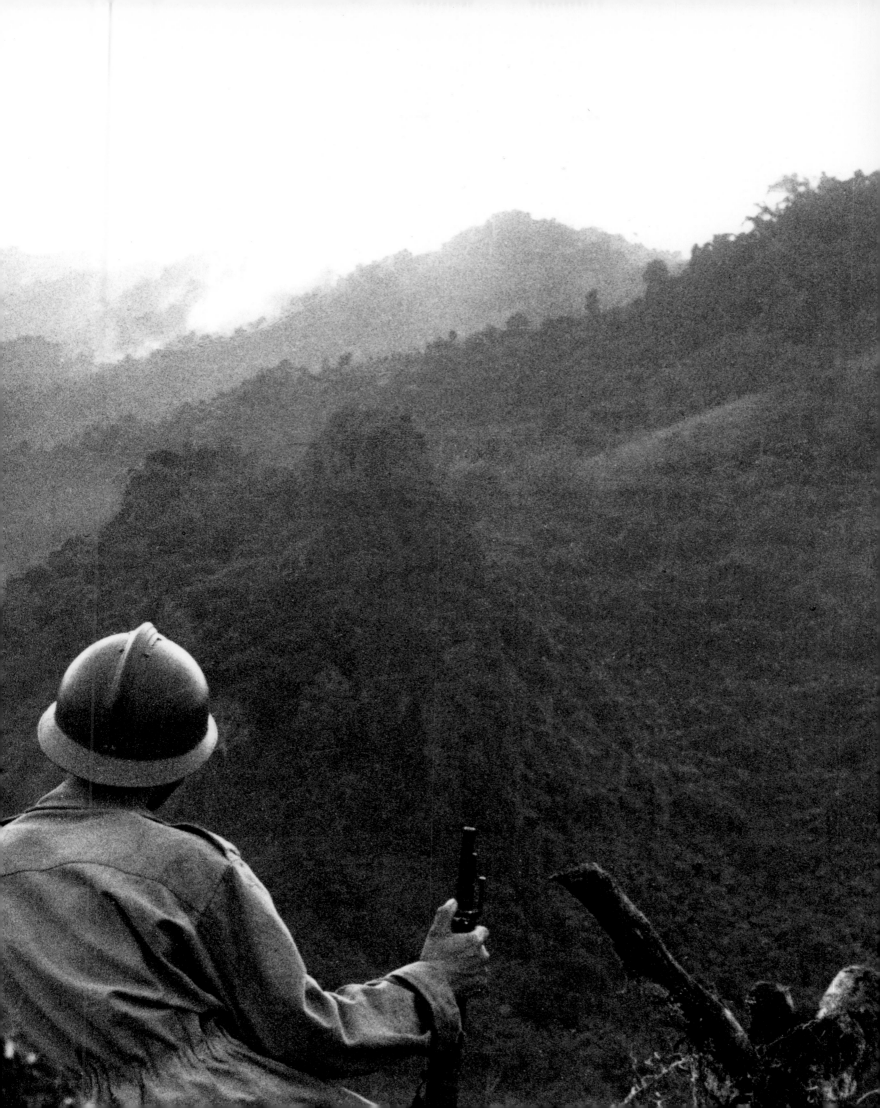

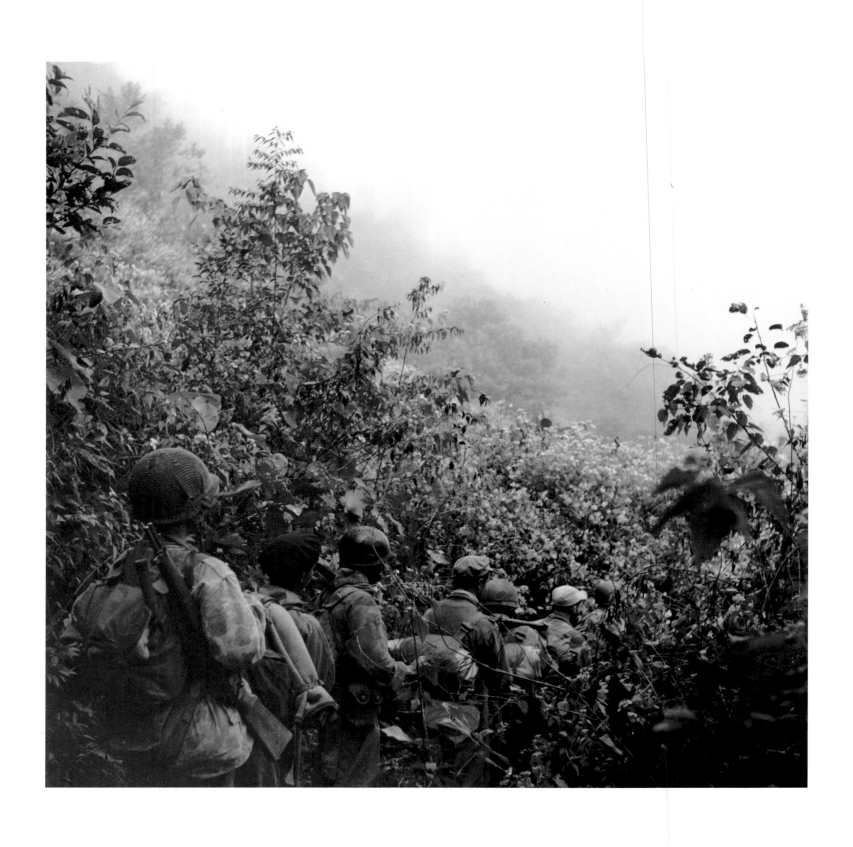

EVERETTE DIXIE REESE
Dien Bien Phu, Vietnam, 1953.
French patrol.

EVERETTE DIXIE REESE
Dien Bien Phu, Vietnam, 1953.

MY INDOCHINA WAR

Pierre Schoendoerffer

Pierre Schoendoerffer is a renowned French film-maker and novelist now living in Paris who, in his early twenties, as a corporal in the French army, was a combat cameraman in Indochina. His close colleagues, Daniel Camus, Raymond Martinoff, and Jean Peraud, also military photographers, were with him at the battle of Dien Bien Phu. Martinoff was killed in the fighting. Schoendoerffer, Camus, and Peraud became prisoners of war when the garrison fell to the Viet Minh on May 7, 1954. Schoendoerffer and Peraud, best friends, tried to escape together. Schoendoerffer was recaptured and spent four months in a POW camp. Peraud vanished. His fate is unknown.

Young French combat photographers and cameramen were soldiers first and foremost. That was the fundamental difference between "our war," the first Indochina war, and the Vietnam War. All went to Indochina for reasons of their own. Once there, however, they discovered something larger and greater than themselves. We served twenty-eight-month tours, with extensions sometimes. We were the black sheep of the world, an army of paupers, but we did not care.

I was lucky enough to have a Bell and Howell (35mm film) camera I could use while keeping both eyes open and maintaining vision both right and left past the camera. Other cameras that had to be carried on the shoulder were dangerous because the right side of the cameraman's vision was obscured. He could not see the danger coming.

The camera had to be rewound every seventeen to eighteen seconds, and the film roll lasted only one minute before it had to be replaced. The film sequences were very short, and that forced me to concentrate on the essential moments. I could not waste film.

Just as a soldier who has a limited amount of ammunition will shoot only when the shot promises to be effective, I was in the same situation with my camera.

Even in the intensity of combat I made an effort to frame and compose properly. Other times I would instinctively shoot because I knew the action in front of me was important. One had to be careful with dust and rain, so I protected my lenses with condoms.

The French Press Information Service had only a dozen photographers and cameramen. We did not live together, as did the soldiers of a military unit, but we had our own military-press compound in Hanoi, where our paths would sometimes cross. We were constantly in the field. Our film footage was shown weekly back home in public cinemas. We were trying to send messages to France through our pictures that said: "Here are our mates! This is the way they live! Look at us! This is what is happening !"

When I had enough film, I was able to control my fear. When I ran out of film, when I could not work with my camera, I felt fear. I don't think I was a coward, but I took cover.

This war, with its dangers and death, was a true love story. Vietnam revealed a sublime sentiment. Great friendship is a rare thing except in a war situation, where the feeling of fraternity and friendship becomes enlarged. It is a counterpoint to the horrors and hardships of war. We were far away and enchanted by our discovery of a world with great richness. It was a very moving and happy period of my life. I have not felt such intense emotion since. Every time I have to reflect on it, I have to work up

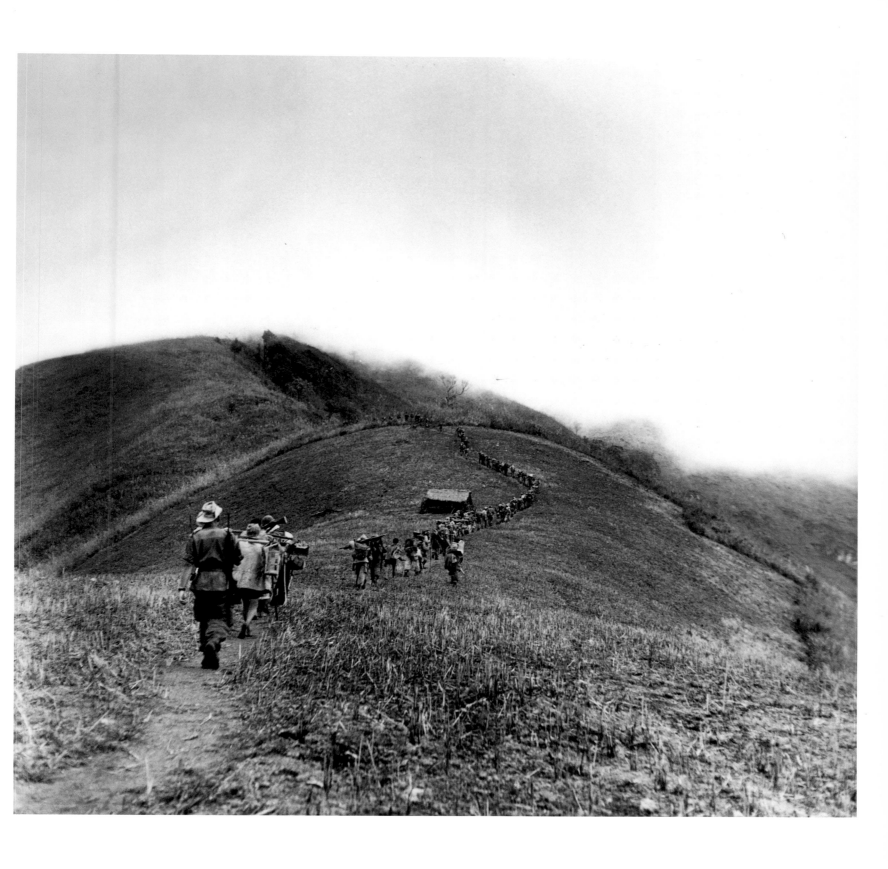

JEAN PERAUD
Tonkin, Vietnam, 1953.
French and Vietnamese French Union troopers proceed
in file across a hilltop north of Lai Chau during a
search-and-destroy operation.
(SIRPA/ECPA)

the necessary concentration to enter the past and re-discover "our skin," the thrills and shivers of that time.

I turned my back on these memories for a long time. Now, as I get older, they flash back, more often than I wish, with extreme clarity. They have been imprinted on me for more than forty years.

I was recovering in Saigon from a leg injury when I got a telegram from my friend and mentor, Jean Peraud, who told me, "I will jump into Dien Bien Phu. Do your best to join me." We always worked together as a team. I went in, for a second time, by parachute on April 18, 1954.

Movements in the open were practically impossible, with the rain, the caved-in trenches, and the permanent shelling by the enemy. Snipers in the hills pinned us down.

For the seven days after May 1, when Elaine One, the French position on the hilltop, fell to the Viet Minh, I ate practically nothing, just drank some water to survive. With each gulp I had to think of the men who had to die to get water for us.

The reasoning side of my mind told me all is finished, and we have been abandoned; the emotional side of my mind spoke differently: "It is impossible to give up, we have to do something!" Until the very last moment there was strong hope that a break through the enemy lines was still possible. We were young and hopeful. The adrenaline charge from the intensity of the battle kept our hopes up until that fatal moment on May 7, 1954, at 3:00 P.M., when the order came to destroy arms and ammunition. Then, and only then, did we feel that we had truly lost.

While the soldiers were destroying their rifles, I destroyed my camera. While they destroyed their ammunition, I destroyed my films, keeping only six reels that I thought were the best out of about thirty or thirty-five. I was still hoping to be able to escape or get the film out. But the Viet Minh took the film from me. I found out later it had not been destroyed. Much

JEAN PERAUD
Dien Bien Phu, Vietnam, 1954.
Colonel Christian-Marie-Ferdinand de La Croix de Castries,
commander of the French Union Forces, at his bunker headquarters.
(SIRPA/ECPA)

later, on a visit to Moscow, the Soviet director of a Viet Minh and Soviet film team, Roman Karmen, described the contents of my six reels to me. I know they may still exist somewhere in the Vietnamese bureaucracy, but I never saw the film.

In the prison camp the Viet Minh commissars tried to degrade us. They were very arrogant and cruel. We were very drained; the lost battle had caused shame, rage, and sadness inside us, and we had no way to overcome these feelings. One does not come out of such an experience as a virgin. Today I know who I am, I know who I was, and I know what I have done.

Peraud never leaves my mind. When I think of the war, I think not only of the horror of it but also of the overwhelmingly intense, magnificent feeling of friendship. Peraud helped me then, and helps me today, to overcome the bad memories.

After the war I tried to forget and put some kind of order into my life. I just tried to be a good film director and author. I concentrated on my career and put all my energy into it. But like oil on water, my memories resurfaced all the time.

Today in Vietnam one can feel a secretive, inward life that is not visible on the surface and yet is there, all around. It is a place that still moves me deeply. The Indochina War gave me a love for these people and this country.

It is a total paradox. When I made my film on Dien Bien Phu with the North Vietnamese in 1991, I told them, "Your land, the Vietnamese earth, has taken some of my tears, some of my sweat, and some of my blood. *'Je me sens chez moi—chez vous.'* That is why I feel at home here."

From an interview with Pierre Schoendoerffer by Rose Marie Wheeler.

THE END OF JEAN PERAUD
(1923-1954)

Bernard B. Fall (1926–1967)

The officers of the headquarters of Dien Bien Phu were being transported eastward by truck with their hands tied behind their backs and their bodies packed so tightly that the smallest bump of the deeply rutted jungle threw them helplessly against each other hour after hour. In their midst were also the war reporters Pierre Schoendoerffer, Daniel Camus, and Jean Peraud. Unable to move, they had seen kilometer after kilometer of jungle forest go by, and they knew that with every minute, with every kilometer, they were going farther away from any chance of escaping. Peraud, who had already served a long stretch in a Nazi concentration camp for his activities in the French resistance, was particularly despondent. He said to Schoendoerffer, "I've just got to get out of this. I can't do it twice. This time I'm sure I wouldn't come out of it alive."

Standing back to back, they searched each other's pockets for an object which could help them to escape. Finally Peraud found that Schoendoerffer still had his Swiss pocketknife in his pocket. At the price of agonizing contortions he succeeded in reaching it and opening its saw blade. Once this was done, it was not difficult to cut each other's bonds, but the problem arose as to the choice of the proper jumping-off point. Since they were not in the last truck of the convoy, the driver and guards of the following truck would surely see them. Therefore, they would have to wait for a particularly sharp turn, which would force the following truck to slow down enough to be behind the other side of the turn while they were jumping from their own truck.

The occasion finally presented itself in a steep crossing of the Black River at Thakhoa, almost midway between Dien Bien Phu and Hanoi. As they had calculated, the steep turn forced the truck behind them to an almost complete halt, and with the other prisoners blocking the view from the cab of their own truck, Peraud and Schoendoerffer jumped off and headed for the forest at the roadside. They found an almost solid wall of fully grown bamboo. For incredibly long seconds they frantically clawed at it, trying to find an opening wide enough to let their bodies through. Peraud finally succeeded just as the truck was coming around the bend, but Schoendoerffer, who had slipped in a puddle of water, was immediately seen by the Viet Minh guards. Shots rang out in all directions as the guards furiously tried to catch up with Peraud while others clubbed the prone Schoendoerffer into unconsciousness and loaded him again on his truck. All his film reels of the battle of Dien Bien Phu, which he had hoarded, were taken from him. Peraud was never seen again, although some rumors have it that he was later murdered in the forest by a greedy tribesman or even that he was later seen in Communist-held Hanoi in the company of a Tai tribal princess who had been caught in the siege ring at Dien Bien Phu. But all this is hearsay.

As far as the French army is concerned, Sergeant Jean Peraud of the French Press Information Service in Indochina, and attached to the 71st Headquarters Company at Dien Bien Phu, disappeared forever somewhere along Road 41 in May 1954. As he had wanted it, he did not have to go through the humiliation of a prison camp twice in his young life.

From Hell in a Very Small Place: The Siege of Dien Bien Phu *by Bernard B. Fall, 1966.*

EVERETTE DIXIE REESE
Dien Bien Phu, Vietnam, 1954.
*French soldiers assemble one of eight tanks that were
flown into Dien Bien Phu in parts by DC-3. In the
background are the airstrip and fortifications of the
garrison. The fall of Dien Bien Phu to the Viet Minh on
May 7, 1954, signaled the end of the French Indochina War.*

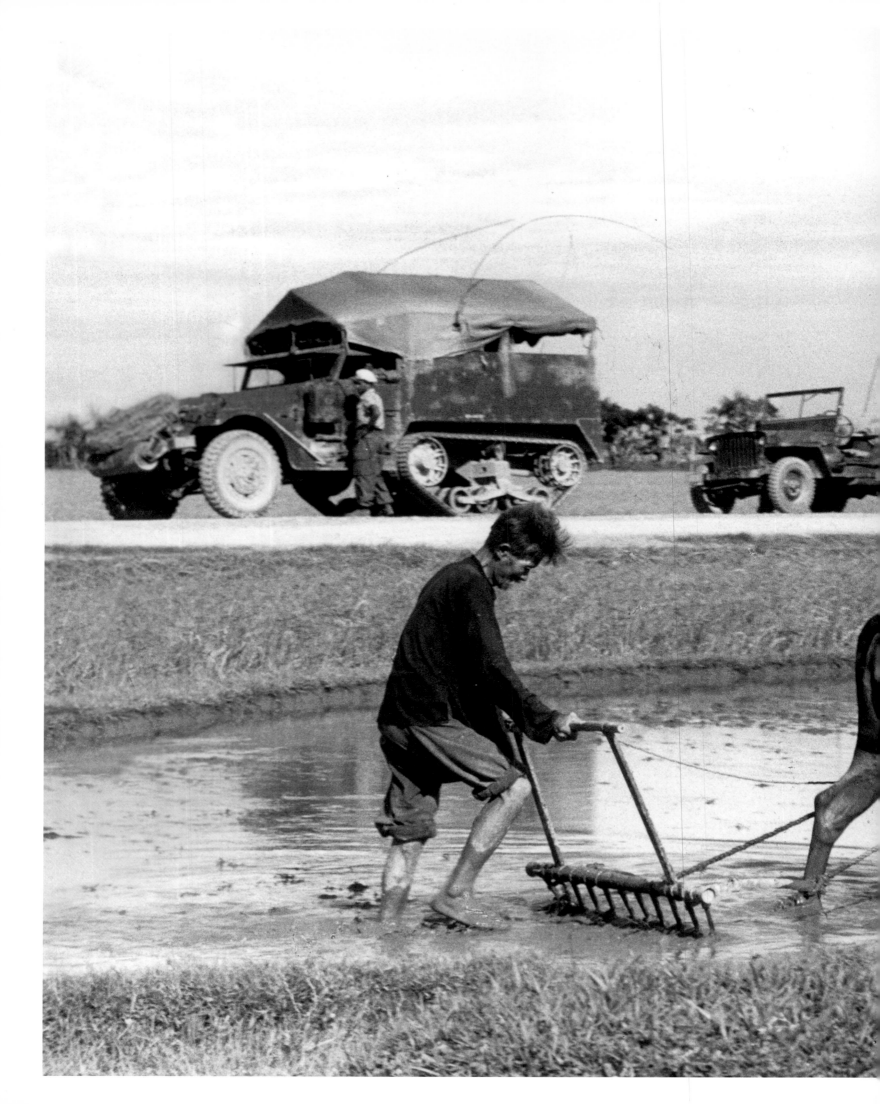

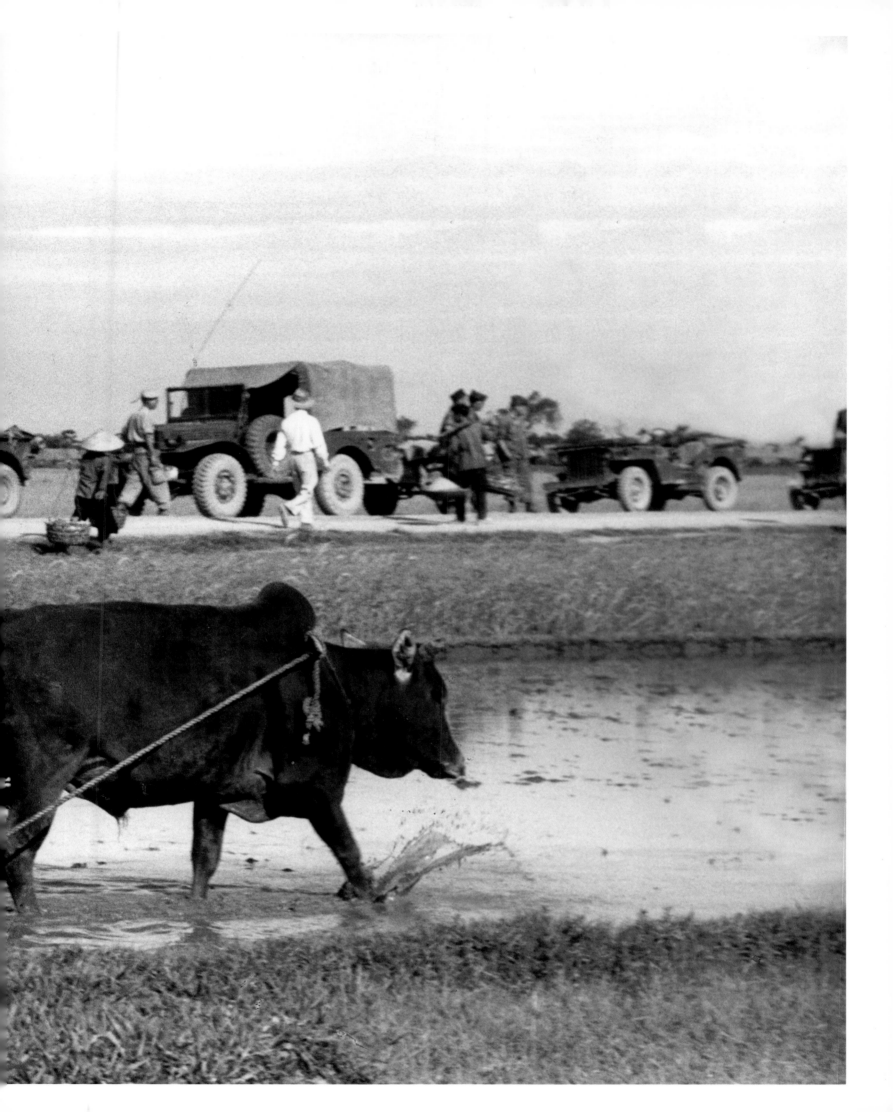

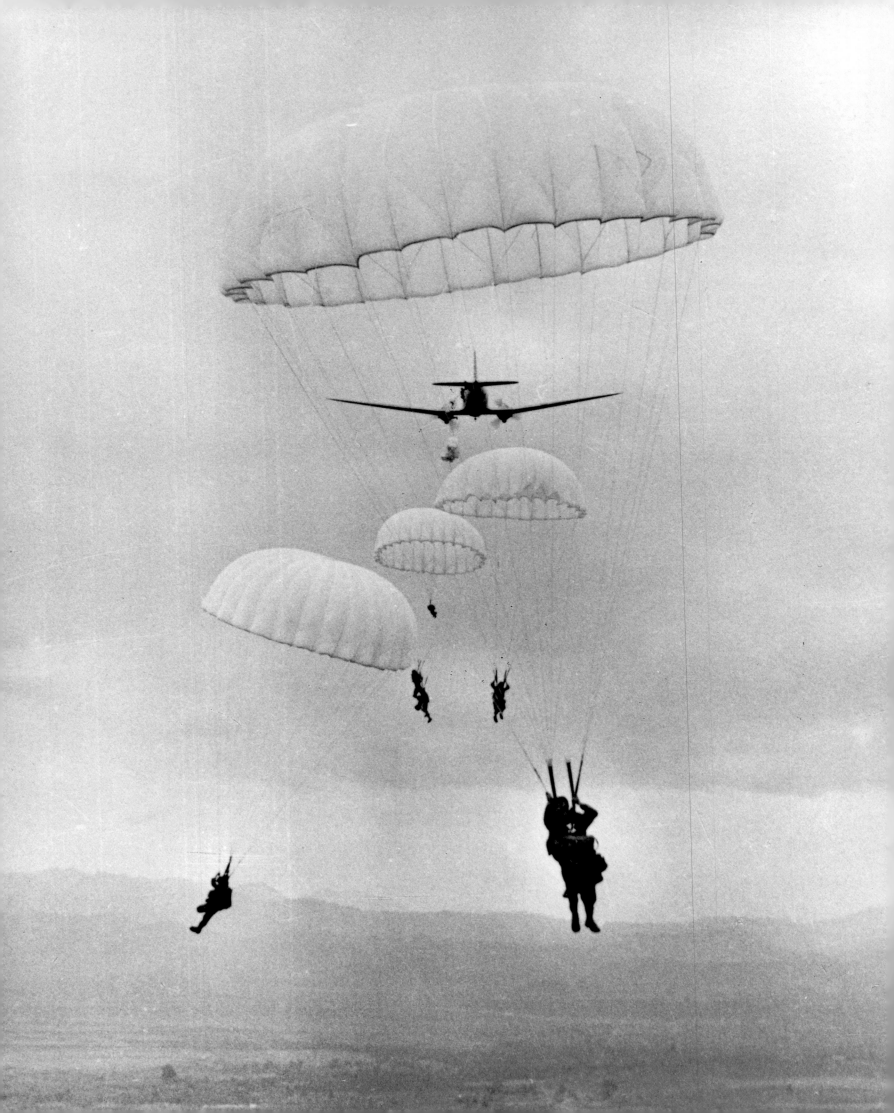

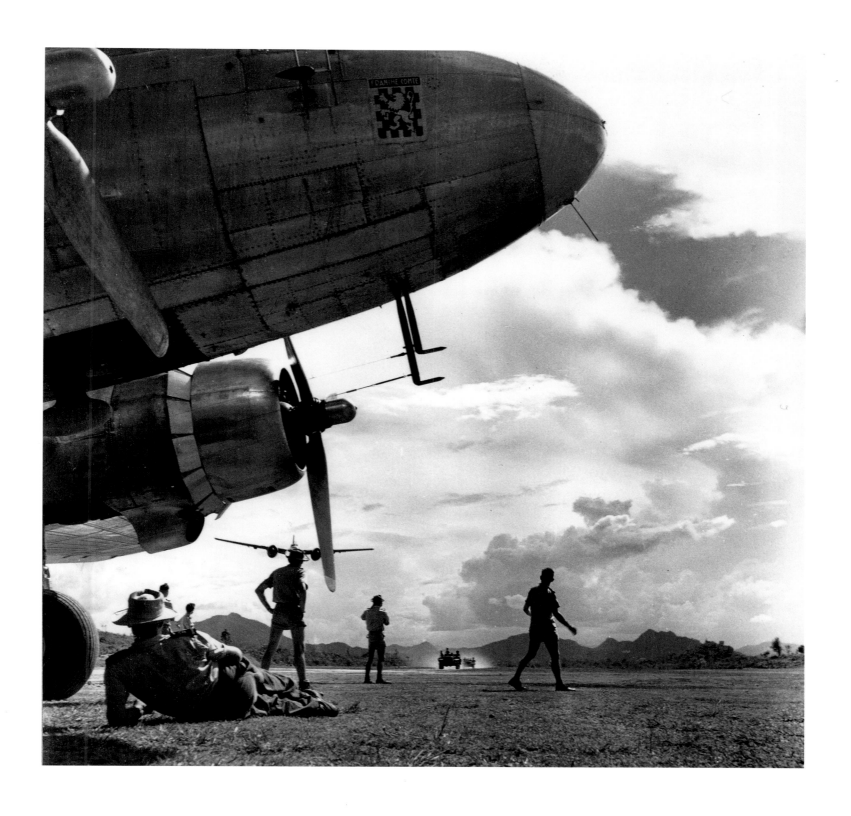

JEAN PERAUD
Laos, 1953.
*French paratroopers of the Sixth Battalion on the Luang
Prabang airfield.*
(SIRPA/ECPA)

JEAN PERAUD
Dien Bien Phu, Vietnam, 1954.
*Paratrooper reinforcements drop into Dien Bien Phu
on March 16, 1954.*
(SIRPA/ECPA)

(pages 52 and 53)
ROBERT CAPA
Red River Delta, Tonkin, Vietnam, May 25, 1954.
Last roll of film. The road to Thai Binh.
(Magnum Photos)

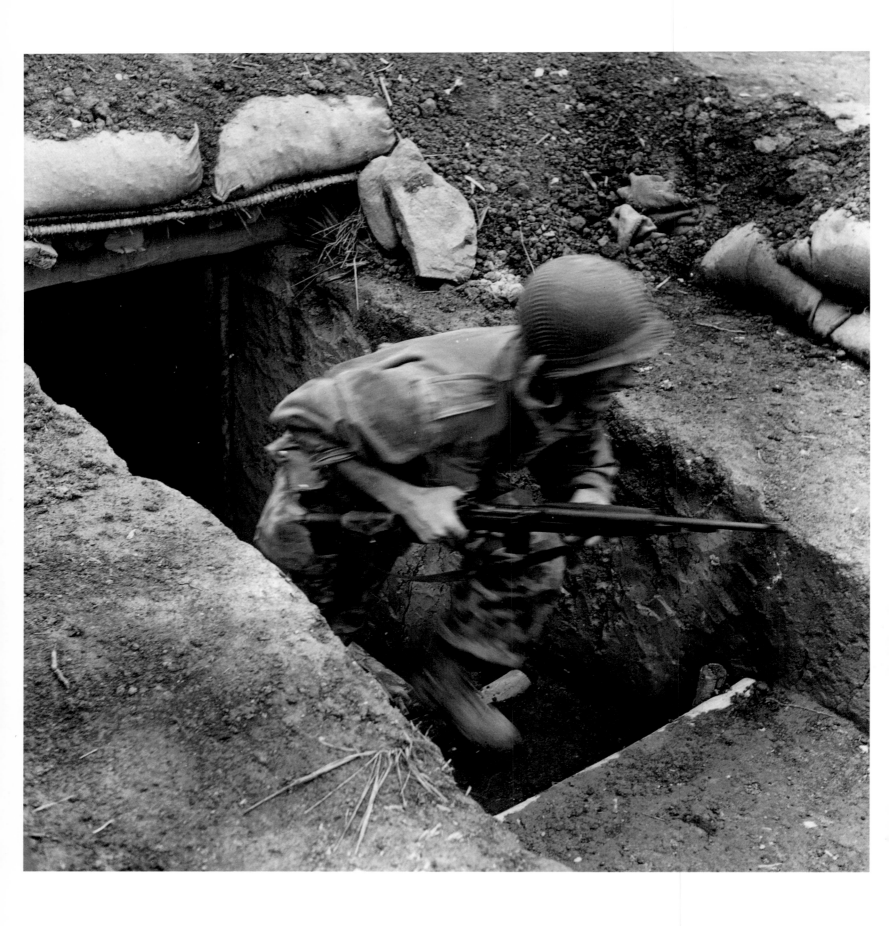

JEAN PERAUD
Dien Bien Phu, Vietnam, 1954.
French soldier during battle, March 13–16, 1954.
(SIRPA/ECPA)

JEAN PERAUD
Tonkin, Vietnam, 1952.
*During the Battle of Na San, French paratroopers
launched an early-morning counterattack to regain
control of a position taken during the night by the Viet
Minh. Hand-to-hand combat on one of the hilltop
positions followed the French charge.*
(SIRPA/ECPA)

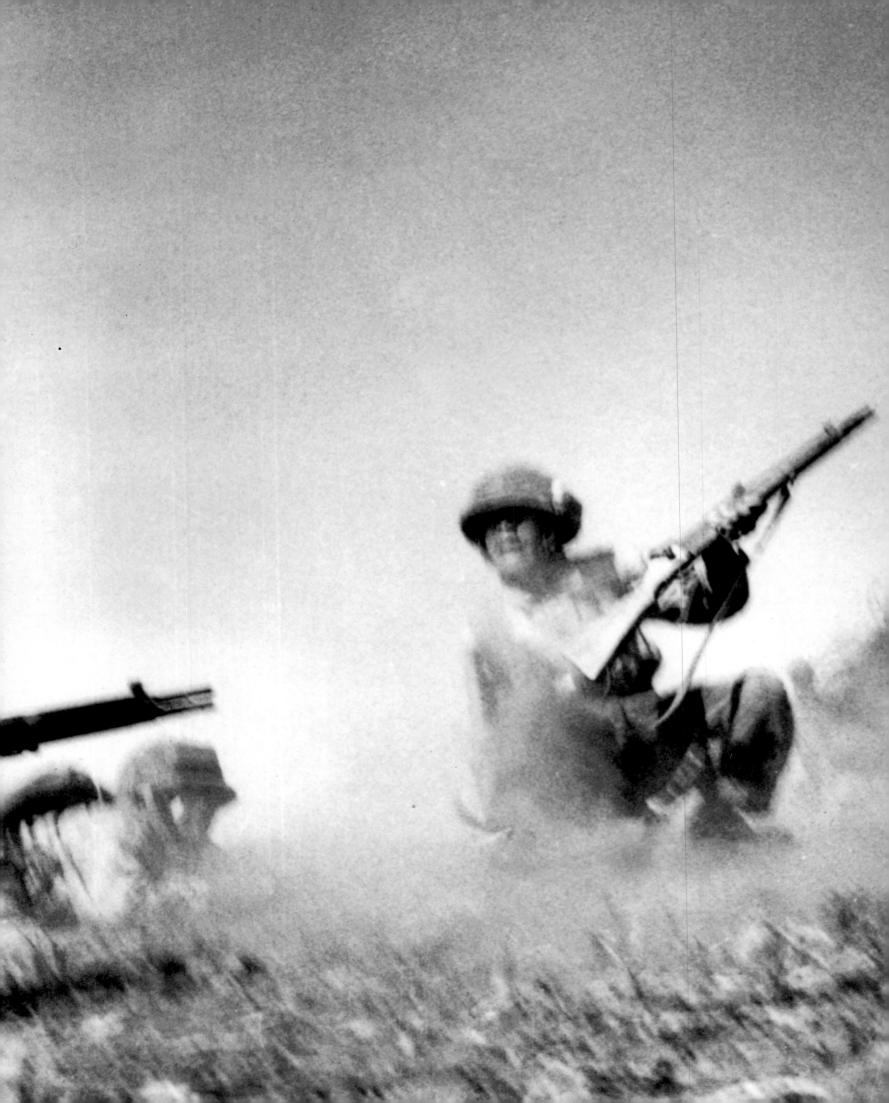

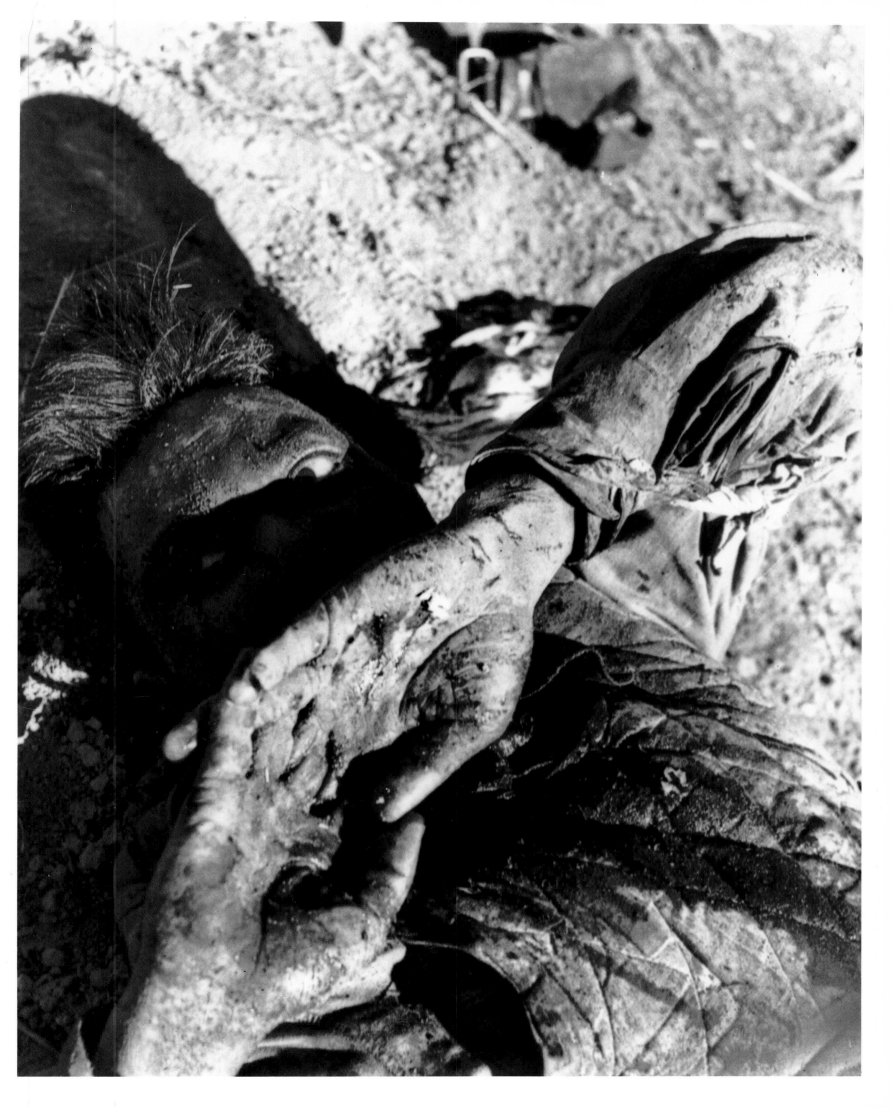

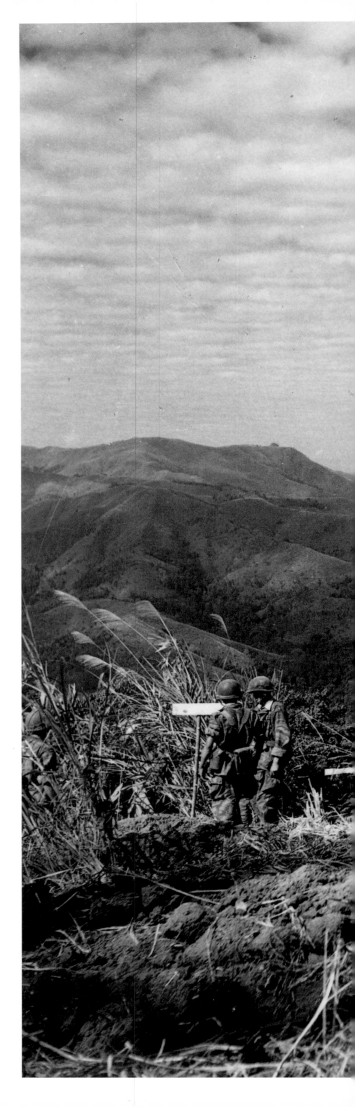

JEAN PERAUD
Near Dien Bien Phu, Vietnam, December 14, 1953.
Funeral for French troops. Major Philippe Leclerc,
commander of the French Second Airborne Group,
is on the right, wearing a bush hat.
(SIRPA/ECPA)

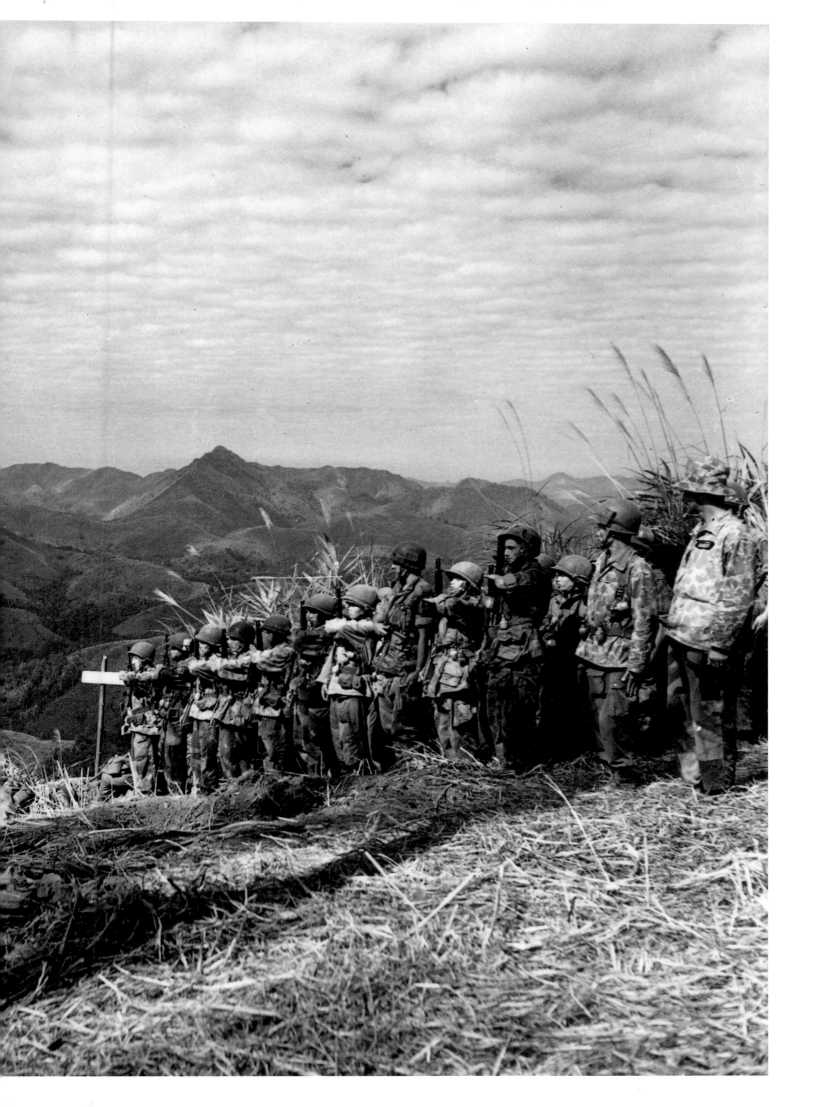

THE DEATH OF ROBERT CAPA, MAY 25, 1954
(1913–1954)

John Mecklin

Capa and I had been touring French outposts in the besieged Red River delta with General René Cogny, French commander in northern Vietnam. Next day we were going out with a two-thousand-man task force that was to relieve, then evacuate, two garrisons some fifty miles south of Hanoi.

A couple of hundred yards beyond Doai Than, the column was stalled again by a Viet Minh ambush. We turned into the field and talked to the sector commander, Lieutenant Colonel Jean Lacapelle. Capa asked, "What's new?"

The colonel's reply was a familiar one: "*Viets partout*" (Viet Minh everywhere).

The sun beat down fiercely. There was firing in every direction: French artillery, tanks, and mortars behind us, the clatter of small arms from woods surrounding a village five hundred yards to our left, heavy small-arms fire mixed with exploding French shells in another village five hundred yards ahead and to our right, the sporadic *ping* of slugs passing overhead, the harrowing *curr-rump* of mines and enemy mortars.

A young Vietnamese lieutenant approached us and began practicing his English, which was limited to a labored "How are you sir? I am good." Capa was exquisitely bored and climbed up on the road, saying, "I am going up the road a little bit. Look for me when you get started again." This was about 2:50 P.M. The lieutenant switched to French and asked if we liked Vietnam.

At 2:55, the earth shook from a heavy explosion. Behind us spouted a column of brown smoke and flames: The French were blowing up Doai Than. Asked the lieutenant, "Does the atomic bomb look like that?" Said Lucas, "Dammit, there goes the picture Capa wanted."

A few minutes later a tank began firing right behind us. The French were mortaring the village to our left, and at 3:05 Moroccan infantrymen began advancing through the paddies to finish the job. I was making notes on this when a helmeted soldier arrived and spoke to the lieutenant in Vietnamese.

Without a trace of emotion the lieutenant said, "*Le photographe est mort.*" I understood the words, but it didn't register and I said "*Pardon?*" The lieutenant repeated the sentence in the same flat voice. This time the words registered, but I was certain I had misunderstood and said to Lucas almost as a joke, "This guy's trying to tell me Capa's dead."

Still deadpan, the lieutenant spelled out the English word with French pronunciation of the letters: day-euh-aah-tay-aash, *death*. Simultaneously a second Vietnamese ran up and beckoned directly to me. The lieutenant questioned him and relayed, "Maybe not dead but wounded by mortar, *très grave.*"

Lucas and I jumped up and ran with the soldier down the ditch. At the point where the road bent, soldiers pointed up and over the road, then disappeared. We scrambled across the road and into a small lowland field. At the foot of the dike, across the V formed by the bending road, Capa lay on his back, the stump of his shattered left leg about a foot from the hole blown in the earth by the explosion. He also had a grievous chest wound.

One camera was clutched in his left hand. I began calling his name. The second or third time, his lips moved slightly like those of a man disturbed in sleep. That was his last movement. It was 3:10 P.M.

An instant later there was a thunderous explosion on the road above us. The blast blew screaming Vietnamese soldiers, miraculously uninjured, into a ditch. A bulldozer had set off a mine, and less than a

continued on page 71

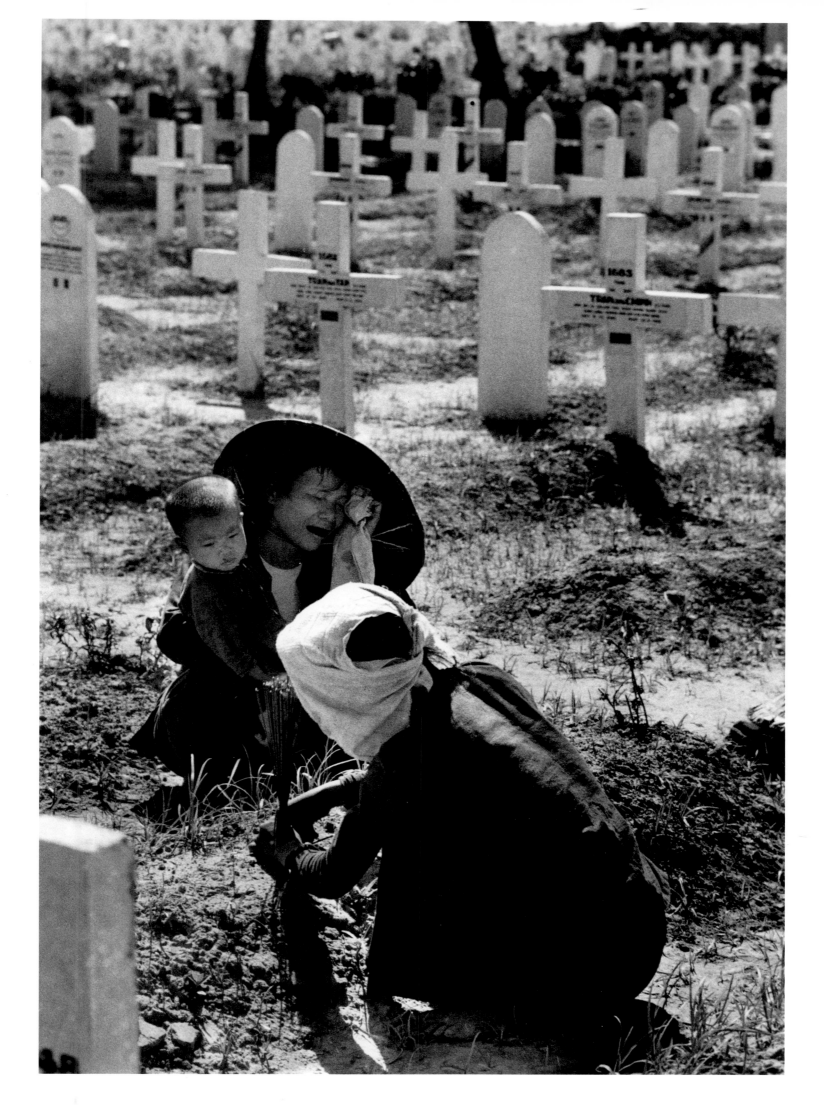

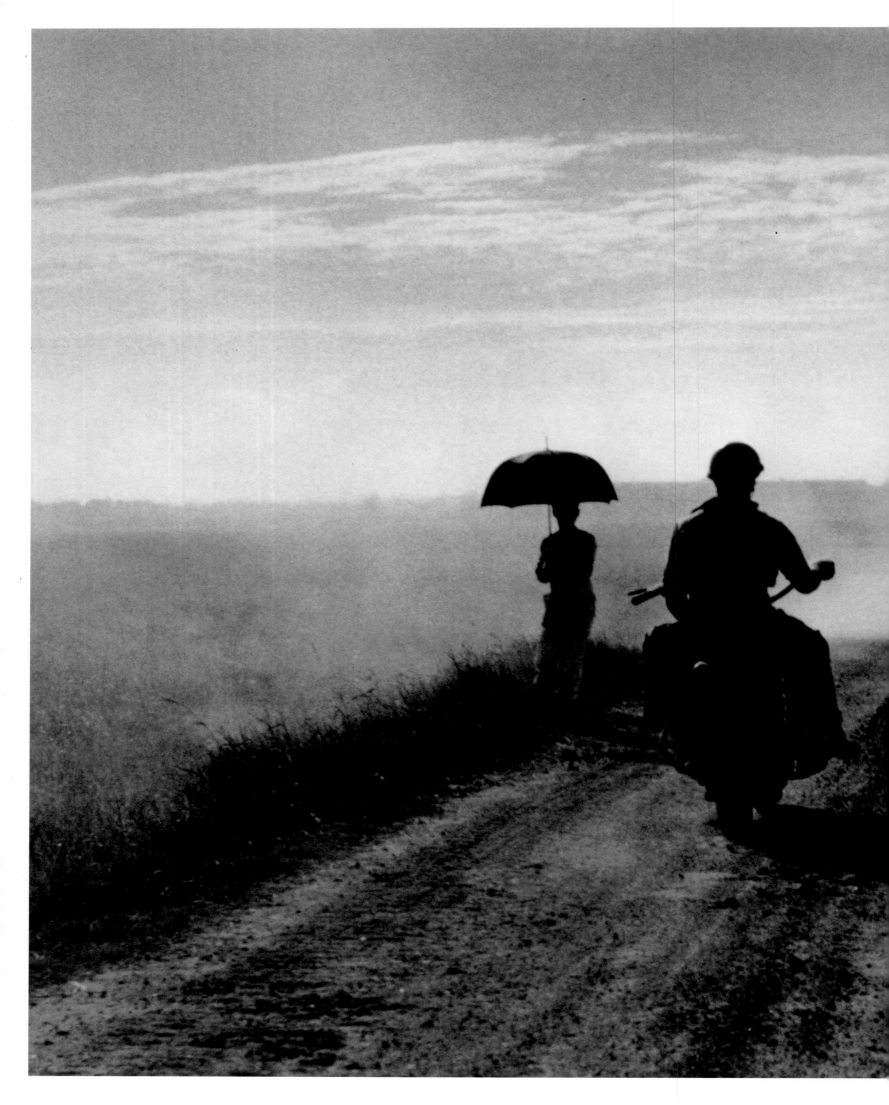

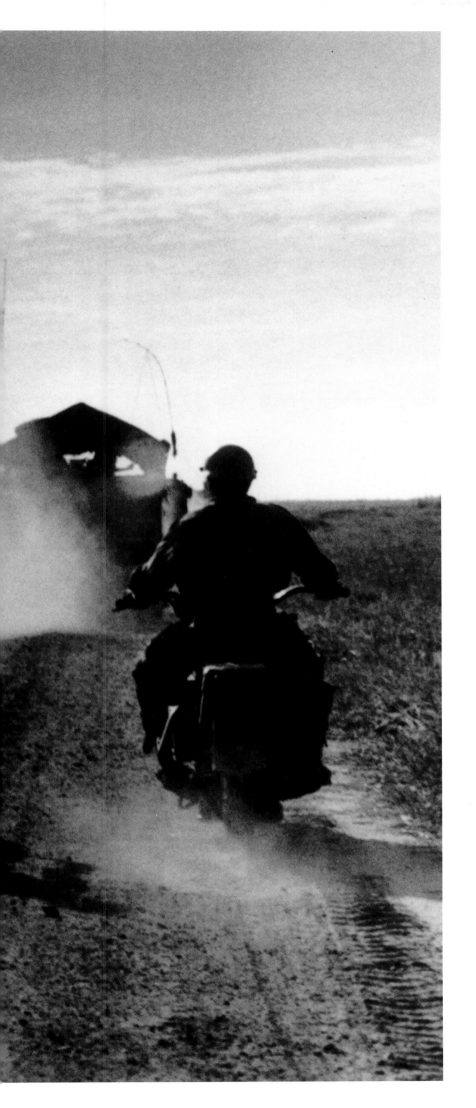

(page 65)
ROBERT CAPA
Nam Dinh, south of Hanoi, Vietnam, May 25, 1954.
*Last roll of film. Military cemetery for French and
Vietnamese French Union soldiers.*
(Magnum Photos)

(pages 68 and 69)
ROBERT CAPA
Red River Delta, Tonkin, Vietnam, May 25, 1954.
Last roll of film.
(Magnum Photos)

ROBERT CAPA
Red River Delta, Tonkin, Vietnam, May 25, 1954.
Last roll of film. The road to Thai Binh.
(Magnum Photos)

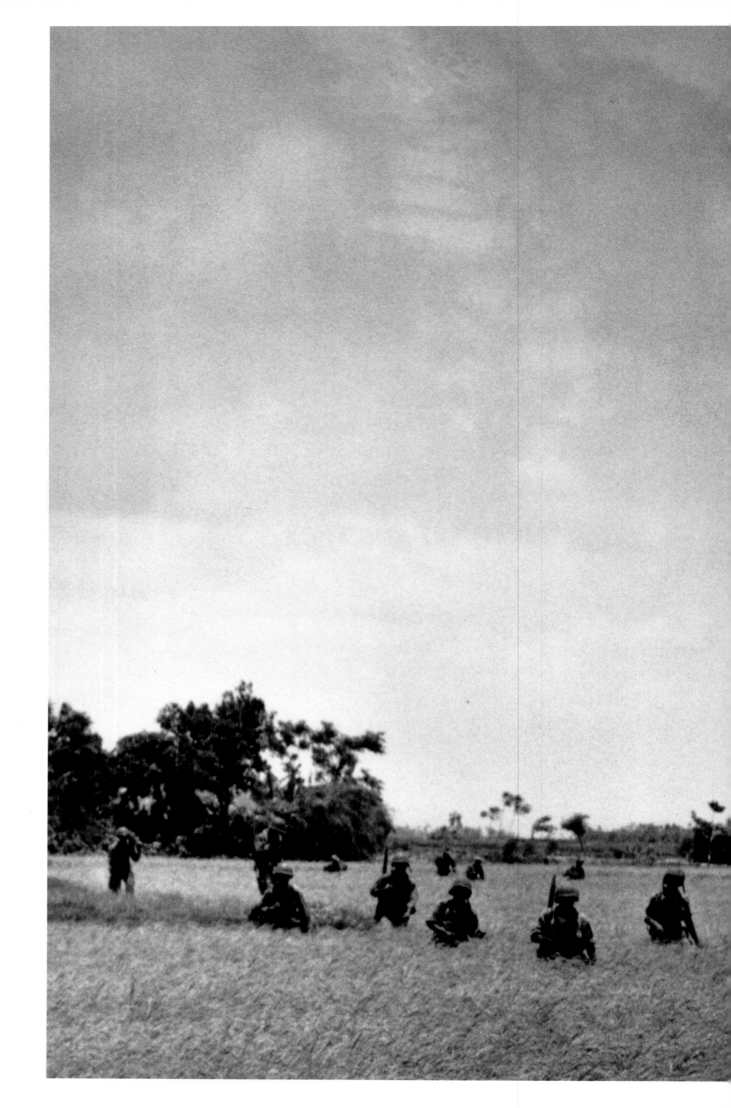

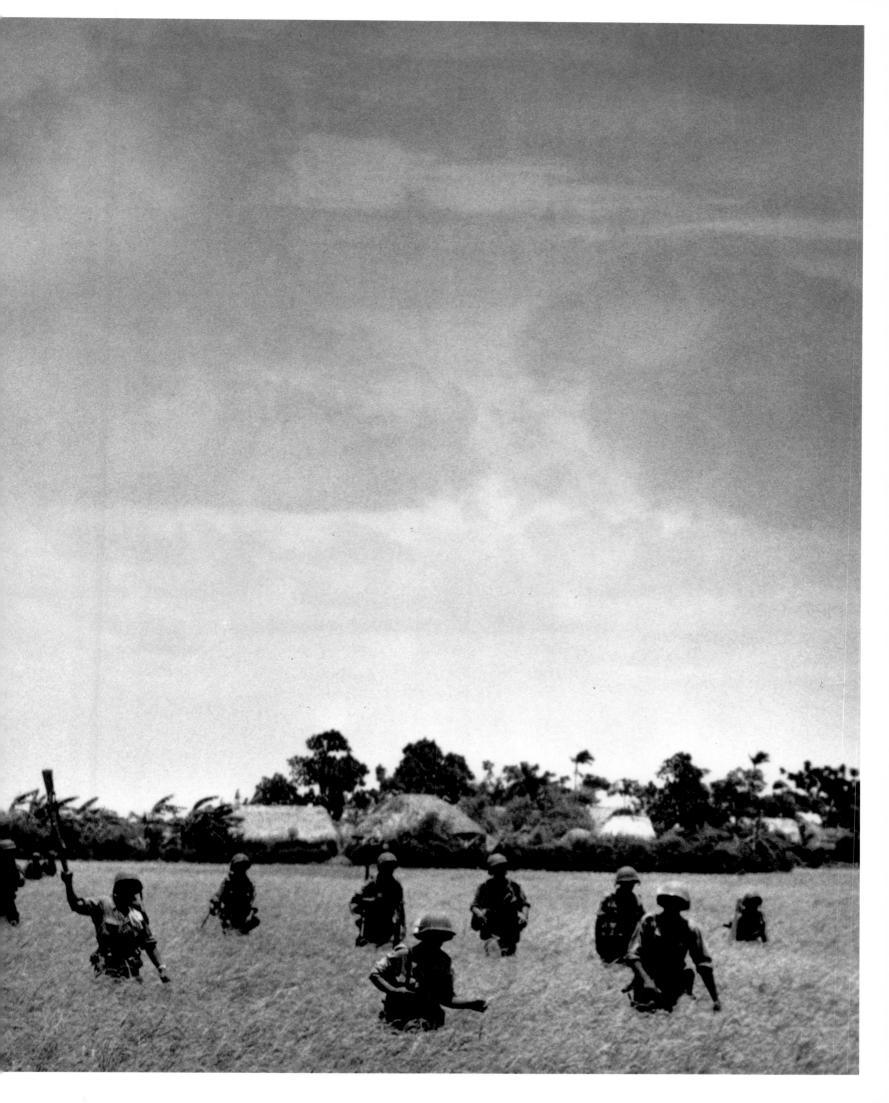

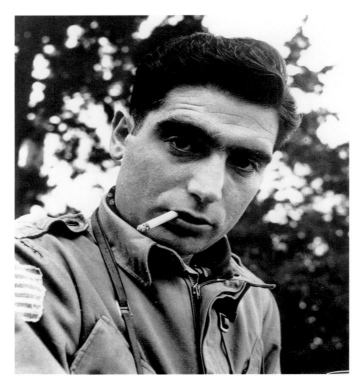

Wire photo and caption, May 25, 1954. (AP)

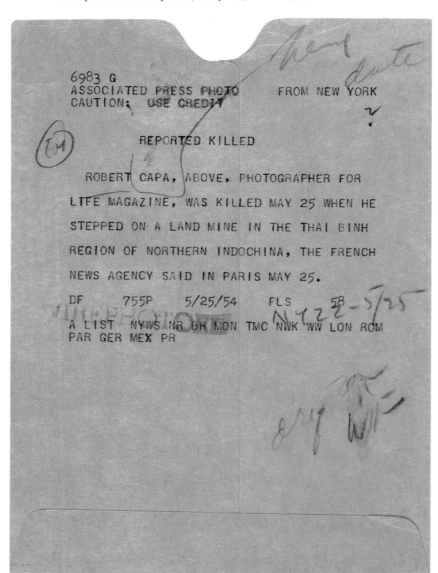

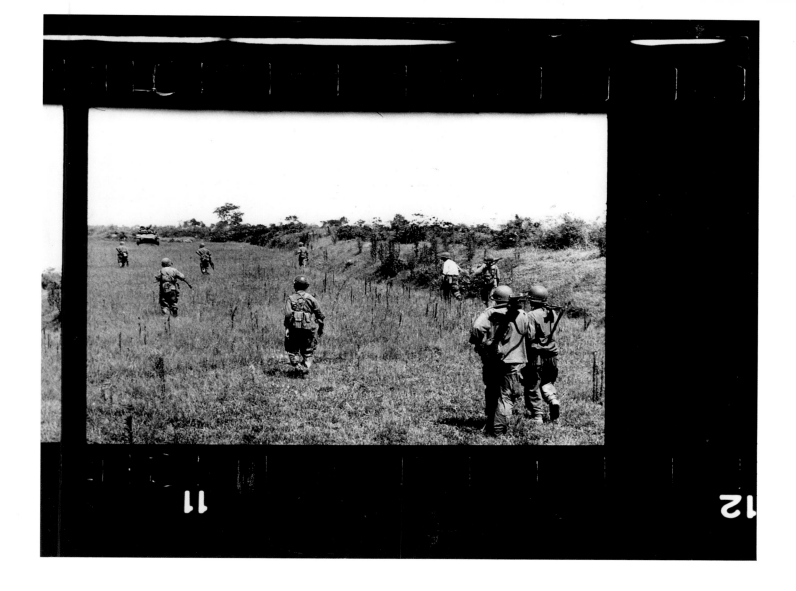

minute later another went off. Investigation revealed they were all antipersonnel mines, and it is almost certain that Capa had stepped on one of these.

The exploding mines brought Colonel Lacapelle charging forward. He flagged an ambulance and hurried Capa back to Dong Qui Thon, five kilometers away. There, a Vietnamese doctor pronounced him dead. Said the operation commander, Lieutenant Colonel Jacques Navarre, General Henri Navarre's

brother, "*C'est l'Indochine, monsieur.*" Then he turned and walked away, past the truck where Capa had lain dozing less than two hours before.

The doctor asked, "Is this the first American correspondent killed in Indochina?" I said yes. He said, "It is a harsh way for America to learn."

Edited from Life, *July 7, 1954.*

ROBERT CAPA
Red River Delta, Tonkin, Vietnam, May 25, 1954.
Final black-and-white frame. The road to Thai Binh.
(Magnum Photos)

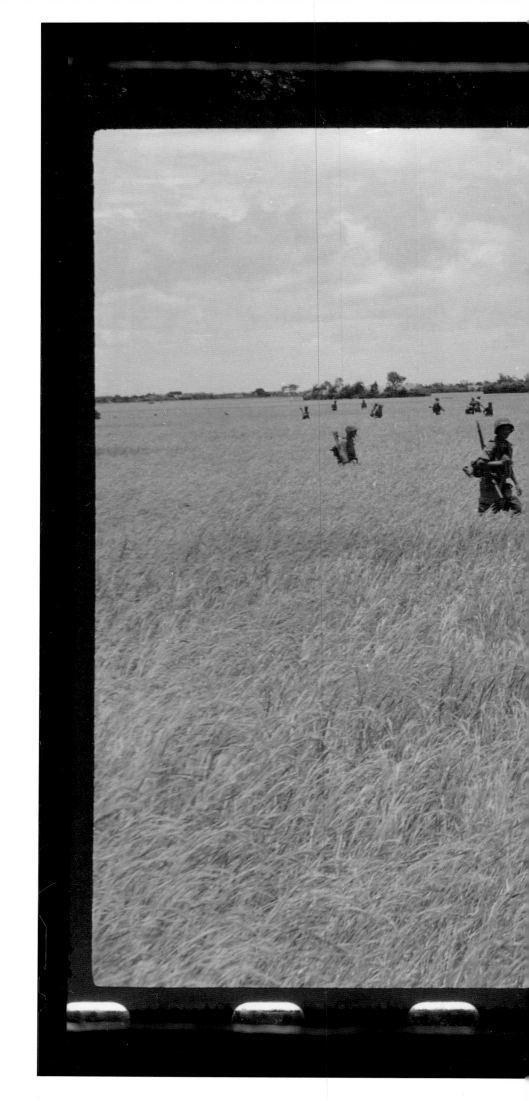

ROBERT CAPA
Red River Delta, Tonkin, Vietnam, May 25, 1954.
Final frame. The road to Thai Binh.
(Magnum Photos)

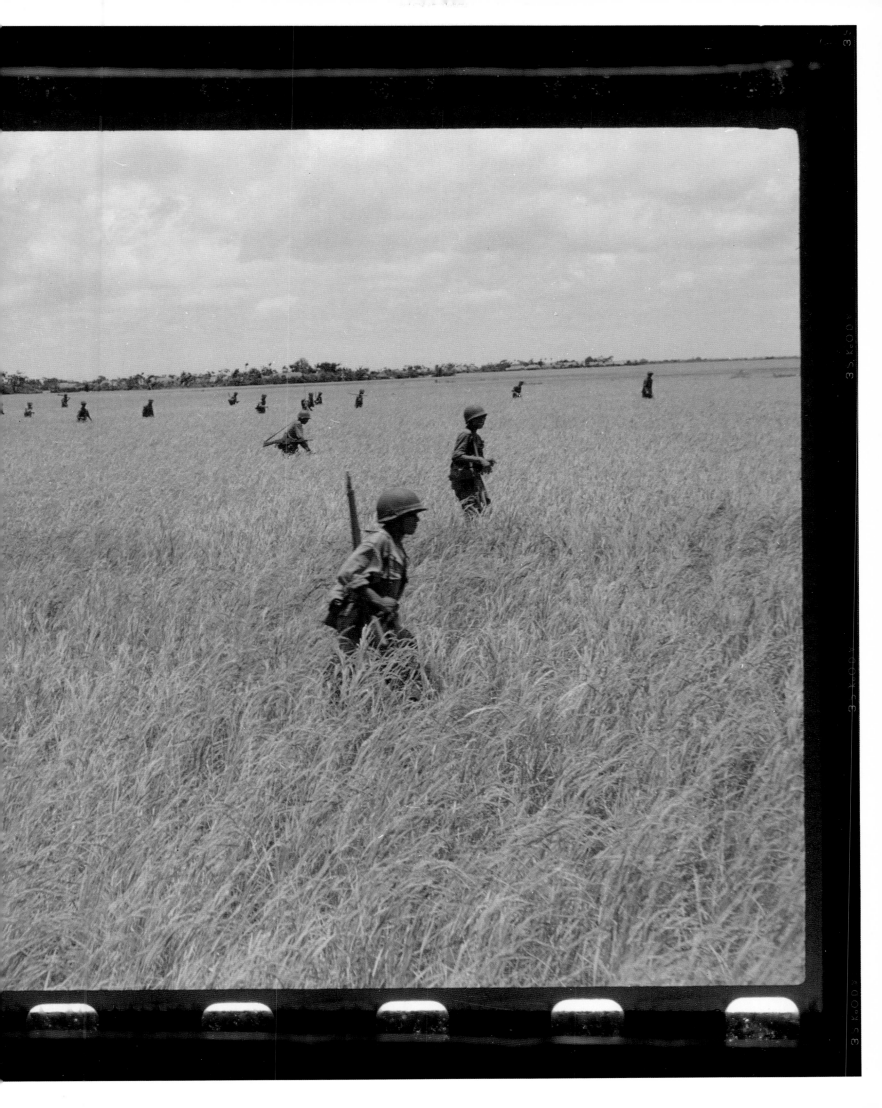

2 ESCALATION

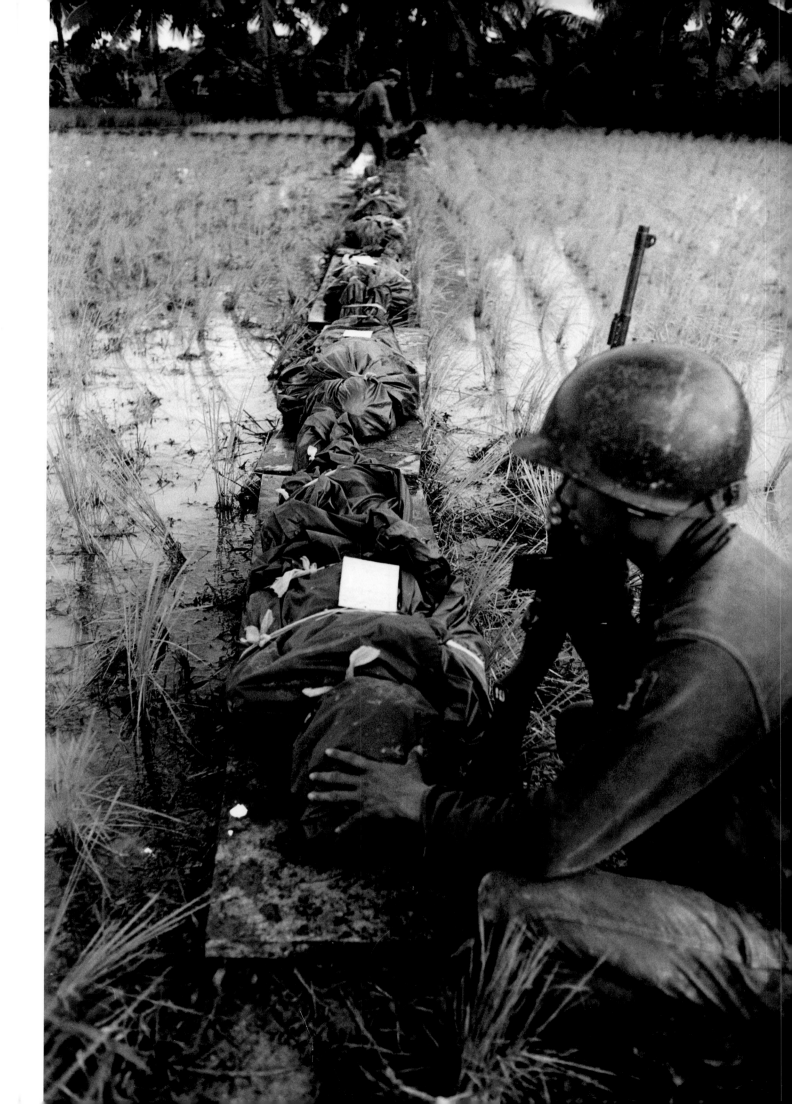

OPERATION NO JOY

In September 1965 the Associated Press photographer Huynh Thanh My returned with South Vietnamese troops to the Mekong Delta, where he had been wounded three months before. This time he was fired upon again. This is his account.

Tan Dinh, Vietnam, Sept. 4 (AP) For two days it had been just another fruitless search of the Mekong River delta with its muck and steaming jungle.

"No Joy," the soldiers called it—no contact with the enemy Viet Cong.

With a storm blowing in from the sea at dusk, the First Battalion set out across a rice paddy. One company moved down the left side of the flooded field, another down the right, a third straight down the middle. A fourth was held in reserve at the rear. Suddenly a submachine gun chattered in the tree line to the left. The government troops hit the water; their faces groped for the mud. Machine guns spat on the right side of the paddies. Another came in directly in front of them. Small-arms fire crackled from behind. The First Battalion was surrounded. We were being hit from all sides.

But for the First Battalion the worst was not over. Two of the armed helicopters, swooping down to pave the way for the relief force, mistook the government troops on the ground for the Viet Cong.

The American gunners, leaning out of the choppers' side doors, opened up with automatic weapons and let go a burst of rockets.

All around me government troops jumped up and screamed frantically at the helicopters to tell them that they were friendlies. There was no place to go. If the soldiers tried to make it to the tree line, the Viet Cong were waiting to meet them with deadly fire.

Helicopters picked up the wounded. The dead were being wrapped in ponchos and laid out in a row on a long, narrow footwalk at the edge of the paddy.

The survivors were getting ready for another night in the mud and water. Night had swallowed the action and left the war, until dawn at least, to the tacticians.

Huynh Thanh My of The Associated Press was on a search-and-destroy operation with Vietnamese infantry soldiers and American advisers. He was killed on October 10, 1965, during a similar assignment.
Photographer unidentified. (AP)

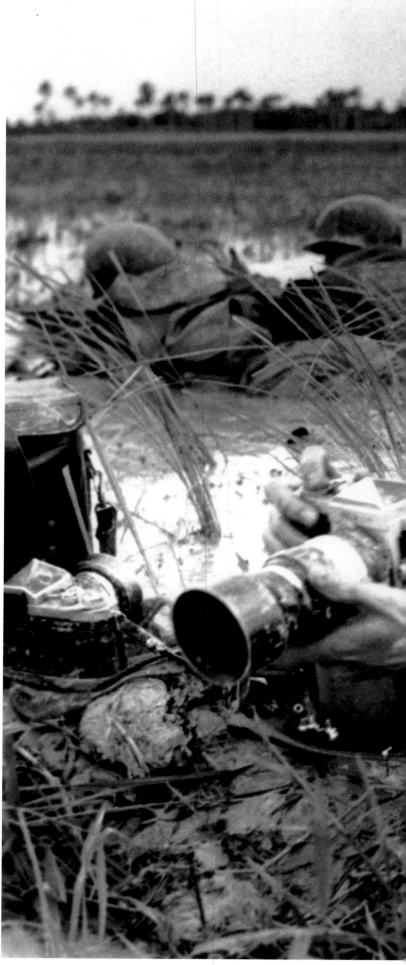

Huynh Thanh My, Mekong Delta, Vietnam, 1965.

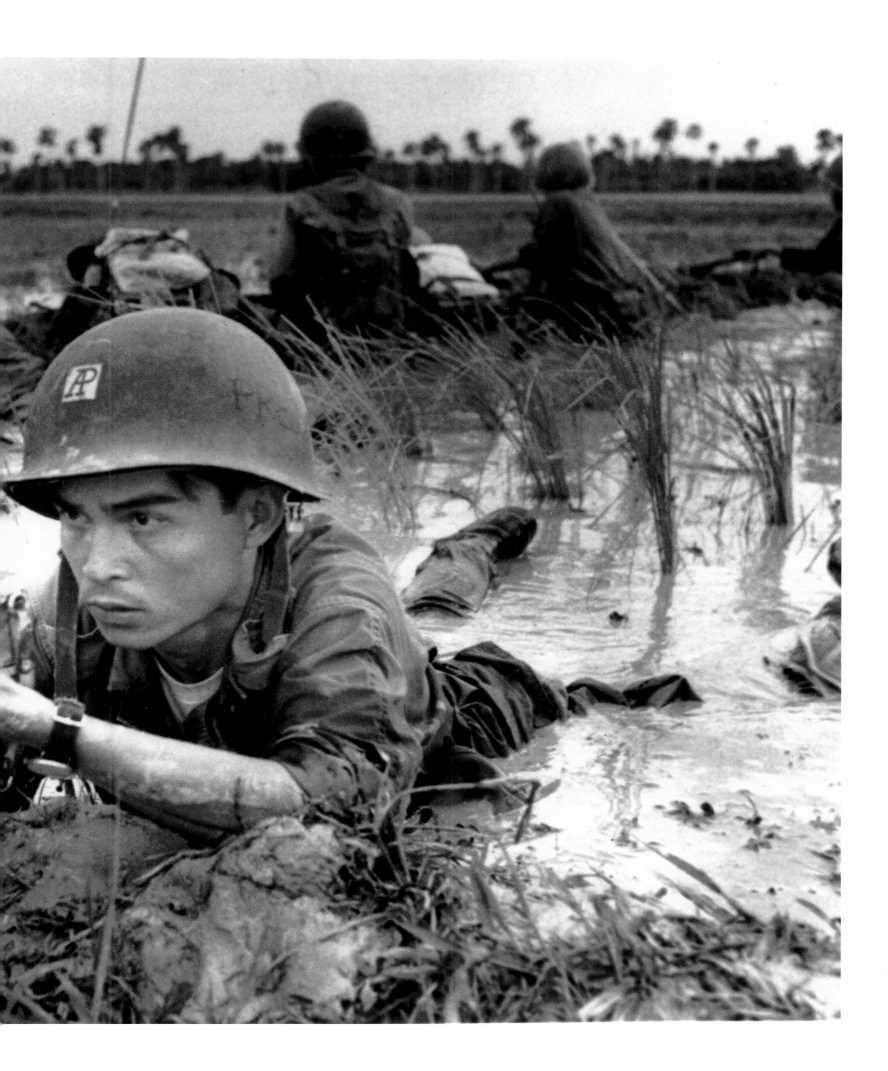

Tran Binh Khuol, U-Minh Forest, Vietnam, 1963.

Tran Binh Khuol accompanied Viet Cong soldiers on daring nighttime raids against South Vietnamese outposts in Camau Province. He was credited for his leading role in these attacks.
Photographer unidentified. (LNA/VNA)

(page 75)
HUYNH THANH MY
Mekong Delta, Vietnam, 1965.
A South Vietnamese soldier and a row of dead comrades from his Ranger battalion, laid out on a paddy dike, awaiting evacuation by helicopter on Tan Dinh Island.
(AP)

(pages 76 and 77)
LARRY BURROWS
Mekong Delta, Vietnam, 1966.
Helicopters transport South Vietnamese troops into battle.
(Life)

TRAN BINH KHUOL
Camau Province, Vietnam, 1963.
Viet Cong guerrillas drag a rocket launcher to attack and overrun the South Vietnamese outpost of Cai Keo.
(LNA/VNA)

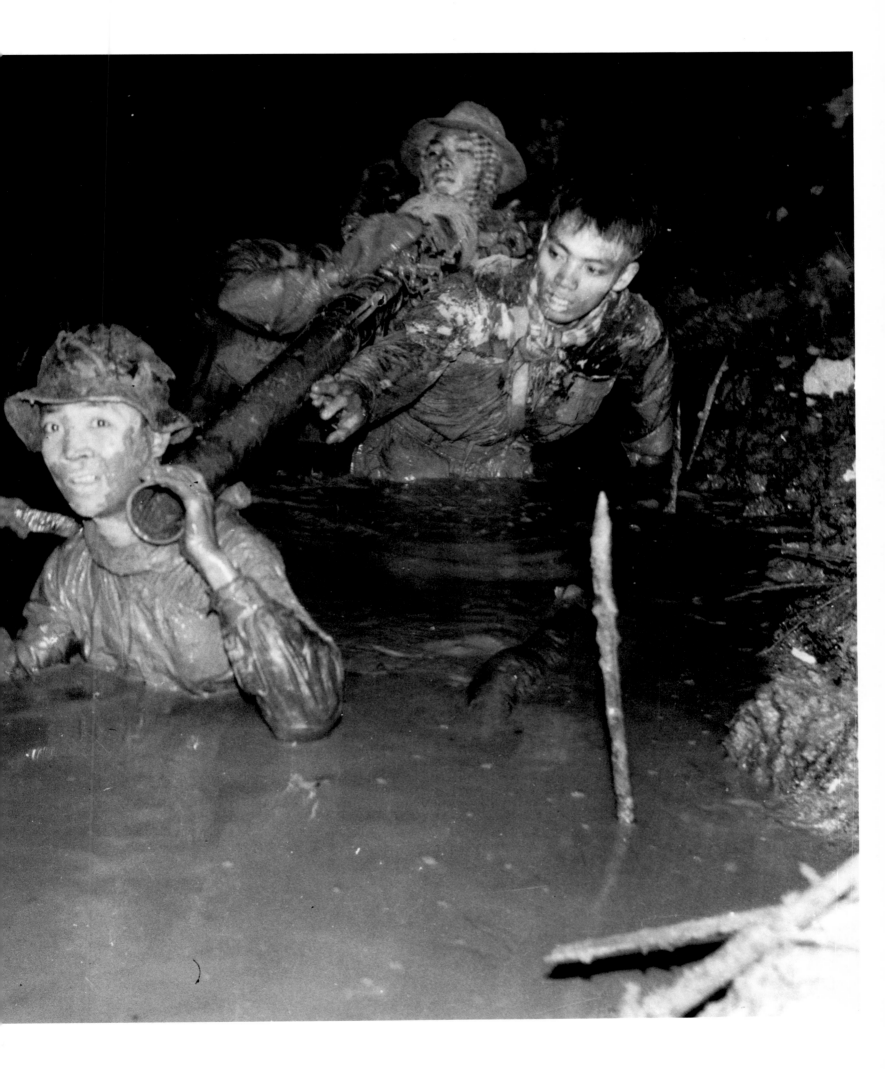

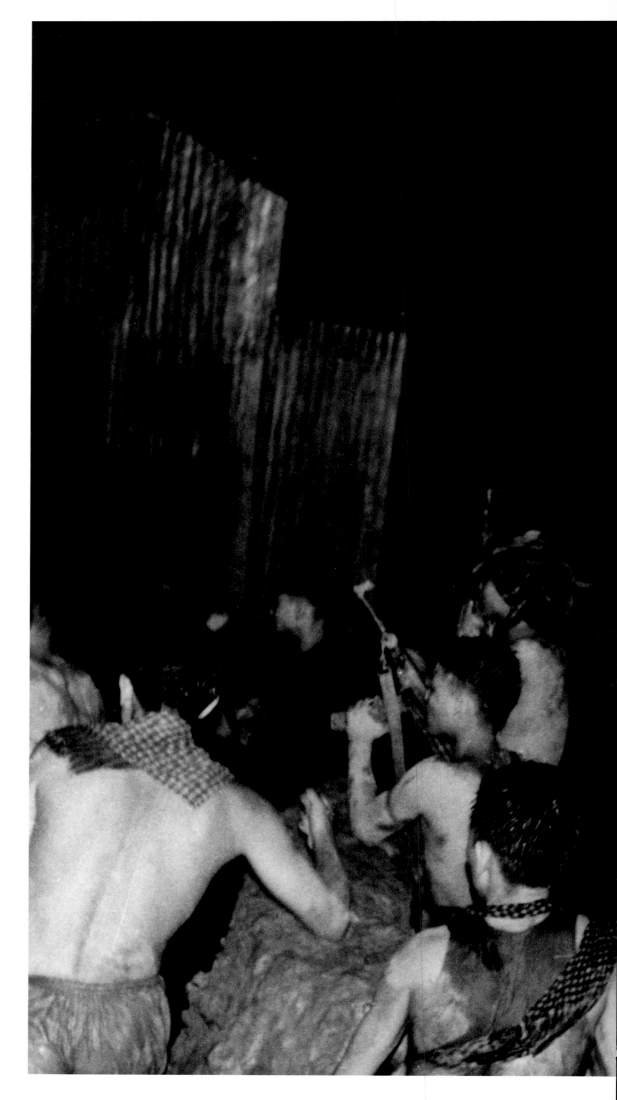

TRAN BINH KHUOL
Camau Province, Vietnam, 1963.
Viet Cong guerrillas attack the South Viet-
namese outpost of Dam Doi during
the night of September 9, 1963.
(LNA/VNA)

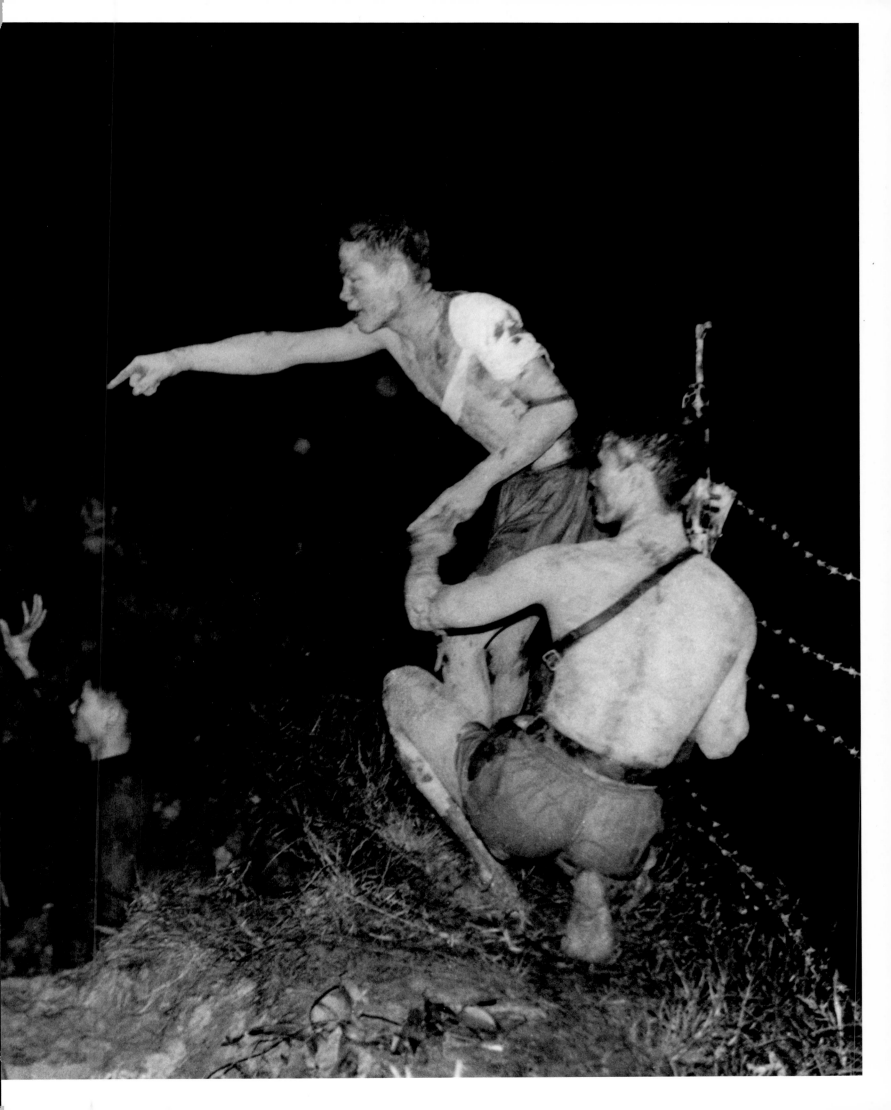

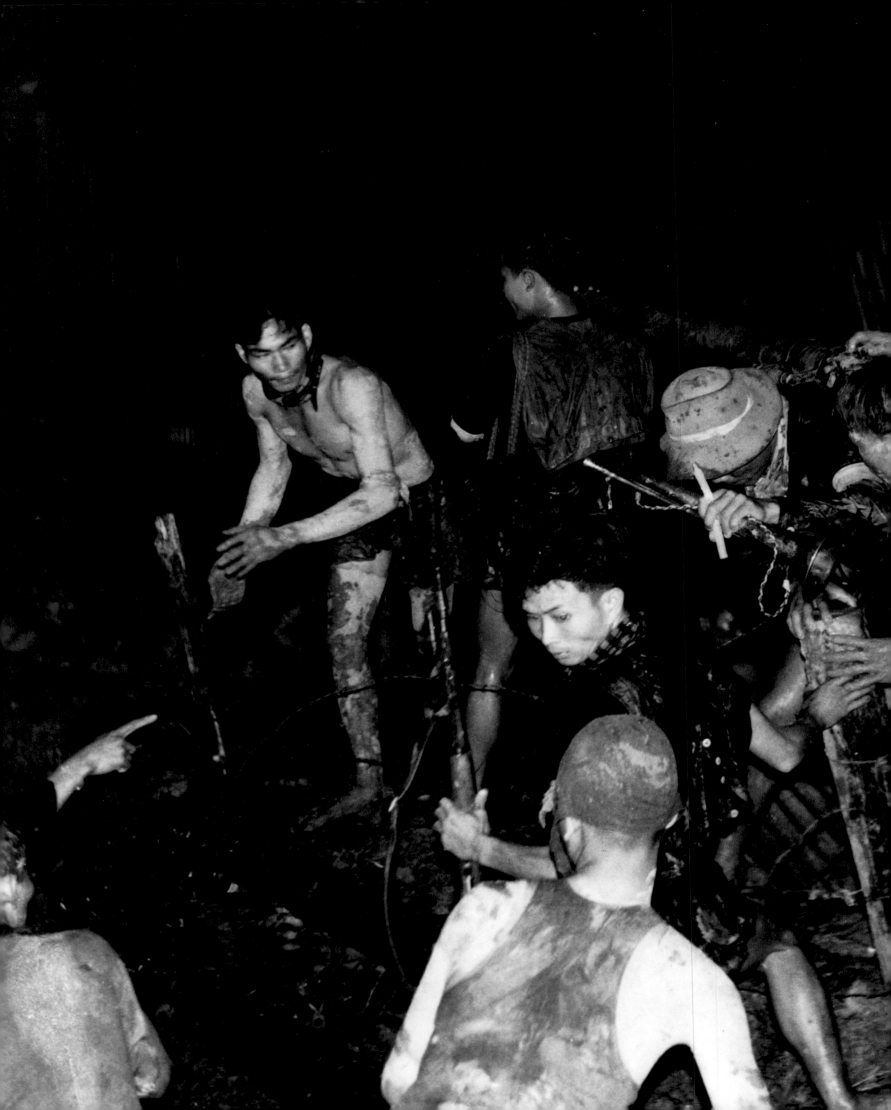

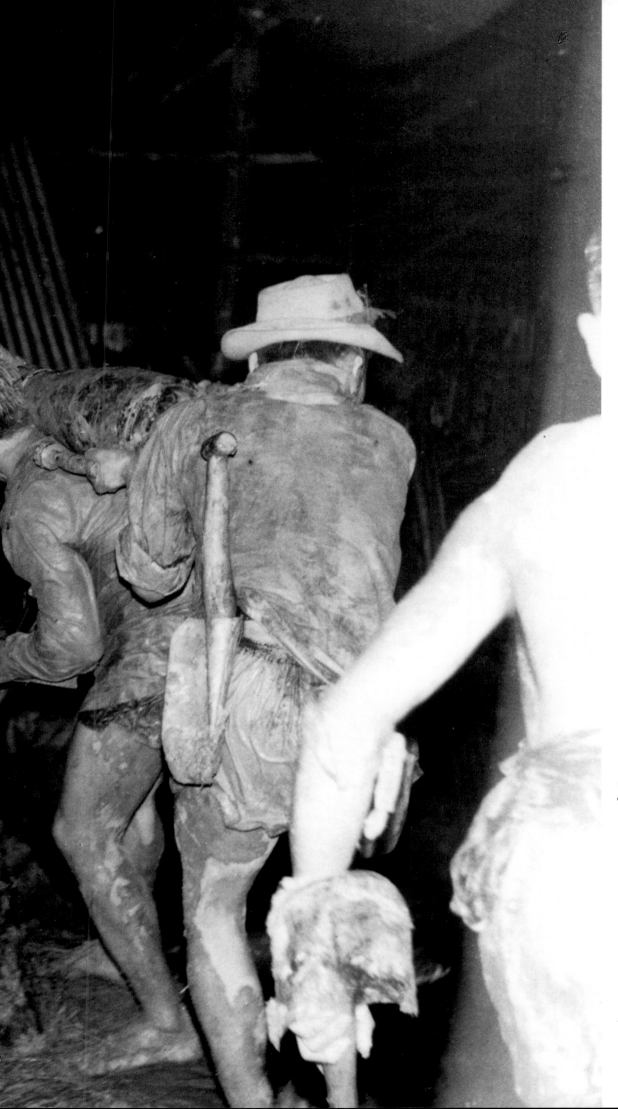

(pages 86 and 87)
LARRY BURROWS
Mekong Delta, Vietnam, 1963.
*South Vietnamese troops with Viet Cong
prisoners.*
(*Life*)

(pages 88 and 89)
LARRY BURROWS
Mekong Delta, Vietnam, 1963.
*Viet Cong soldiers lie dead, gathered beside
their flag, while captured comrades huddle in
defeat. Americans in the picture were advisers
to the Vietnamese.*
(*Life*)

TRAN BINH KHUOL
Camau Province, Vietnam, 1963.
*Viet Cong guerrillas attack the South Viet-
namese outpost of Dam Doi during
the night of September 9, 1963.*
(LNA/VNA)

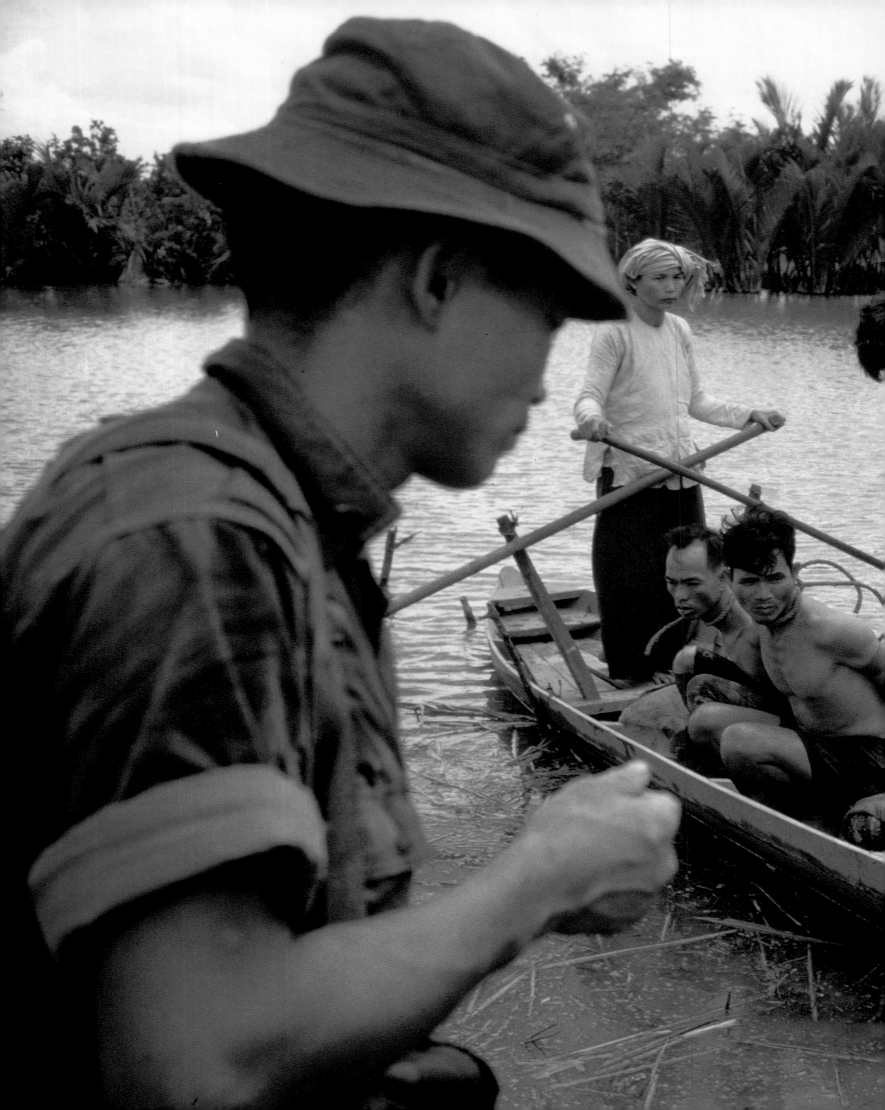

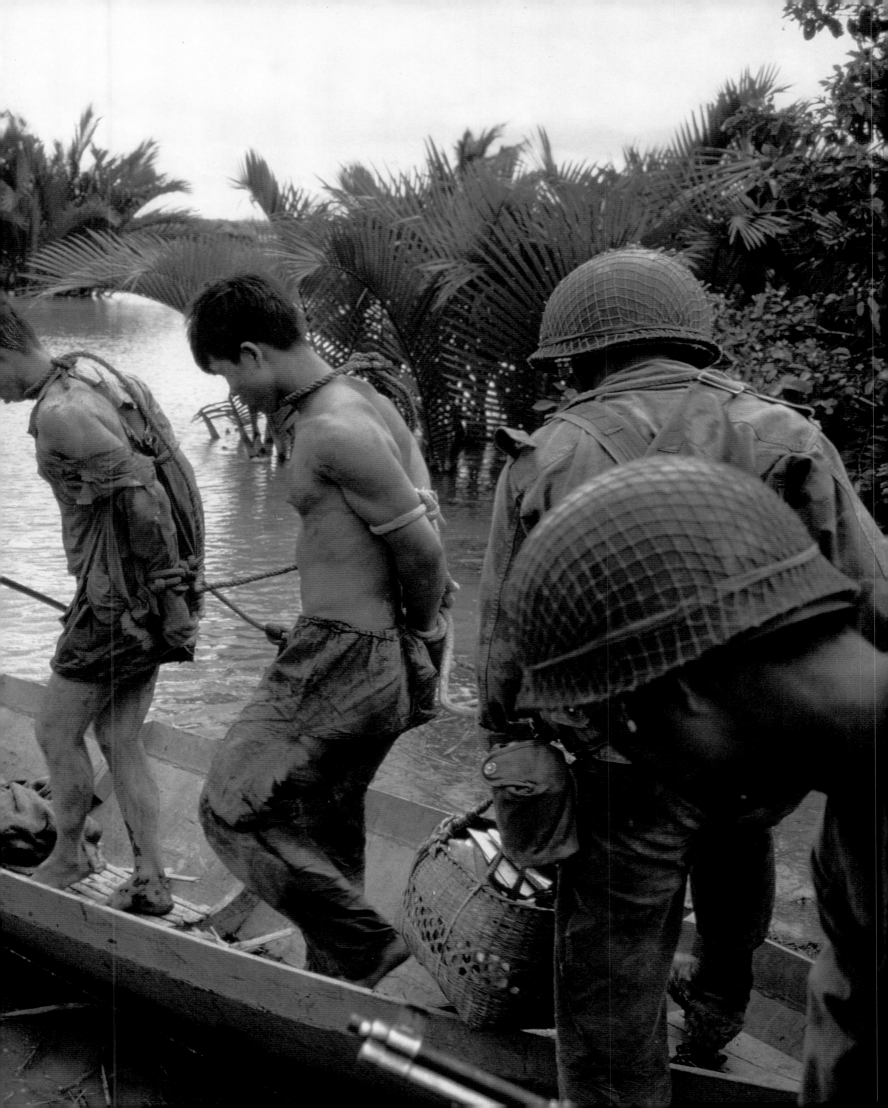

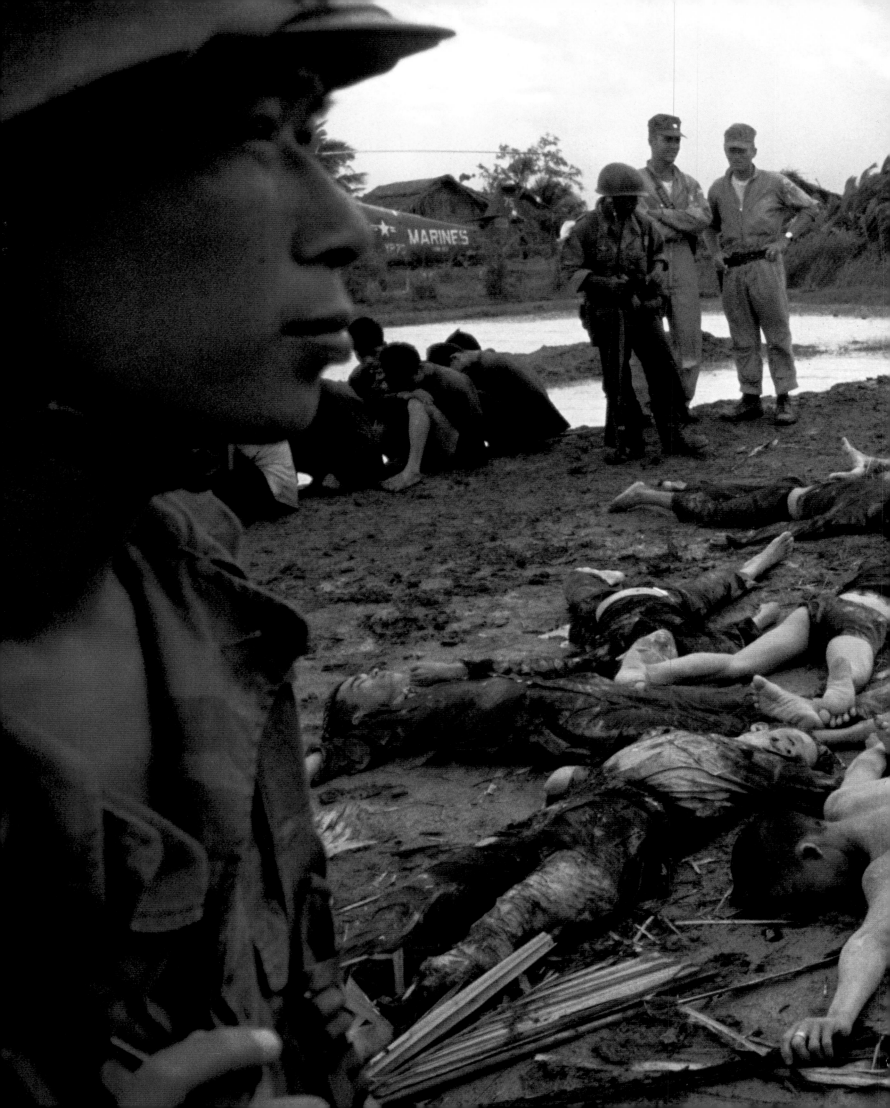

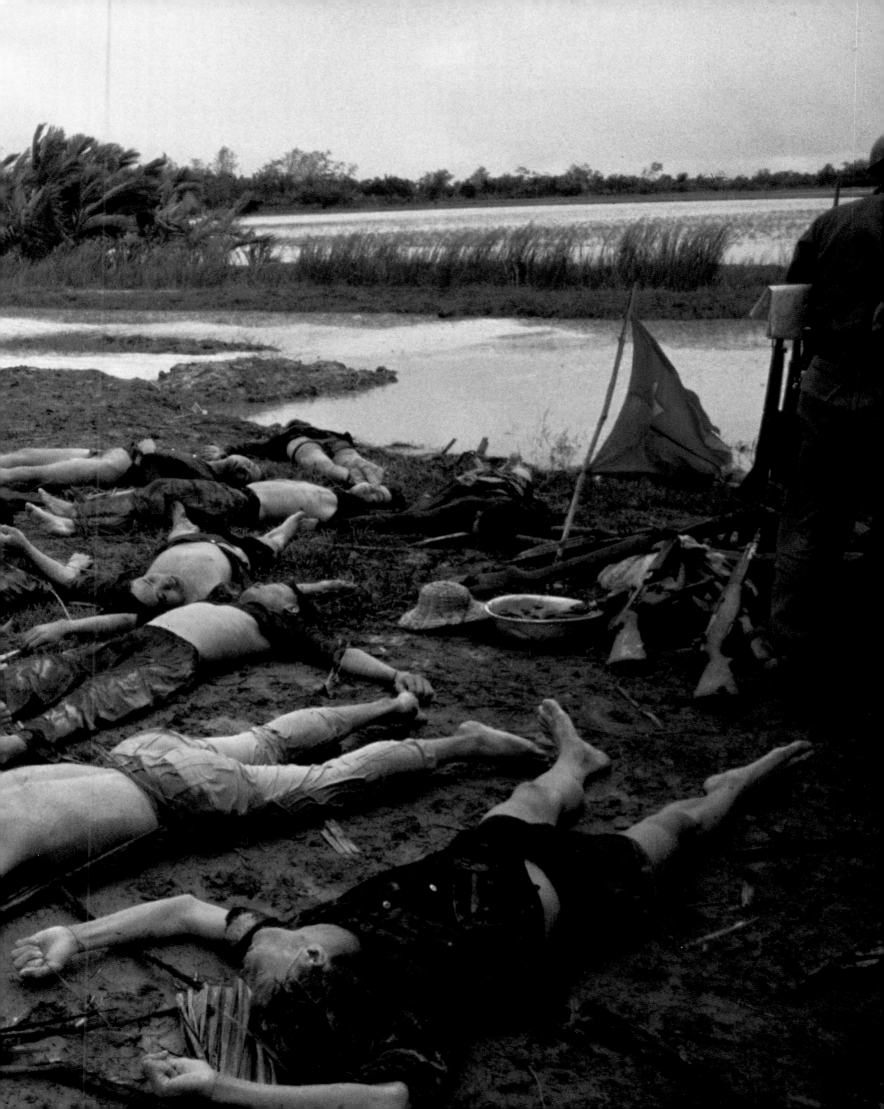

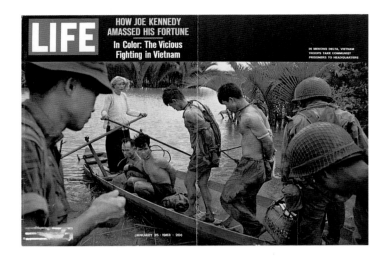

LIFE MAGAZINE, JANUARY 25, 1963
THE VICIOUS FIGHTING IN VIETNAM

Larry Burrows (1926–1971)

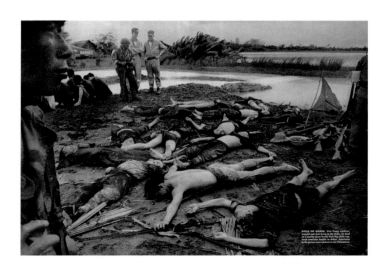

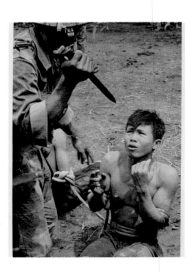

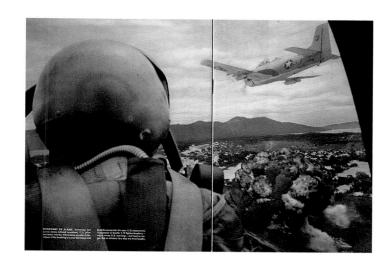

WEAPONRY OF FLAME. *[caption illegible]*

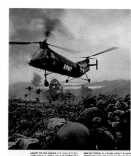

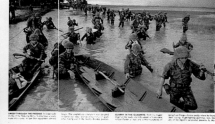

DESPITE BATTLEFIELD SETBACKS
THERE IS HOPE—WITH CAUTION

by MILTON ORSHEFSKY

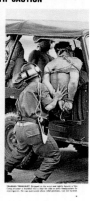

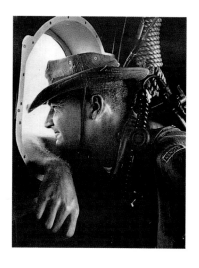

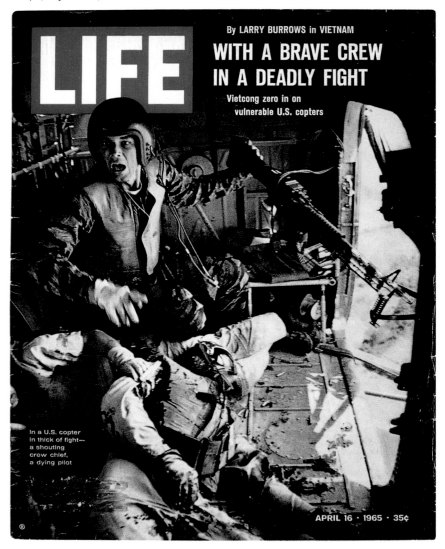

LARRY BURROWS
(1926–1971)

Tad Bartimus

Larry Burrows photographed fifty combat missions to get what he wanted for *Life* magazine's first major cover story about the Vietnam War. On January 25, 1963, the then most powerful magazine in America ran Burrows's pictures of dead and captured Viet Cong guerrillas in a fourteen-page spread that set the standard for all war reportage to follow.

Promoting still-rare color photography, *Life*'s editors took the extraordinary step of publishing a pull-out cover and promoting Burrows's efforts in a detailed note from the managing editor. The photos, including the cover shot, a woman rowing a boatload of prisoners roped together at the neck, proved to Americans that their own soldiers were involved in a major conflict halfway around the globe. Inside, Burrows's keen eye captured U.S. advisers jumping out of a helicopter, a South Vietnamese soldier threatening a

Viet Cong with a bayonet, modern firepower in a napalm strike, the burning of a peasant's hut, and the stunning double-page photo of an enemy "body count" with Americans in the background.

The essay was seminal on two counts: It showed South Vietnamese fighting and killing Communists with the help of Americans, and it was a great journalistic achievement. Burrows caught, close-up, the cruelty and brutality of war in the faces of his subjects. His hallmark of exquisitely framed shots combined with technical excellence made the photos aesthetically powerful. His efforts were matched by the meticulous attention given to the story by *Life*'s editors and technical staff. Color was difficult to shoot and reproduce, and such a generous allotment of pages to one story that wasn't breaking news was extremely rare. The layout was also a step

continued on page 96

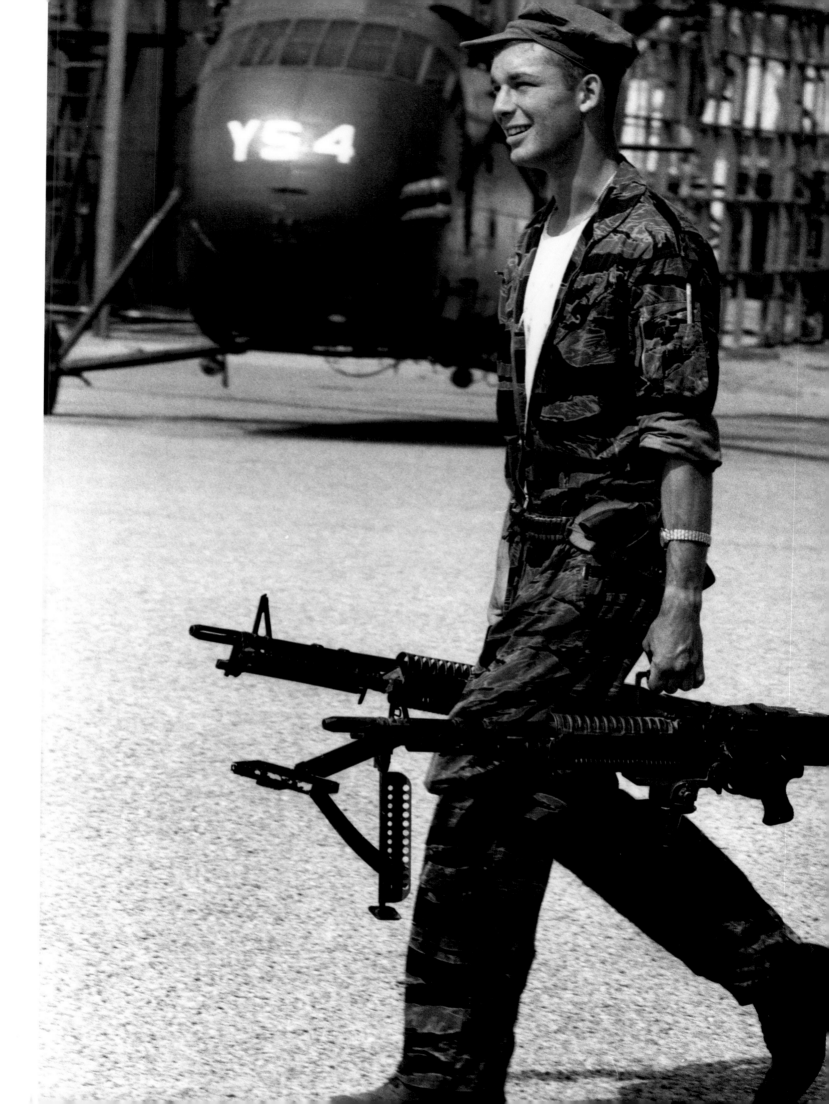

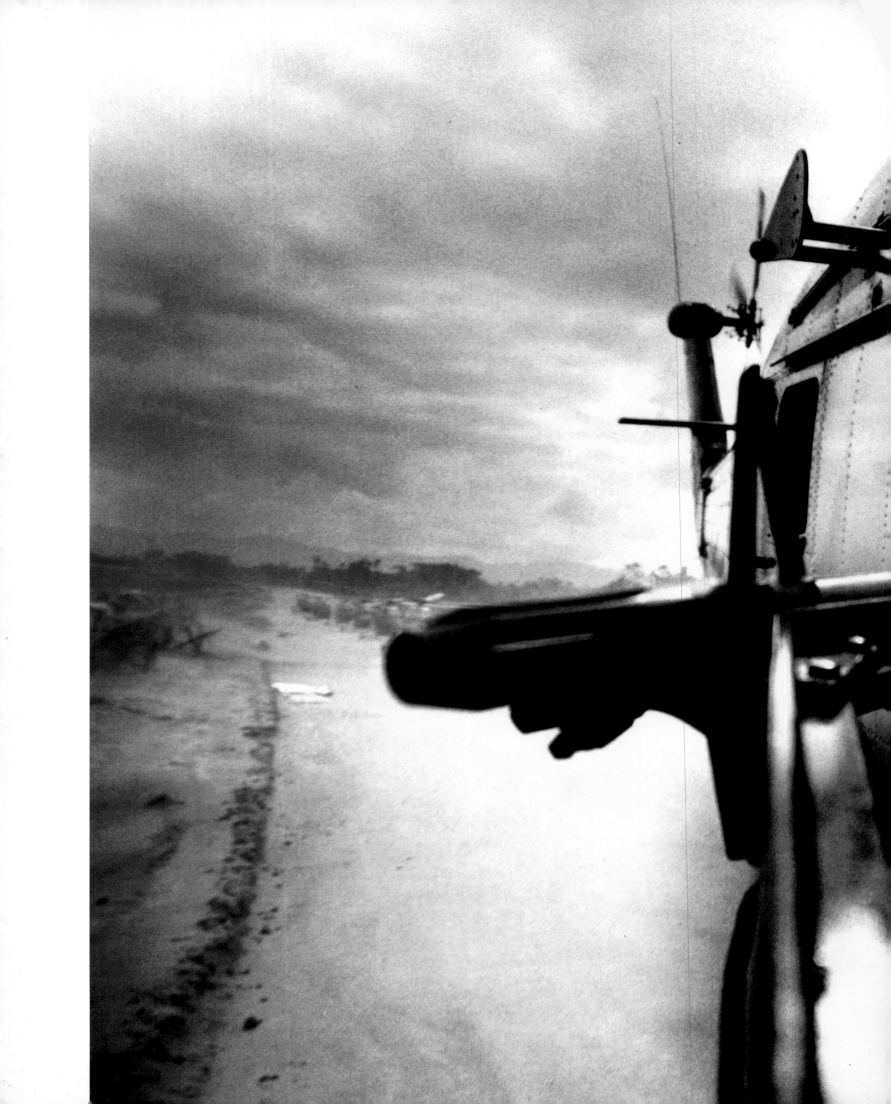

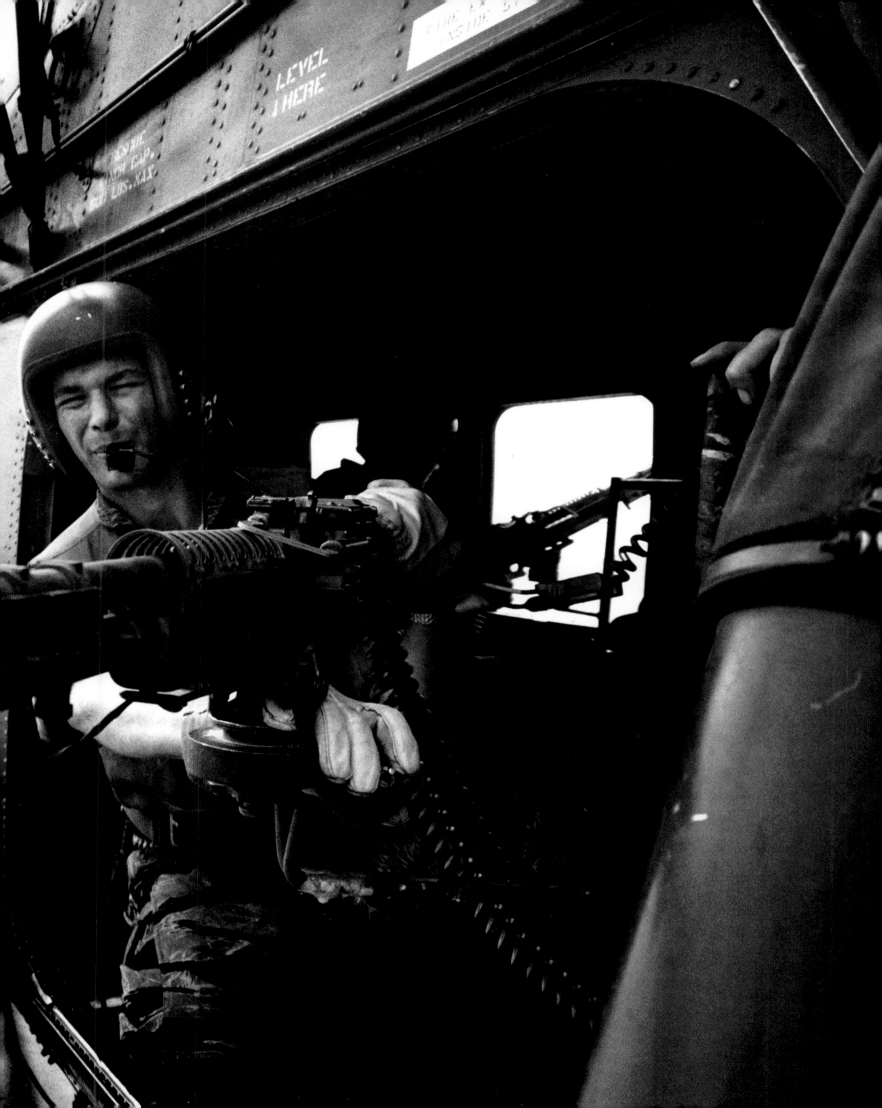

forward for the magazine, which had seldom showcased one image on a full page, let alone on two.

Larry Burrows, in his professional and courageous way, so early in the war, became the photographer by whom others measured themselves.

"Larry is either the bravest man I ever knew or the most nearsighted," said a colleague of the time.

In fact, though he had one of the greatest photographic eyes, Burrows was so blind as a teenager that the British army wouldn't take him during World War II. Instead, he was sent to the coal pits; on leave, he worked part-time as a "darkroom tea boy" for *Life*.

"When I was in blitz-torn London, I didn't have the equipment or the ability to express my feelings about war," he said later, when his name became synonymous with Vietnam. "That has a great deal to do with my feelings now—to show the interested and shock the uninterested people into realizing and facing the horrors of war.

"I will do what is required to show what is happening," he said. "I have a sense of the ultimate—death. And sometimes I must say, 'To hell with that.'"

There were Suez and the Congo and civil war in Lebanon. Then there was Vietnam. He was one of the first of the best to arrive, in 1962, and was "rather a hawk" in those early days of American advisers, a viewpoint that changed with disillusionment. A Briton, he was asked once back at *Life*'s New York headquarters how the war was going.

"Well, you American chaps have quite a problem," he answered. "Thank God it isn't my war."

The response was swift and on the money: "Larry, if it isn't your war, just whose is it?"

Working out of a hotel room with two double beds—one for the masses of camera gear he was constantly cleaning and rebuilding—Burrows spent most of his time in the field, alone, seeking out the action, claiming that one extra seat on the chopper. He wore a bush jacket of his own design so he'd have plenty of pockets. He carried extra film rolls in his socks. His sole vanity was insisting on bathing and dressing for dinner wherever possible. It was, he said, a civilized thing to do.

As the war ground on, Burrows sought ways to help *Life*'s readers identify with and relate to Vietnam's victims as well as to show the real war the way he and the soldiers saw it—close to the ground. His combat photos captured the intensity of battle but also left the viewer with a haunting sense of the exhaustion and despair in those frightened faces. His essays became increasingly personal, focusing on just one or two people to tell the big story.

The most dramatic and perhaps best-remembered photo story of the Vietnam War was "One Ride with Yankee Papa 13," which appeared on April 16, 1965. Anyone who ever saw the black-and-white, fourteen-page spread never forgot it. Burrows documented one mission in the dangerous life of Marine Lance Corporal James C. Farley, and he also helped Farley try to rescue a downed pilot. Afterward the helicopter squadron commander gave Burrows a set of air crewman's wings with the comment, "You've earned it."

(page 93)
LARRY BURROWS
Da Nang, Vietnam, 1965.
Yankee Papa 13 *Crew Chief James Farley carries M-60 machine guns to his helicopter at Da Nang airbase.* (*Life*)

(pages 94 and 95)
LARRY BURROWS
Near Da Nang, 1965.
As Yankee Papa 13 *approaches the landing zone, Crew Chief James Farley opens fire with his M-60 machine gun.* (*Life*)

LARRY BURROWS
Near Da Nang, Vietnam, 1965.
Crew Chief James Farley, with his gun jammed and two wounded comrades aboard, shouts to his gunner. (*Life*)

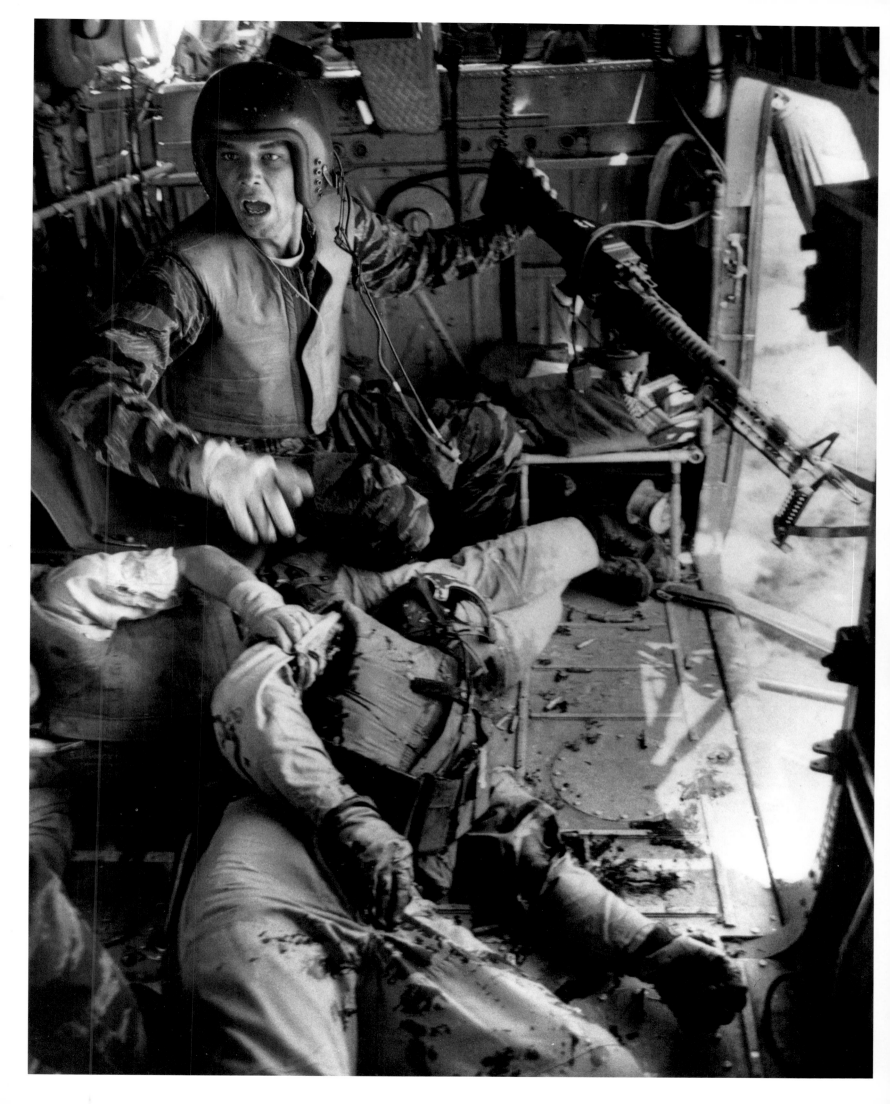

Do I have the right to carry on working and leave a man suffering? To my mind, the answer is "No, you've got to help him."

You cannot go through these elements without obviously feeling something yourself—you cannot be mercenary in this way because it will make you less a photographer.

There have been moments—yes—when your lips go dry, and anybody who does not—does not have any fear—then he is a complete idiot.

You can't go out, as you see people. A hill near the DMZ not so long ago, when suddenly—it was just after five o'clock as a matter of fact—in came some 122 [-millimeter] rockets. People that you had seen alive just a few minutes ago suddenly were all dead, and you realize that it could have been you.

There was one particular story which was called "One Ride with Yankee Papa 13," which involved seventeen helicopters, four of which were shot down, and quite a lot of people were killed and wounded.

We tried to rescue a pilot off a ship, and we were trapped between these two .30-caliber machine guns. The VC were on the tail of the downed helicopter. We landed alongside; the co-pilot from this downed ship, wounded, climbed on board.

The pilot in our ship gave word for Farley, who was the crew chief, to go and rescue the pilot—who was slumped over the controls.

We could see him. Farley ran across, I ran after him, and visually—the sound of gunfire and with all that was happening—but trying to do it visually was extremely difficult. It looked documentary. It was frustrating. But rather than go into a long story about that—the co-pilot who had climbed onto our ship had two bullet holes, one in the arm and one in the leg, and one we hadn't noticed, which was a third one, which was just under the armpit. And he died. The story came out in Life *the following week. Some eighteen months later the mother wrote to me. She said she had just seen another story which I did for the magazine. And she didn't understand what I was trying to do or what I was trying to say—to be able to photograph death, to photograph the suffering. She said:"Now I understand, because of this last particular story which ran." And she said, "I want to thank you for whatever help you gave my son, Jim, during the last moments of his life."*

It was a very sad moment, a very touching moment, when our crew chief broke down—cried. Everybody was very tense because everyone had suffered through it. And so often I wonder whether it is my right to capitalize, as I feel, so often, on the grief of others. But then I justify, in my own particular thoughts, by feeling that I can contribute a little to the understanding of what others are going through; then there is a reason for doing it.

LARRY BURROWS, *from* Beautiful Beautiful, *a BBC film, 1969.*

<div align="center">

LARRY BURROWS
Da Nang, Vietnam, 1965.
In a supply shack, the tragic and frustrating mission over,
Crew Chief James Farley weeps.
(Life)

</div>

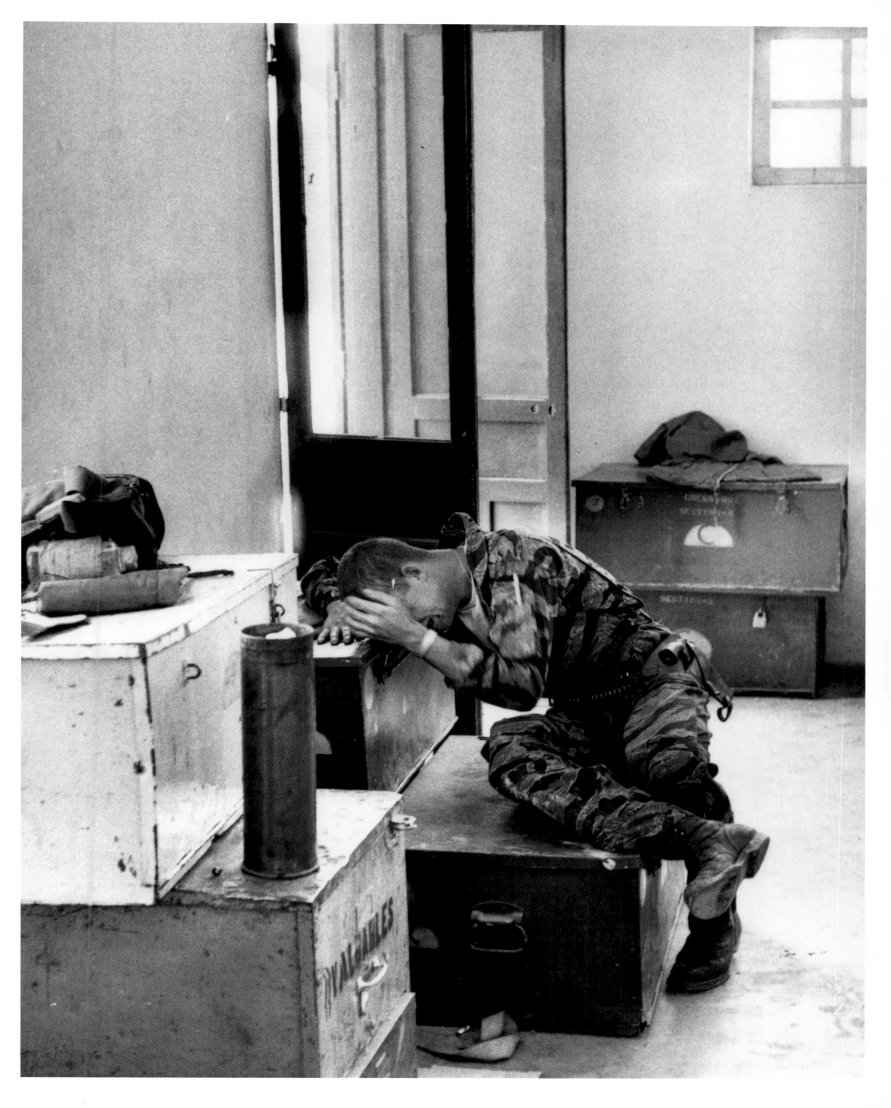

THE OTHER SIDE

William Tuohy

While war photographers whose work appeared in the Western media often received public accolades and honors, cameramen on the other side operated in the shadows, in the jungles and the paddies, secretly and anonymously. They were assigned to the Vietnam News Agency (VNA), with the North Vietnamese forces, and to the Liberation News Agency, to operate with the National Liberation Front (NLF), better known as the Viet Cong.

For them there were no periods of action with allied troops in the field interspersed with rest periods in Saigon or even Hong Kong and Bangkok. For them there was unrelenting service with combat units; indeed, in the field they were considered soldiers first and cameramen second. Few NLF photographers expected to survive their long, grueling war of liberation. And they emerged from the shadows as individual photographers only years later, after the war, when their achievements became known. But many died in combat, their photographic deeds unrecorded.

Propaganda was deemed an essential factor in the NLF's successful campaigns against the French, the South Vietnamese government, and the U.S. forces. Aspiring combat photographers were trained by the VNA in the north. Indoctrination could last up to a year. Cameramen were taught to dismantle their cameras blindfolded and construct replacement parts.

They learned to process and print film in the field. They were instructed to conceal their film when on sensitive missions, sometimes in American ammunition cases, which could be hidden in canals and streams and retrieved later.

They received thorough military training.

Then they moved back down the Ho Chi Minh Trail, through Laos and Cambodia and into South Vietnam, a three- to six-month hike fraught with the dangers of bombs and skirmishes along the way. It was a precarious existence marked by the perils of a guerrilla soldier's life, including illness and malnutrition.

Many photographers, like Hoang Chau, never made it. One of the first to go South, he was killed while crossing the Sre Pok River near the Laotian border. His body was never recovered, and he remains missing in action. His son Hoang Long, also a photographer, was given a certificate attesting to his father's having died in action for the revolution. Many other cameramen remain MIAs.

Photographer Bui Dinh Tuy, then twenty-three, was instructed to establish a photo branch for the NLF. He traveled south with a group of fifty photographers, bringing along cameras, film, photo paper, and processing chemicals. During the fourteen-week trek they were ordered not to take pictures in order to keep their mission secret. They were given enough food at stops to reach the next station.

In the south Bui Dinh Tuy checked into NLF headquarters, a movable jungle outpost in Tay Ninh Province, near the Cambodian border. There they began using a rudimentary darkroom, which doubled as air-raid and artillery shelter.

Bui's men were assigned to NLF cultural units or combat groups. They had no formal military rank but carried weapons. In advanced NLF camps they would often develop pictures underground, some in the tunnels around Cu Chi, just northwest of Saigon, home of the U.S. Twenty-fifth Infantry Division.

Pictures were kept in boxes in underground shelters, and some were lost in monsoon floods. The photographers were supplied with NLF couriers for transporting their pictures.

The photos were sent first to NLF military headquarters, then forwarded to Hanoi—by boat, vehicle, and foot. The routing could go through Cambodia and by flights from Phnom Penh to China for transshipment to Hanoi. There were no facilities for wirephoto transmission. Between 1965 and 1970, film moving up the trail would take at least three months to reach Hanoi.

The VNA in Hanoi decided where to distribute the pictures. The photographers never learned whether their pictures were published.

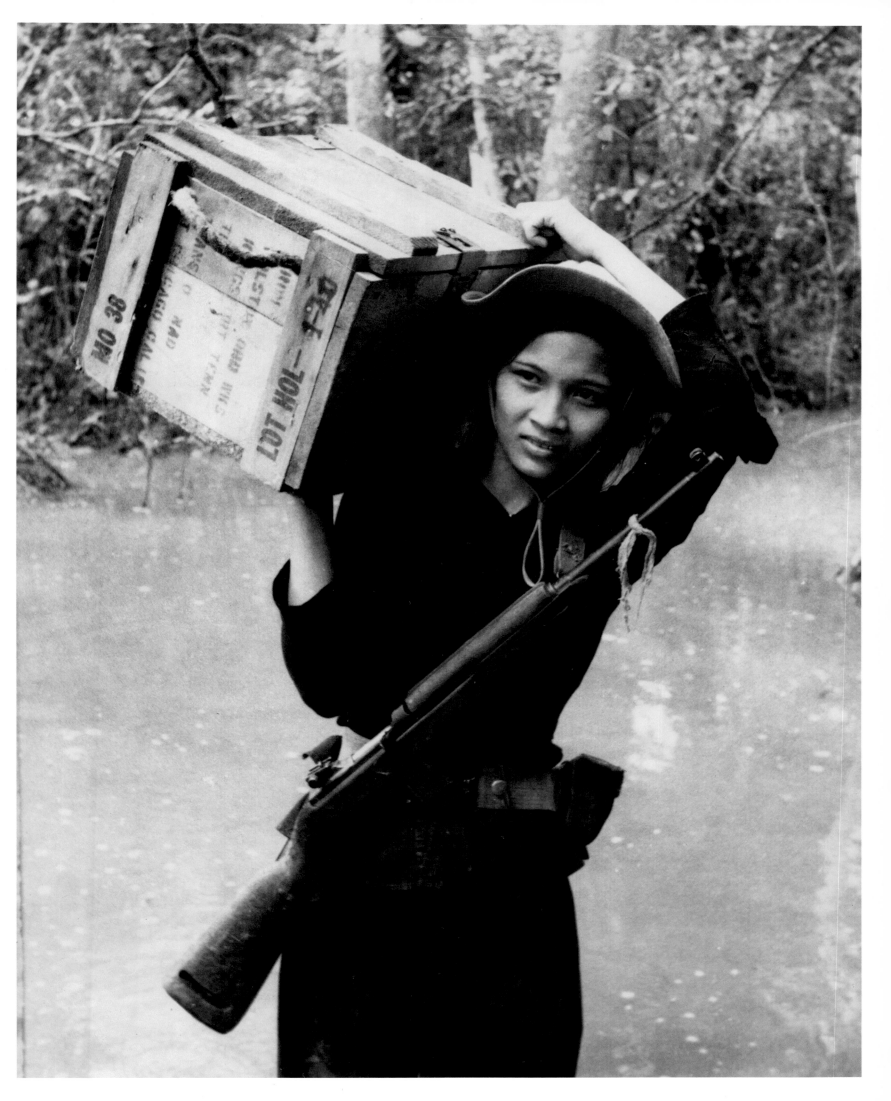

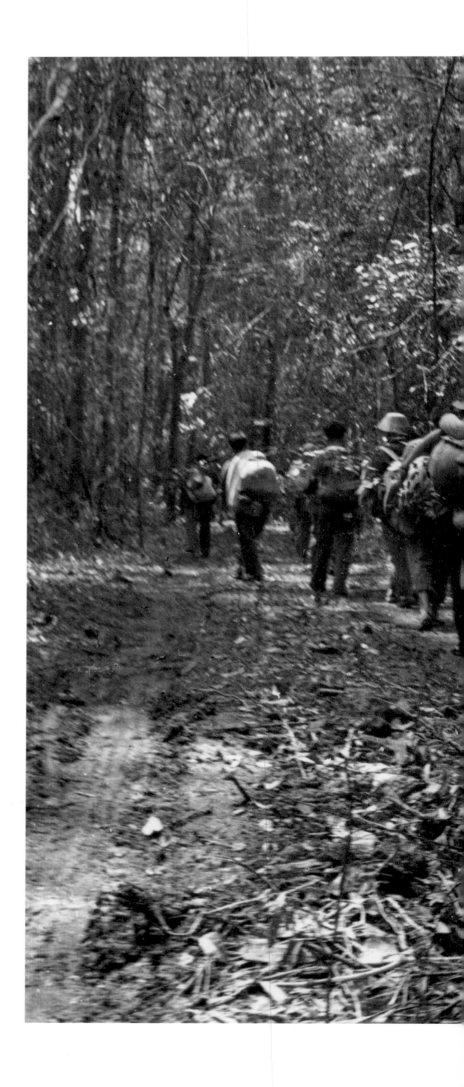

(page 101)
BUI DINH TUY
Ho Chi Minh Trail, Vietnam, 1966.
A woman soldier of the North Vietnamese army carries an
ammunition crate along the Ho Chi Minh Trail.
(VNA)

(pages 102 and 103)
HO CA
Vietnam, undated.
A column of soldiers of the Peoples' Revolutionary Army
during a training exercise. Ho Ca made three separate
exposures for this picture.
(VNA)

VO VAN QUY
Vietnam, undated.
North Vietnamese soldiers move single file through the
jungles northwest of Saigon. Sausage-shaped sacks of
rice are slung over their packs.
(LNA/VNA)

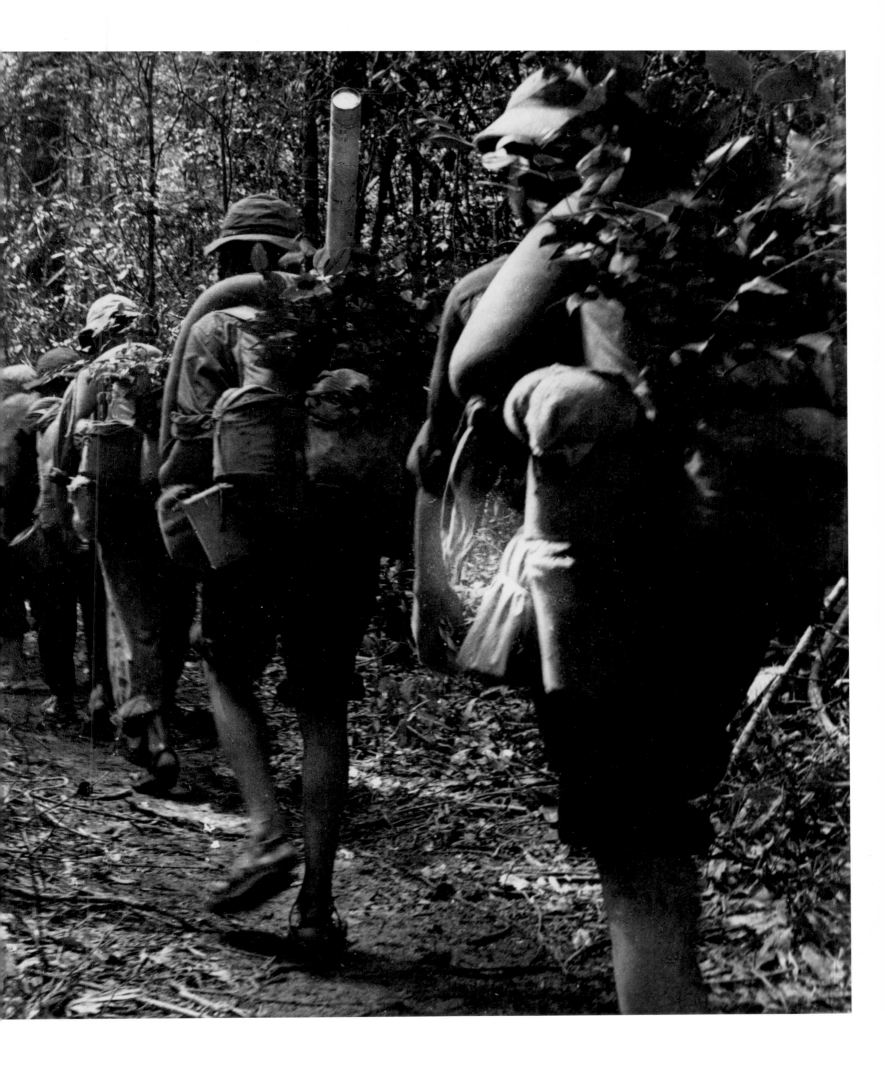

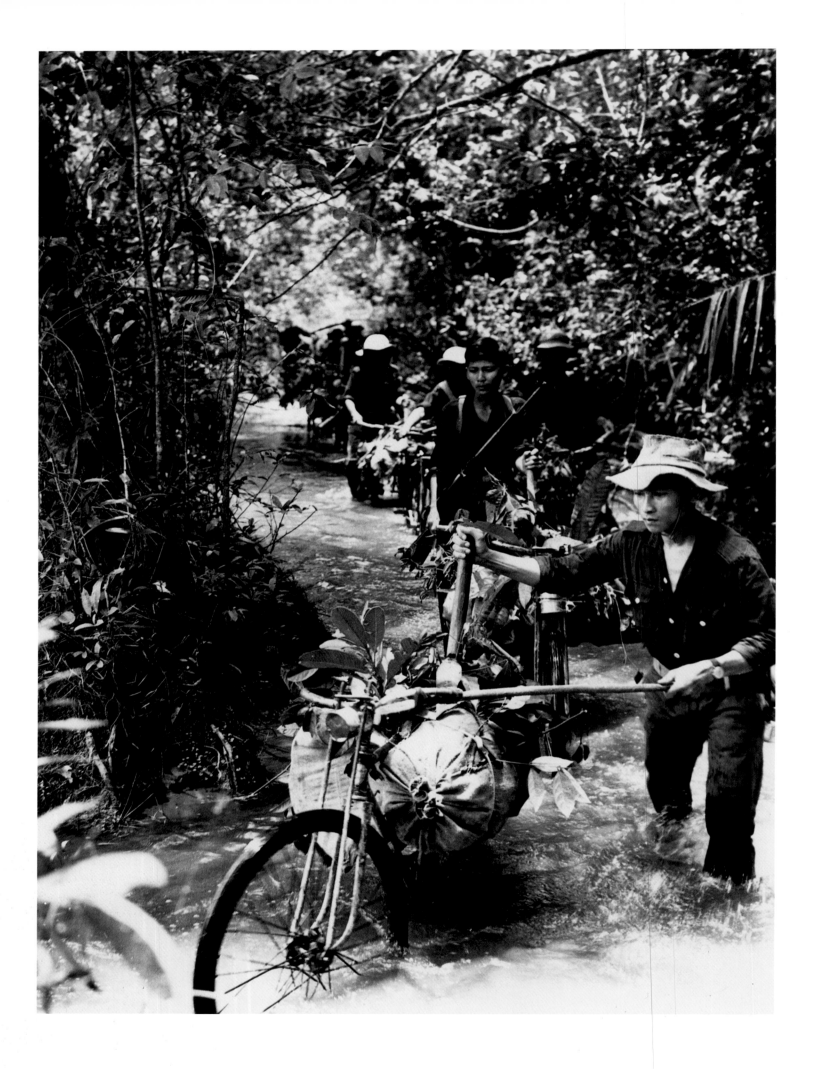

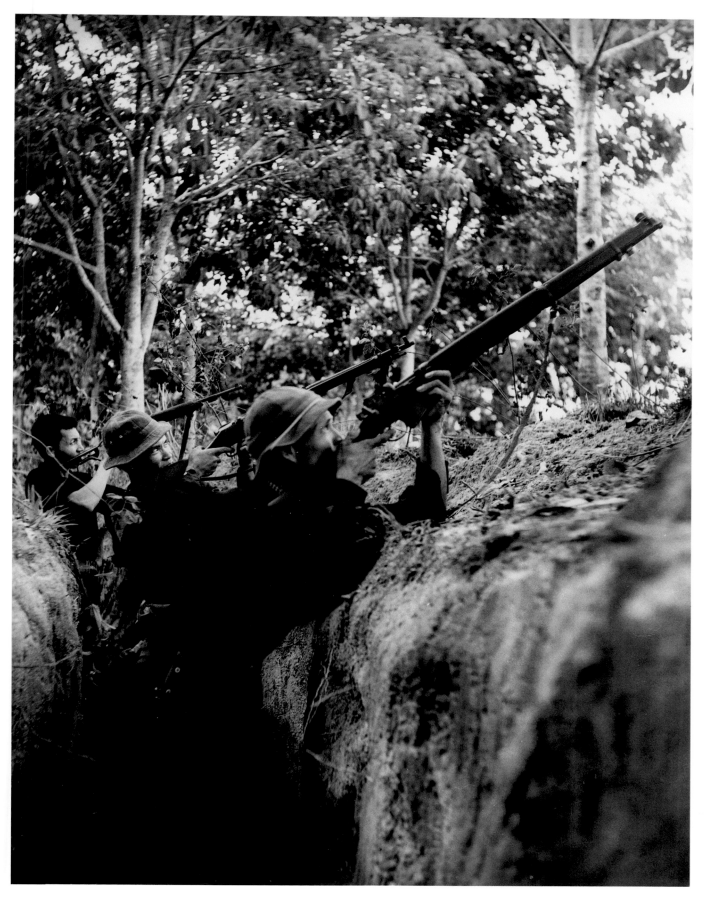

BUI DINH TUY
Ho Chi Minh Trail, Vietnam, 1968.
Viet Cong guerrillas and soldiers of the North Vietnamese army use bicycles to transport supplies.
(LNA/VNA)

NGUYEN LUONG NAM
Vietnam, 1966.
Viet Cong guerrillas fire at passing aircraft. Their weapons date back to the French Indochina War.
(LNA/VNA)

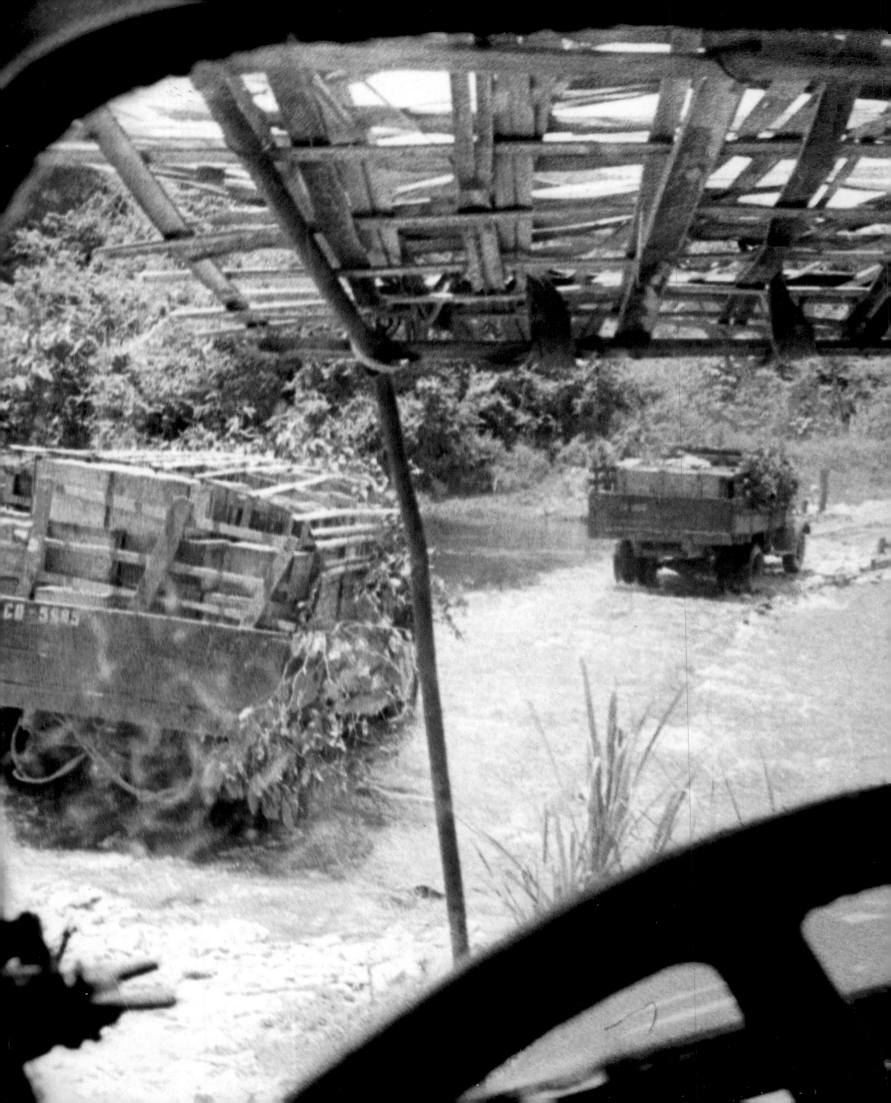

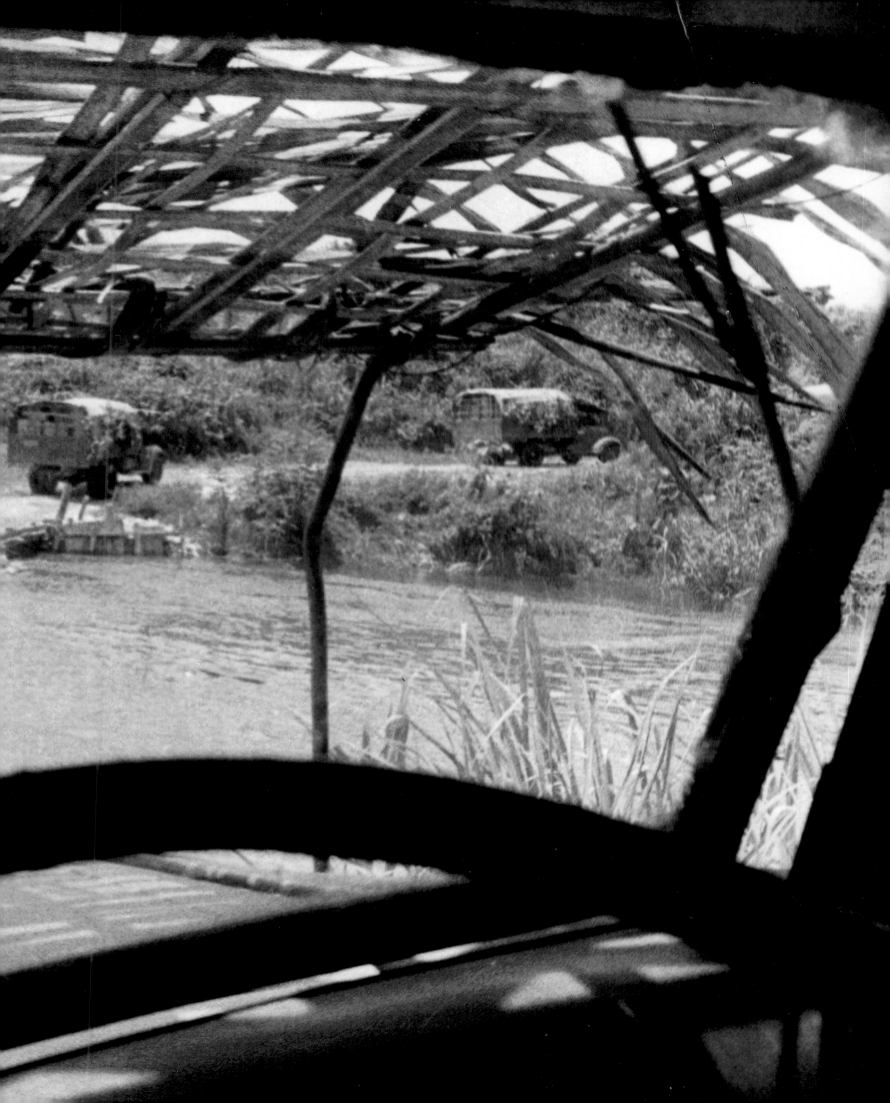

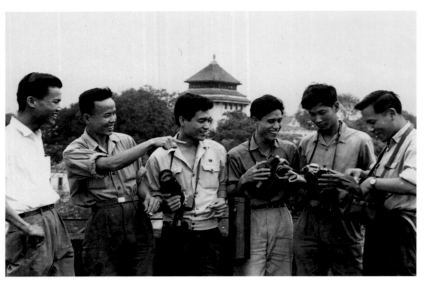

LUONG NGHIA DUNG
Hanoi, Vietnam, 1967.
After completion of their Vietnam News Agency training, Luong Nghia Dung (second from left) and five other aspiring North Vietnamese photographers with their newly issued equipment.
(VNA)

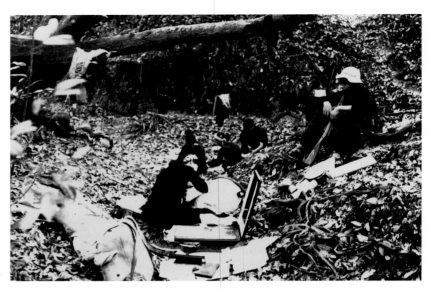

UNIDENTIFIED PHOTOGRAPHER
Near Cu Chi, Vietnam, undated.
Viet Cong photo technicians use a photo dryer as they work in a trench near the tunnel system of Cu Chi, west of Saigon.
(LNA/VNA)

UNIDENTIFIED PHOTOGRAPHER
Near Tay Ninh, Vietnam, undated.
Technician-photographer Le Thi Nang retouches a photograph at the National Liberation Front headquarters. She was killed in action in 1972.
(LNA/VNA)

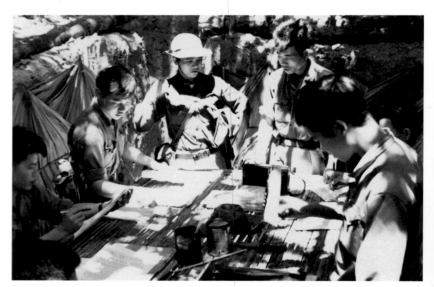

UNIDENTIFIED PHOTOGRAPHER
Near Tay Ninh, Vietnam, undated.
Viet Cong journalists and printers put together illustrated propaganda posters and pamphlets, working in a printing plant in a bunker of the National Liberation Front headquarters.
(LNA/VNA)

VIETNAM NEWS AGENCY AT WAR

Nguyen Khuyen

Nguyen Khuyen, founder and executive editor of the English-language daily Vietnam News, *was a war correspondent of the Vietnam News Agency from 1961 to 1985.*

Except for the camera, our war photographers were indistinguishable from the soldiers.

The difference between this style of operation and that of the photographers on the other side is obvious. The difference was removed when Vietnamese photographers shared the fate of death with their foreign colleagues.

The pictures taken by the photographers killed in combat remind us what great talent is lost forever when it becomes inevitable that a high percentage of those at the sharp end of fighting have to lose their lives.

The photographs speak harshly of the reality of war and human tragedy. Any appreciation of their artistic or technical value is dwarfed by their content.

If we look today with great attention at the photographs, we ourselves can get the eerie sensation of becoming the photographer. We sense his fears—but we know more: We know that death will follow soon. The consequence of his work is inevitable and dreadful. The fear and anticipation of death expressed in many of the war photographs overshadow the hectic and bloody scenes they show.

War was everywhere. The entire country of Vietnam was the action.

Many photographers surely realized they would never live to enjoy peace again. Most must have sensed that they would never return.

Looking long and carefully at the work of the dead photographers will bring us together with them and allow us to give them the respect that survivors should retain for those who have perished.

(pages 108 and 109)
LUONG NGHIA DUNG
Ho Chi Minh Trail, Vietnam, undated.
Camouflaged with bamboo matting and foliage, Soviet-made trucks of a North Vietnamese army convoy carry supplies south.
(VNA)

SEAN FLYNN
Duc Phong, Vietnam, 1966.
A Viet Cong suspect is hung up and questioned by mercenaries of the Chinese Nung tribe. The Nungs formed a unit organized and commanded by U.S. Special Forces. After fifteen minutes in this position, the suspect admitted being a sniper.
(UPI)

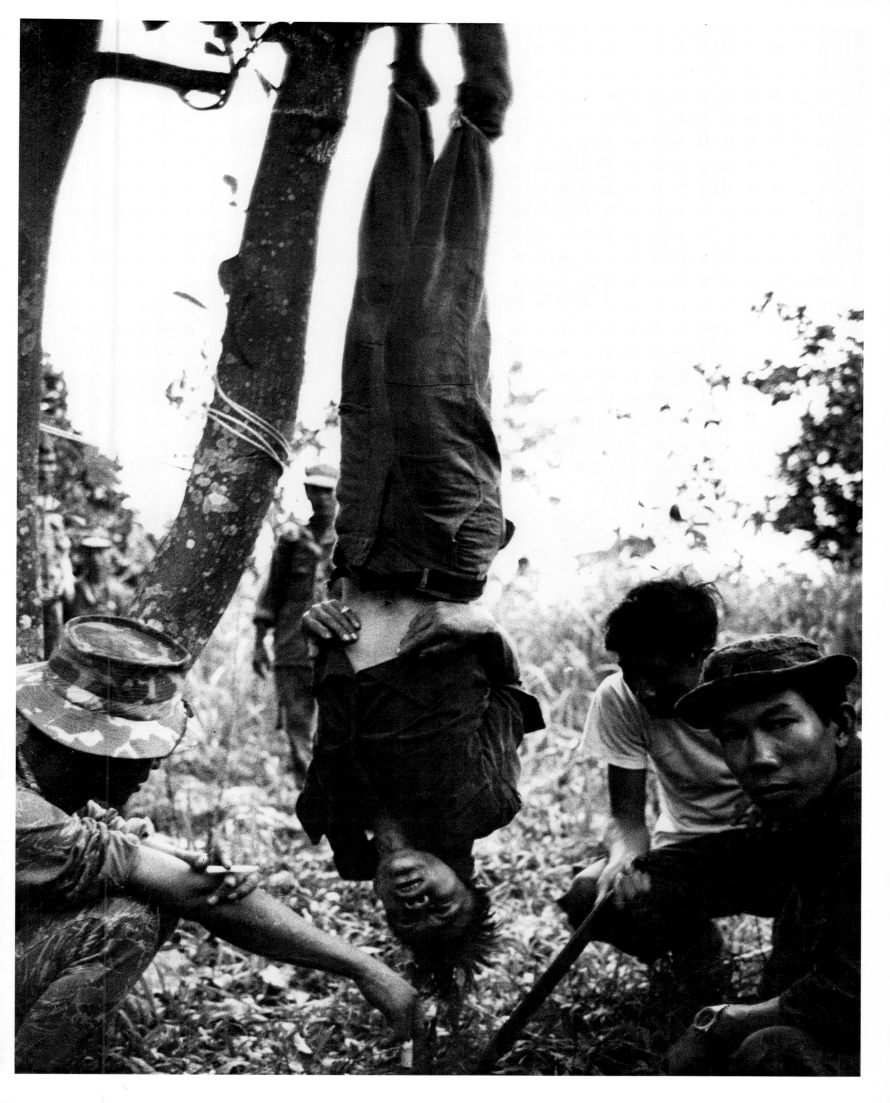

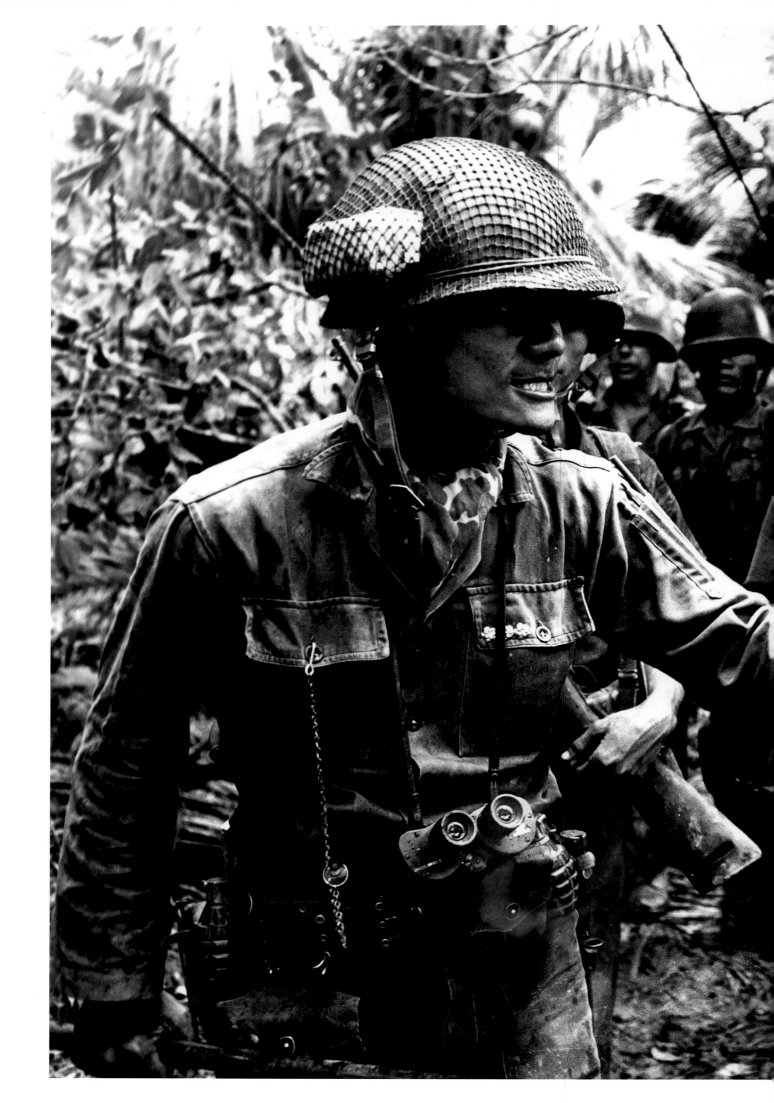

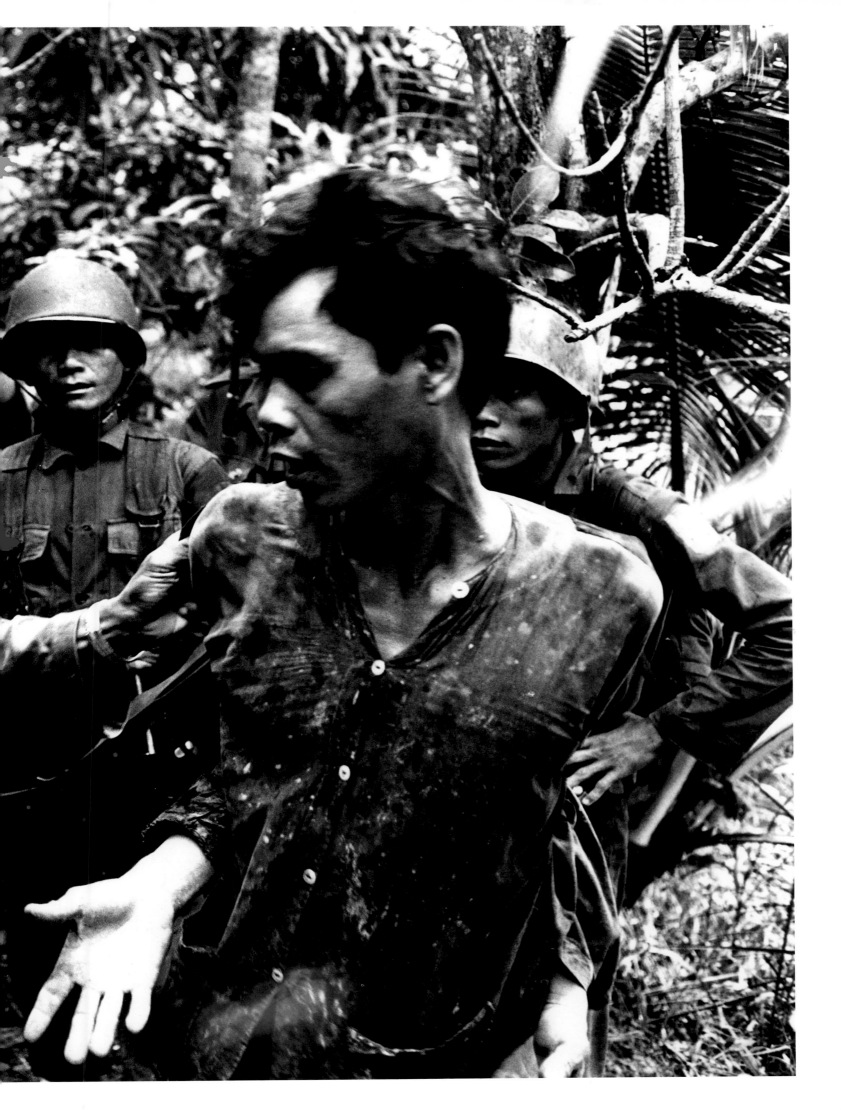

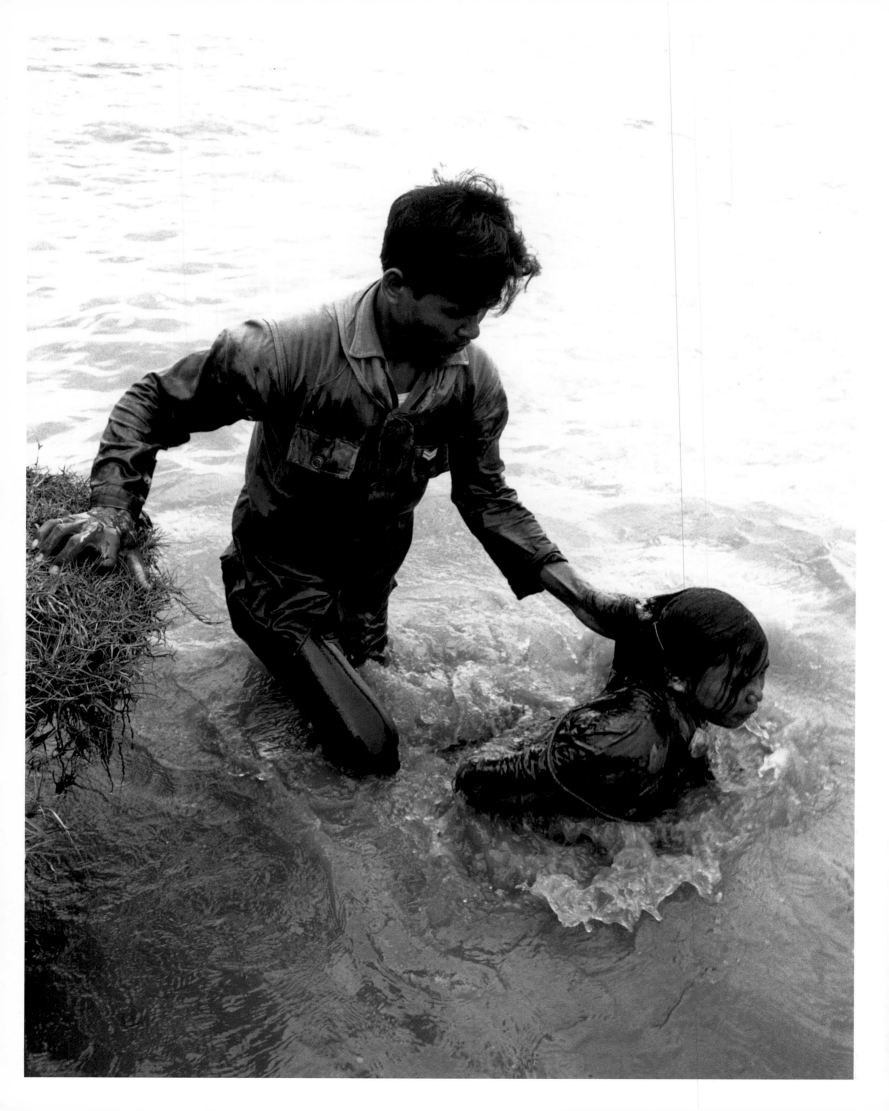

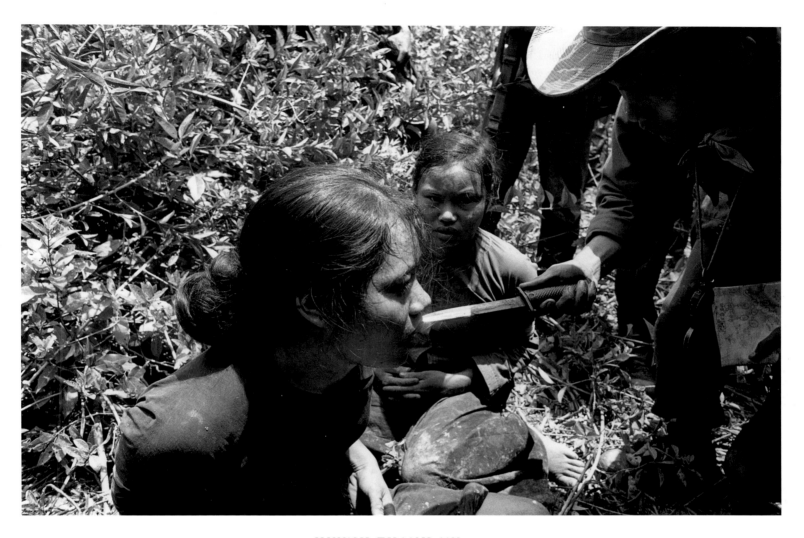

HUYNH THANH MY
Ap La Ghi, Mekong Delta, Vietnam, 1965.
Interrogation of a Viet Cong suspect by South Vietnamese soldiers.
(AP)

HUYNH THANH MY
Mekong Delta, Vietnam, 1965.
*The woman had her hands tied and was submerged repeatedly
as soldiers interrogated her. They sought information about the
local guerrilla forces. She was later imprisoned.*
(AP)

(pages 114 and 115)
HUYNH THANH MY
Tan Dinh Island, Mekong Delta, Vietnam, 1965.
*Vietnamese battalion commander Captain Thach Quyen
interrogates a captured Viet Cong suspect.*
(AP)

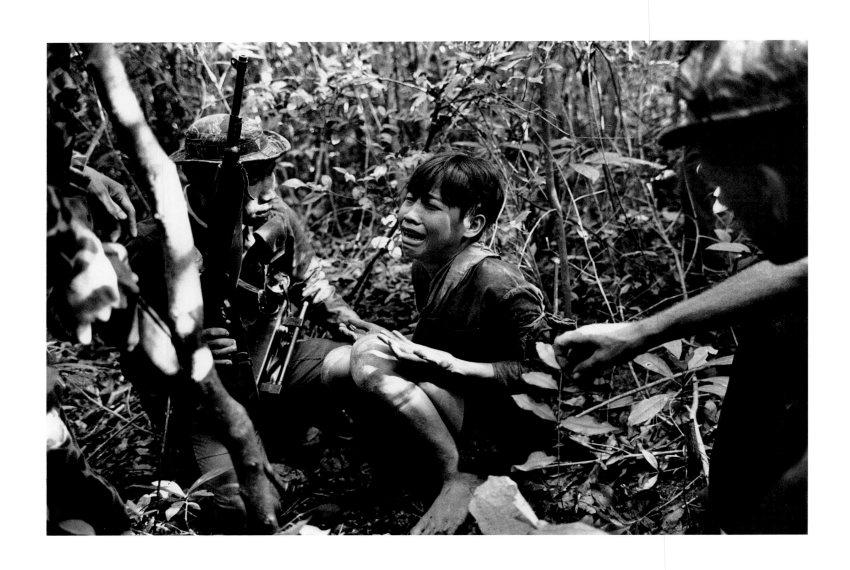

SEAN FLYNN
Duc Phong, Vietnam, 1966.
A young Viet Cong suspect cries after hearing a rifle shot.
His captors, Chinese Nung tribesmen in the service of the
U.S. Special Forces, pretended to shoot his father, a ruse
designed to make the boy reveal information about
Communist guerrillas.
(UPI)

BERNARD KOLENBERG
Near Ban Me Thuot, Vietnam, 1965.
An abandoned child squats on the ground after her parents fled
the arrival of Vietnamese marines searching for mountain
tribesmen who favor a movement to autonomy.
(AP)

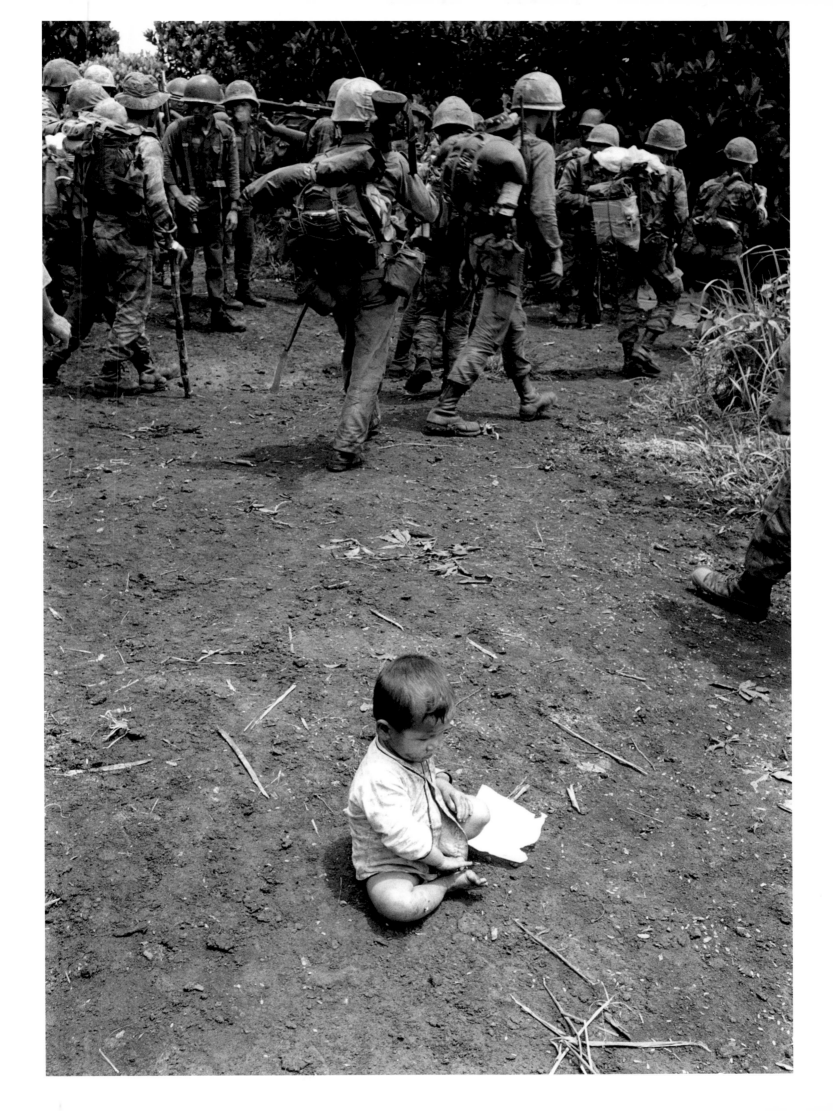

HENRI HUET
Bong Son, Vietnam, 1966.
A Vietnamese mother and her children are framed by
the legs of a soldier from the U.S. First Cavalry Division.
(AP)

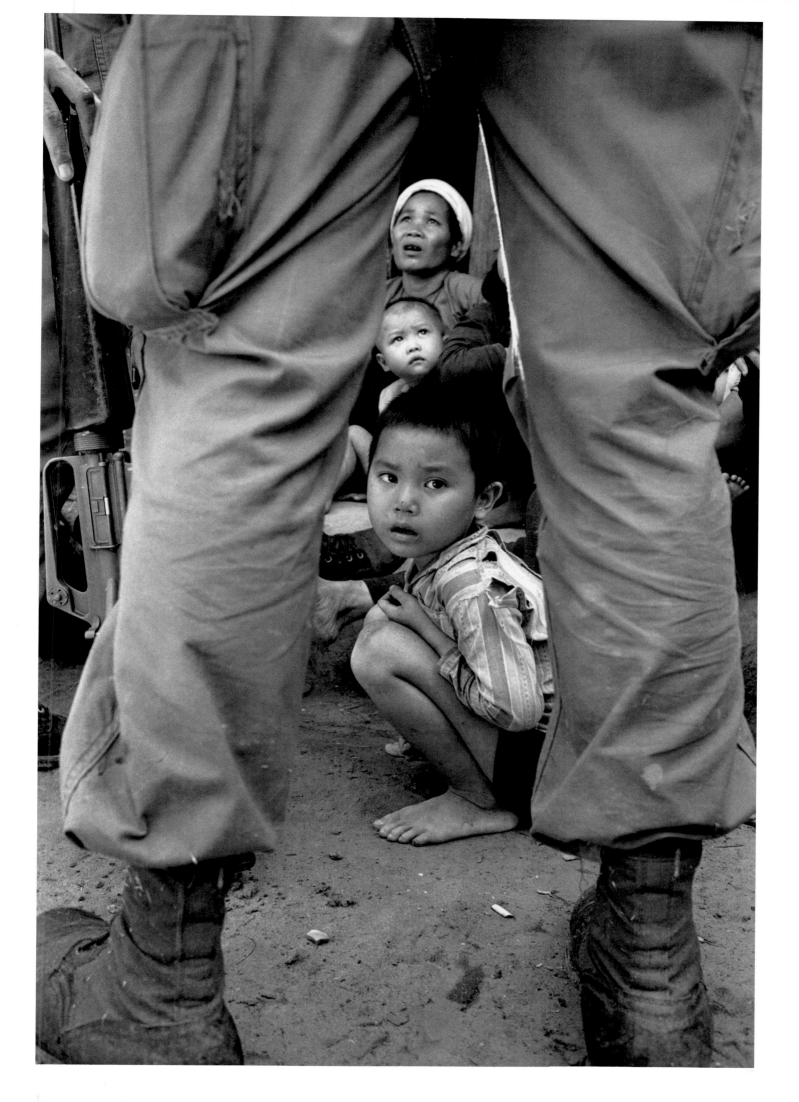

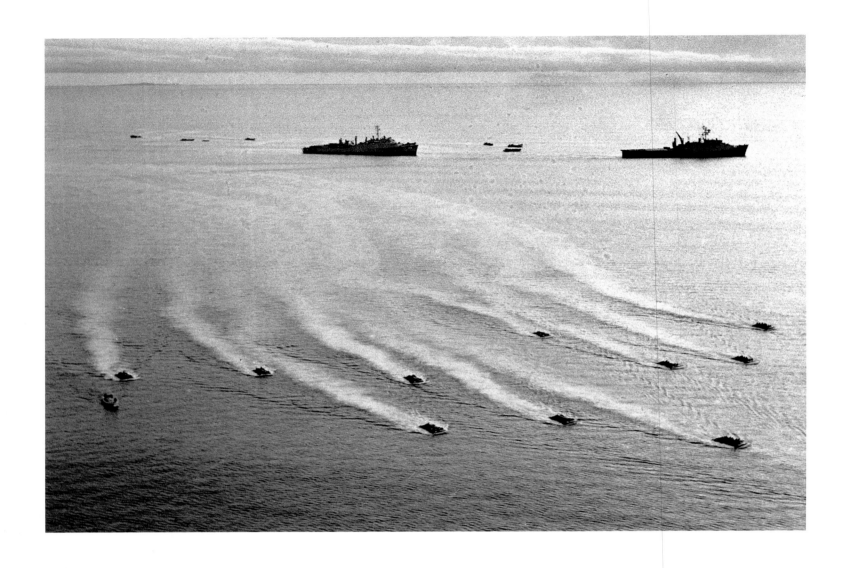

HENRI HUET
South of the DMZ, Vietnam, 1966.
U.S. Marines are brought ashore in landing craft.
(AP)

HENRI HUET
Vung Tau, Vietnam, 1966.
Soldiers of the U.S. Army Eleventh Armored Cavalry Regiment walk ashore.
(AP)

(pages 124 and 125)
HENRI HUET
North of Saigon, Vietnam, 1966.
*U.S. Army helicopters providing support for U.S. ground troops fly into a
staging area fifty miles northeast of Saigon. The fuel for a mobile gas
station is stored in large rubber tanks.*
(AP)

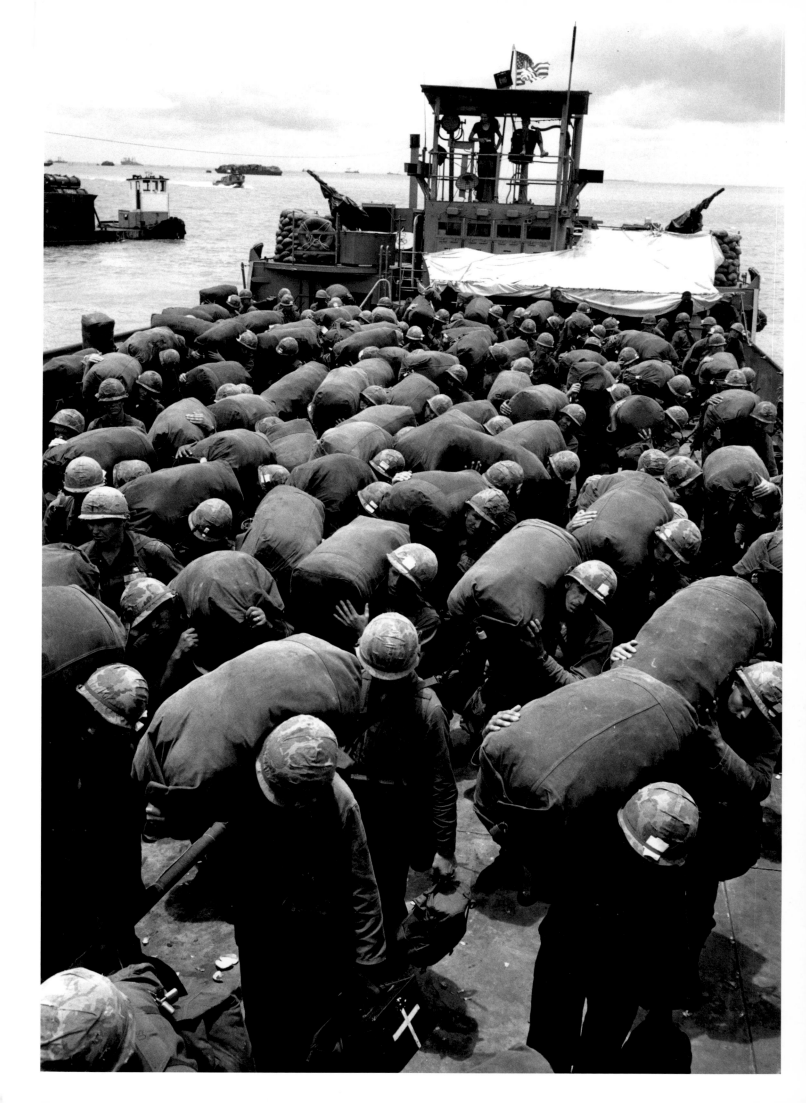

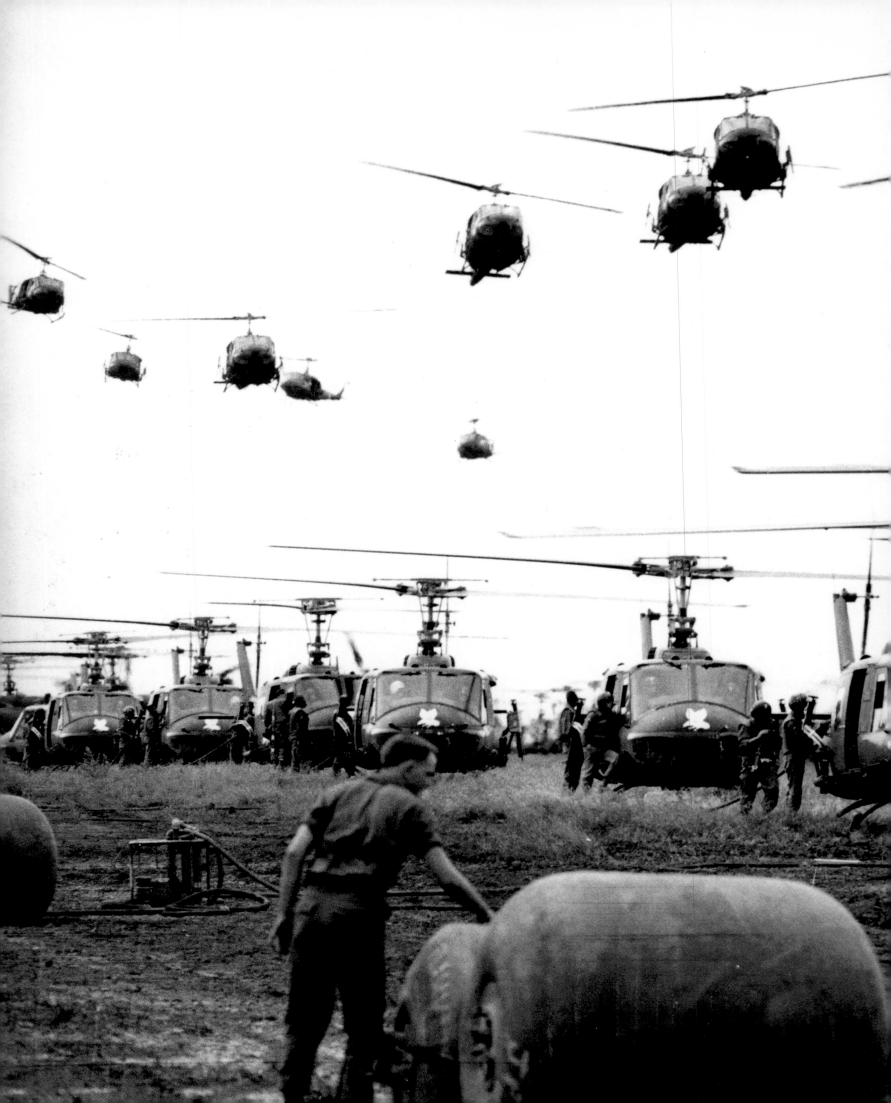

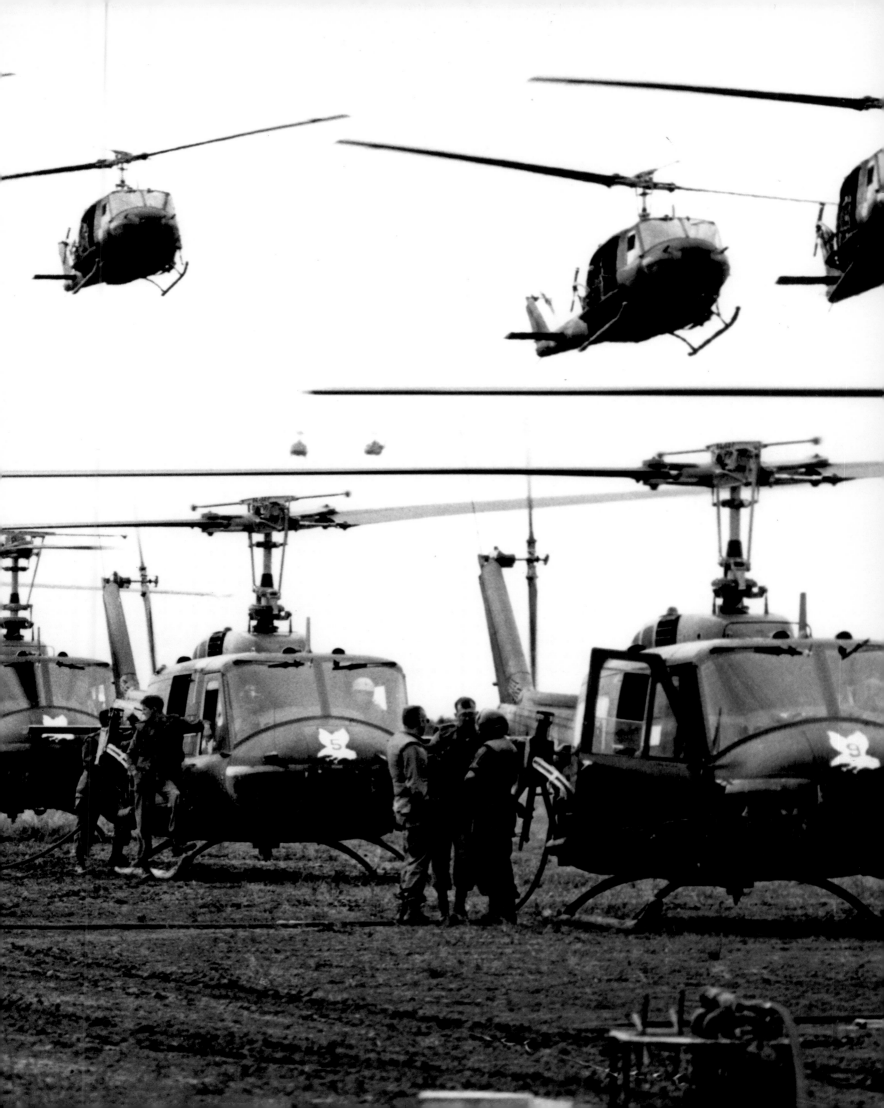

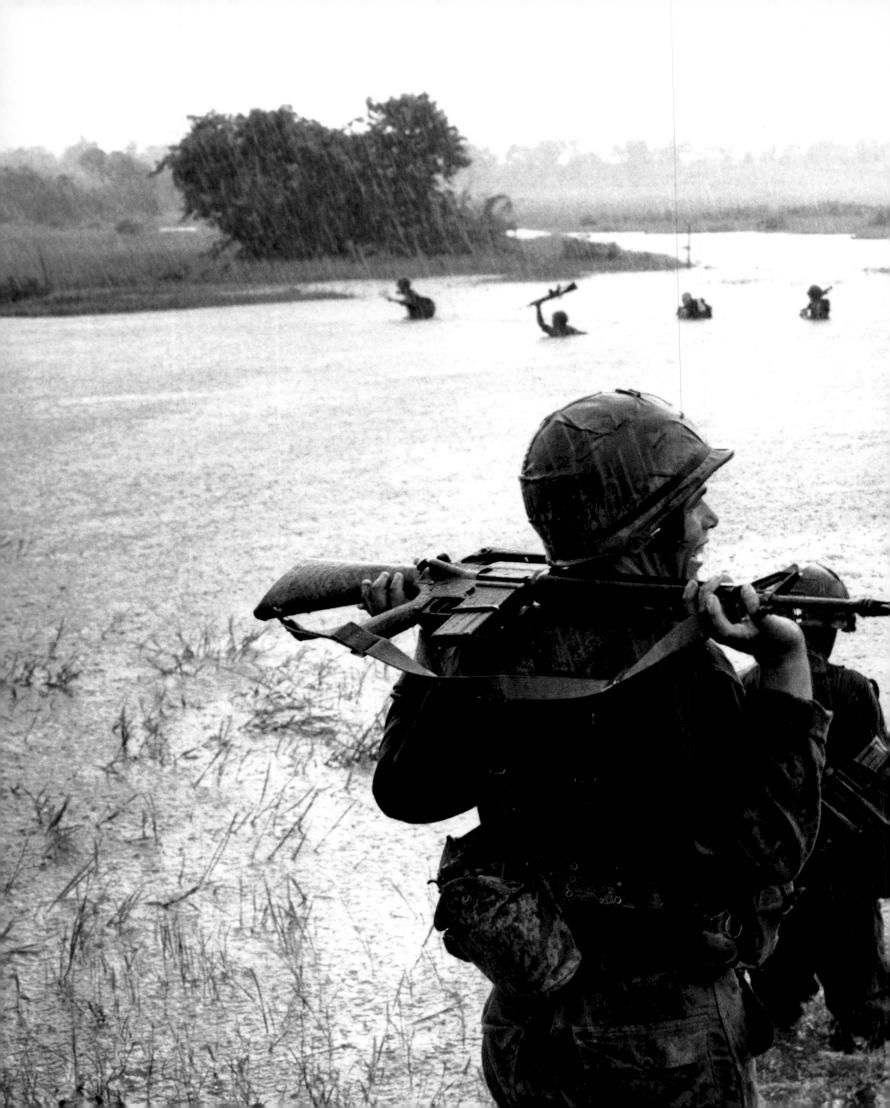

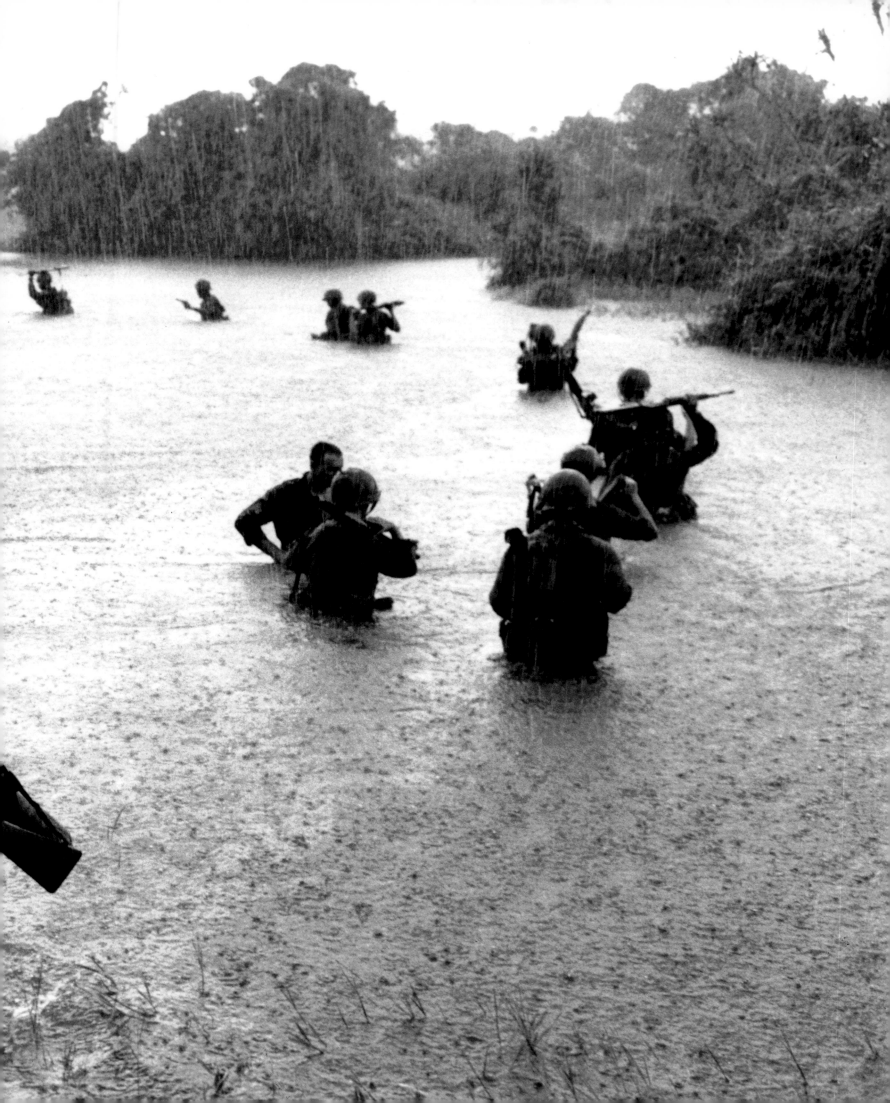

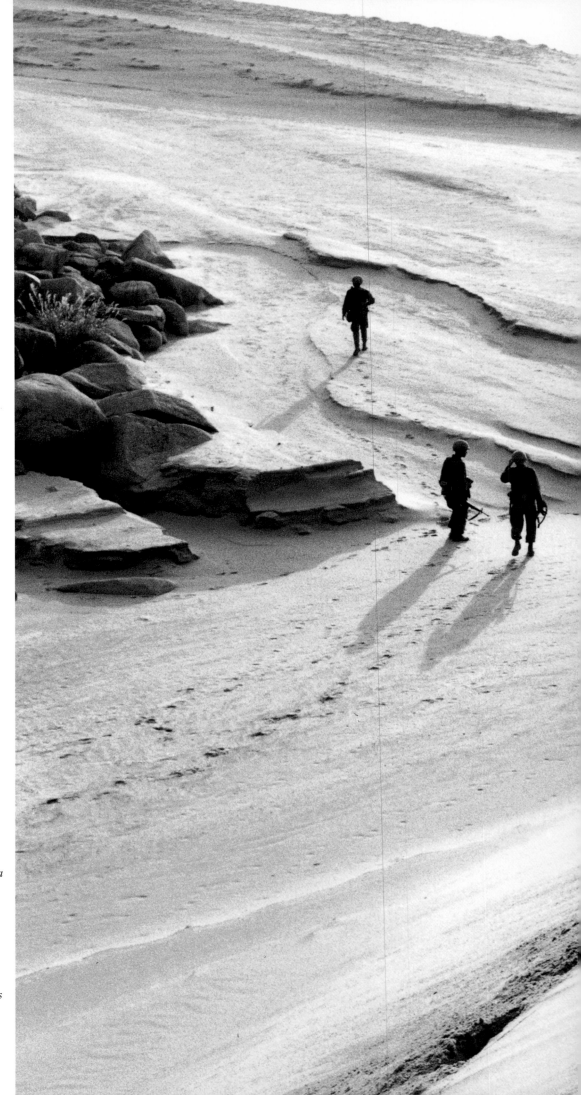

(pages 126 and 127)
HENRI HUET
War Zone C, Vietnam, 1965.
Soldiers of the U.S. 173rd Airborne Brigade on a
twelve-day patrol in the jungles near Ben Cat.
(AP)

HENRI HUET
Qui Nhon, Vietnam, 1966.
A First Cavalry reconnaissance unit on the sands
of the central coast in Operation Thayer II.
(AP)

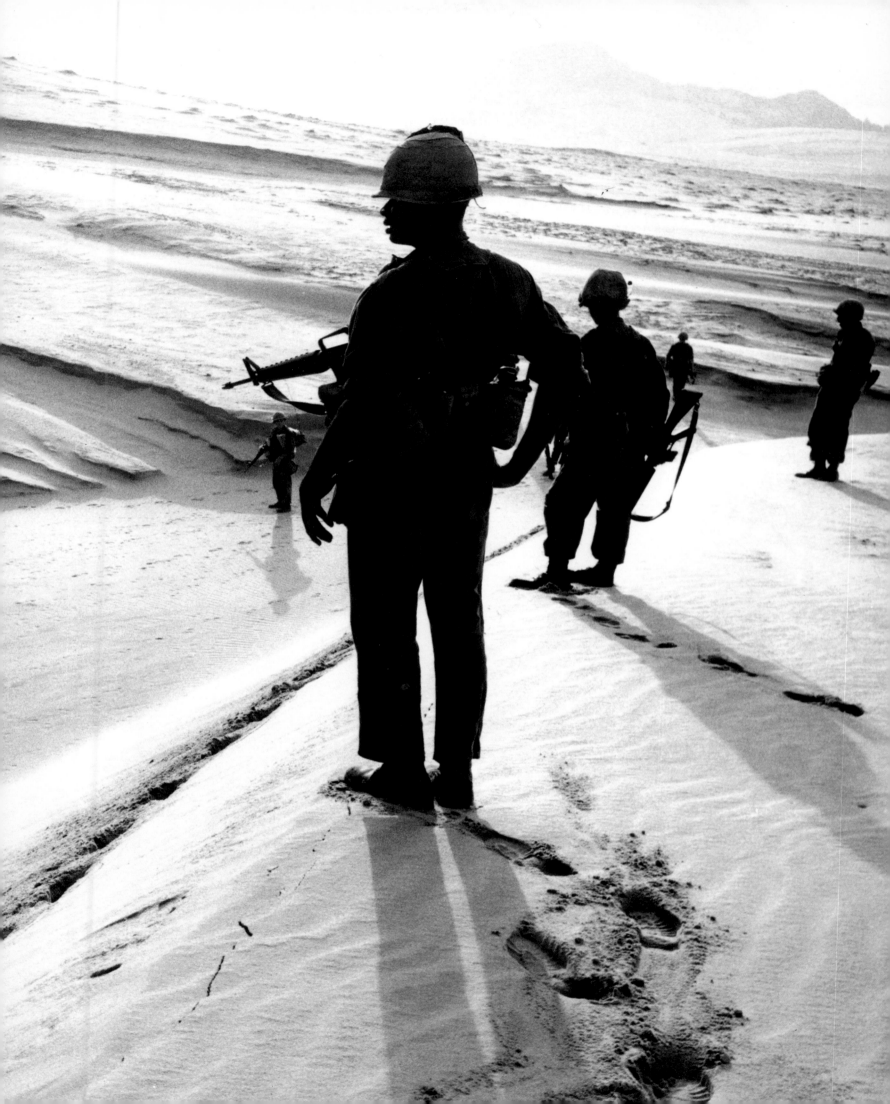

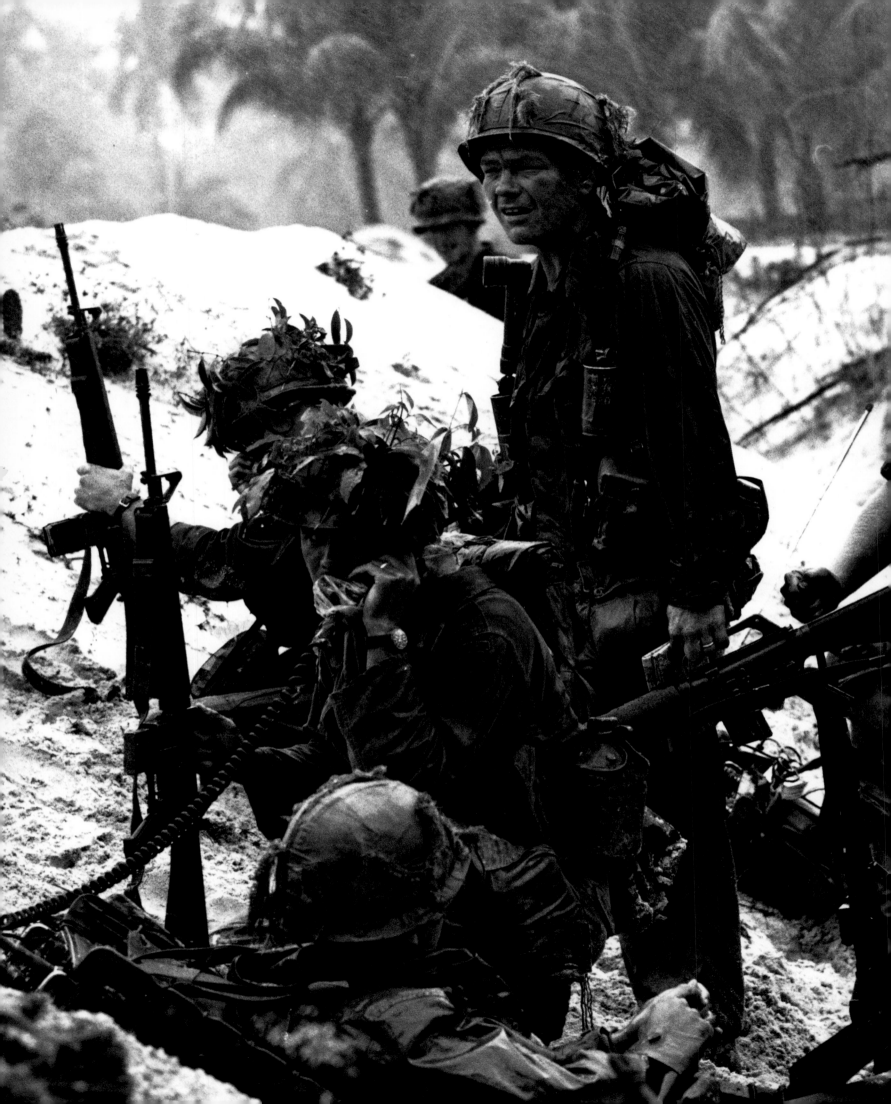

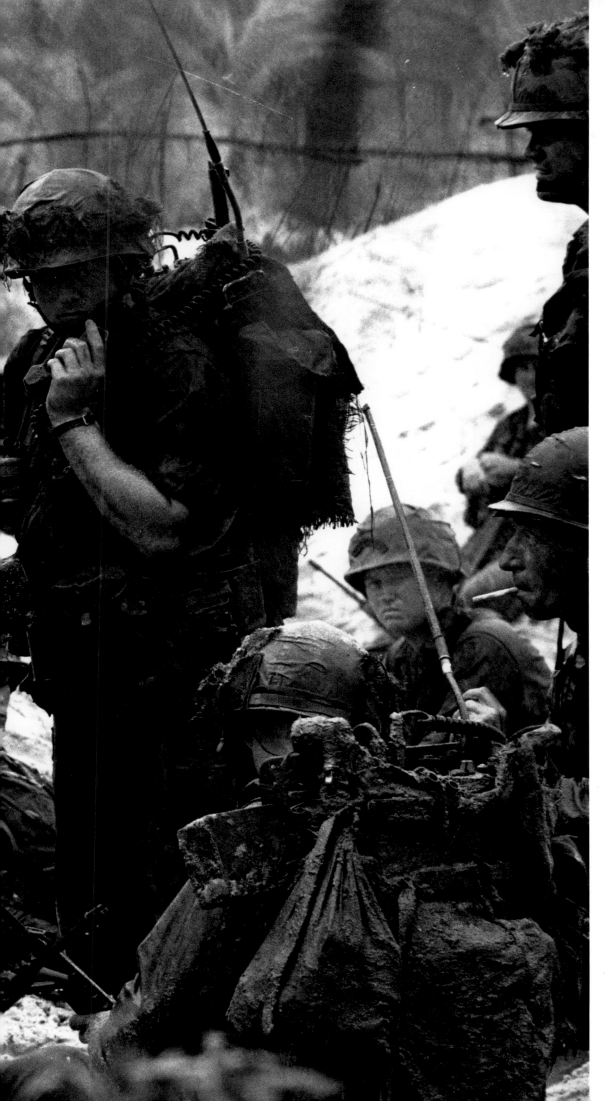

(pages 132 and 133)
DANA STONE
Bong Son, Vietnam, 1966.
Soldiers of the U.S. First Air Cavalry Division point their weapons at villagers whom they flushed from the brush along the riverbank.
(UPI)

HENRI HUET
An Thi, Vietnam, 1966.
Radio operators and command staff of the U.S. First Air Cavalry Division gather after daylong fighting in Operation Masher, one of the largest operations of the war.
(AP)

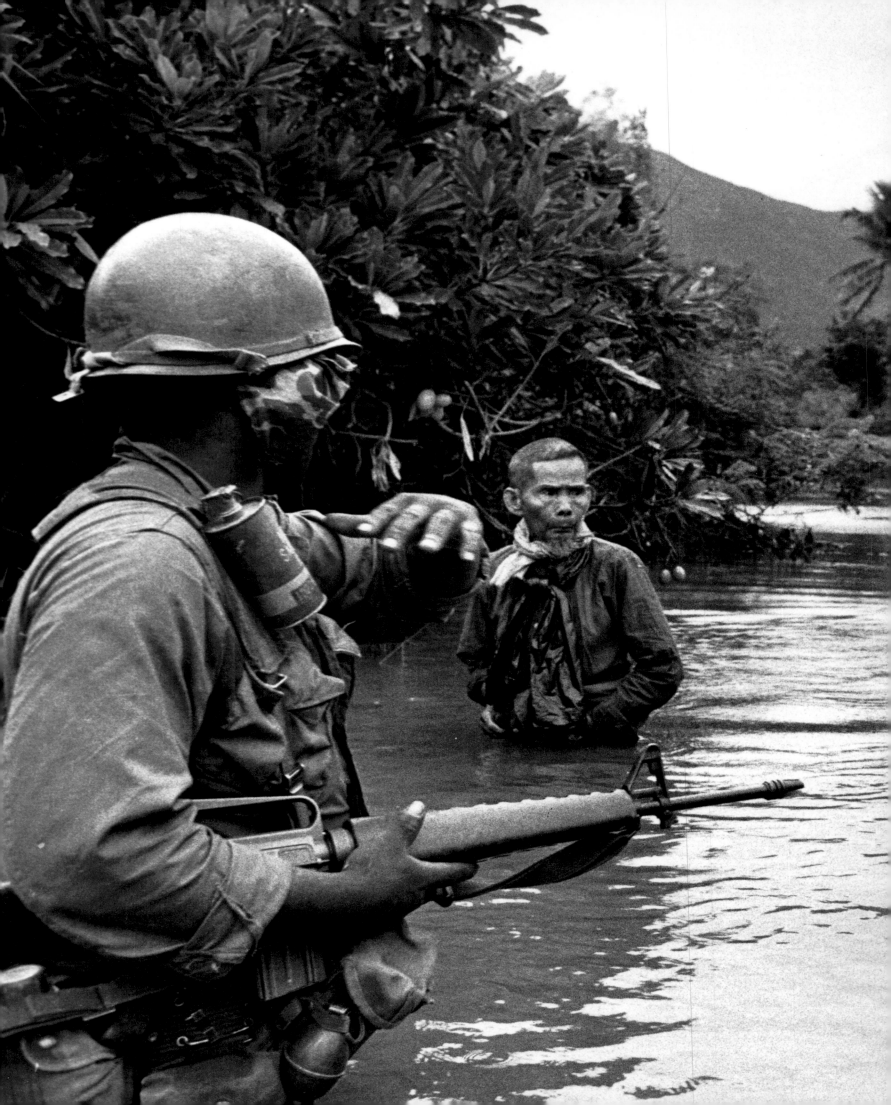

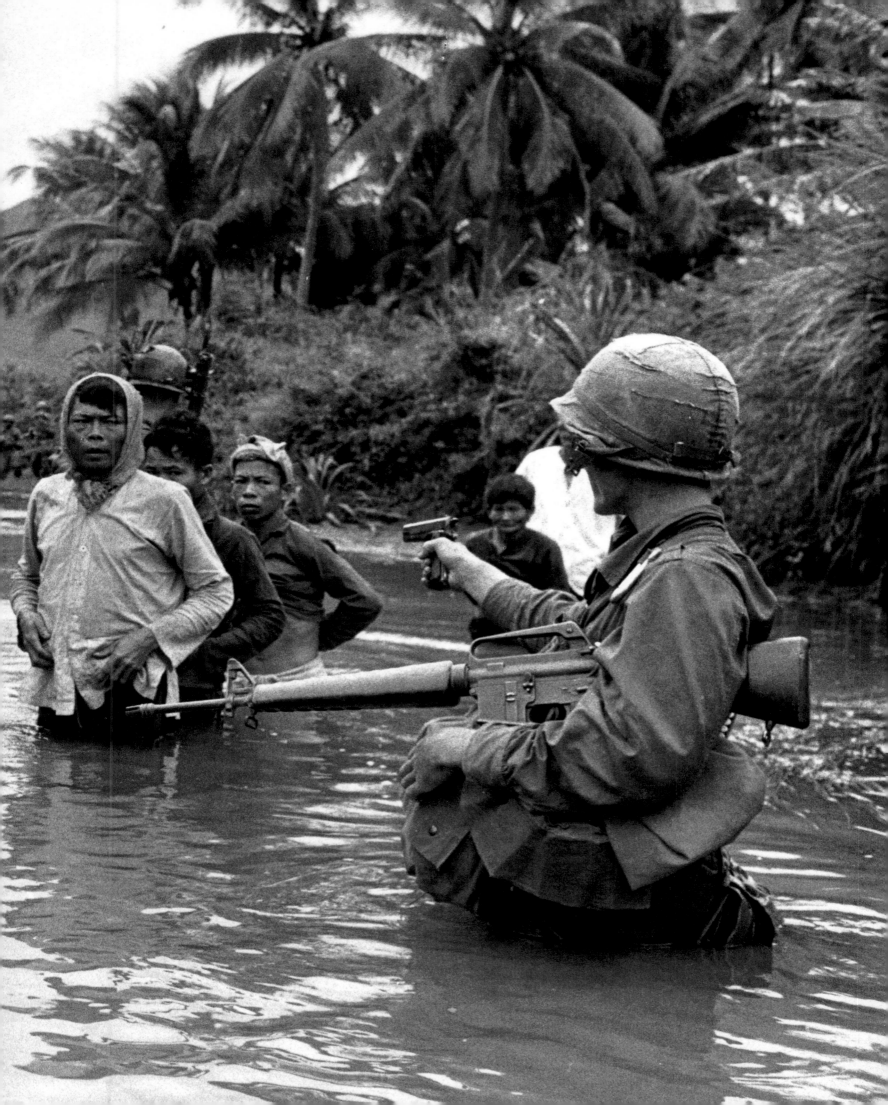

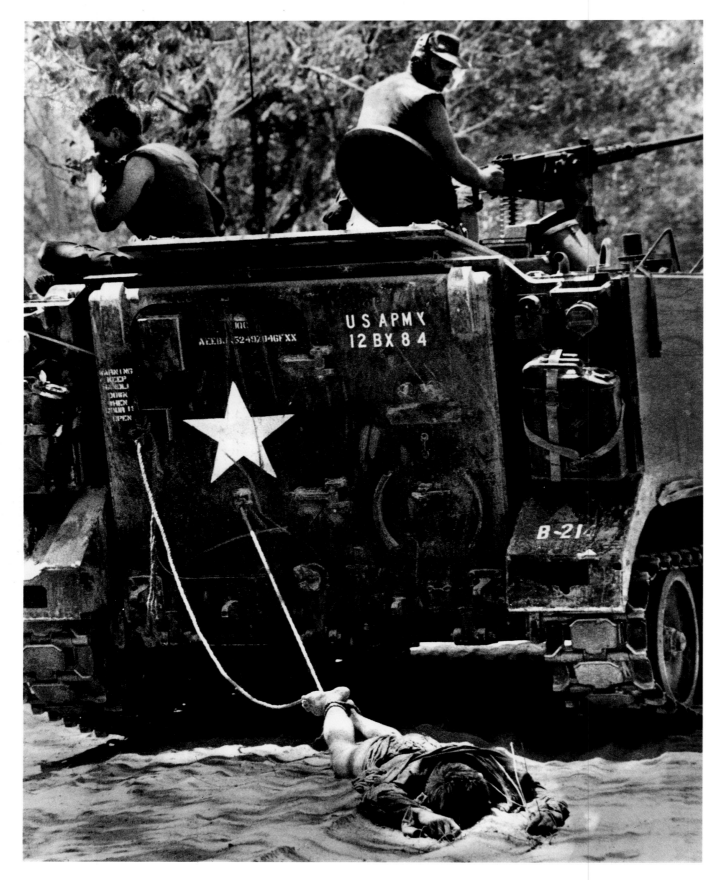

KYOICHI SAWADA
Tan Binh, Vietnam, 1966.
*The body of a Viet Cong soldier is dragged behind an armored vehicle
en route to a burial site after fierce fighting on February 24, 1966.*
(UPI)

KYOICHI SAWADA
Bong Son, Vietnam, 1966.
*An injured North Vietnamese soldier is led from his bunker by soldiers
of the U.S. First Cavalry Division. This soldier held up the U.S.
advance for one hour with machine-gun fire from his position.*
(UPI)

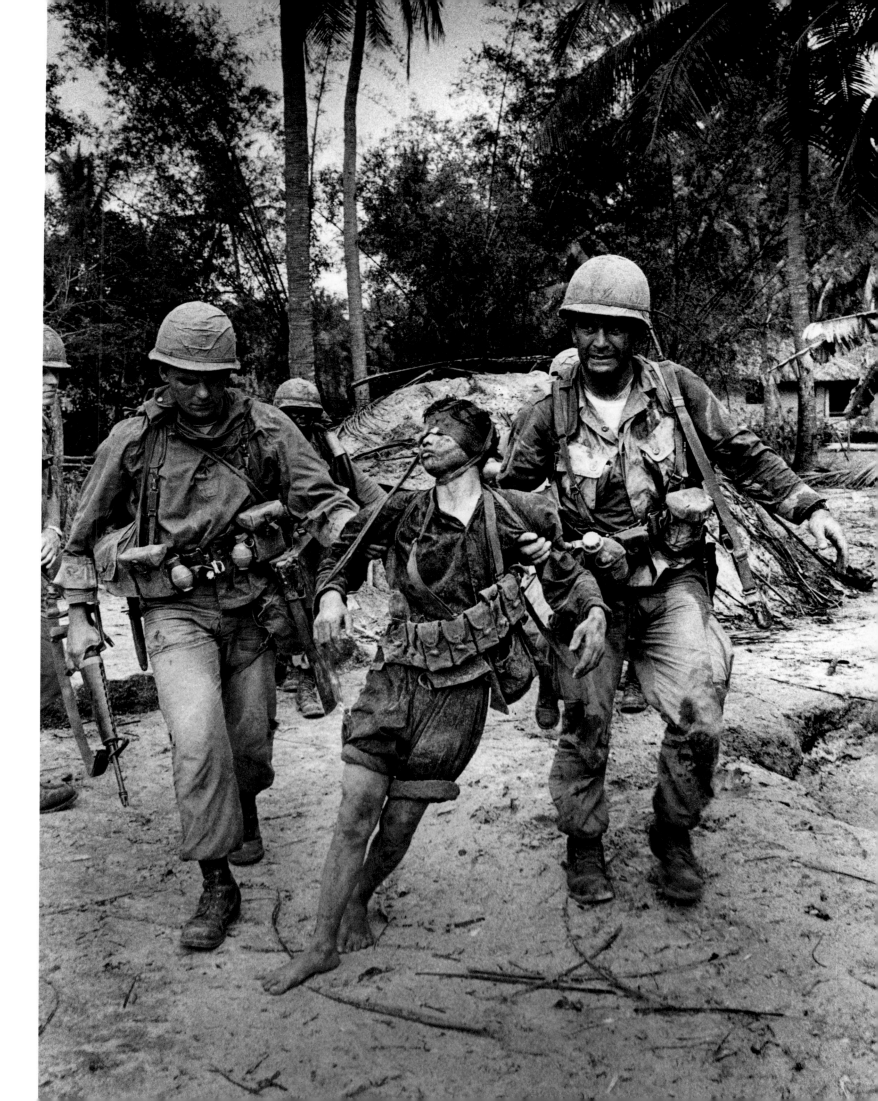

DICKEY CHAPELLE
(1918–1965)

Tad Bartimus

Georgette Louise Meyer of Milwaukee reinvented herself as Dickey Chapelle, war correspondent, a generation before the women's movement propelled females to the front lines. She did it against the standards of her time and despite the near unanimous opposition of male journalists and the prejudice of most of her subjects. Yet throughout her career as a photographer in one hot spot after another, she insisted she was not a feminist. Her ambivalence about her trailblazing coverage in World War II, Hungary, Cuba, and Vietnam led to a string of contradictory labels ranging from sex-crazed broad to naïve agent of the CIA. Dickey never seemed sure of where she fit in.

"I have," she wrote of herself in April 1945, "a fine incipient case of split personality, the masculine lined up against the feminine. This is no place for the feminine."

But the freelancer who was too prickly to be tied down to just one job craved being where the action was, and promoted herself to editors and potential employers as "the first woman" to reach an assignment or get a story or as the photographer who had "stayed the longest and gone further forward than any reporter, man or woman."

World War II united Dickey with the U.S. Marine Corps in what would prove to be her most enduring of many love affairs. She was on the front lines at Iwo Jima and Okinawa, writing and photographing for *Life*, *Reader's Digest*, *The National Observer*, and *National Geographic*.

In 1962, she won the Overseas Press Club's George Polk Award for her coverage of Vietnam. By then Dickey Chapelle was well known among her colleagues, but her dream of being a household name, like Marguerite Higgins or Margaret Bourke-White, was still unrealized, so she took bigger risks. At age forty-one, she made her first parachute jump. Marine commandant Wallace M. Greene, Jr., unpinned his own corps insignia from his uniform and presented it to Dickey when she decided to return to Vietnam in 1965.

Patriotic and blatantly biased toward the military, Chapelle found it harder to sell her stories on Vietnam as opposition to the war grew. Constantly short of money and afraid her career was faltering, she knew her chance for a breakthrough story was in the field with the troops, not sitting through press briefings in Saigon.

At forty-seven, she was having to struggle to meet the physical demands facing war correspondents. Nonetheless, as a Marine commander would later eulogize, "She'd spread her poncho in the mud like the rest of them and eat out of the tin cans like she hated it, the way we do, not because it was something cute. In fatigues and helmet you couldn't tell her from one of the troops and she could keep up front with the best of them."

When she went on Operation Black Ferret, sixty-four miles south of Da Nang, she still lived for the thrill of being, as she put it, on the "bayonet borders" of the world.

Dickey Chapelle died on the morning of November 4, 1965, while on patrol with the Marines. Shrapnel from a land mine tore open her carotid artery. She wore a wildflower in the hatband of her bush hat and pearls in her ears. Her last words reportedly were "I guess it was bound to happen."

DICKEY CHAPELLE
Mekong Delta, Vietnam, 1962.
A South Vietnamese soldier prepares to execute a Viet Cong prisoner.

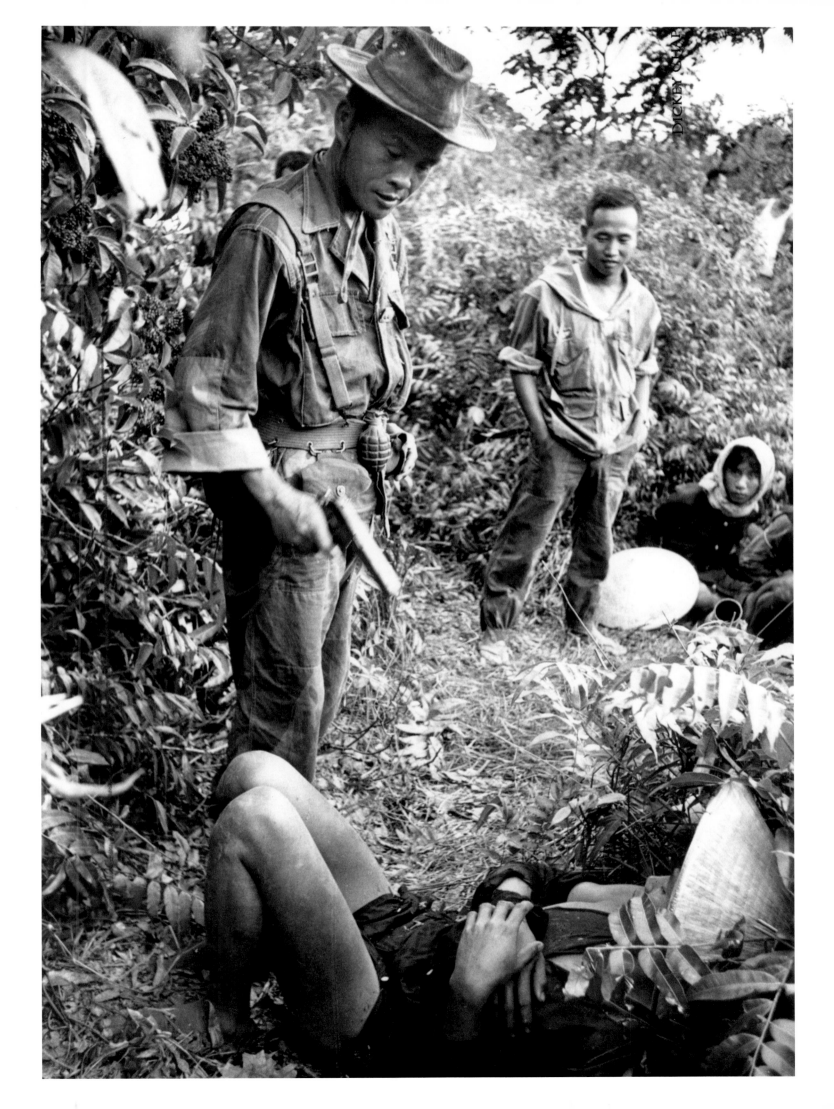

Dickey Chapelle, 1958. Lew Lowery. (USMC/AP)

D 7218 (NY8)
ASSOCIATED PRESS RADIOPHOTO FROM SAIGON
CAUTION: USE CREDIT

LAST RITES FOR DICKEY CHAPELLE

CHAPLIN JOHN MCNAMARA OF BOSTON, MASS.,
MAKES THE SIGN OF THE CROSS AS HE ADMIN-
ISTERS LAST RITES TO DYING WAR-CORRES-
PONDENT MISS DICKEY CHAPELLE IN SOUTH
VIET NAM NOV. 4. MISS CHAPELLE WAS ON
ASSIGNMENT FOR THE NATIONAL OBSERVER WITH
A U.S. MARINE UNIT ON A COMBAT OPERATION
NEAR CHU LAI WHEN SHE WAS SERIOUSLY
WOUNDED BY AN EXPLODING MINE BOOBY
TRAP THAT ALSO INJURED FOUR MARINES.
SHE DIED ON WAY TO HOSPITAL IN HELI-
COPTER.

H/RH 740A 11/4/65 RCA/SAI 97
NYT NWYS11 NBC NR2 S&S STS SAMER46
MEX ZZ BAI PR TMC NWK WW

HENRI HUET
Chu Lai, Vietnam, 1965.
*U.S. Marine Corps chaplain John Monamara of Boston
administers the last rites to war correspondent Dickey Chapelle.*
(AP)

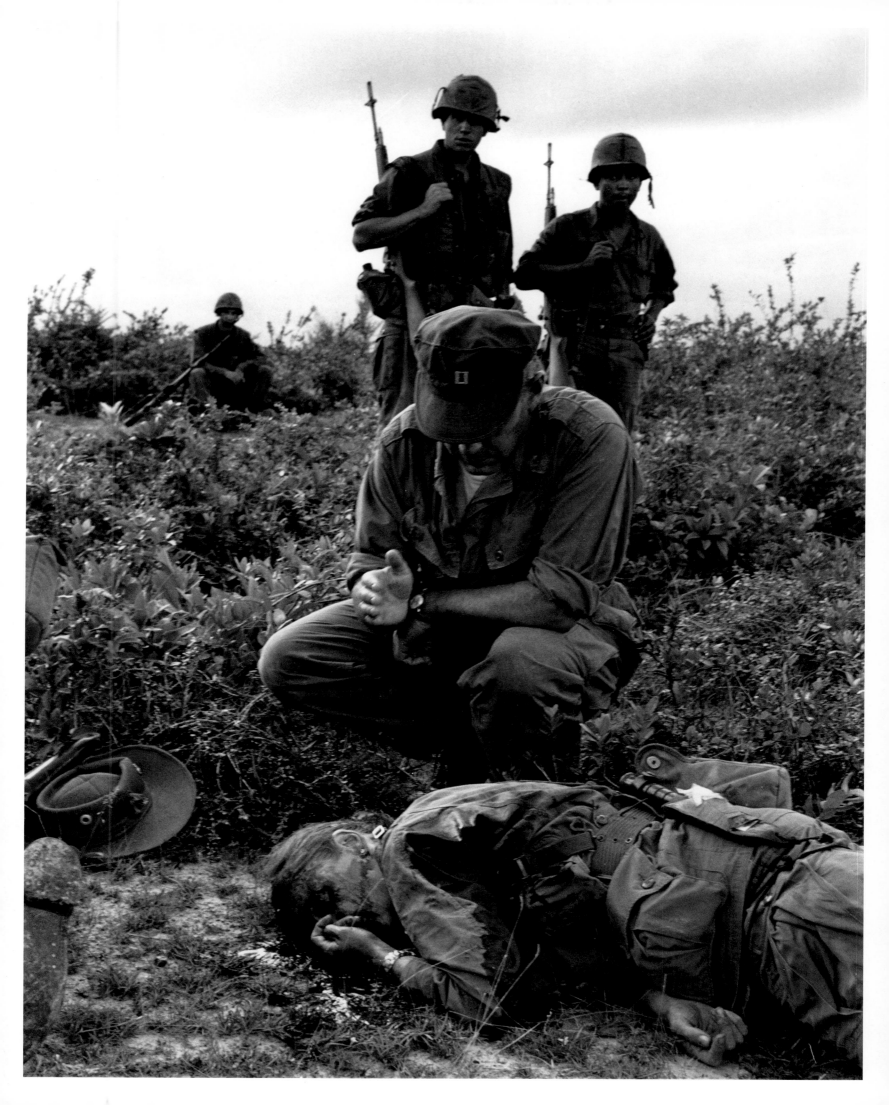

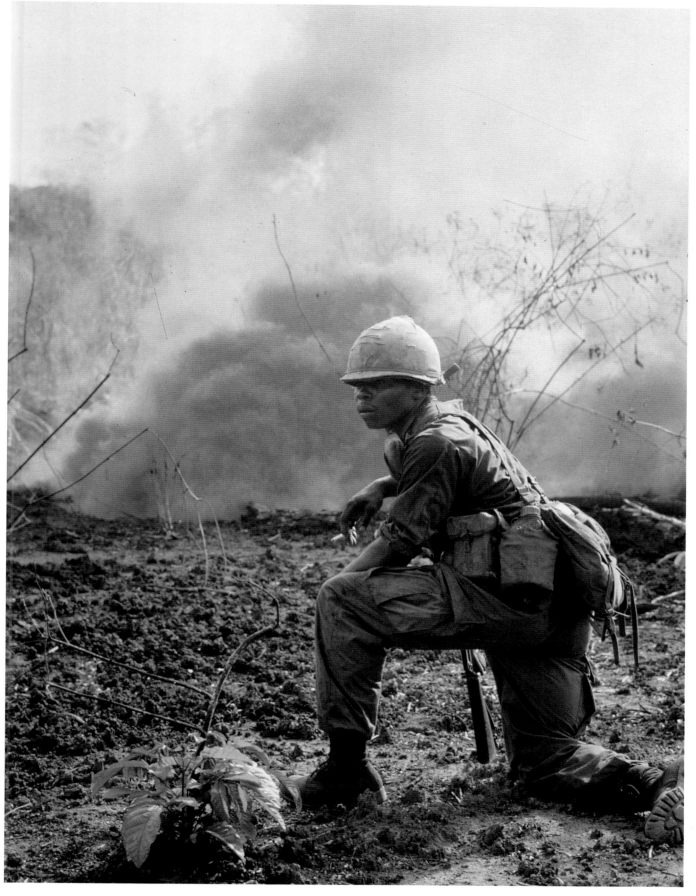

KYOICHI SAWADA
Vietnam, 1966.
Red smoke grenade marks a jungle clearing, indicating where helicopters should land. (Cressendo)

KYOICHI SAWADA
Vietnam, 1966. (Cressendo)

(pages 142 and 143)
LARRY BURROWS
Vietnam, 1962.
Vietnamese Air Force T-28 Skyraiders flown by U.S. Air Force pilots drop napalm on Viet Cong targets. (Life)

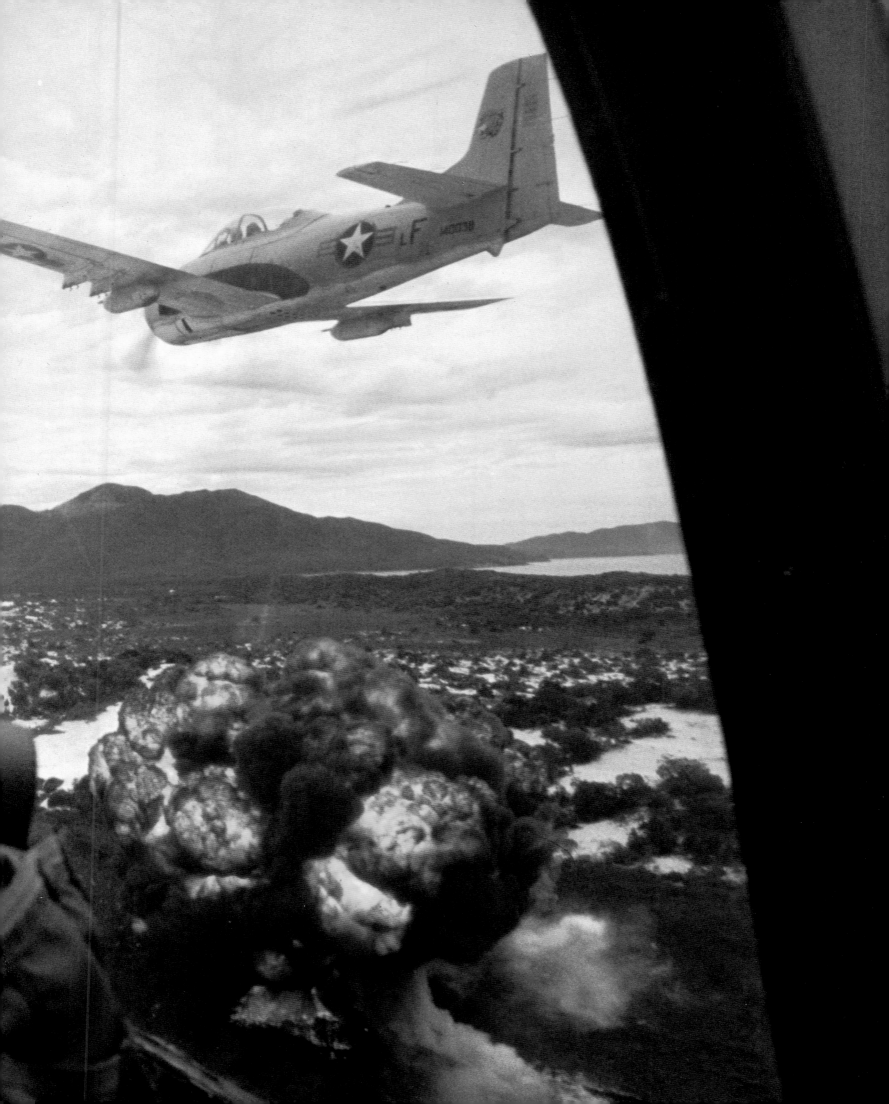

3 THE QUAGMIRE

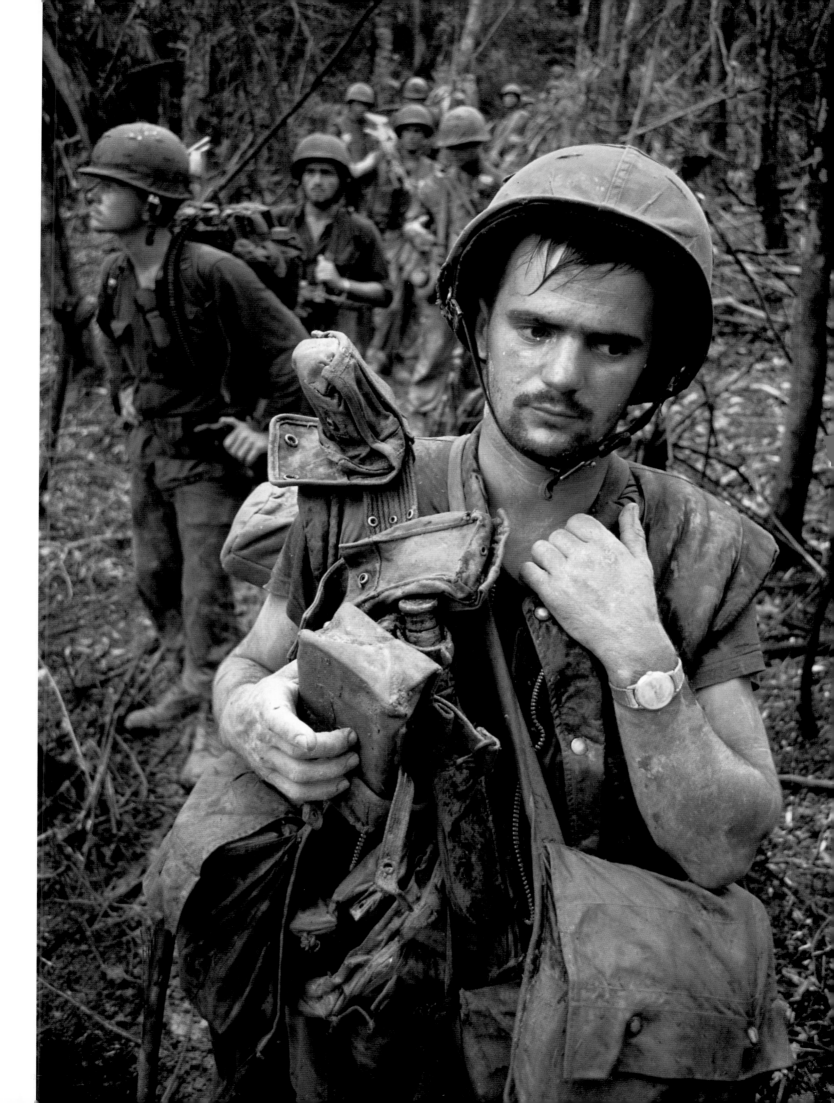

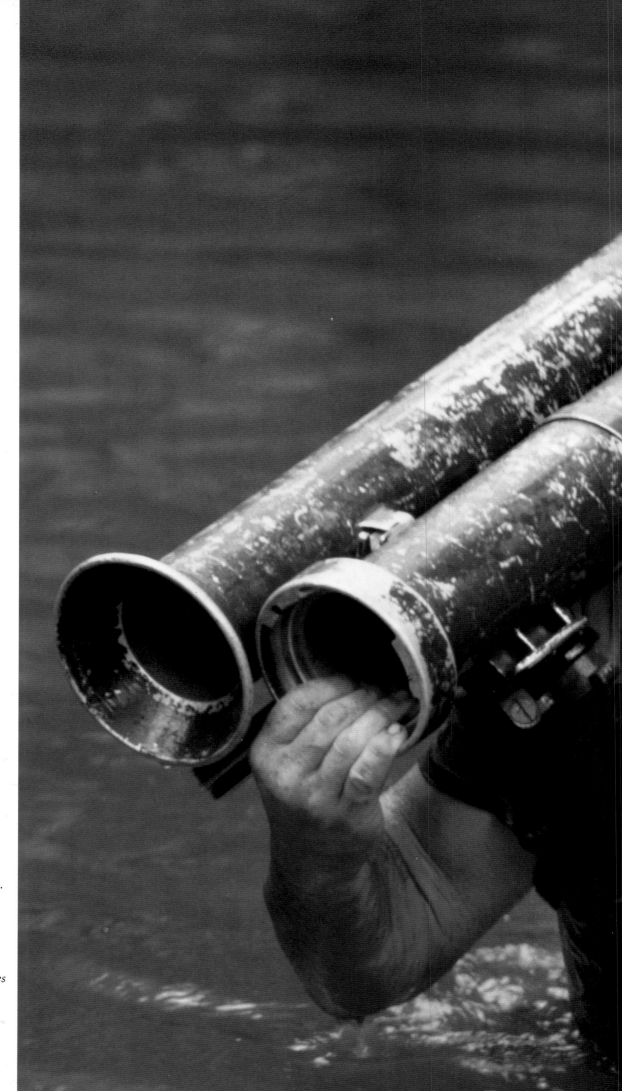

(page 145)
LARRY BURROWS
South of the DMZ, Vietnam, 1966.
*A U.S. Marines forward reconnaissance
patrol sets up to counterattack North
Vietnamese infiltration south of the DMZ.*
(*Life*)

LARRY BURROWS
South of the DMZ, Vietnam, 1966.
*Marine gunner John Wilson, shouldering
a rocket launcher, was part of a U.S. Marines
reconnaissance force. He was killed in
action twelve days later.*
(*Life*)

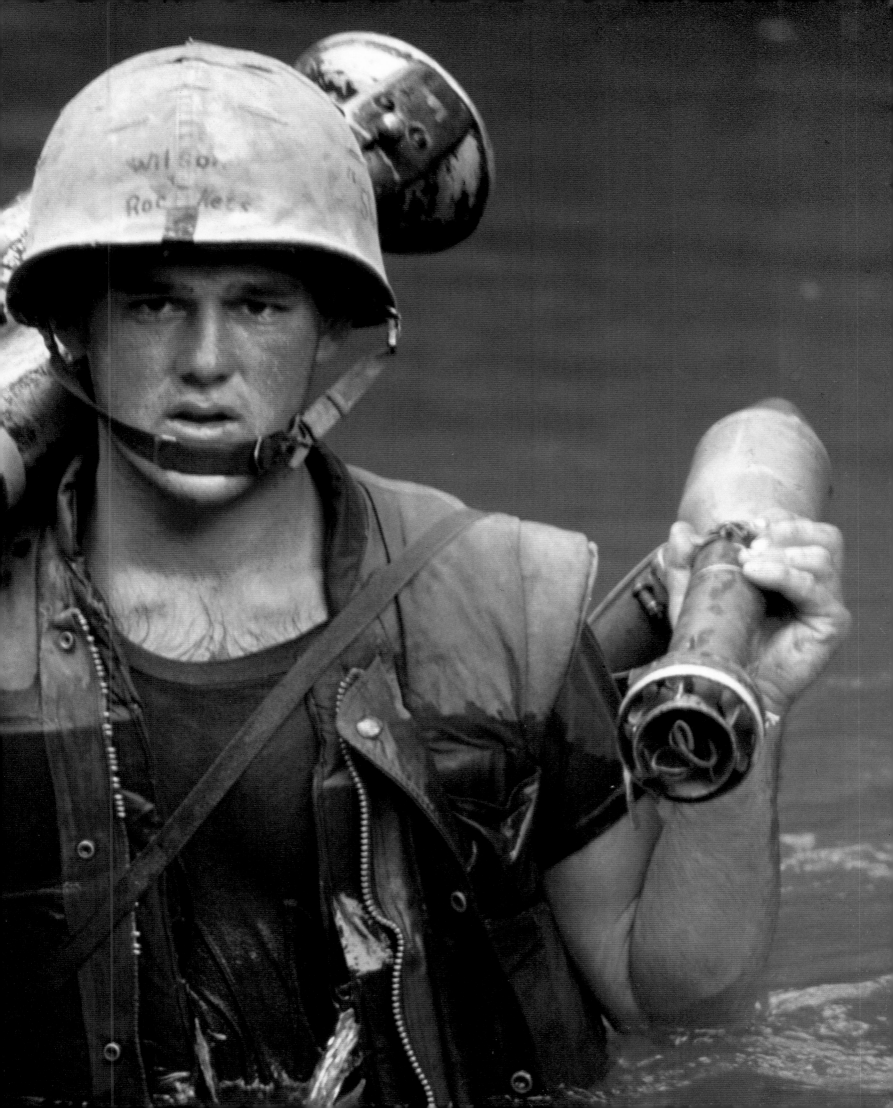

HENRI HUET
Near An Thi, Vietnam, 1966.
Private First Class Lacey Skinner of
Birmingham, Ala., under fire from the
Viet Cong during a fourteen-hour battle
along the central coast.
(AP)

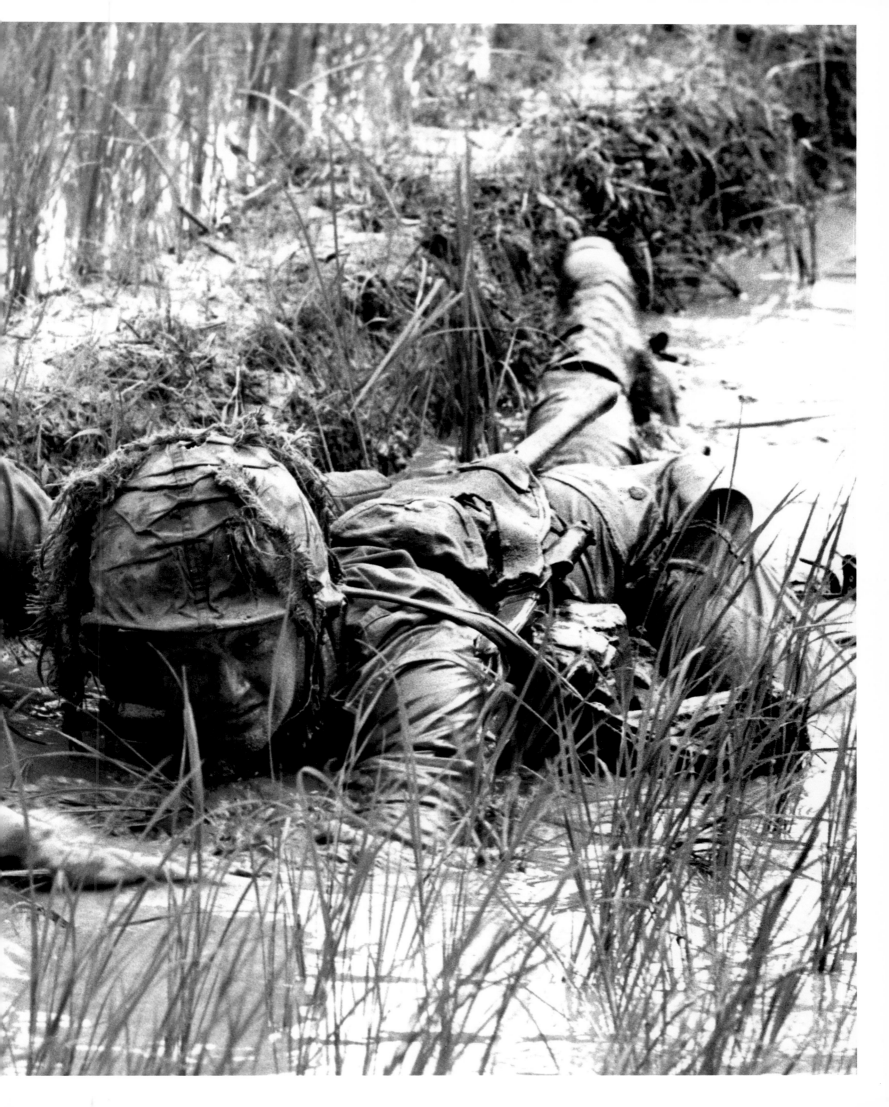

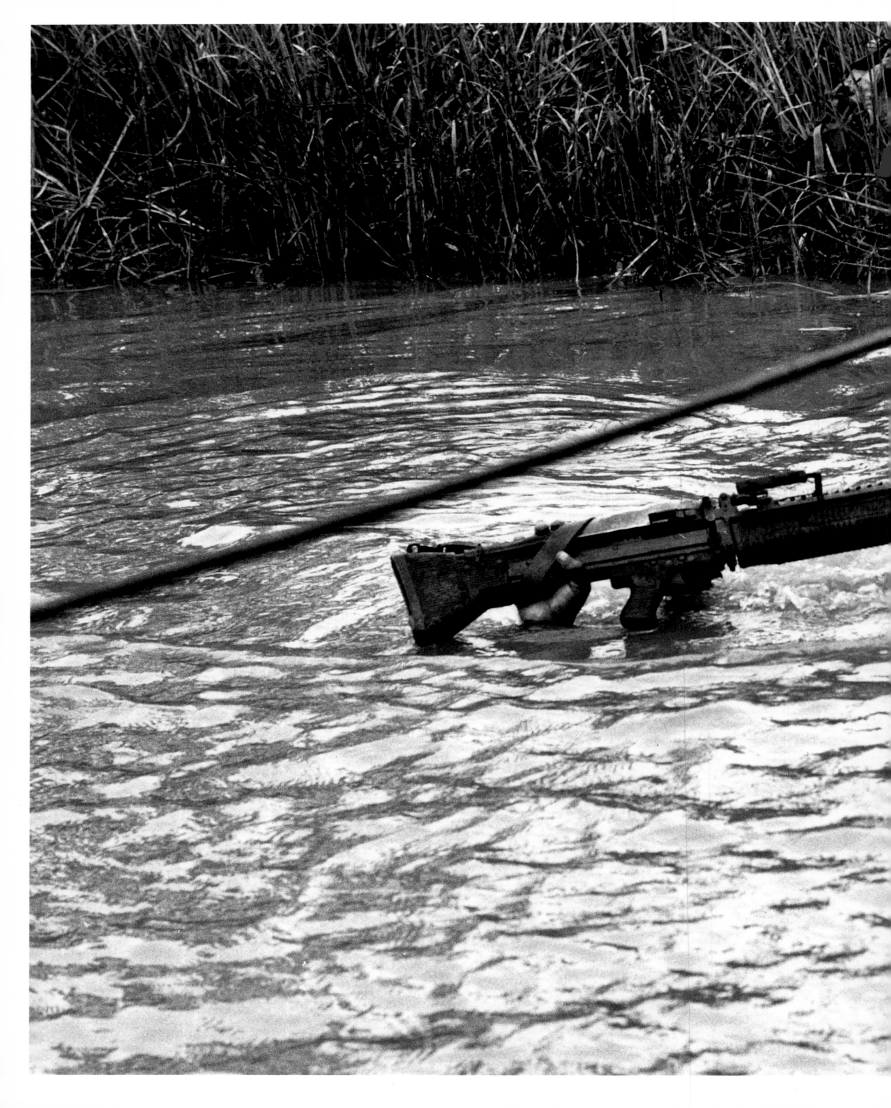

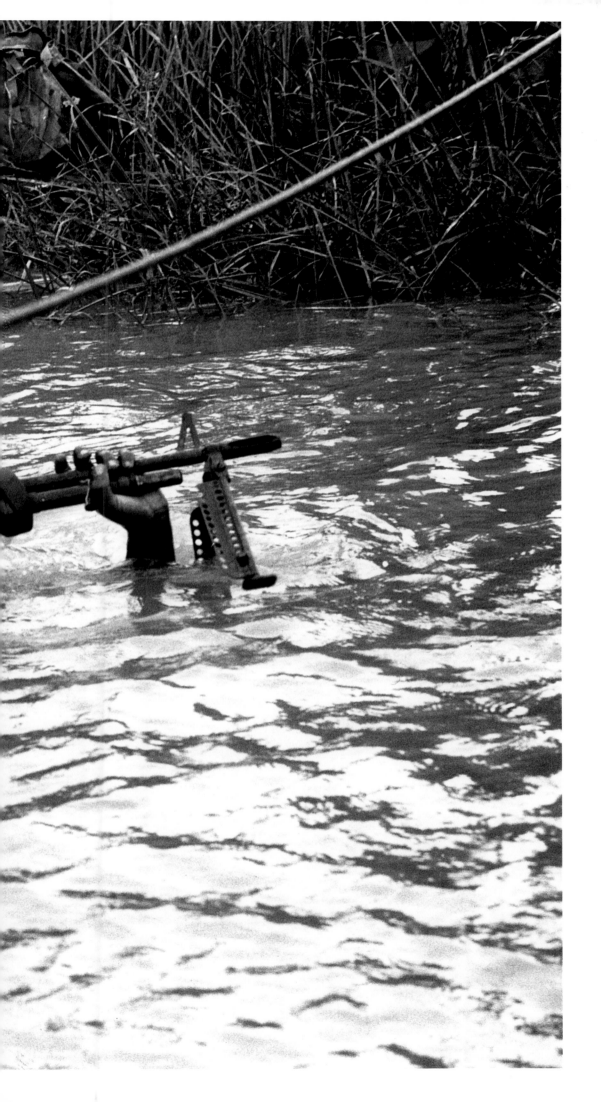

(pages 152 and 153)
KYOICHI SAWADA
Qui Nhon, Vietnam, 1965.
The 1966 Pulitzer Prize–winning photograph.
A Vietnamese mother and her children escape
bombs from a U.S. air strike.
(UPI)

HENRI HUET
Mekong Delta, Vietnam, 1968.
(AP)

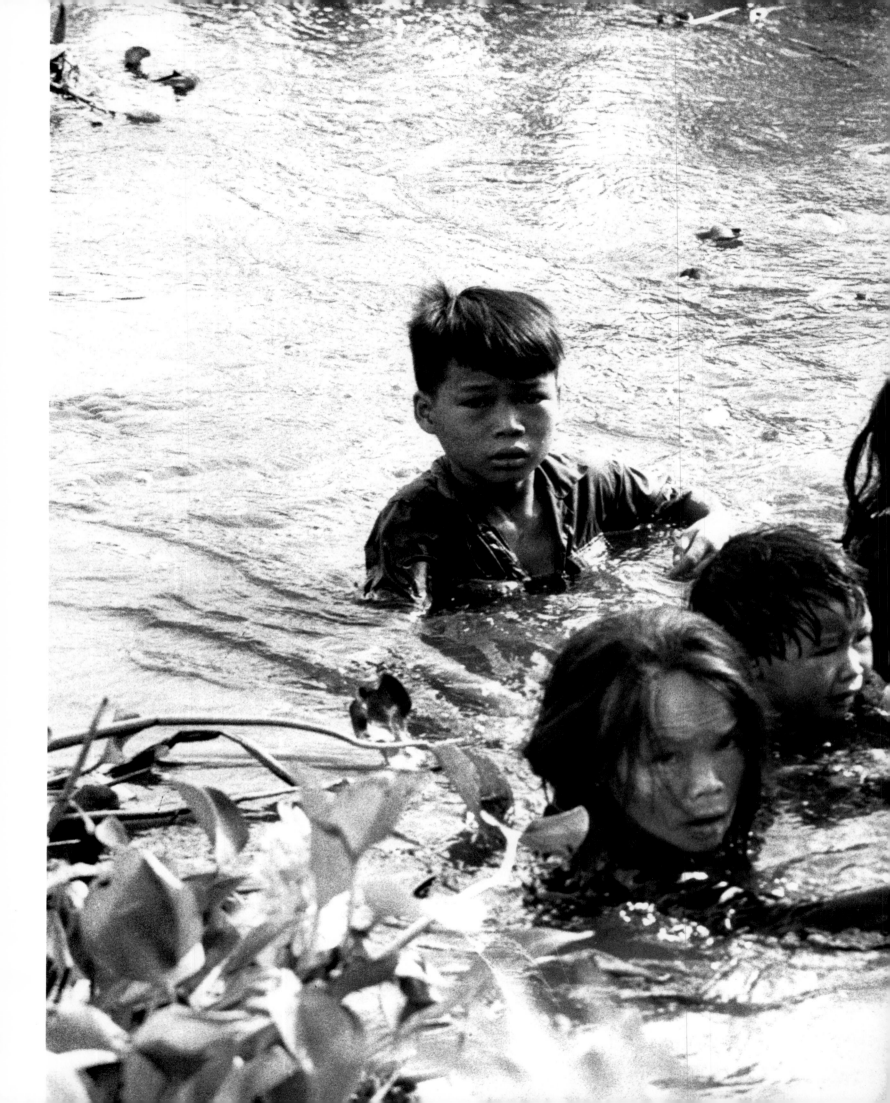

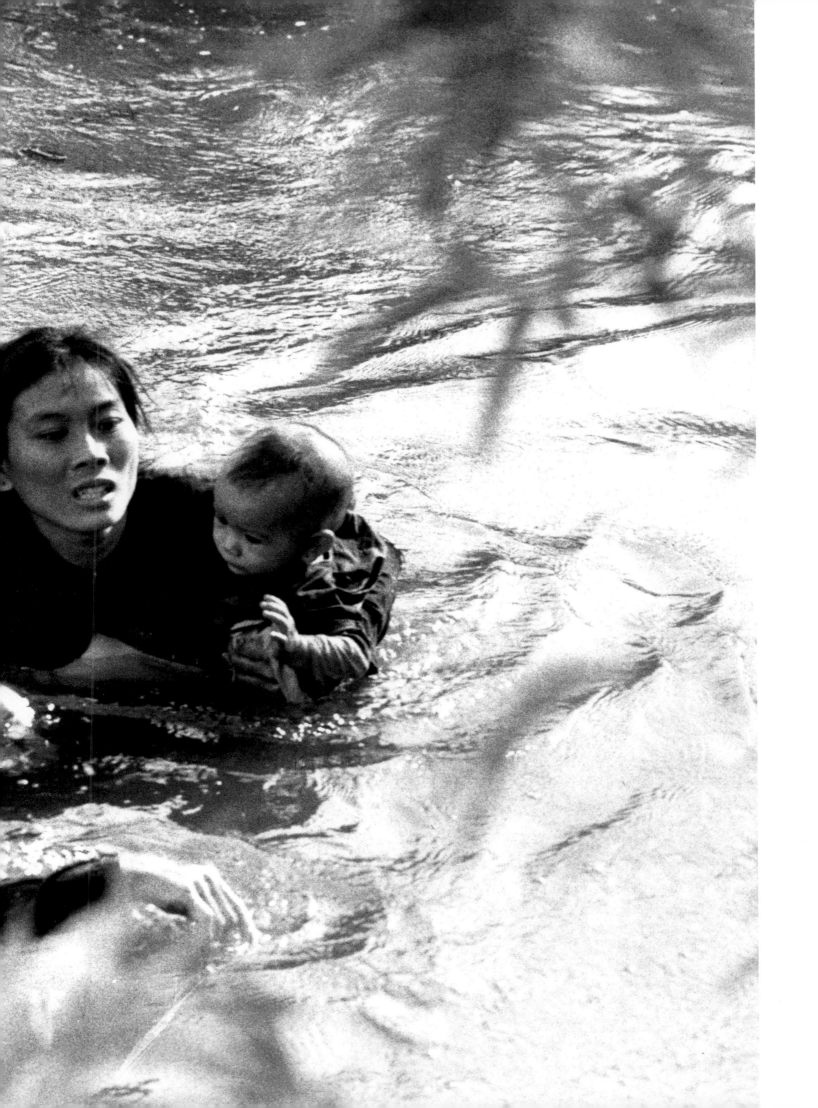

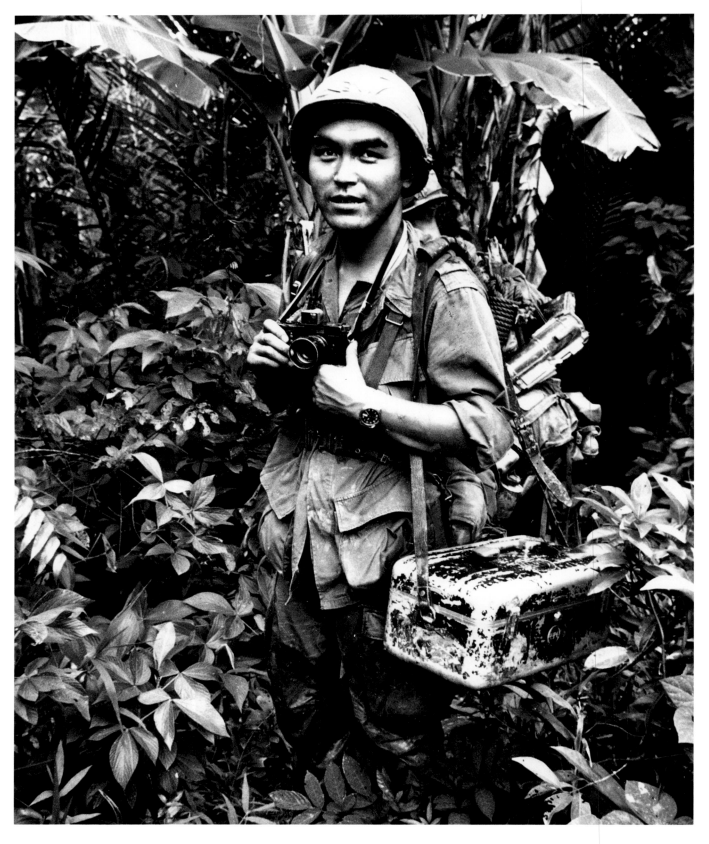

Kyoichi Sawada, Vietnam, 1967. Horst Faas. (UPI)

Loc Thuong, Vietnam, 1966.
Kyoichi Sawada presents a print to the women and children shown in his dramatic photo. Leon Daniel. (UPI)

THE PHOTOGRAPHERS

Tad Bartimus

Each came for a reason and died taking a chance. They were veterans and amateurs, staff shooters and independents, gun-toters and pacifists. One never sold a photograph; two had won Pulitzer Prizes. Some were buried with honors and mourned by nations; others simply disappeared. They came from around the globe to become the greatest assemblage of photojournalists in history.

If they'd all been gathered together on the Continental Palace's terrace, watching beautiful women in *ao dai*s glide by, they wouldn't have been able to speak one another's mother tongue. But in the field, in the mud and blood and monsoon, they found a common language through the lens.

Some stayed on for the glory, the money, the thrill. Others returned, again and again, because it was the place to be. North Vietnamese and Viet Cong shooters didn't have a choice: Their orders said stay until victory or death. All lived for the next picture; it could be the best one of all.

"Got another *Time* cover; I think that's the eighth picture I've had in *Time* and *Newsweek* since July," the American Dana Stone said into a tape recorder in 1967. "That's a lot; that's more than I could've gotten anywhere else in the world, so I guess it pays off."

"If you hear that I'm coming back soon, forget it," Oliver "Ollie" Noonan wrote home to America shortly after his arrival in Saigon. "I like this place. It's really great over here for a newspaperman." Like those who'd arrived before him and those who would come after his death in a helicopter crash in 1969, Noonan relished the camaraderie and the competition.

Rookie photographers, like second lieutenants, had a life expectancy of fifteen minutes. Some survived just long enough for colleagues to learn their names. Others were not who they seemed. After the Englishman James Gill was killed in Vietnam in 1972, friends went to his apartment to pack up his posses-

sions and discovered that he was a deserter from the British marines named James Cattell.

Some photographers carried guns, others smoked opium, many drank. Some spent all their money when they got it; a few got rich off spoils. Some won every major award in photojournalism; some barely sold a single photo. To live in a war zone is to live on top of the world; friendships are closer, love deeper, fear stronger. Vietnam was not a cautionary tale. All that mattered was the work and staying alive to get it out.

Some survived only weeks. Those who lived long enough became legends. Old Vietnam hands were pied pipers to newcomers. Cults sprang up around them. "Stick close to him," one youngster would whisper to another, pointing to François Sully or Larry Burrows or Henri Huet. "He's lucky. He'll keep you alive." Everybody knew it was nonsense, but . . .

Longevity in war isn't just luck. Survivors are smart, superstitious, careful. Sometimes that still isn't enough.

Robert Capa epitomized the experienced professional in Vietnam. He was covering his fifth war when he set out with French troops in 1954 to photograph a story in the Red River Delta near Hanoi. He spent the day in late May photographing rice paddies surrounded by tanks. Routine. There was a false step. Only the legend remains.

Everette Dixie Reese, a Texan working as a freelancer and for the U.S. Information Agency, covered Dien Bien Phu and the cease-fire following France's defeat. He captured rare images of peace between the two Indochina wars. His landscapes reveal rain forests before defoliants, rice fields without B-52 craters, marketplaces free of barbed wire. Some of his favorite shots were of Cambodia's Elephant Brigade and the Laotian royal family. A civilian pilot was flying Reese above Saigon for aerials of an attempted coup when their tiny L-5 Stinson was shot down on April 29, 1955.

Civilian cameramen, soundmen, correspondents for radio, television, and newspapers, special writers for magazines, even newsreel cameramen with the French in the first Indochina war—members of every journalistic medium lost their lives from 1945 to 1975. Death was not discriminatory or selective.

Cameraman Terry Khoo and his replacement, Sam Kai Faye, decided on the spur of the moment to leave Hue on the morning of July 20, 1972. Engaged to be married in a week, Khoo was leaving Vietnam the next day, after seven years, to take a plum job in ABC News's Bonn bureau. Faye, a veteran, had just returned to Vietnam for another tour. Both cameramen already were celebrated still photographers; Faye had won the British Commonwealth photo contest twice and Khoo's photos were widely printed in Asia. A sniper shot Faye first. Khoo stayed with him, calling out "I'm OK" to a soundman who escaped. A sniper then killed Khoo. Their bodies weren't recovered for several days. A Vietnamese army cameraman was killed with them in the same open field near Quang Tri, one of dozens of military photographers who perished during the war.

Some photographers were highly educated, even scholars; others came without formal schooling to find an education in life. Kyoichi Sawada was an orphan who discovered photography as a clerk in a camera shop. His UPI bosses in Tokyo wouldn't assign him to Vietnam, so he went there on vacation; his pictures from that trip landed him a permanent staff job in Vietnam, where he won the 1966 Pulitzer Prize for news photography. A cautious man who always wore a helmet, he reluctantly agreed in 1970 to introduce an eager new UPI bureau chief to Cambodia's Route 2. Twenty-six miles out of Phnom Penh both were shot to death in their rented blue Datsun.

That year twenty-four Western journalists died or disappeared in Cambodia.

Because they spoke the language, knew the terrain, had the contacts, and worked cheap, Vietnamese photographers were the backbone of coverage for the Western news organizations. Huynh Thanh My set the standard for the rest of his countrymen, including his younger brother. After Thanh My was killed in 1965, his brother Huynh Cong Ut hung around the AP office begging to be taught how to take pictures. Eventually the kid, dubbed Nick by the AP staff, was hired full-time by the wire service. In 1972, Nick Ut took the photo of the little girl burned by napalm and running down a road that won the Pulitzer Prize.

In Ho Chi Minh's army, photographers were soldiers first, then journalists. "The photographer was expected to dismantle the camera blindfolded, know how to do makeshift repairs and even make replacement parts, as well as process and print in the field. They carried light arms at most times, used rocket launchers, mortars, and threw grenades and often had to fight their way out of tight spots. They wore uniforms and were often seen with AK-47s slung over their shoulders and a camera around their neck." Two of the seventy-two Communist photographer-correspondents killed in the war were women, Le Thi Nang and Ngoc Huong.

The circle closed. A war that began with the death of the French photographers Raymond Martinoff and Jean Peraud in 1954 ended with the loss of their countryman Michel Laurent on the eve of the end of the war. Between November 24, 1945, and April 30, 1975, 135 combat photographers died in Vietnam, Laos, and Cambodia. They were all loved; they were all unlucky. None lived to grow old.

It is for their photographs, not their dying, that the world remembers them.

Published Harrisburg, Pa., 1961.

Published Philadelphia, Pa., 1966.

In the mid-1960s, Bernard Fall, the French-born scholar, was a man of great prestige because he was then virtually the only historian writing in English—and writing with knowledge, insight, and personal experience—of the French Indochina War. He was also an accomplished photojournalist who brought his gifts to the reporting of the new American war. In 1965, during one of his many trips to Vietnam, Bernie was using the New York Times *office as a kind of Saigon headquarters. I took a call for him from one of the public affairs officers at General Westmoreland's command. Since Bernie had been in the country a couple of weeks, the officer said, General Westmoreland was wondering why he had not requested an interview. I relayed the message. "Tell him I'm spending my time in the field trying to find out what's really going on," Bernie replied. "I'll call for an interview just before I leave if there's still time to spare."*

This incident was typical of Fall's cockiness and his determination to report on the war from the cutting edge. It explains why his writing was so authentic. It also explains why he was killed two years later, once again taking risks to find the truth. He left us seven books and a trove of magazine and newspaper articles. His best books on the French tragedy—the popular Street Without Joy *and his masterly history of the Battle of Dien Bien Phu,* Hell in a Very Small Place—*still speak with eloquence. Had he lived, there is little doubt that he would have written equally fine books on the American war.*

Neil Sheehan

HENRI HUET
Bernard B. Fall, Vietnam, 1967.
(AP)

THE LAST TAPE

Bernard B. Fall (1926–1967)

Bernard B. Fall was reporting the war as he saw it at the time of his death. He was on the "Street Without Joy," a stretch of coastal road between Hue and Quang Tri, with a group of U.S. Marines. The following transcription is an extract from a tape recording made on February 21, 1967.

[Sound of gunfire and of the plane, a lot of gunfire, much excitement, shouting of instructions, etc.]

BERNARD FALL: *There's our machine gun firing. They're running!*

VOICE: *Advance word—they're moving off to the left. Moving off to the left . . . running.*

BERNARD FALL: *There's our mortar.*

VOICE: *What are they shooting at?*

BERNARD FALL: *What do you mean—they're shooting at the buffalo boys. Oh, for Christ's sake! Those Vietnamese. Oh, my God. [A lot of gunfire here.] There they go. They're shooting at some buffalos apparently. [Gunfire.] How does he know?*

VOICE: *See that guy right in the center? You can hardly see—move across—got on a white jacket—see that hat? Set up about eleven hundred meters. Open up with a burst of ten.*

BERNARD FALL: *It's impossible at eleven hundred meters to distinguish. [Gunfire].*

VOICE: *Very good.*

BERNARD FALL: *There's no return fire whatever, but the Chieu Hois who are with us—they are former Viet Cong returned to the government side and are fighting now with the government forces—well, they assured us that Charlie Company is moving right through the area, and by tonight we will know whether what we killed were genuine VC with weapons or simple people. I personally looked through the binoculars of the platoon leader from the machine-gun platoon and I saw people fleeing to the boats and waving the Vietnamese government flag with three red stripes on a yellow background. Find out more about this later. This is Bernard Fall on the Street Without Joy. [Silence.] . . .*

First in the afternoon about four-thirty—shadows are lengthening and we have reached one of our phase lines after the firefight and it smells bad—meaning it's a little bit suspicious. Could be an amb—[The tape ends here.]

From Last Reflections on a War: Bernard B. Fall's Last Comments on Vietnam, *1967.*

SAM CASTAN
1935–1966
LOOK SENIOR EDITOR

SAM CASTAN
(1935-1966)

John Laurence

Sam Castan died fighting. He was a civilian journalist who became a warrior in the last minutes of his life, leading a small desperate group of American soldiers out of a trap, saving their lives, losing his own. He joined the story he came to cover, and the story ennobled him.

He was thirty-one years old—a thoughtful, introspective, personable man with a round happy face, a native New Yorker who became a student of Southeast Asia. He had been visiting Vietnam for three years and writing stories about it for *Look* magazine, stories that suggested how he hated the war, the way it corrupted everything it touched. This time he went to An Khe to interview and photograph U.S. soldiers in combat. He wanted to find out how U.S. troops were holding up psychologically and to compare military operations of the U.S. and South Vietnamese

armies. The story was to be called "Are We Fighting Alone?" But he was having trouble finding combat. Lately, it seemed, every time he got near a battle, the fighting stopped. He joked about it, called himself "the luckiest guy in Vietnam."

Originally Castan went to Vietnam to cover the war, to make a name in his profession, and to test himself under the pressure of combat. He excelled at all three. This would be the ultimate test. An American platoon was being overrun, and he was caught in the center of it. He had a choice: to stay in a shallow hole on a red dirt ridge surrounded by North Vietnamese troops and die, or try to lead an escape.

There were no easy choices in Vietnam. Every reporter and photographer who worked in the field worried about this one: What do you do when faced with the likely prospect of death? Pray for a miracle? Fight back? Try to surrender? Die passively?

Officially civilian journalists were noncombatants and were supposed to be unarmed. Unofficially some carried weapons, usually pistols. The majority did not. It was a practical as well as a moral

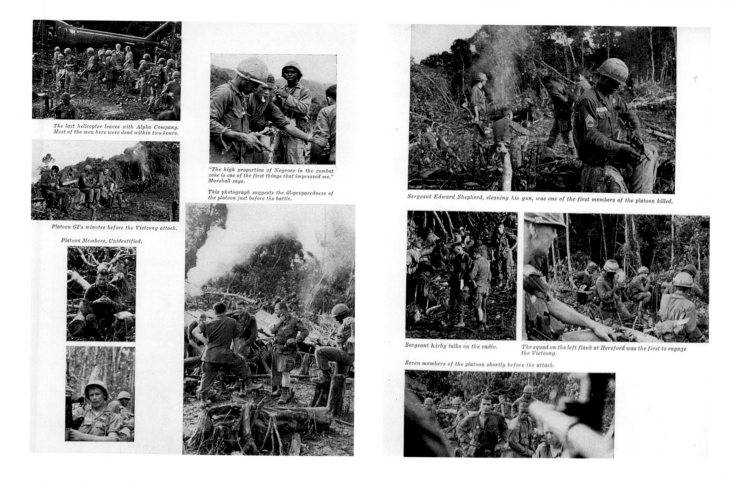

These photographs of U.S. soldiers were taken by Sam Castan minutes before the attack that killed eighteen of them. His film was recovered from the body of a North Vietnamese soldier also killed in action. The pictures were published later by Harper's Magazine.

issue. You couldn't fire a weapon and cover the story at the same time. But in the fiercest combat, journalists sometimes took up arms and fought beside the soldiers they were covering. Some found the excitement of close battle the most intense experience of their lives—nothing was so exhilarating, so life-enhancing, as surviving it.

On May 21, 1966, Sam Castan was trapped with twenty-two soldiers of the First Cavalry Division on a mountain ridge in the Vinh Thanh Valley near An Khe. The Americans were outnumbered ten to one, encircled, pinned to the ground by a fusillade of incoming fire. Machine guns, mortar shells, rockets, and rifle bullets had killed or wounded almost every man in the platoon. Castan was wounded twice. North Vietnamese soldiers were inside the perimeter and shooting the wounded. At that point Castan crawled out of his hole, ran to the acting platoon sergeant, and shouted, "When are we going to get the

hell out of here?" The sergeant decided to move. Castan asked for a weapon and was given a pistol.

Moments later Castan, the sergeant, and four other soldiers broke out of the doomed circle and ran down the ridgeline into the high jungle, the reporter leading the way, firing his pistol at North Vietnamese troops who faced him. The North Vietnamese counterattacked, and in the most furious close-quarters combat, Castan was shot in the head and killed. In his final moments he was steady, unselfish, shouting to the others that he was hit, warning them away. Then he was silent.

A few minutes later reinforcements arrived, and the North Vietnamese withdrew. In thirty minutes of fighting the American platoon had lost eighteen men. Four of the original twenty-two soldiers on the ridge survived, at least two of them due to the inspired action of the courageous journalist from *Look*.

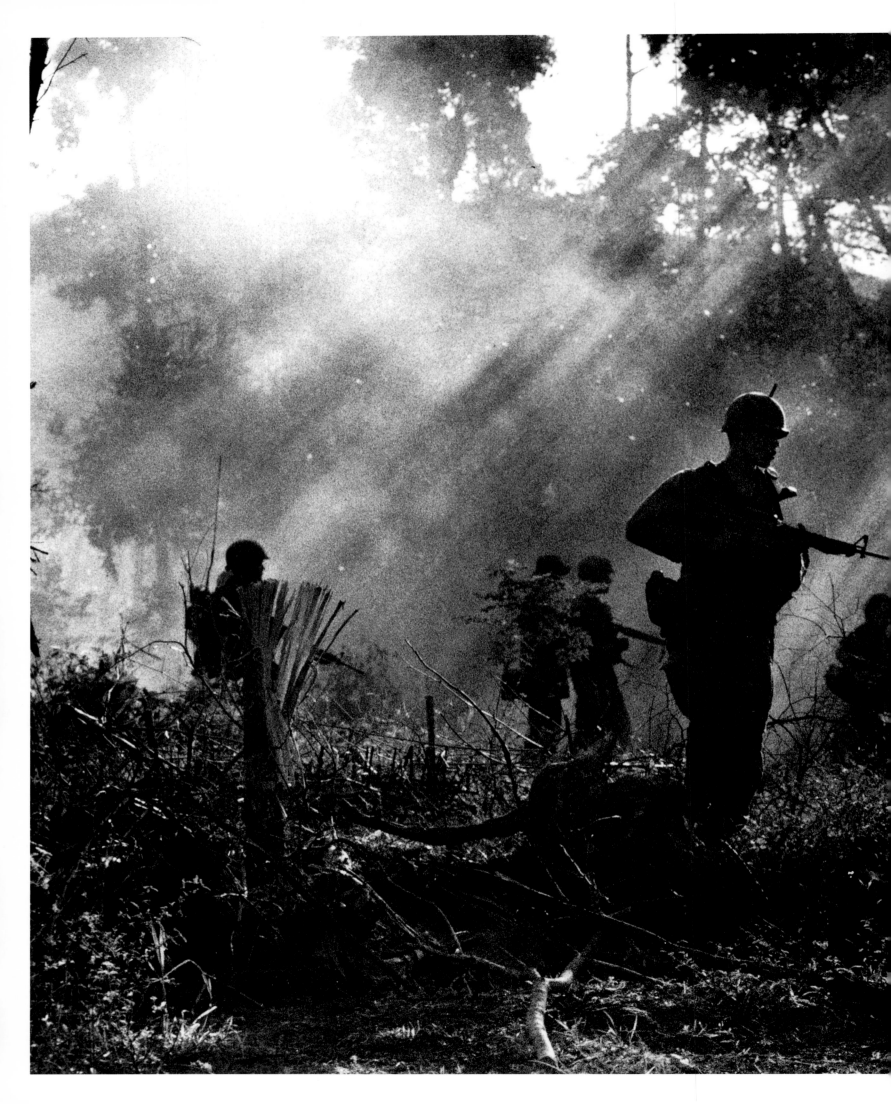

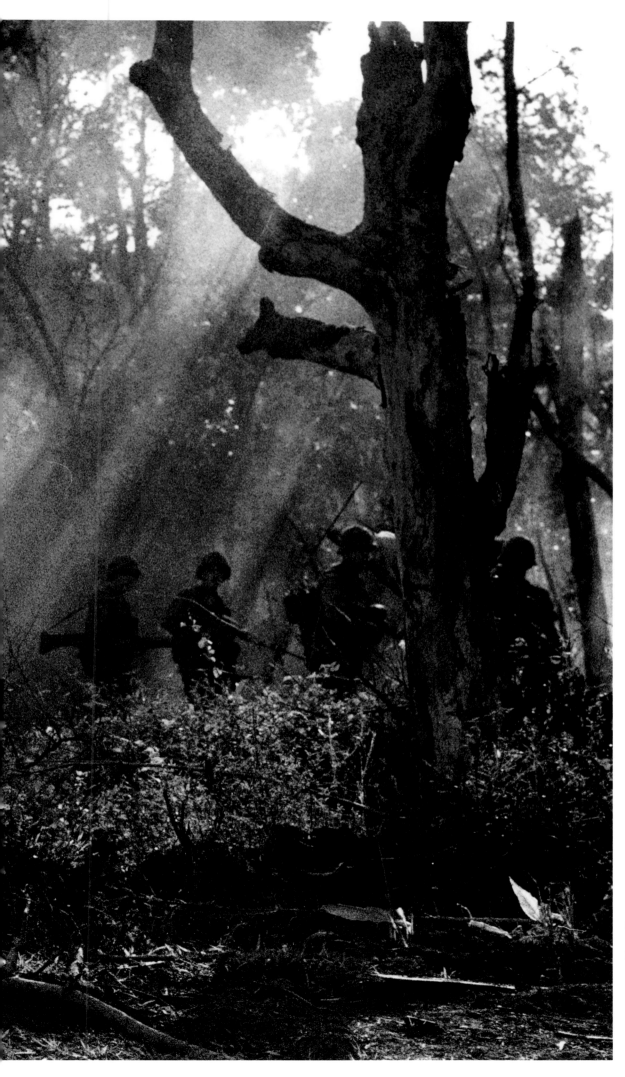

GILLES CARON
A Shau Valley, Vietnam, 1967.
*Troops of the 173rd Airborne Brigade
on Hill 875, where the jungle concealed
enemy bunkers. In five days of pitched
fighting, many Americans never saw an
enemy soldier.*
(Gamma)

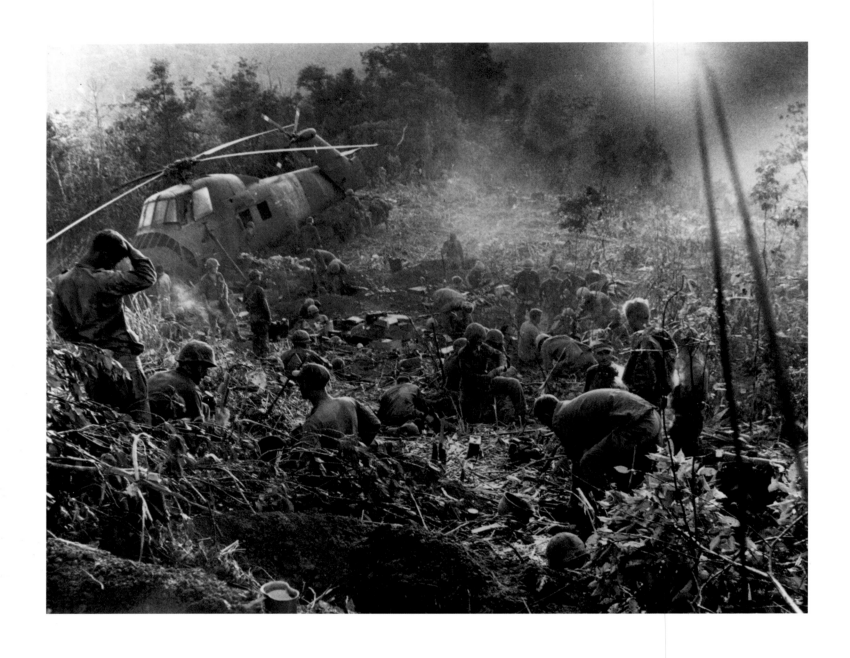

HENRI HUET
South of the DMZ, Vietnam, 1966.
*Weary after a third night of fighting against
North Vietnamese troops, U.S. Marines crawl from
foxholes. The helicopter, at left, was shot down when
it came in to resupply the unit.*
(AP)

DANA STONE
A Shau Valley, Vietnam, 1968.
*Soldiers of the U.S. First Air Cavalry Division board a
Chinook helicopter that will take them from the valley,
where they have been operating for a month against North
Vietnamese troops defending the Ho Chi Minh Trail.*
(AP)

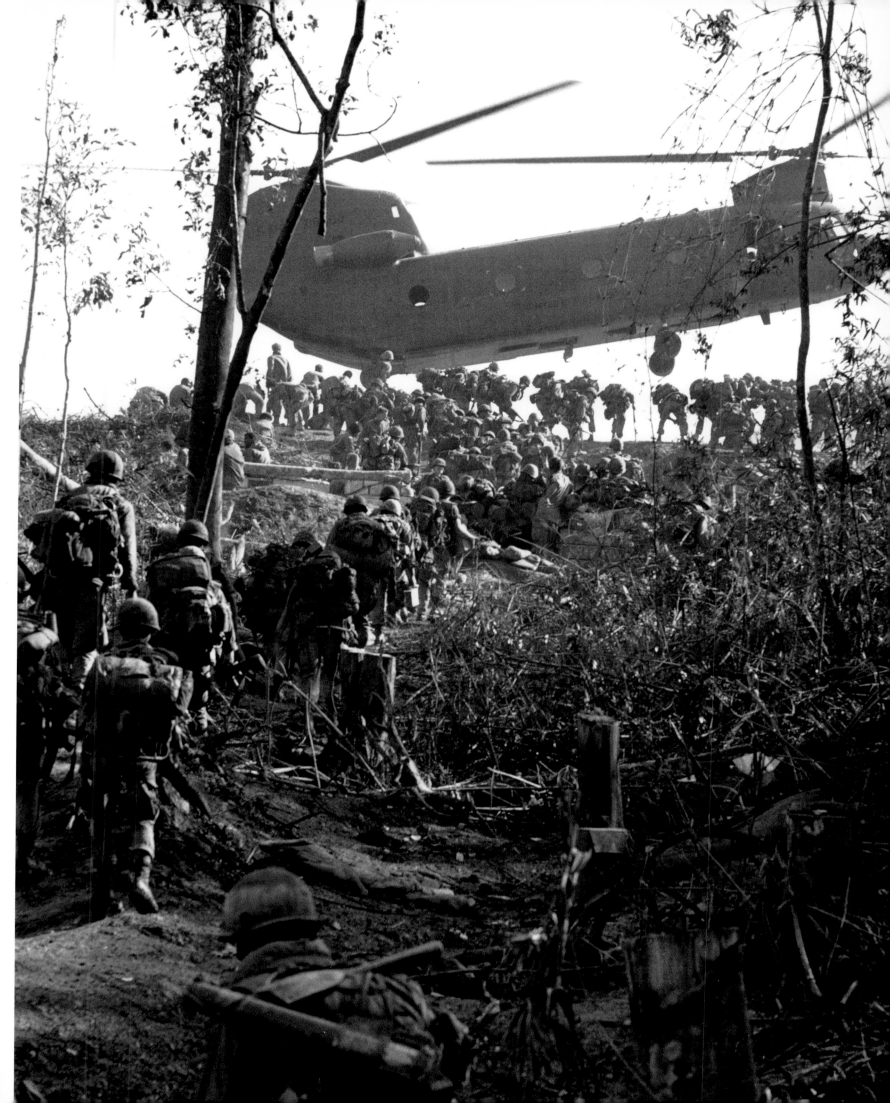

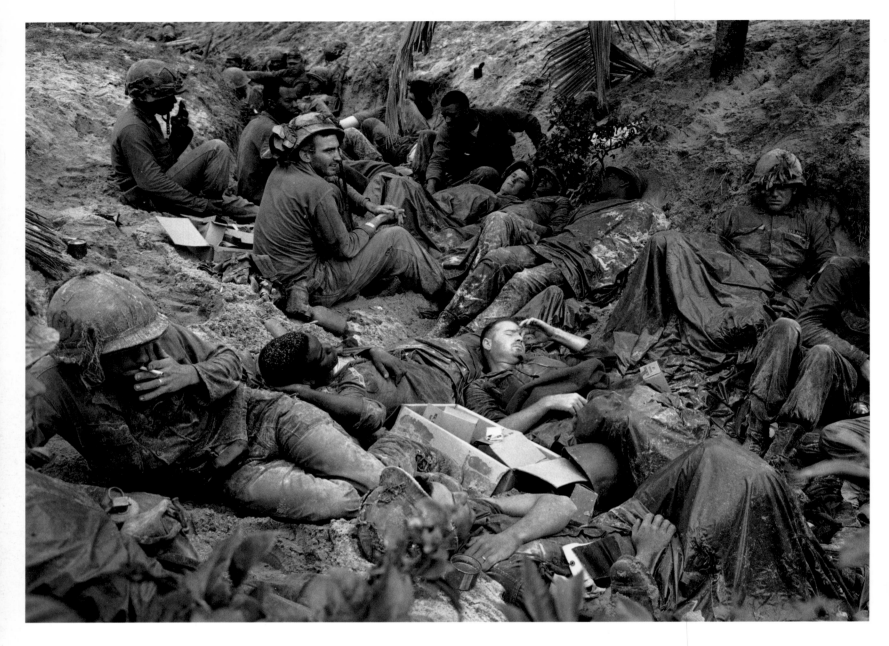

In January 1966, Associated Press correspondent Bob Poos and photographer Henri Huet accompanied the U.S. First Cavalry Division into action on the central coast of South Vietnam. This is an extract from their account.

An Thi, Vietnam, Jan. 30 (AP) A drenching rain fell throughout Friday night and in the predawn hours of Saturday, then slacked off about dawn.

The light of dawn exposed a picture of bloody battle—the dead and wounded in the muddied trench, the empty cartridge clips and ration boxes scattered about, the shell holes.

In the village a rooster crowed, and hens pecked in the mud. A pig rooted through empty C-ration cans.

It was a dawn that did not come peacefully.

From the newswire of The Associated Press, January 30, 1996.

HENRI HUET
An Thi, Vietnam, 1966.
(AP)

HENRI HUET
An Thi, Vietnam, 1966.
(AP)

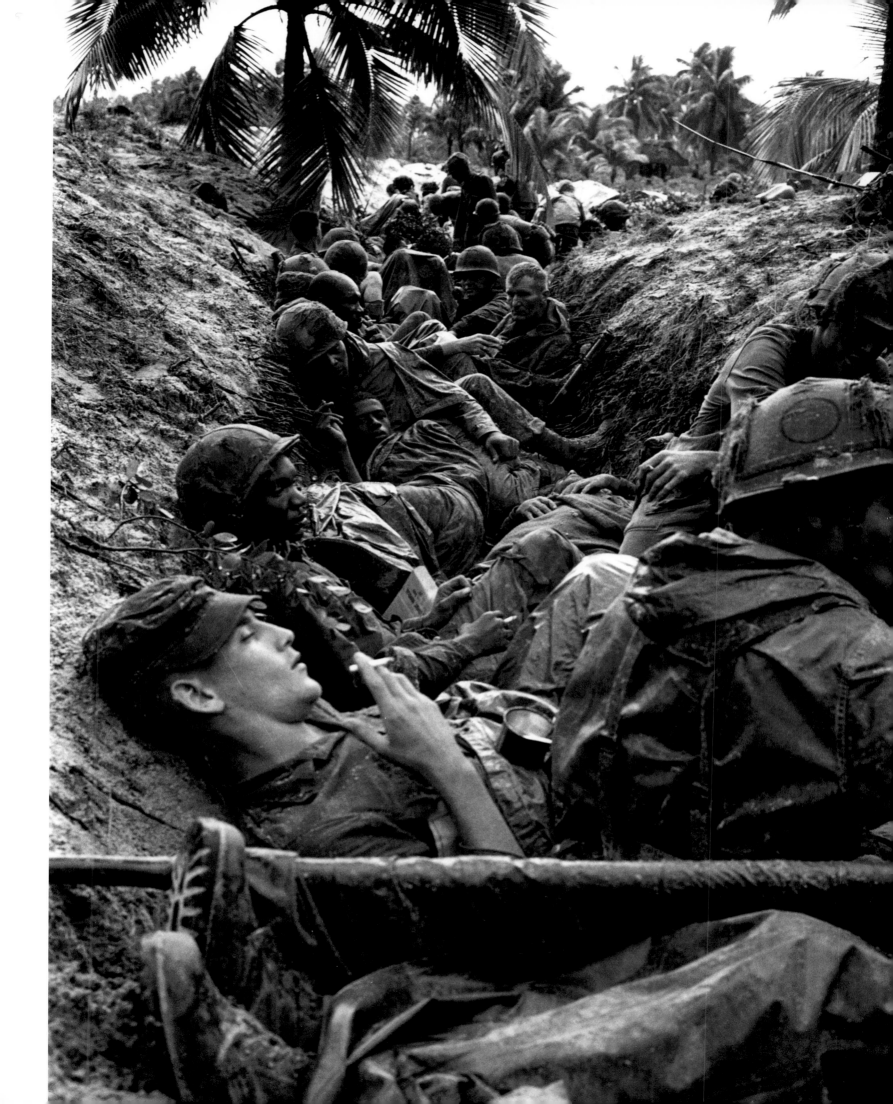

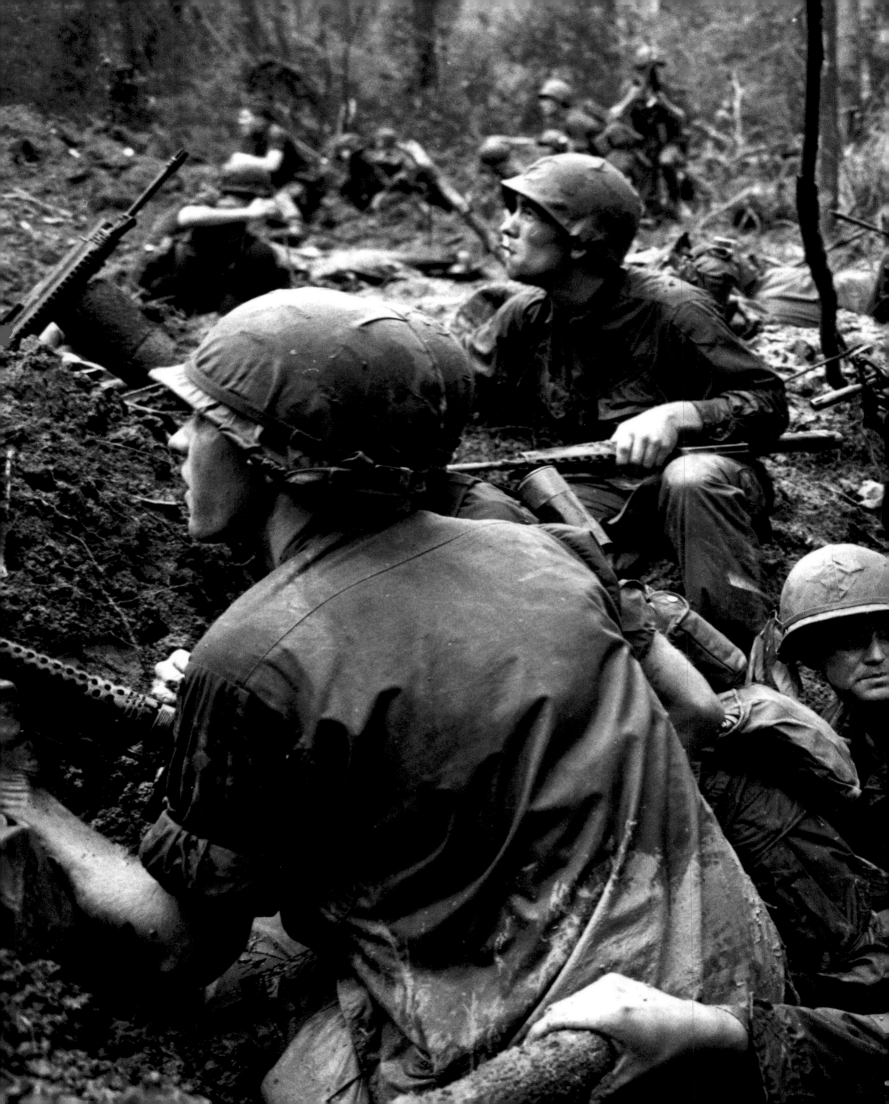

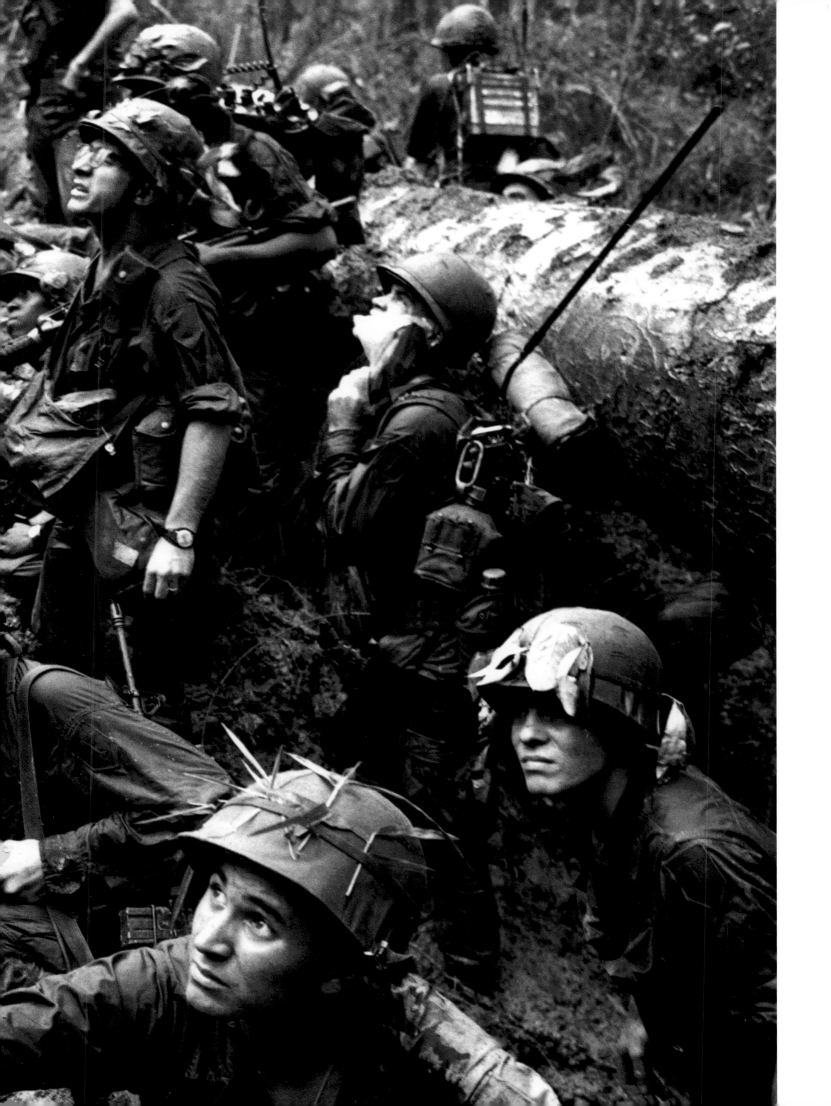

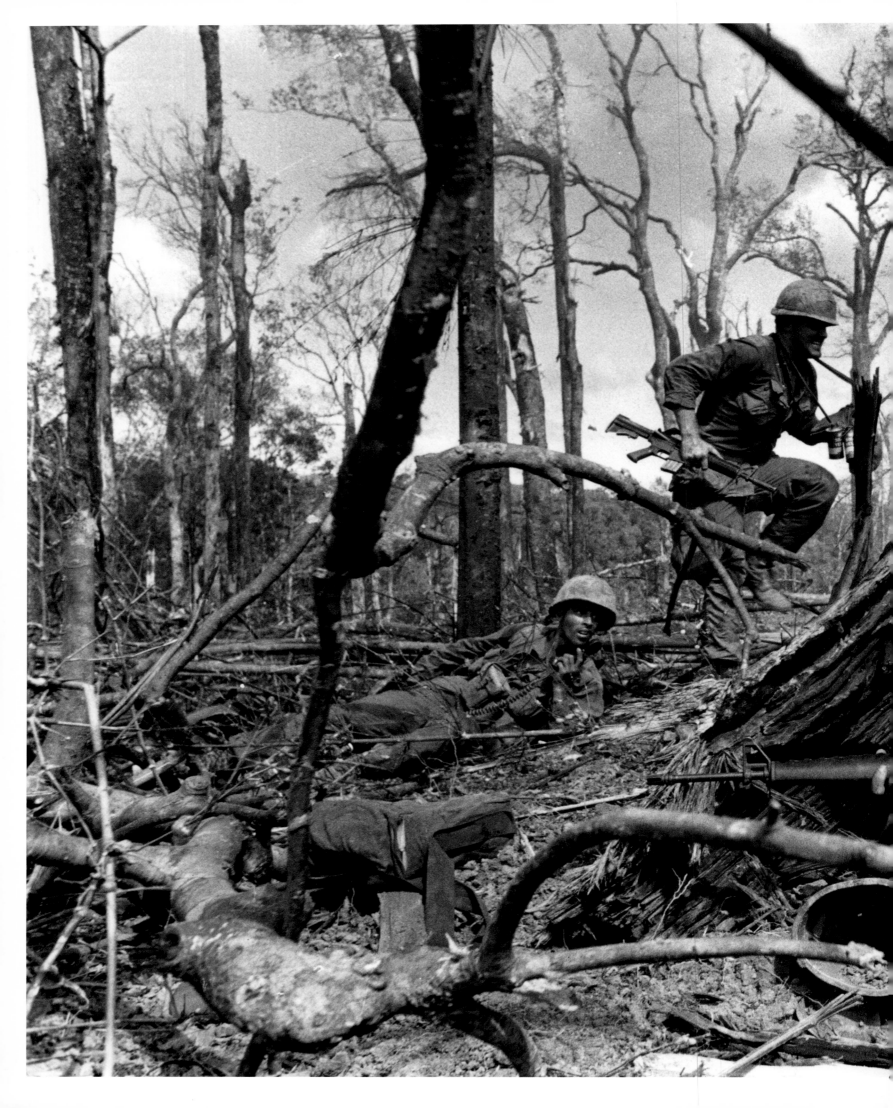

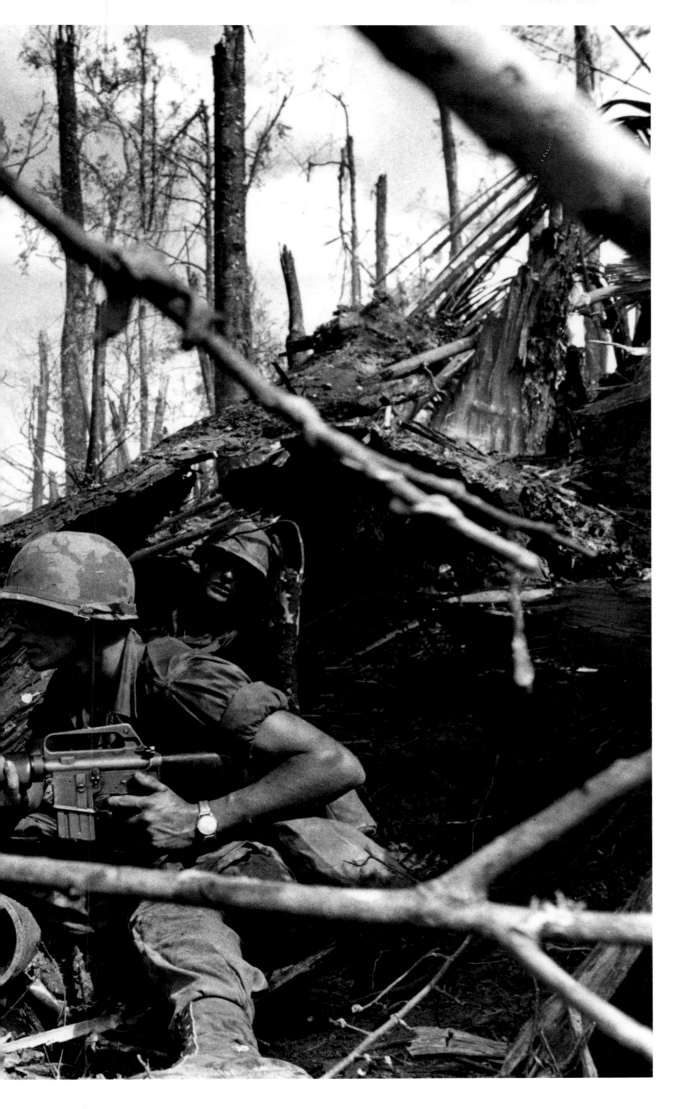

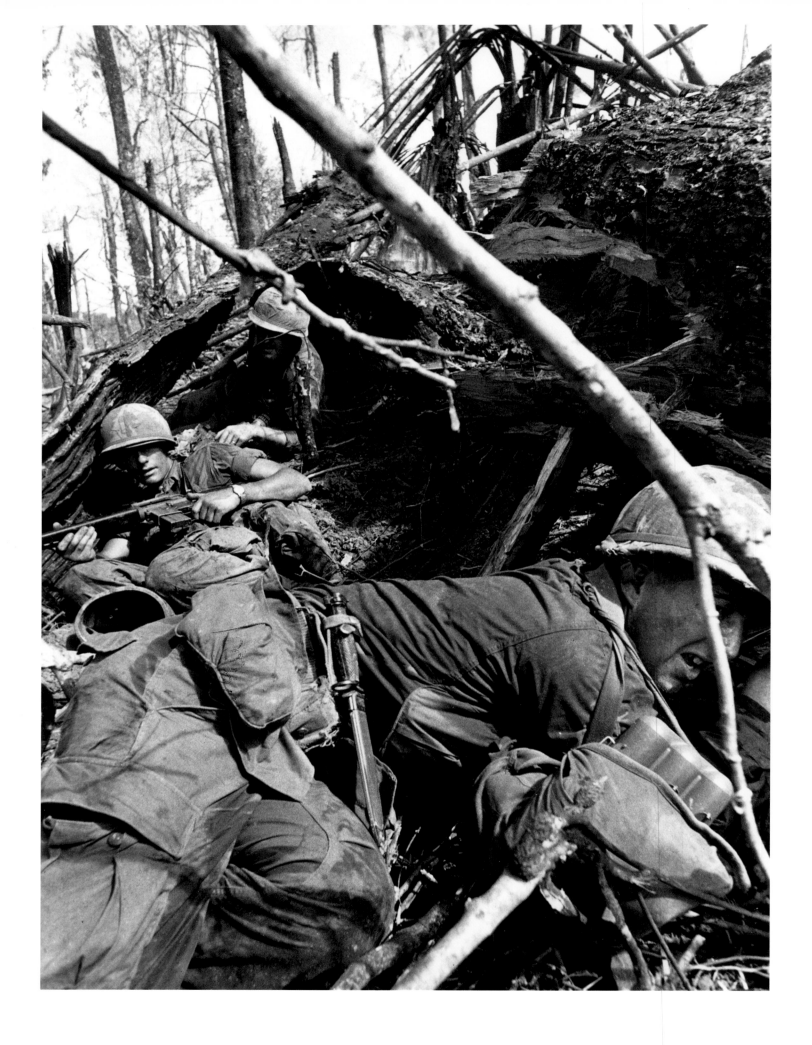

In 1967, a prolonged battle between the largest North Vietnamese force assembled to date and the Americans was fought in the central highlands. U.S. paratroopers attacking dug-in Communist forces suffered some of the heaviest casualties of the war. French photographer Gilles Caron and The Associated Press's correspondent Peter Arnett witnessed some of the fighting on Hill 875. The following day Arnett filed this story for the AP newswire.

War painted the living and the dead the same gray pallor on Hill 875. The only way to tell who was alive and who was dead amongst the exhausted men was to watch when the enemy mortars came crashing in.
The living rushed unashamedly to the tiny bunkers dug into red clay on the hilltop; the wounded squirmed toward the shelter of trees that had been blasted to the ground. Only the dead didn't move, propped up in the bunkers where they had died in direct mortar hits, or facedown in the dust where they had fallen to bullets.

PETER ARNETT, *Hill 875, Dak To, Vietnam, from the newswire of The Associated Press, November 1967.*

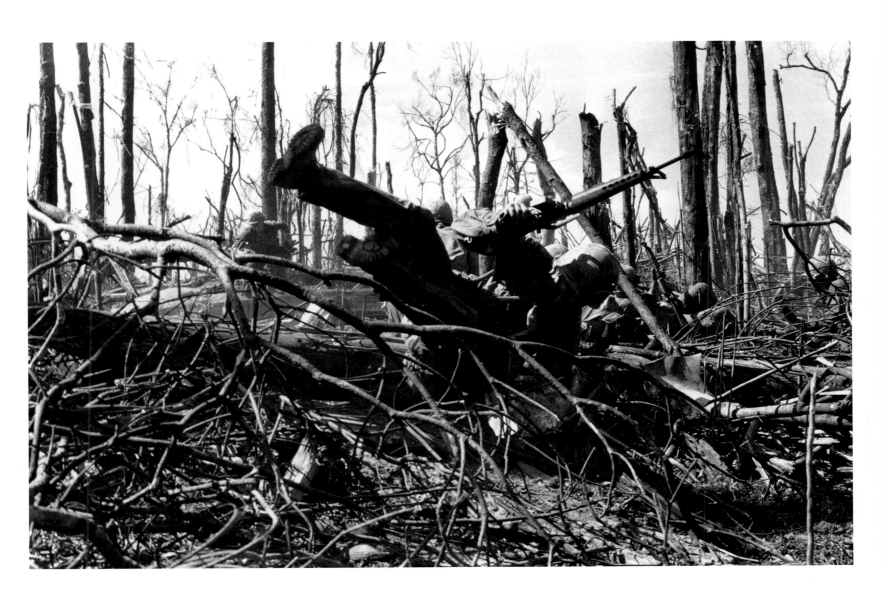

After Charlie Chellappah was killed in February 1966—the third Associated Press photographer to die in Vietnam in less than a year—AP's Saigon photo editor, Horst Faas, was ordered to report the circumstances of Charlie's death to AP's president. Chellappah had been in Vietnam less than three weeks. Here are excerpts of Faas's report.

Here are the last pictures by photographer Charlie Chellappah. He took them while working in the thick of fighting February 14 in an area known by American GIs as Hell's Half Acre. And it was there that he was killed that day.

This last roll of film was released by the authorities today along with his other personal effects. The pictures show, better than any words could, how close Chellappah was to the action up to the moment of his death.

The GIs call it Hell's Half Acre because so much blood has been spilled there. It is about twenty-five miles northwest of Saigon, near Cu Chi, where the U.S. Twenty-fifth Infantry Division has set up operations.

The area is partially a dense jungled rubber plantation, honeycombed with Viet Cong tunnels and superbly camouflaged sniper positions. Infantrymen inched their way as they tried to expand the perimeter of their camp. They battled the thick overgrowth, the insects, battalions of biting red ants, and the crafty guerrillas that sniped at them from concealed positions they had taken years to prepare.

Picture number 24A was his last click of the shutter. It shows a soldier hunched over, holding the face of a seriously wounded comrade. Behind is another wounded American.

They, together with several others, had been blasted by a Viet Cong claymore mine. Apparently it was only minutes later that Chellappah was killed.

A claymore mine exploded into the command group of one company. Chellappah and several others rushed to the fallen men. Moments later the second claymore was detonated, killing several troops and Chellappah.

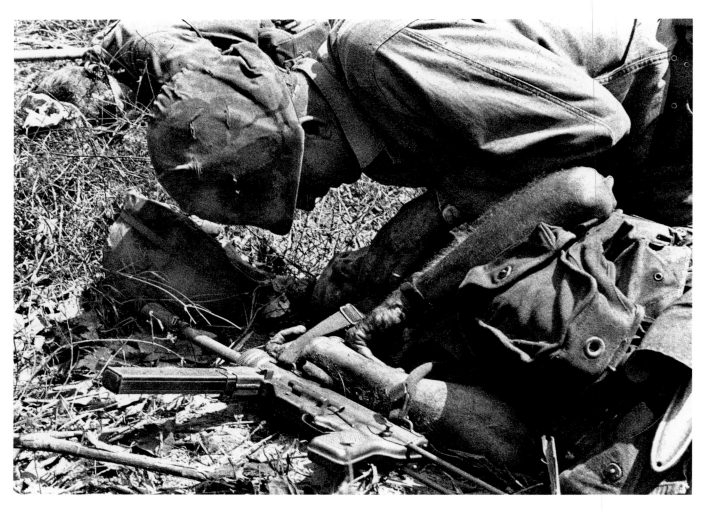

CHARLIE CHELLAPPAH
Cu Chi, Vietnam, 1966.
Last roll of film.
(AP)

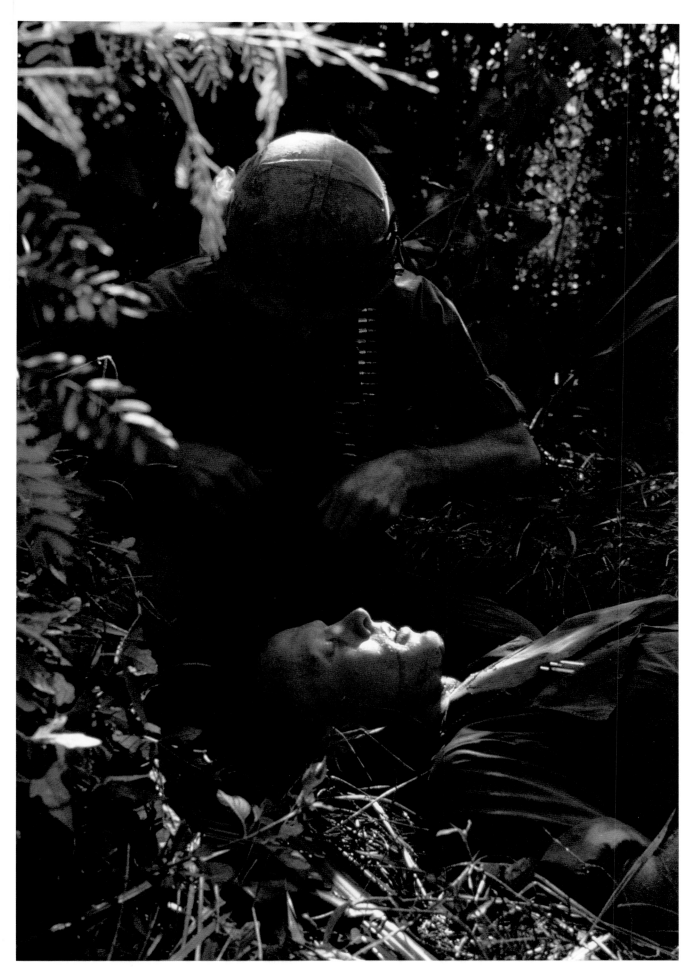

GILLES CARON
A Shau Valley, Vietnam, 1967.
(Gamma)

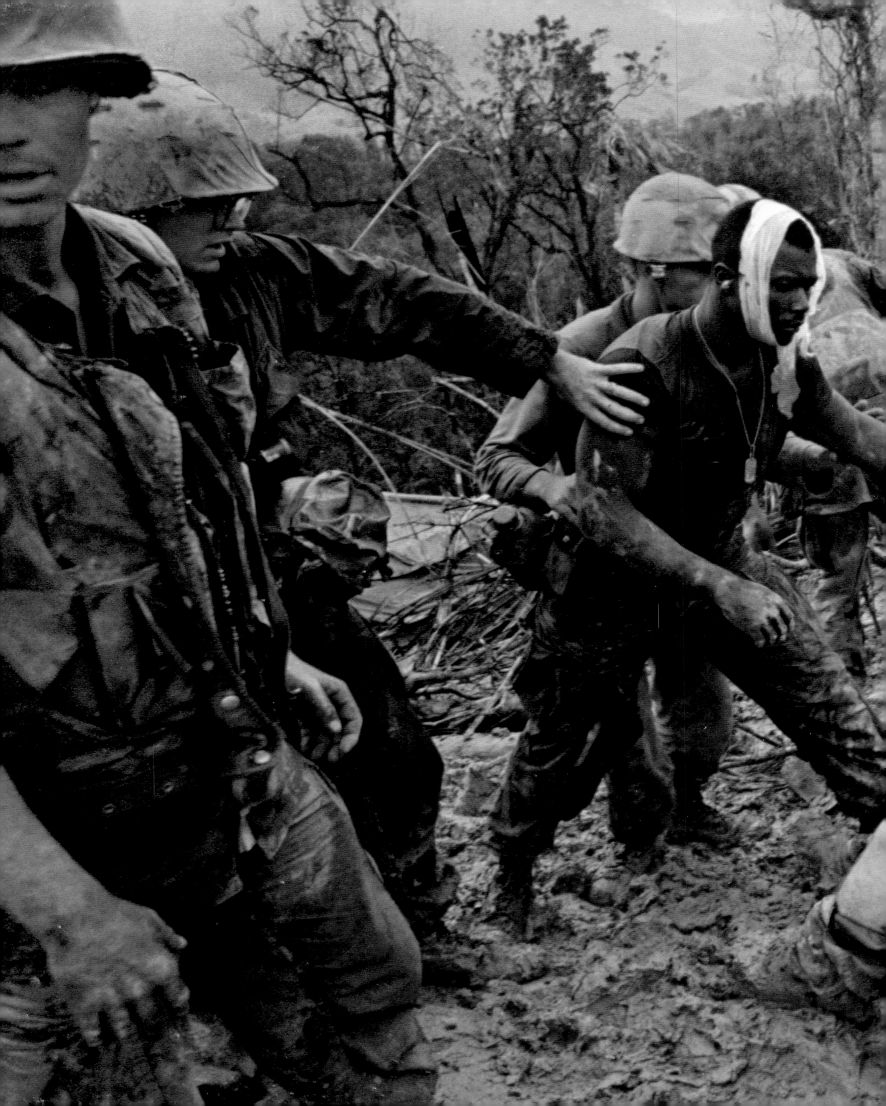

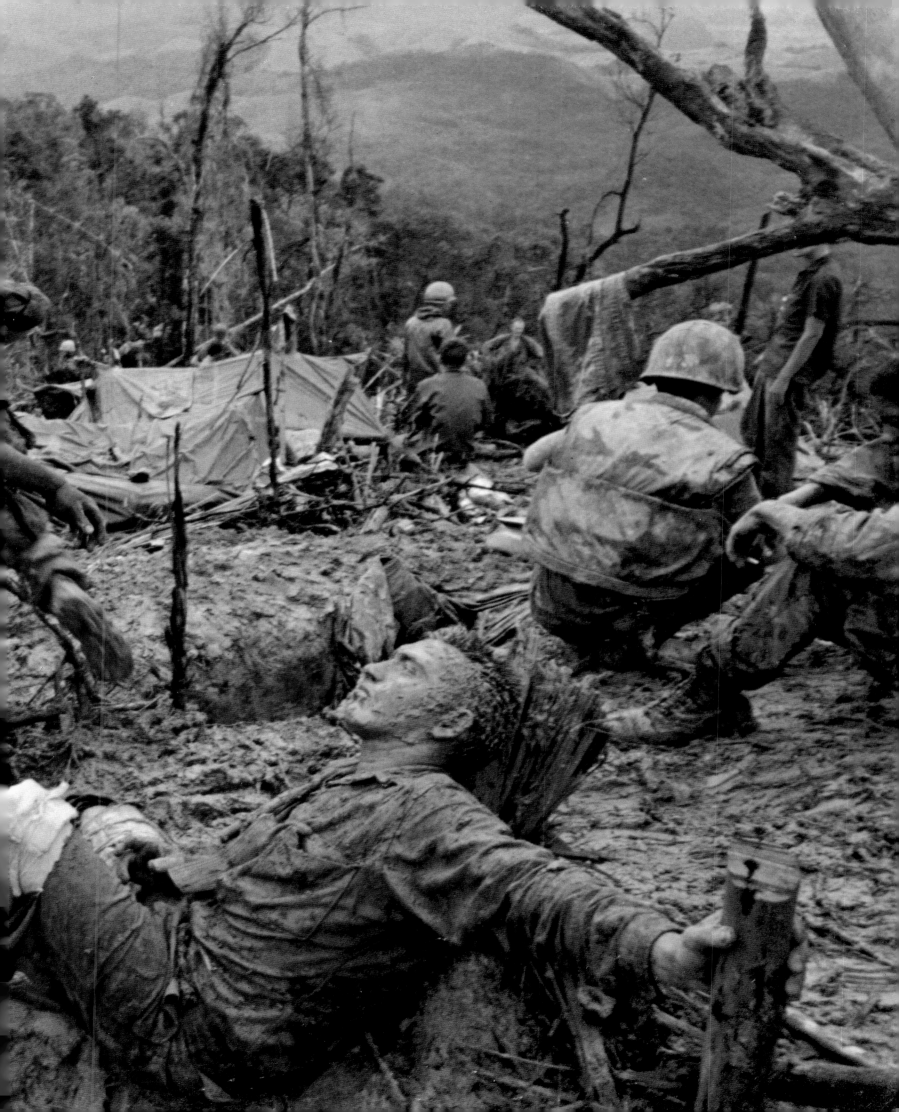

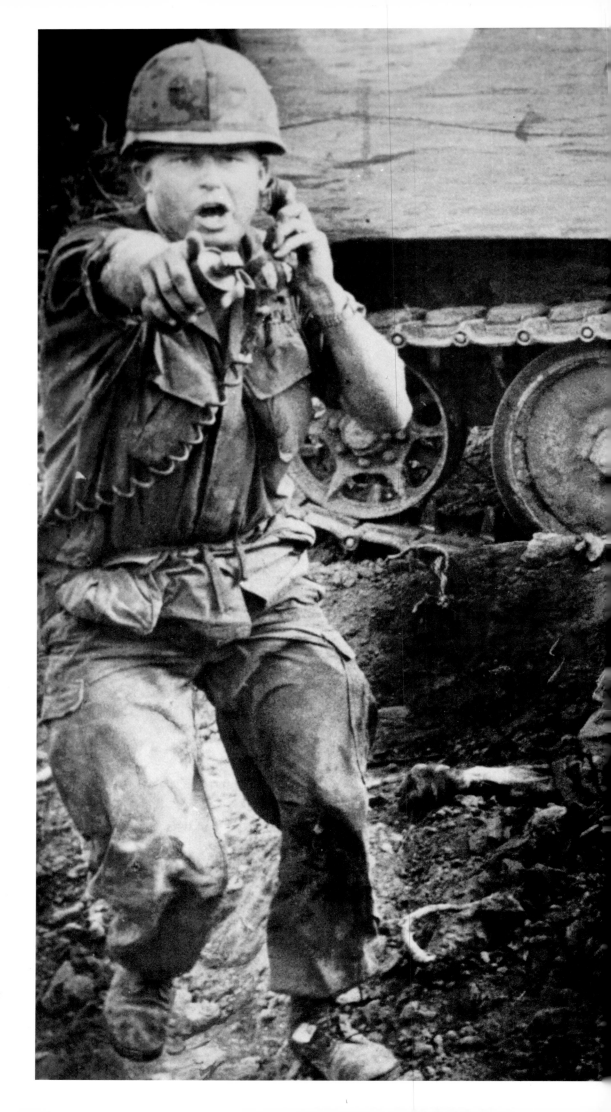

(pages 176 and 177)
LARRY BURROWS
South of the DMZ, Vietnam, 1966.
First-aid center, where wounded Marines
were treated before being helped to
air-evacuation points.
(*Life*)

OLIVER NOONAN
Near Saigon, Vietnam, 1969.
During an ambush by Viet Cong guerrillas, a
wounded soldier awaits evacuation.
(*The Boston Globe*/AP)

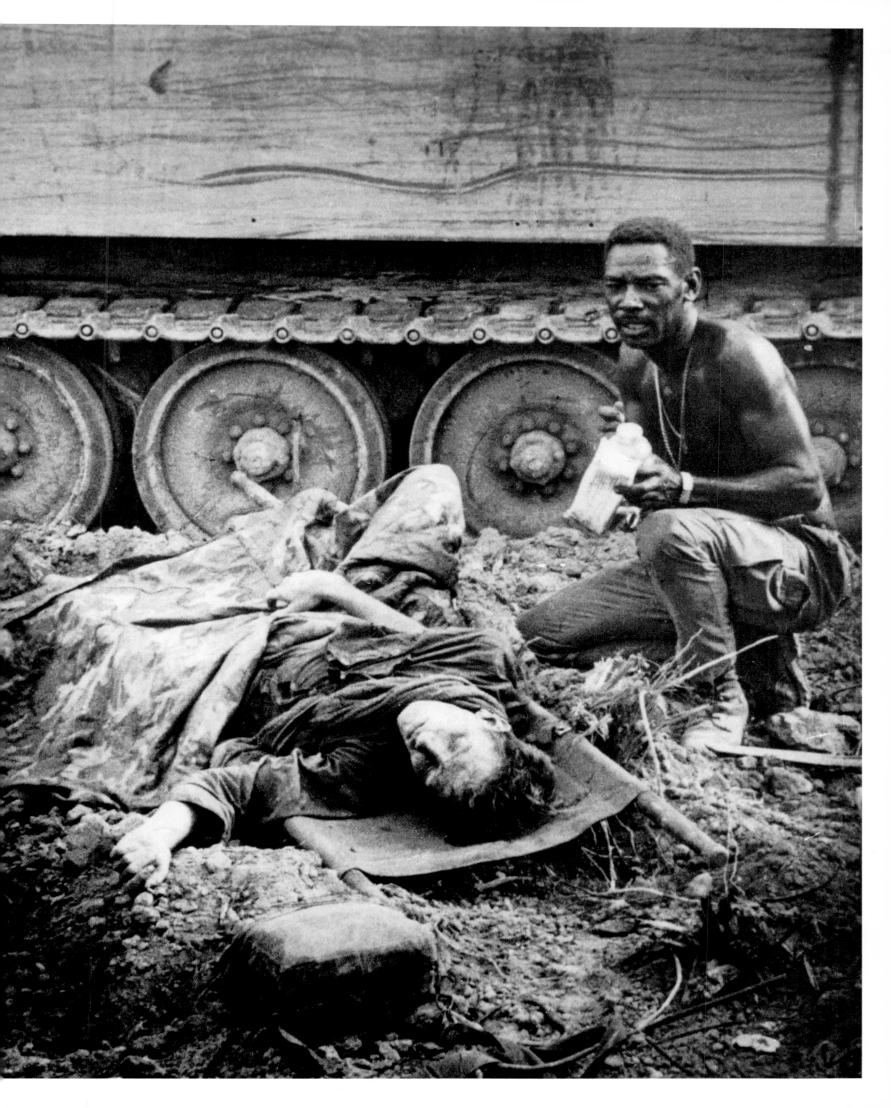

A MEDIC—CALM AND DEDICATED

This picture, at right, by photographer Henri Huet, and those on the following pages appeared in many newspapers around the world and in Life *magazine on February 11, 1966. They have become part of an unforgettable sequence of one man's dedication. This extract is from the accounts of Huet and Associated Press correspondent Bob Poos.*

Although his own wound was so completely bandaged that he could barely peer out of one eye, Private First Class Thomas Cole, a young medic of the First Cavalry Division, spent hours tending fellow soldiers worse off than he. One was Staff Sergeant Harrison Pell, whose bandaged head Cole cradled on his knee as he fed C rations to him, then carefully wiped his face.

After President Johnson had called off his 1965 Christmas peace offensive, the First Cavalry had pushed off on Operation Masher—one prong of the biggest offensive ever mounted in the central highlands, control of which had become the tactical key to the war. Altogether twenty thousand American, South Vietnamese, and South Korean troops were participating in the offensive aimed at trapping an estimated eight thousand North Vietnamese regulars and Viet Cong soldiers in the coastal area about three hundred miles north of Saigon. Henri Huet of The Associated Press was with the first battalion to see action.

Medic Thomas Cole aided many wounded men during his ten months in Vietnam with the U.S. First Cavalry Division.

Cole's luck ran out on June 20, 1966, after he had taken part in every major battle the First Cavalry had been in since he had arrived in Vietnam. He was severely wounded while on an operation near the hamlet of Dong Tre, 255 miles north of Saigon.

"We were approaching the creek bed," Cole said before he was evacuated home, "and fighting broke out. A couple of guys were hit, and one of them, a sergeant, was thrashing around on the ground and screaming for a medic.

"I started running down to help him, and I felt something hit me and spin me around, and the next thing I knew, my face was hitting the gravel."

One bullet had shattered his left arm above the elbow, and another tore a large hunk of flesh from his left thigh.

Cole had extended his enlistment to stay with his buddies in the Second Battalion of the Seventh Cavalry.

"My mother got kind of put out with me for doing it," he said, "but I didn't want to leave the rest of the guys here."

Medic Cole had volunteered to go on this last operation in spite of the fact that he had less than two weeks to serve in Vietnam and could have remained back at the base camp.

From the newswire of The Associated Press, February and June 1966.

HENRI HUET
Vietnam, 1966.
*Wearing a bloody bandage over the left side of his face,
medic Thomas Cole of Richmond, Va., cradles the head
of Staff Sergeant Harrison C. D. Pell from Hazleton, Pa.,
of the First Cavalry Division.*
(AP)

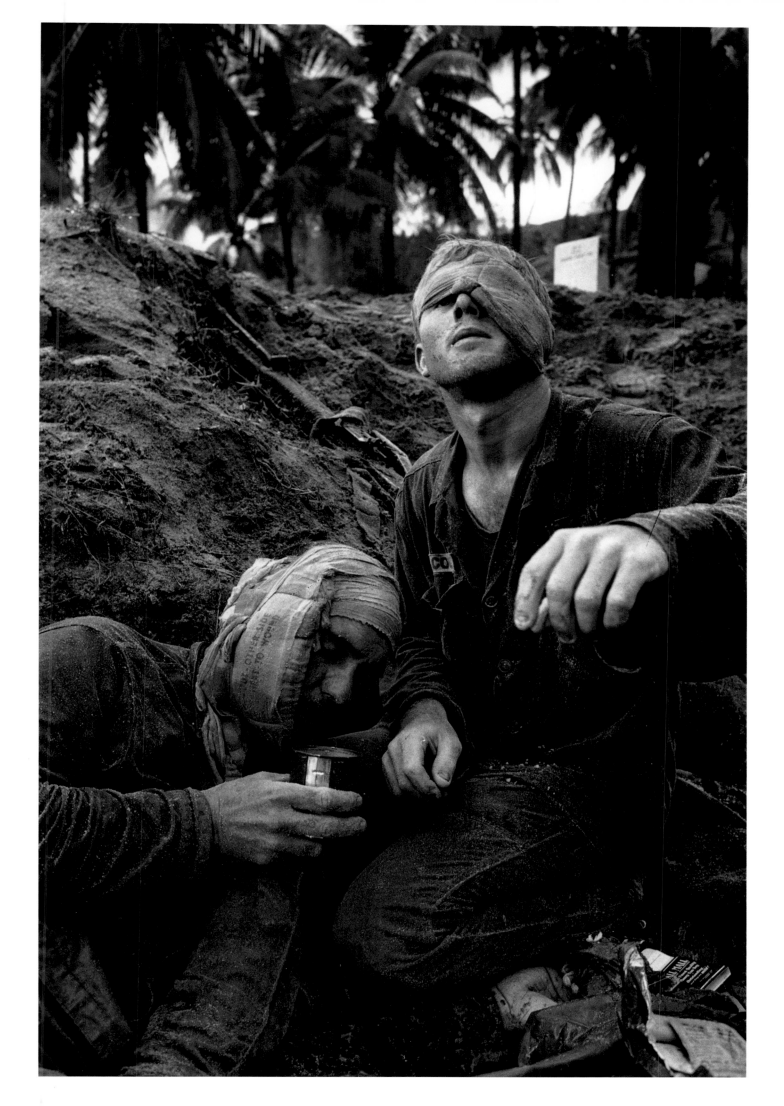

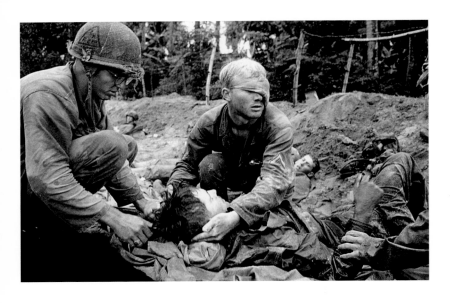

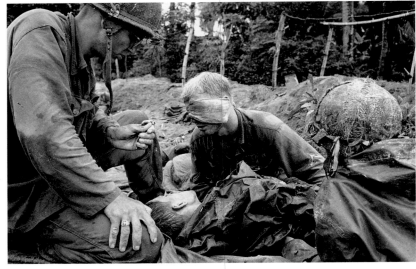

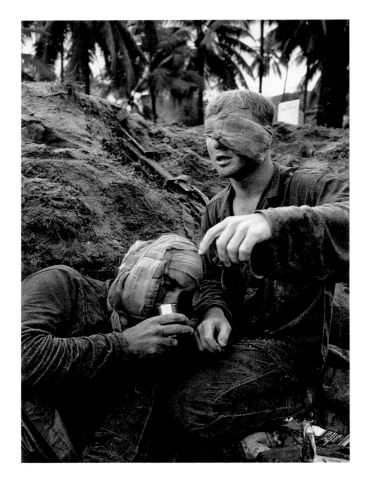

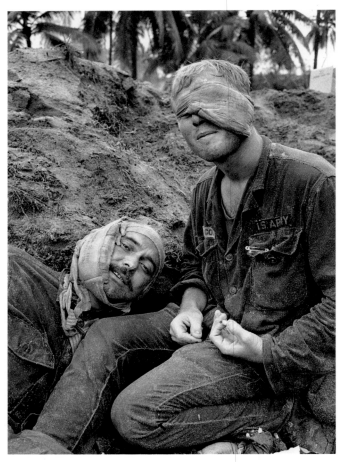

HENRI HUET
Vietnam, 1966.
(AP)

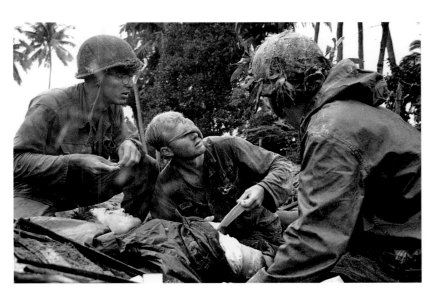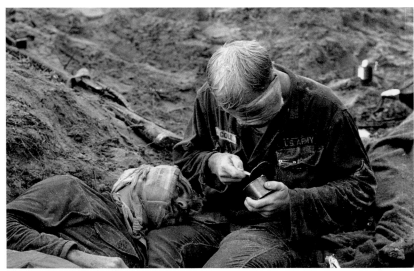

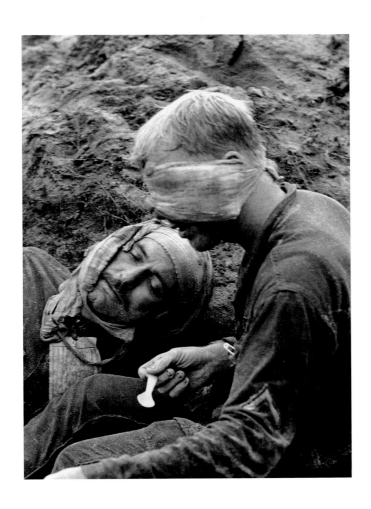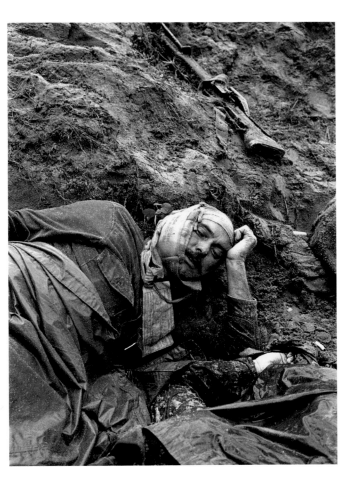

HENRI HUET
Vietnam, 1966.
Sergeant Adolph J. Breecher of Saginaw, Mich.
(AP)

HENRI HUET
South of the DMZ, Vietnam, 1966.
U.S. Marine after a three-day fight. His unit was pinned down on a hilltop for forty-eight hours until reinforcements arrived.
(AP)

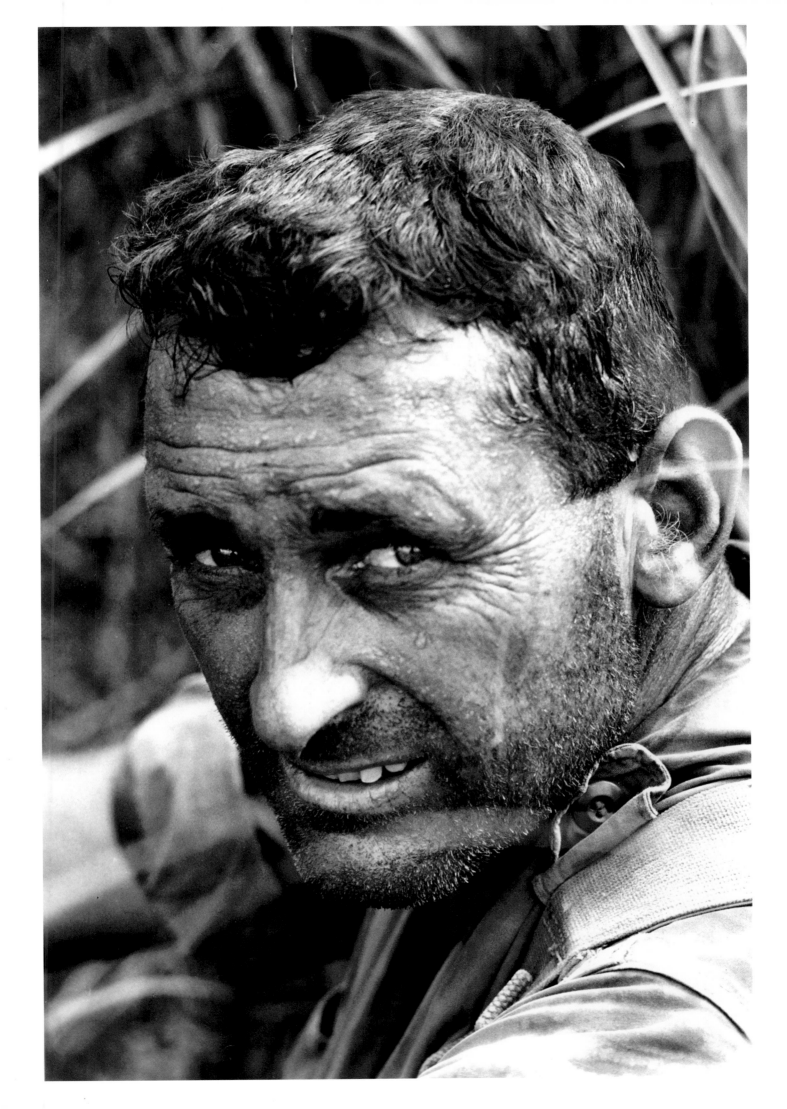

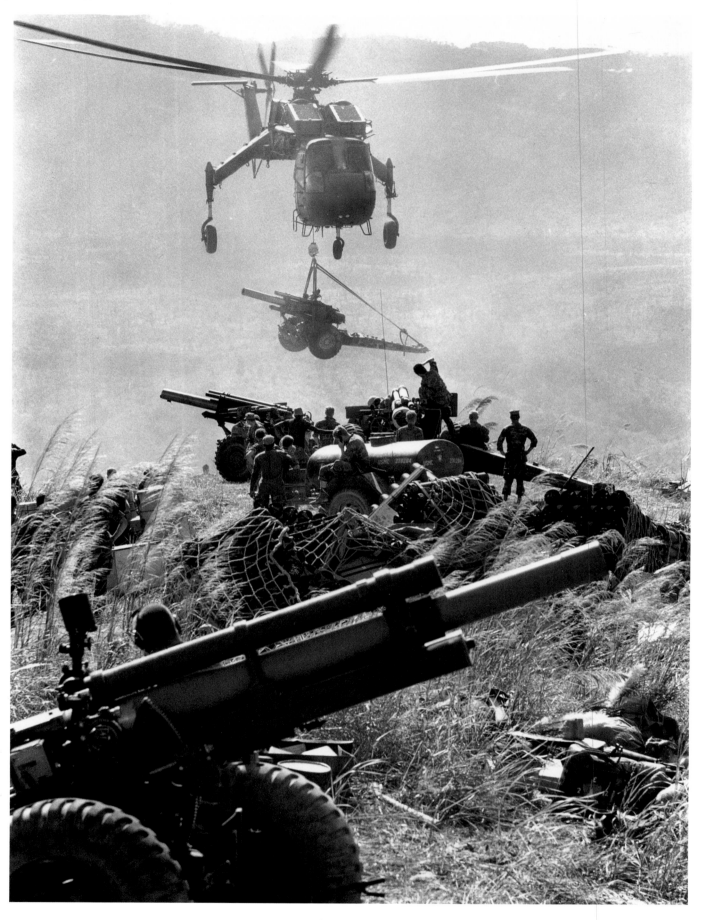

HENRI HUET
Khe Sanh, Vietnam, 1969.
*A helicopter lifts a 155mm howitzer cannon to the top of a
hill during a U.S. Marine–South Vietnamese thrust.*
(AP)

CLAUDE ARPIN-PONT
Kontum, Vietnam, 1967.
*Paratroopers of the 101st Airborne Division carry out a
practice jump in the central highlands. Parachuting became
a rarity; airborne troops were carried by helicopter.*

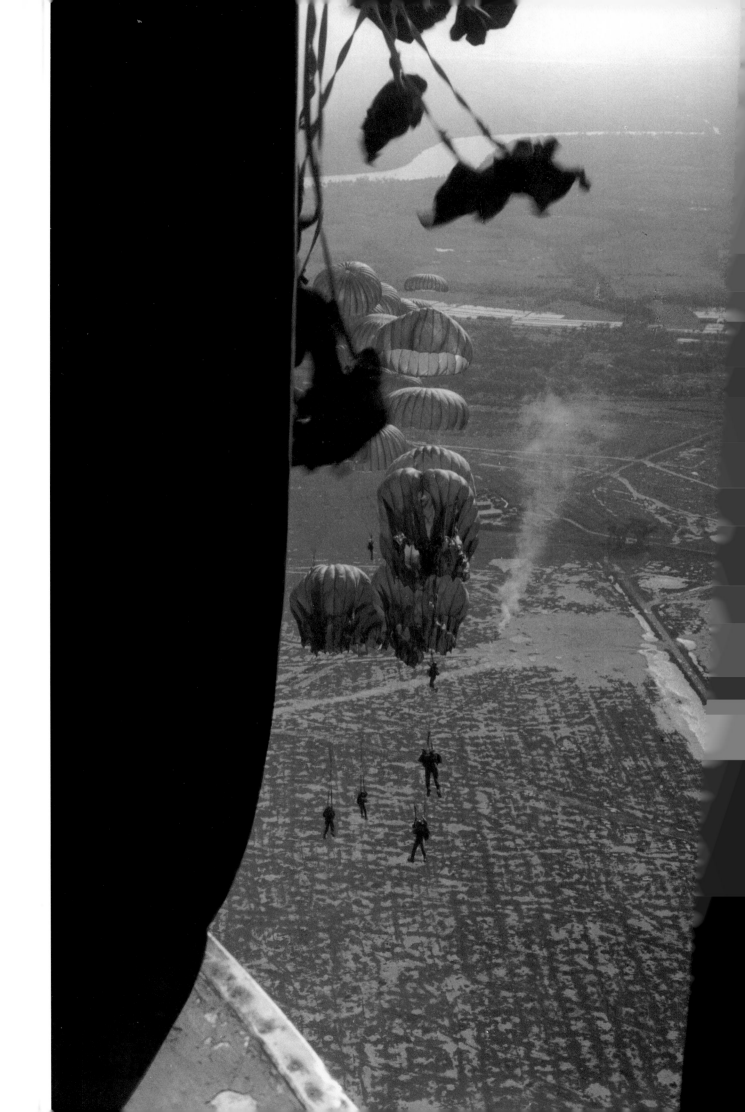

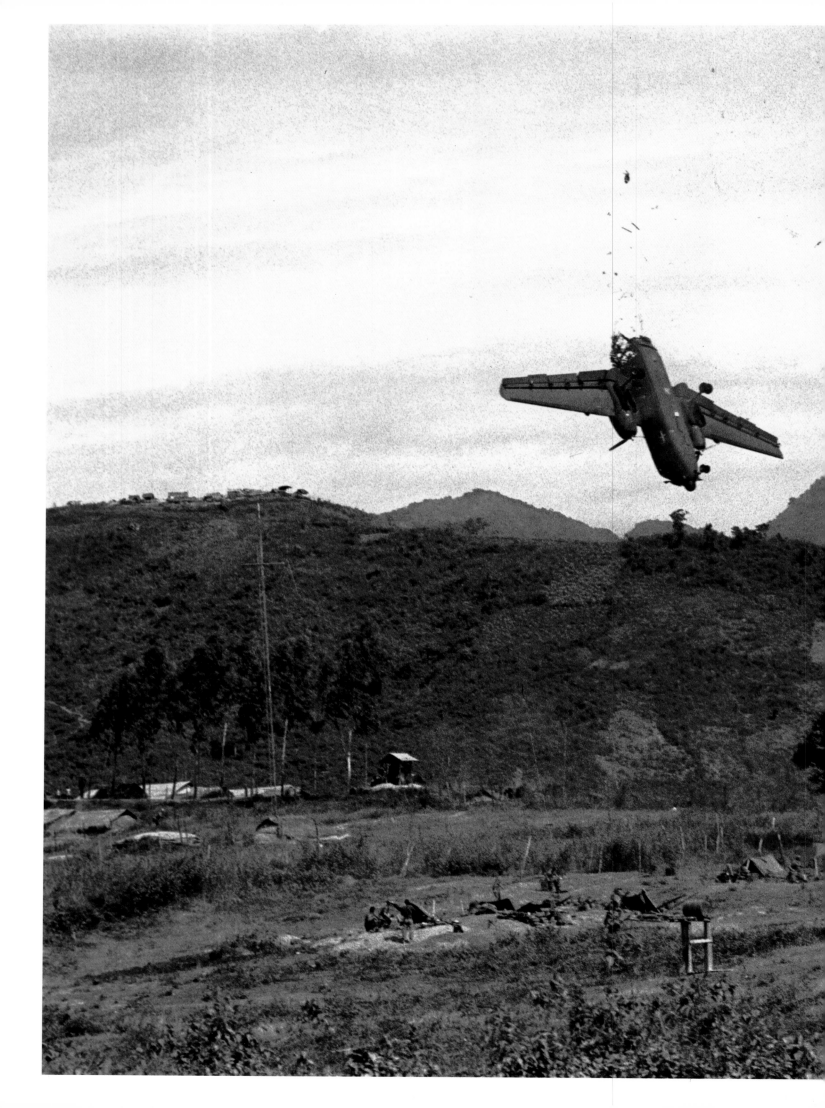

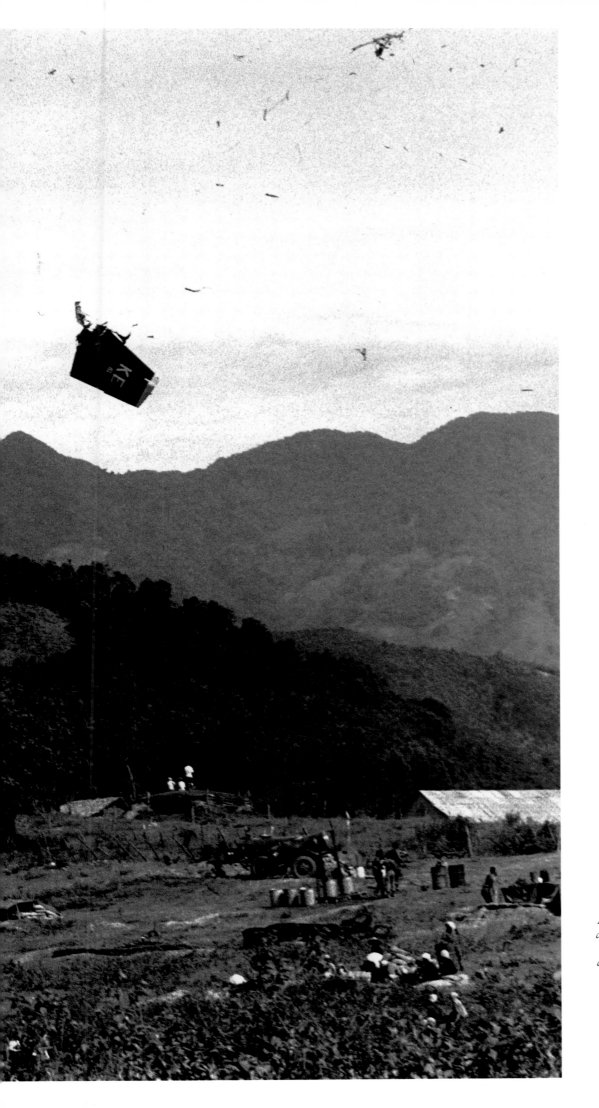

HIROMICHI MINE
Ha Phan, Vietnam, 1967.
A U.S. twin-engine transport Caribou crashes after being hit by American artillery near Duc Pho on August 3, 1967. U.S. artillery accidentally shot down the ammunition-laden plane, which crossed a firing zone while trying to land at the U.S. Special Forces camp. All three crewmen died in the crash.
(UPI)

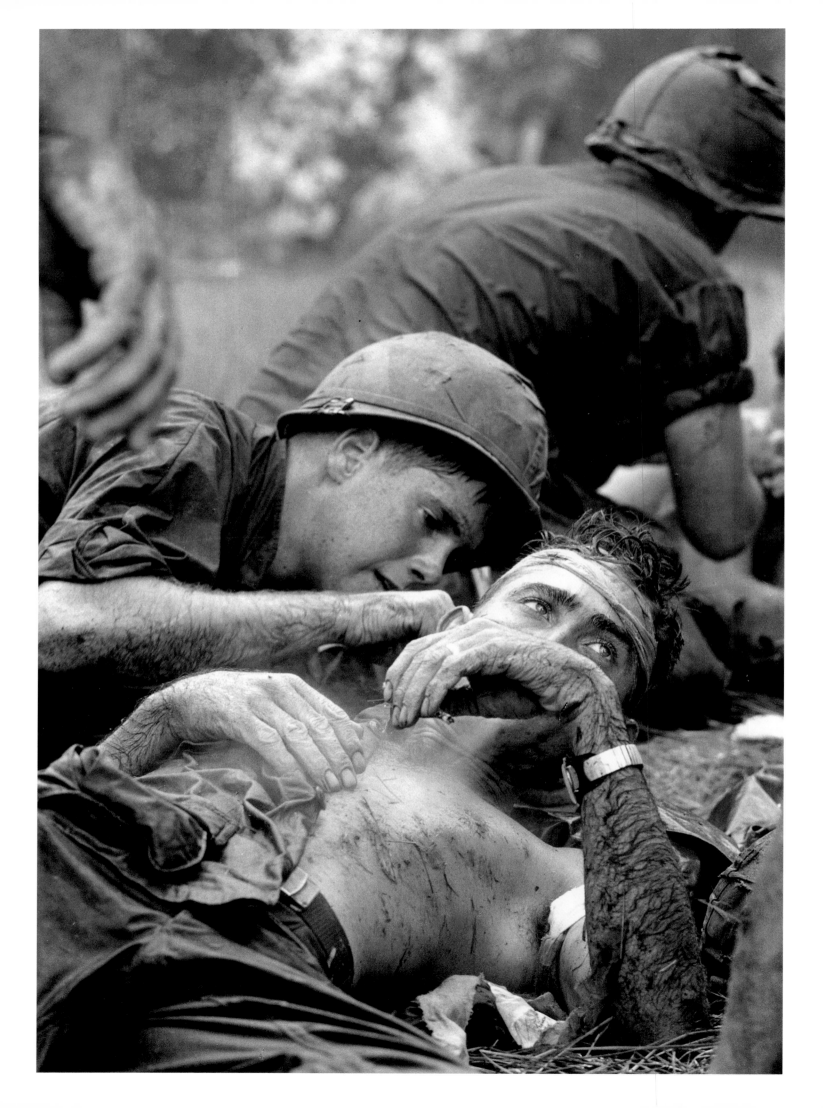

WAR ZONE D BATTLE

The photographer Henri Huet gave this account in his report for The Associated Press newswire on June 17, 1967.

War Zone D, Vietnam (AP) – The First Battalion of the U.S. First Infantry Division hiked into the clearing after a three-hour march through the jungle and looked around for defensive positions. Lumbering Chinook helicopters started to settle down in the clearing, fifty miles north of Saigon, with ammunition, sandbags, and heavy equipment.

Suddenly the Viet Cong struck from ambush positions in brush and trees, shooting first at the hovering Chinooks. Everyone dived for cover. Soldiers directing the choppers waved for them to get away. Officers ordered their men to get along the tree line. Swinging their M-16 rifles into action, the men hunched forward. The fire from AK-47 submachine guns used by the guerrillas built up. It seemed to spread by stages all around the clearing—an area about four hundred yards long covered with knee-high saw grass. You couldn't see any Viet Cong, but you could see bullets chopping the brush.

One soldier was brought back with a bad wound in the abdomen. "If we can't get him out, he's going to die," a medic said. "We've got to get a helicopter."

"We can't get a helicopter in here now," a sergeant replied.

Two medics worked over the man. Specialist 5 James Callahan of Pittsfield, Massachusetts, gave the soldier mouth-to-mouth artificial respiration. Specialist 4 Mike Stout of Sapulpa, Oklahoma, massaged the man's heart to try to keep the beat going.

It was no use. In a few minutes he was dead. The medics wrapped him in a poncho and turned to other wounded.

The fight went on for three hours. As suddenly as it began, it stopped just like that. The Viet Cong had pulled out. Medics and riflemen pitched in to place the American dead and wounded aboard helicopters for evacuation. The Americans lost 31 killed and 115 wounded. A division spokesman said an initial body count showed 196 guerrillas dead in the field.

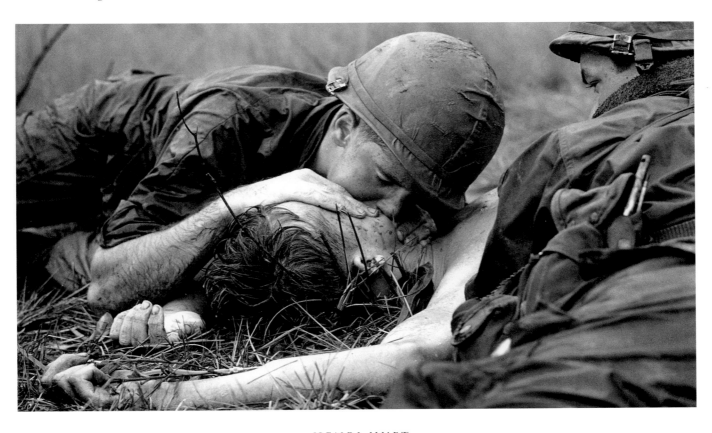

HENRI HUET
War Zone D, Vietnam, 1967.
Specialist 5 James E. Callahan tends an infantryman during an ambush near Saigon.
(AP)

HENRI HUET
War Zone D, Vietnam, 1967.
Specialist 5 James E. Callahan applied mouth-to-mouth resuscitation.
The effort failed.
(AP)

MUDDY WAR

The photographer Henri Huet gave this account in his report for The Associated Press newswire on June 15, 1967.

Phuoc Vinh, Vietnam (AP)—The wounded GI pressed his body into the thick mud behind a log, his bandages smeared with muck.

Another GI slid his mud-splattered M-16 rifle over the log and began firing back at Viet Cong hidden in the nearby trees.

Some American infantrymen crawled through the mud on their bellies, sliding behind poncho-wrapped dead men for cover.

Fifteen men took cover in a huge mud hole left by bombs dropped from U.S. planes supporting the infantrymen. Others dragged the wounded through the mud on ponchos to the rear of the line.

Mud churned up by American bombs during the monsoon rains is another enemy for U.S. First Division infantrymen fighting in the Viet Cong–dominated War Zone D, forty-seven miles northeast of Saigon.

The men fall into foxholes and quickly sink knee-deep into the mud. Jumping off assault helicopters, many stumbled into mud holes cratered by bombs.

U.S. fighter-bombers saturated the landing zone to destroy any enemy mines planted there and to clear the immediate area of Communist troops.

The mud is worst in the landing zones and other open areas. Most of Zone D is thick jungle, and it is only mud under the canopy where bombs have penetrated the undergrowth.

Each day two companies [of the Sixteenth Infantry, First Battalion] fan out into the jungle to seek out the enemy.

A Company spotted four Viet Cong at 4:30 P.M. The enemy ran. An air strike was called down on the fleeing Viet Cong.

Nearly two hours later to the north of A Company, Viet Cong troops hidden by the thick jungle opened fire from all directions on B Company.

B Company pulled back and called for artillery fire on the Communist positions. The Americans moved forward again and once more ran into fire. Six infantrymen were killed and twelve wounded.

They pulled back a second time, dragging their wounded and dead through the thick mud to a small opening cratered by American bombs, from which helicopters could take the wounded out.

The Viet Cong kept firing and wounded three more Americans.

The helicopters arrived and couldn't land because the opening in the trees was too small. They hovered overhead and lowered a litter.

The Viet Cong opened up on the helicopters. One was hit. A second helicopter came in and managed to lift out one wounded man under heavy fire. It, too, was hit and barely made it back.

By then it was 7:30 P.M., and darkness had fallen. It was impossible to take the wounded out by helicopter. The company had to walk through the jungle back to the battalion command post, carrying their dead and wounded.

HENRI HUET
War Zone D, Vietnam, 1967.
*Half-submerged, two infantrymen crawl forward firing and take cover
behind the poncho-wrapped bodies of three dead soldiers.*
(AP)

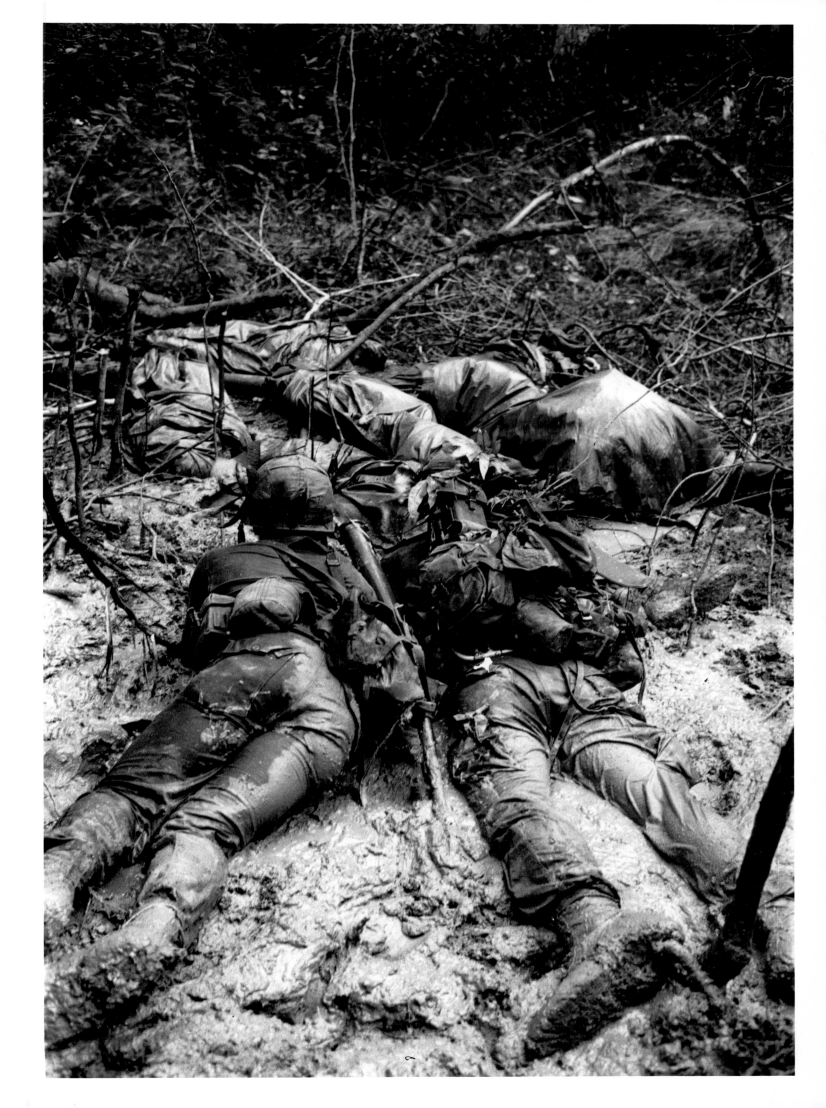

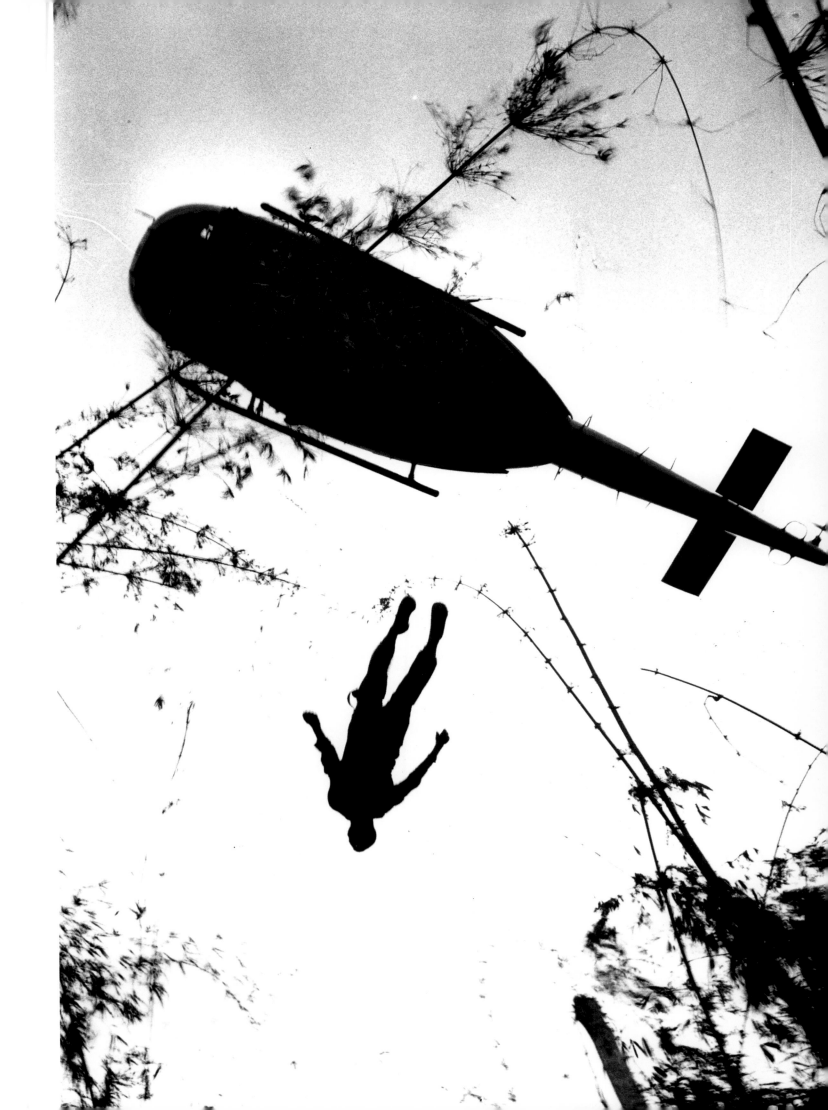

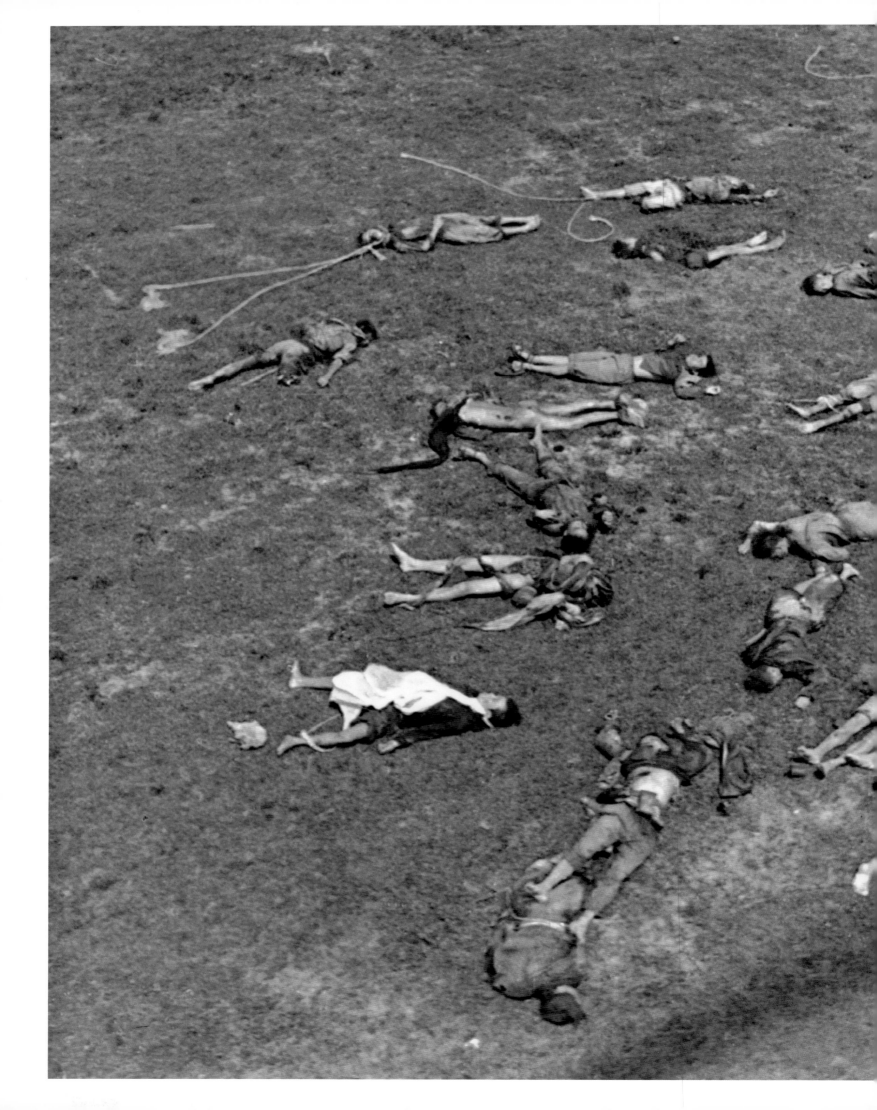

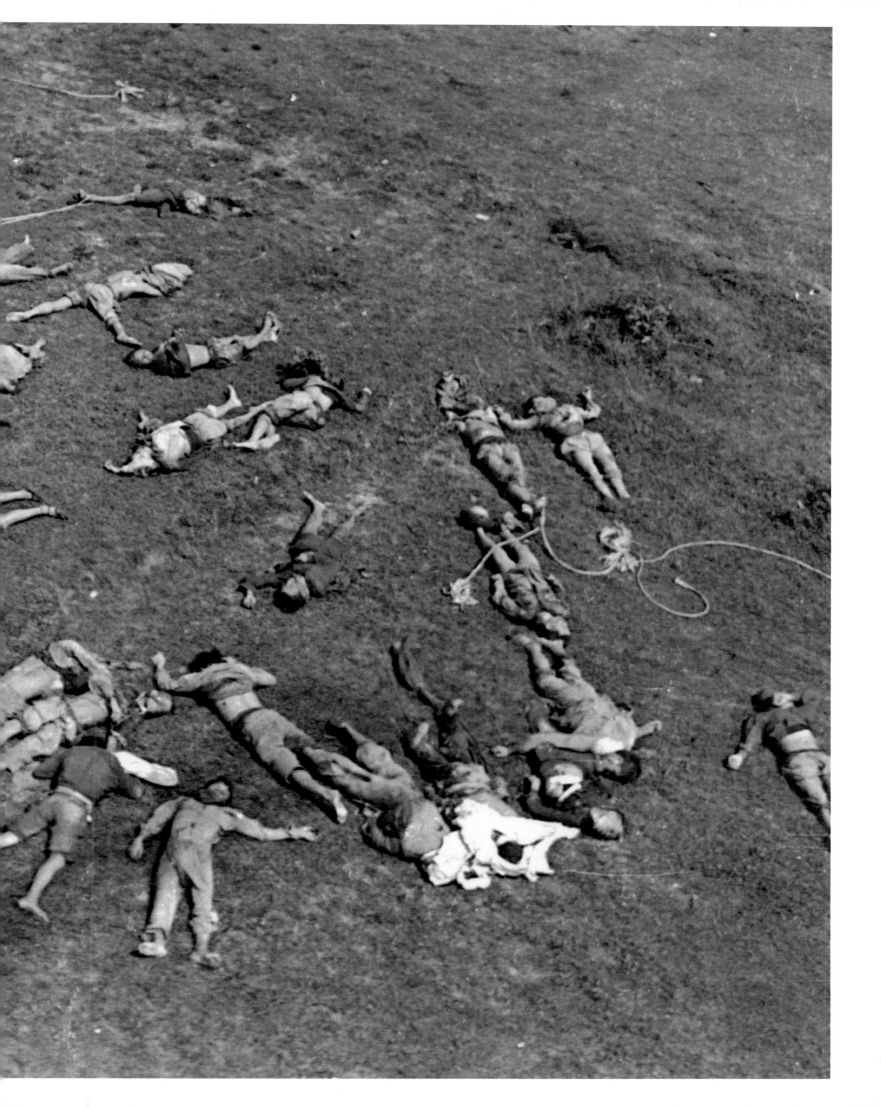

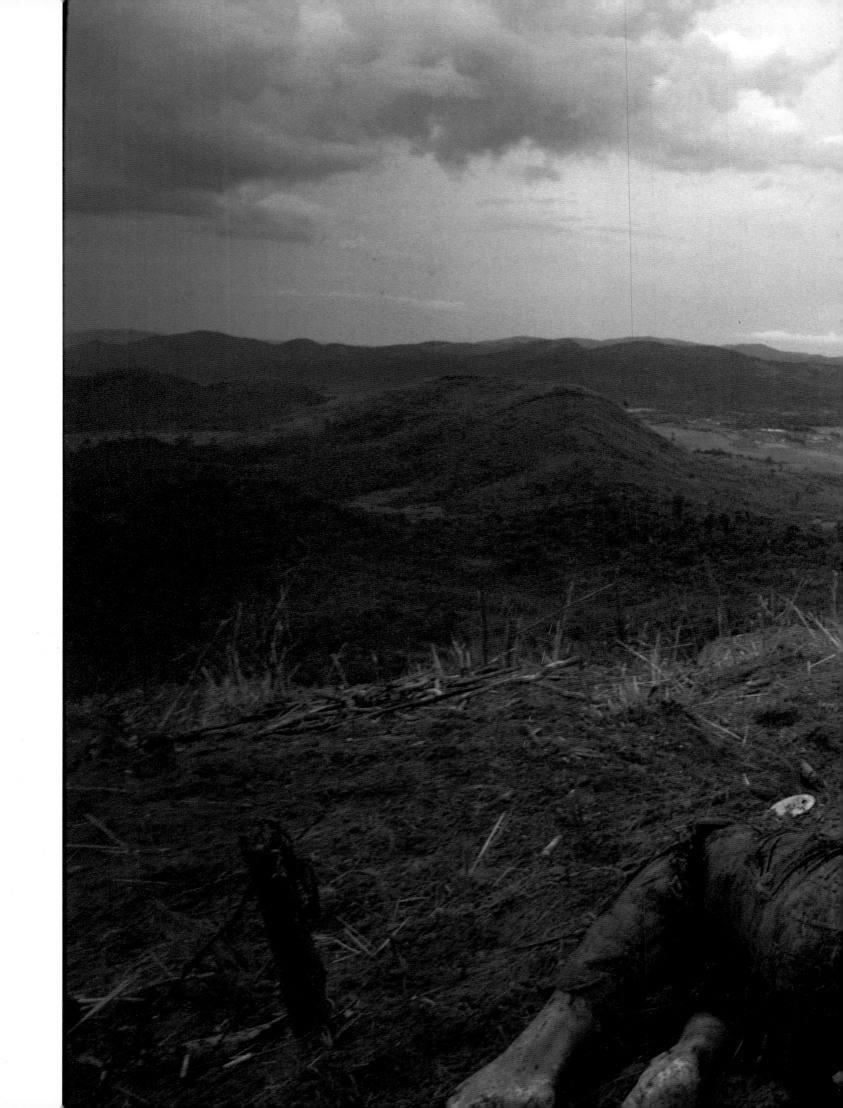

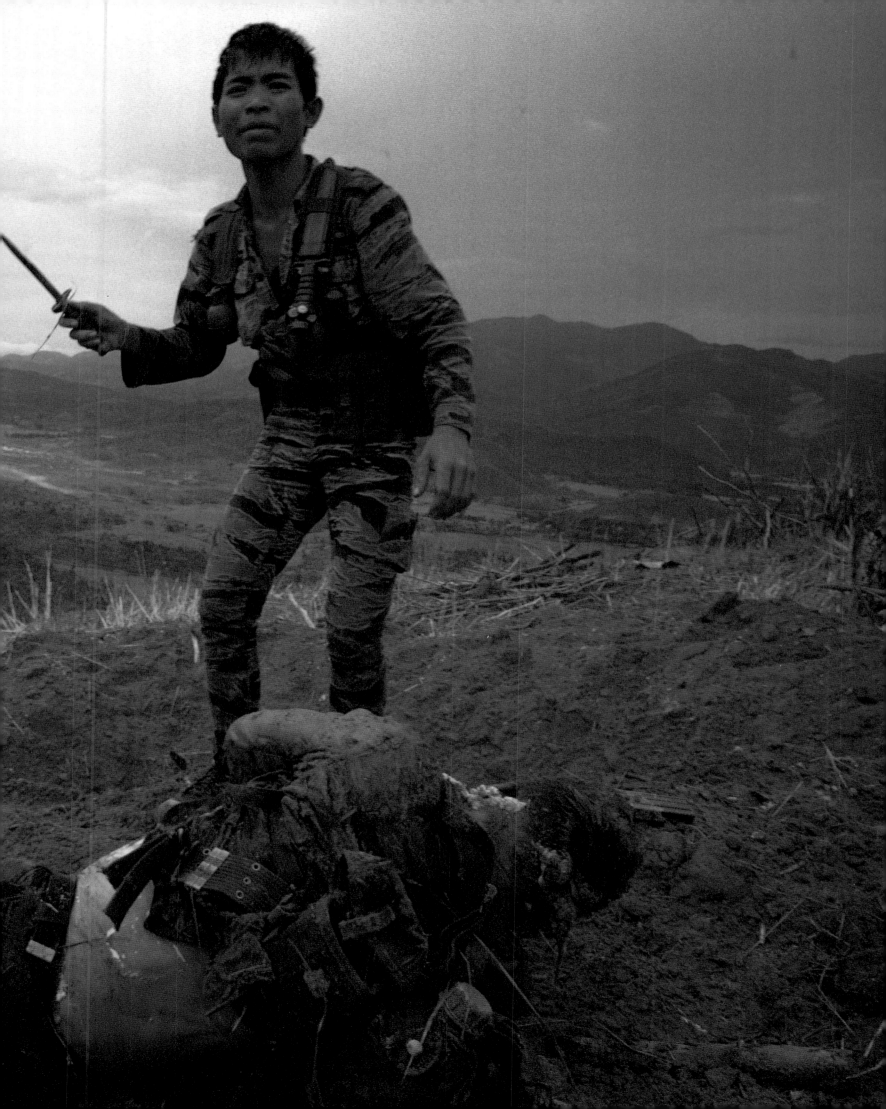

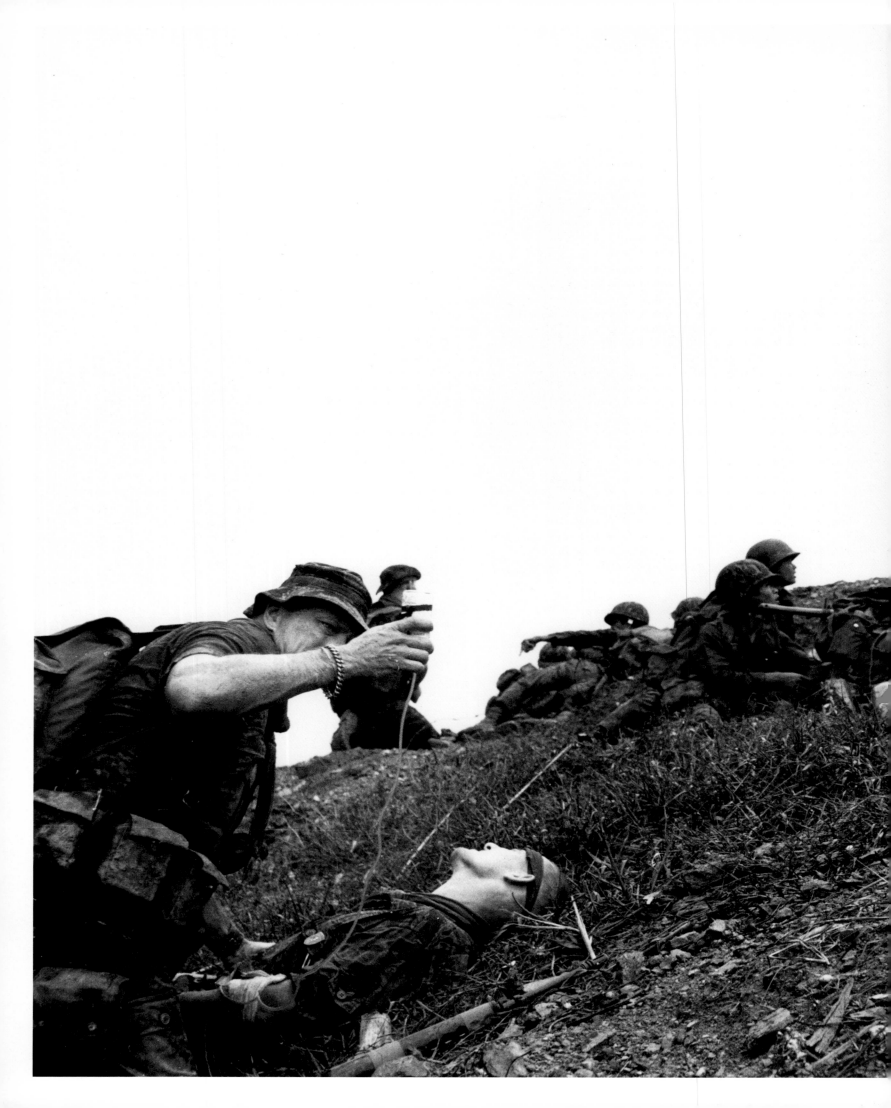

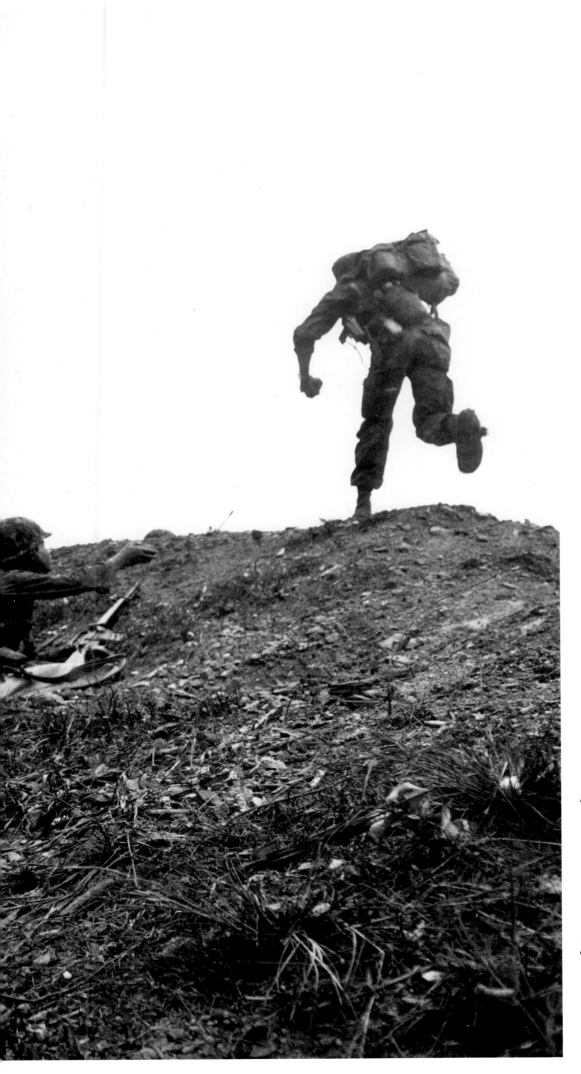

(pages 198 and 199)
SEAN FLYNN
Ha Than, Vietnam, 1968.
*In hand-to-hand combat, South Vietnamese
Special Forces troops and their U.S. commanders
had retaken a hilltop outpost. The soldier is
using a bayonet to cut open the web gear of a
dead South Vietnamese.*

DANA STONE
Ha Than, Vietnam, 1968.
*Holding a grenade, a U.S. Special Forces trooper
charges over the top of a hill in an attack against
North Vietnamese assailants. At left,
a medic treats a wounded officer who had
been hit by a grenade.*
(AP)

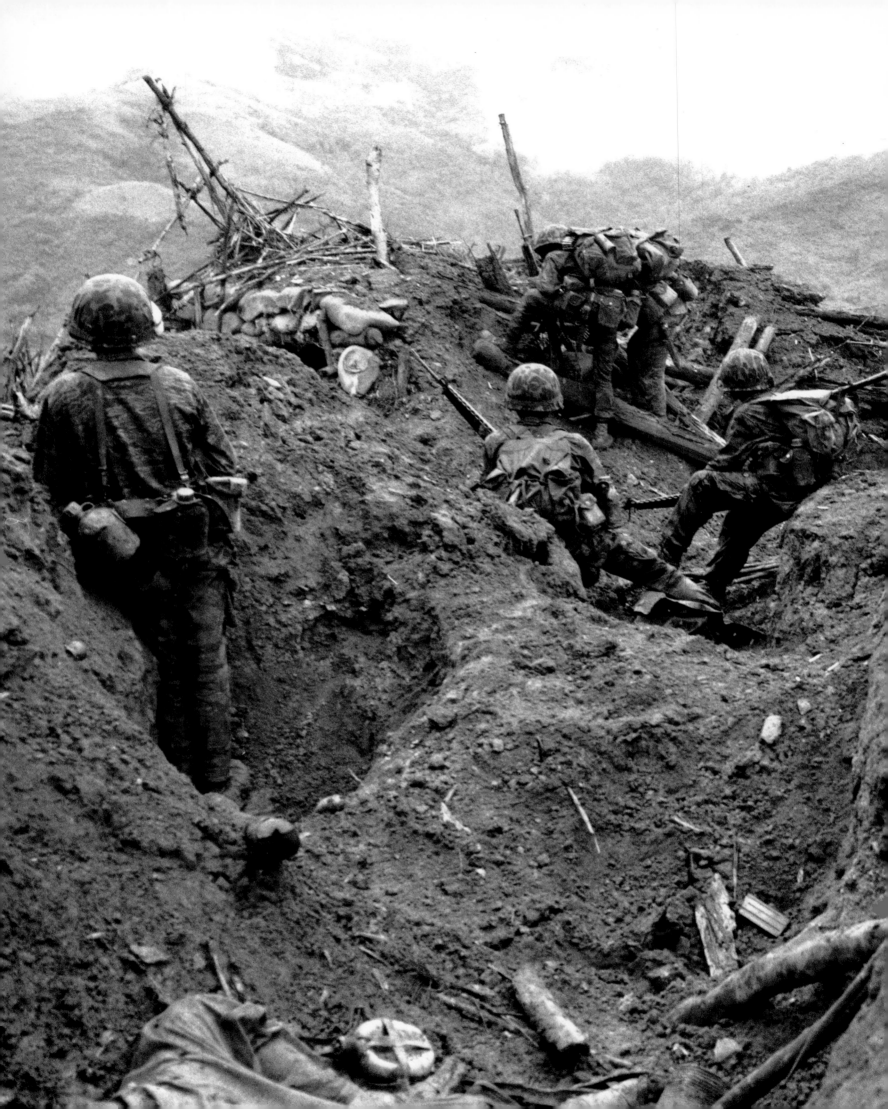

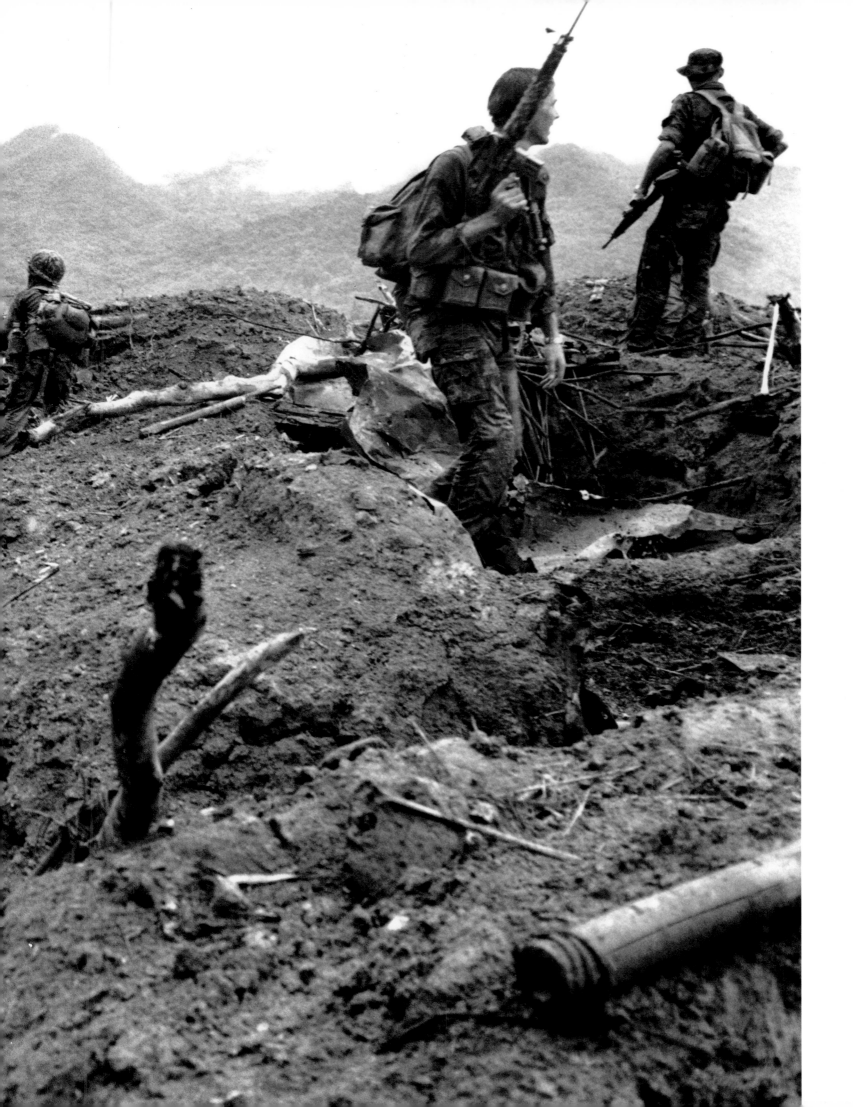

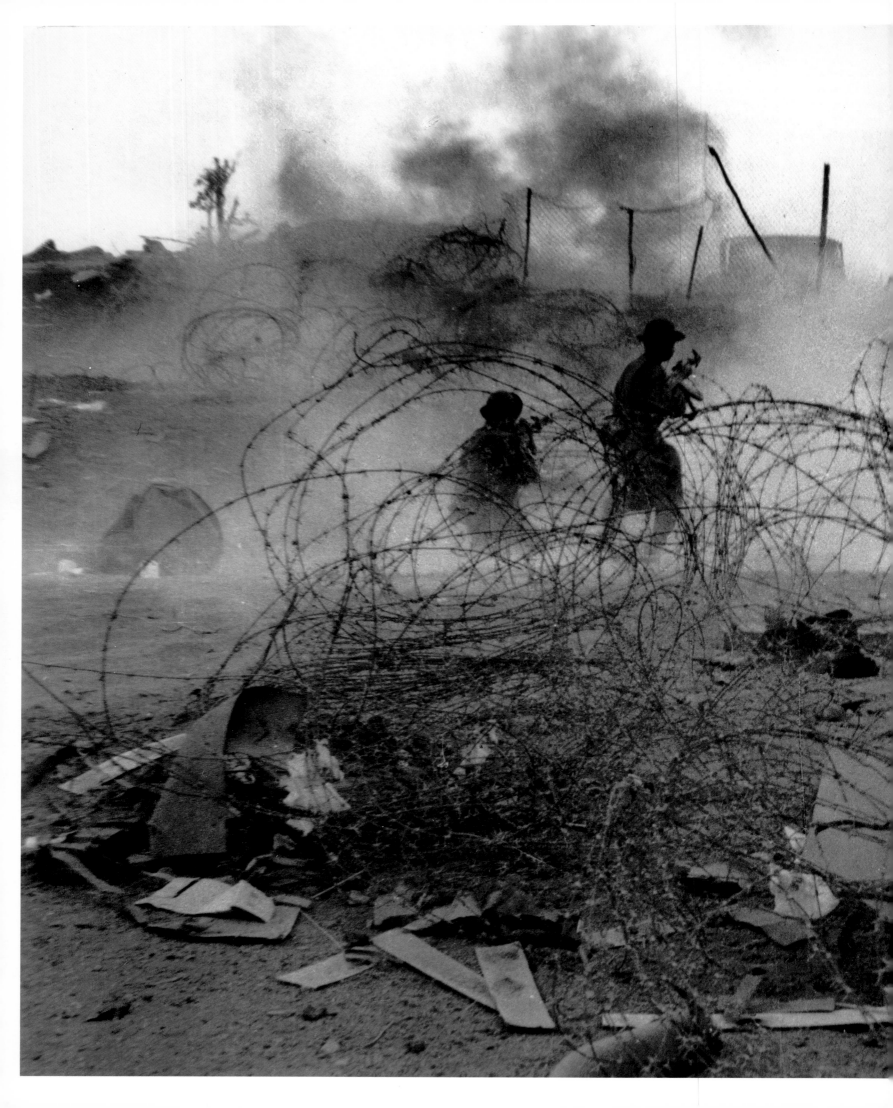

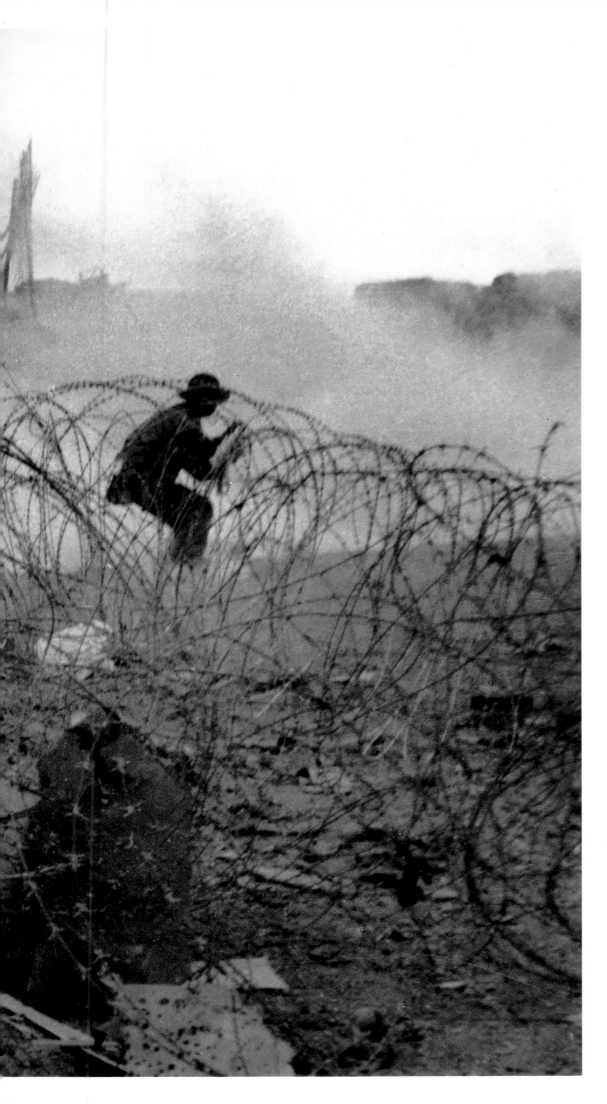

(pages 202 and 203)
DANA STONE
Ha Than, Vietnam, 1968.
*South Vietnamese Special Forces troopers
led by U.S. Green Beret officers reoccupy a
hilltop outpost after hand-to-hand combat.*
(AP)

LUONG NGHIA DUNG
DMZ, Vietnam, 1972.
*North Vietnamese army soldiers charge
through the barbed wire of a South
Vietnamese firebase.*
(VNA)

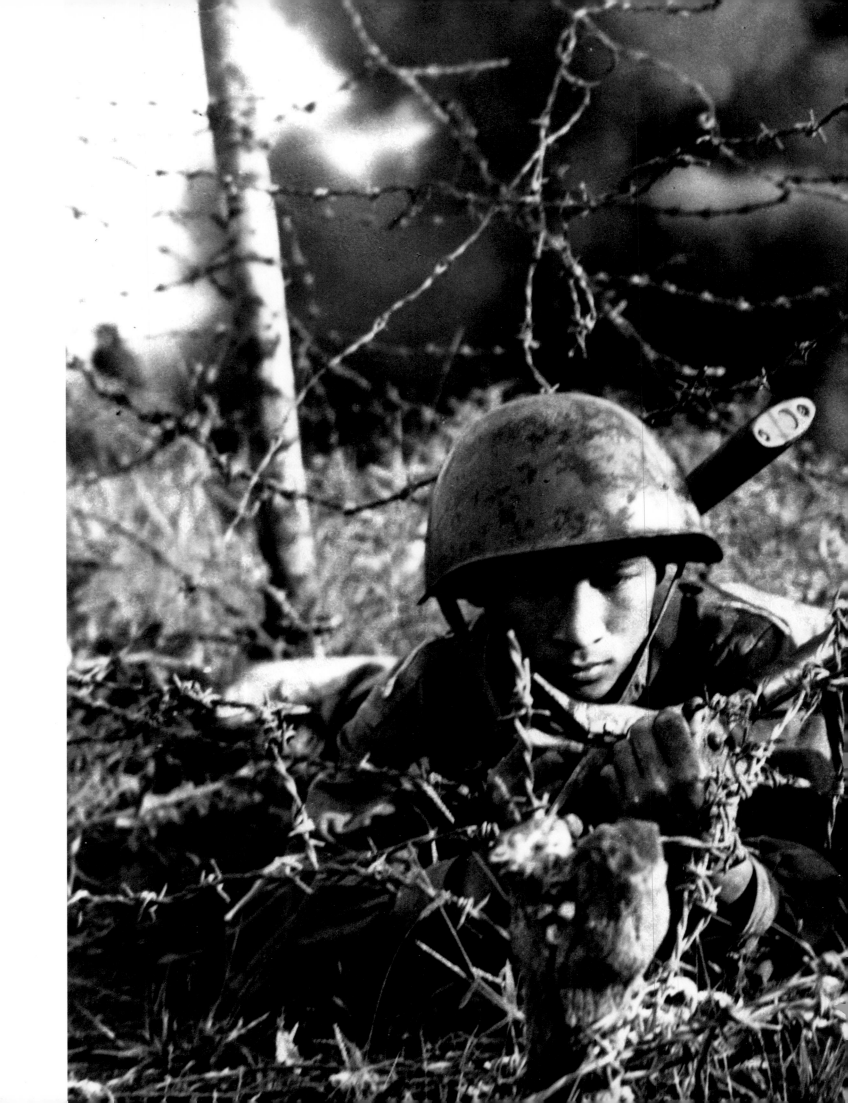

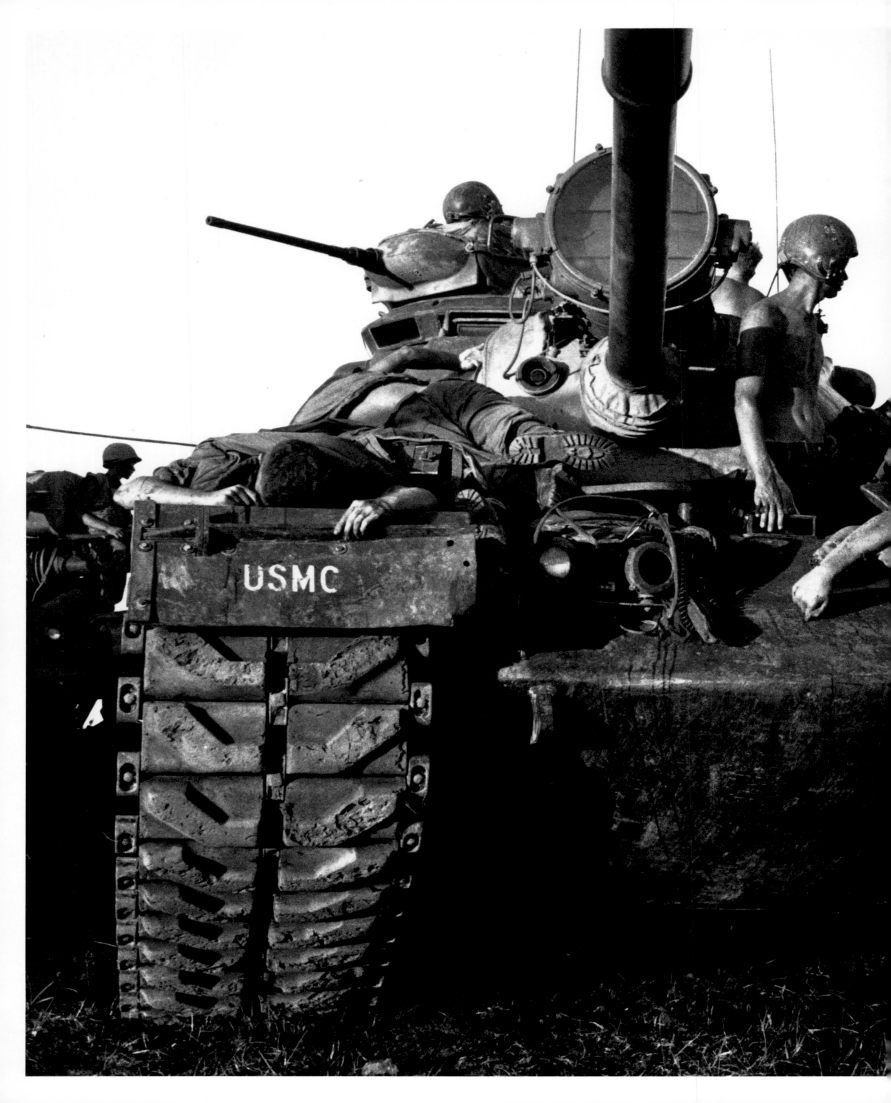

(pages 206 and 207)
HO CA
DMZ, Vietnam, 1970.
*North Vietnamese soldiers cutting through
the wire of a defense line.*
(VNA)

DANA STONE
Con Thien, Vietnam, 1967.
*A U.S. tank carrying the bodies of fallen
Marines moves out, following hand-to-
hand combat. Tanks sent in to recover the
dead and wounded had to withdraw under
North Vietnamese counterattacks.*
(UPI)

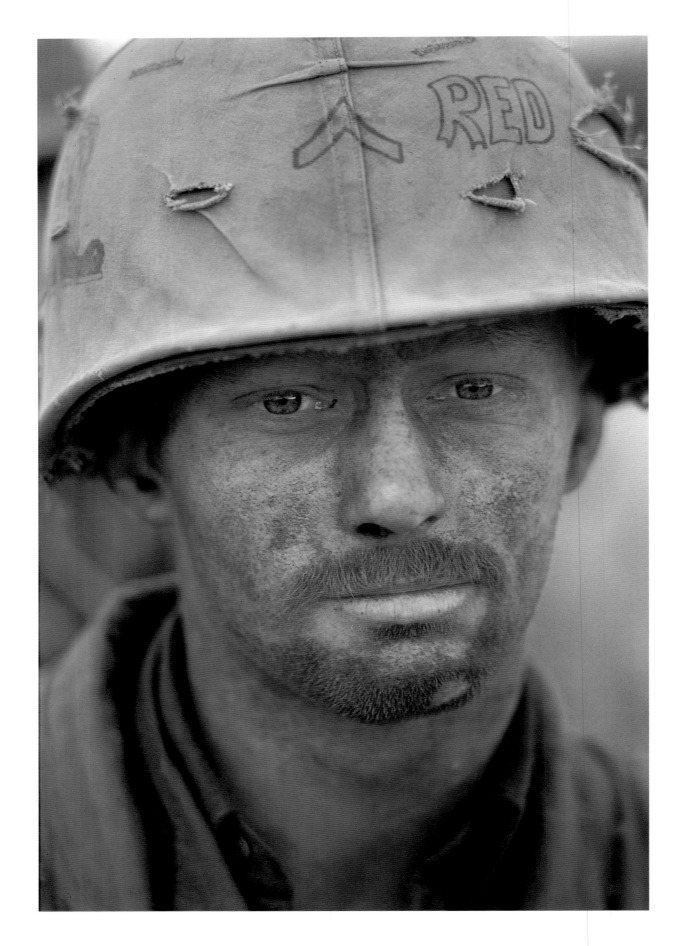

ROBERT J. ELLISON
Khe Sanh, Vietnam, 1968.
*The Marines were under siege for several months at Khe
Sanh. This portrait was published in* Newsweek *after
Ellison was killed.*
(Black Star)

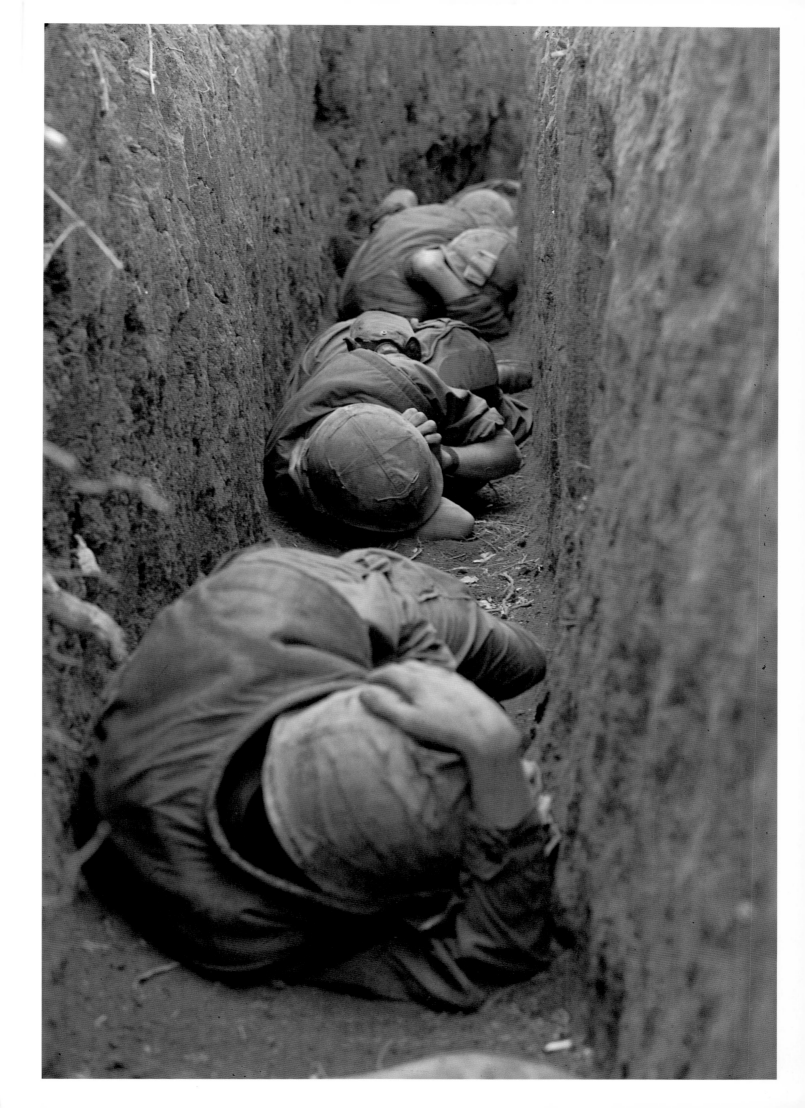

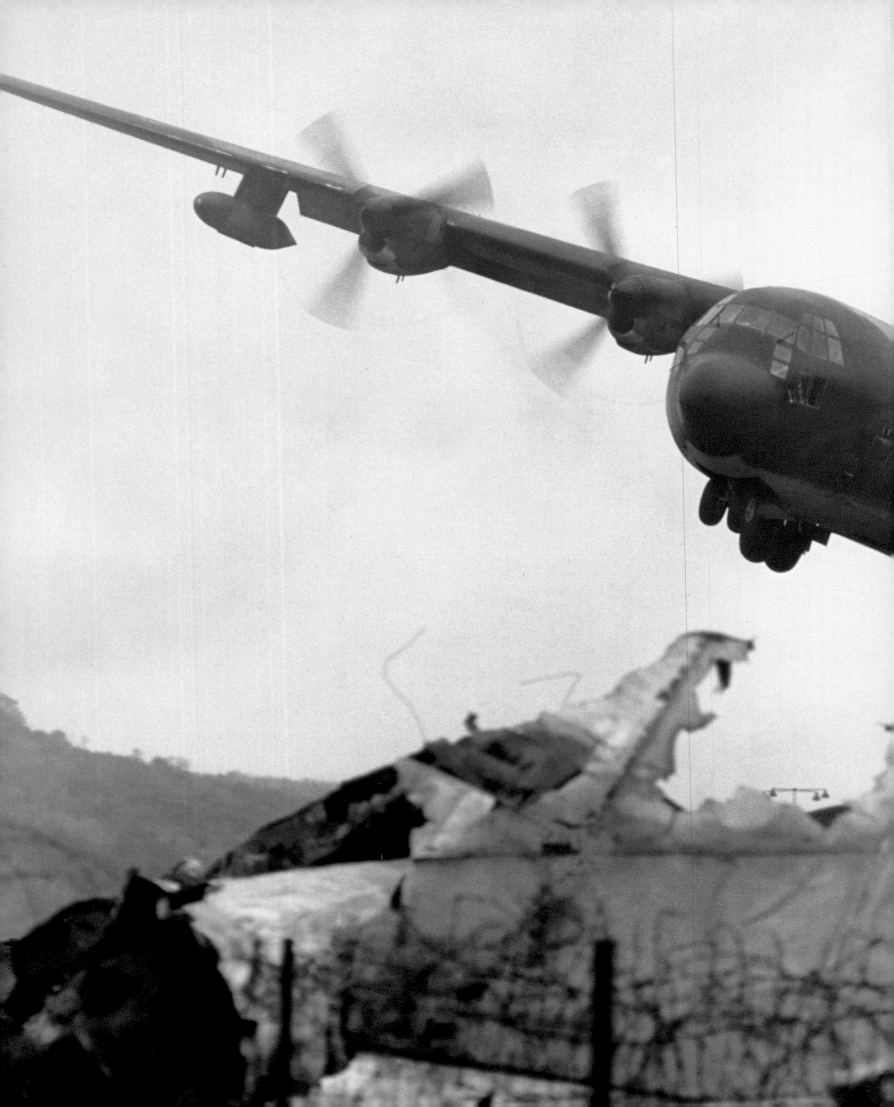

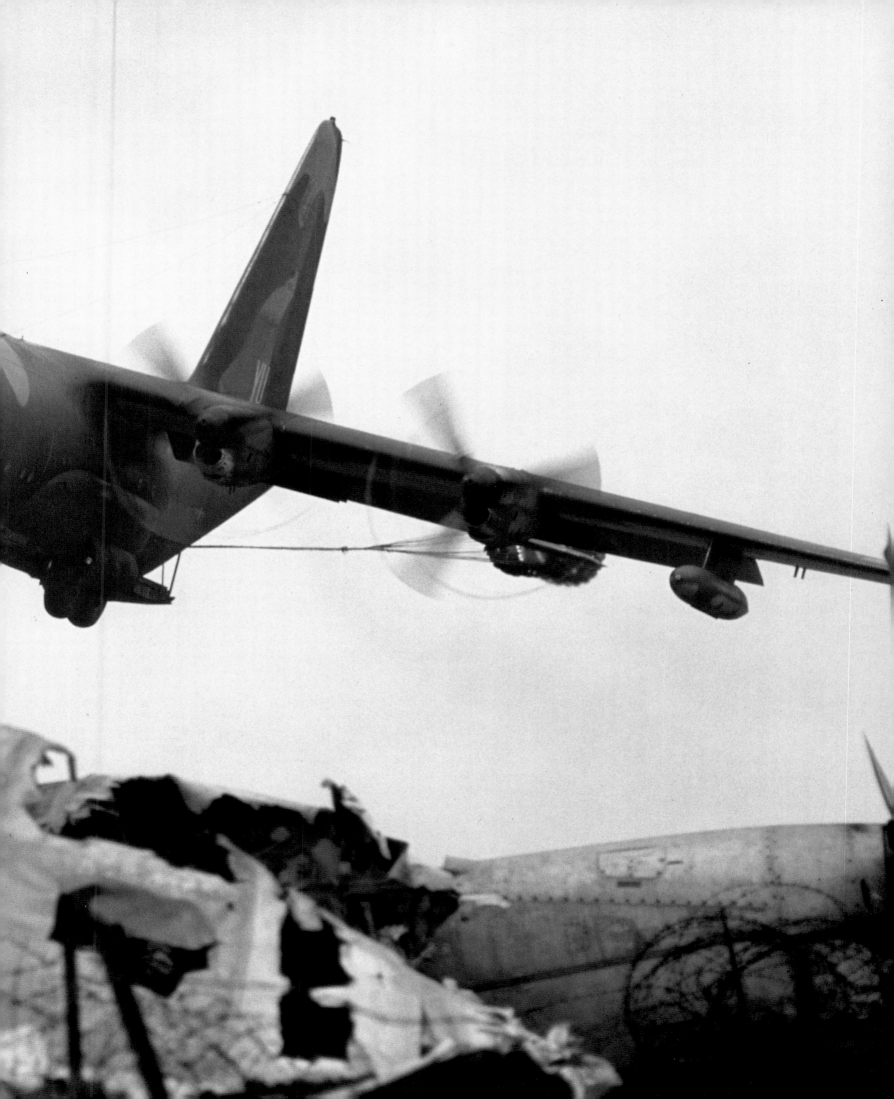

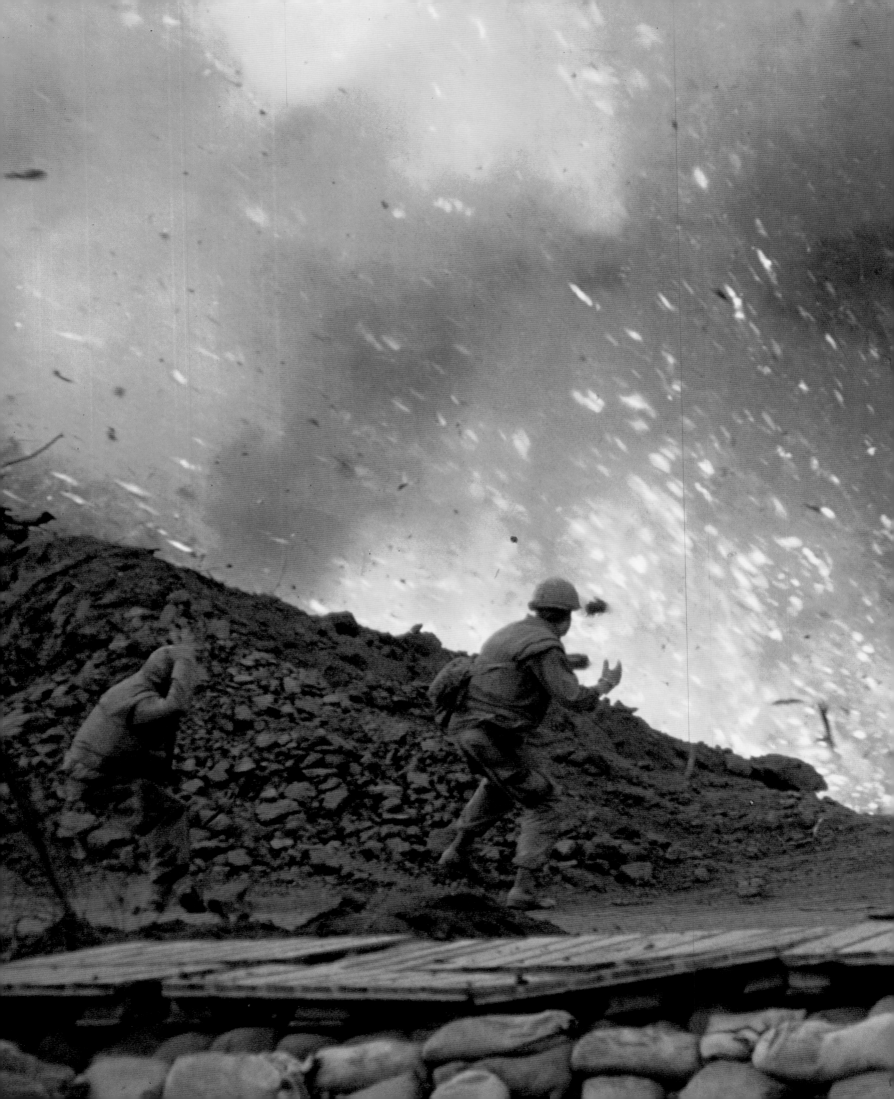

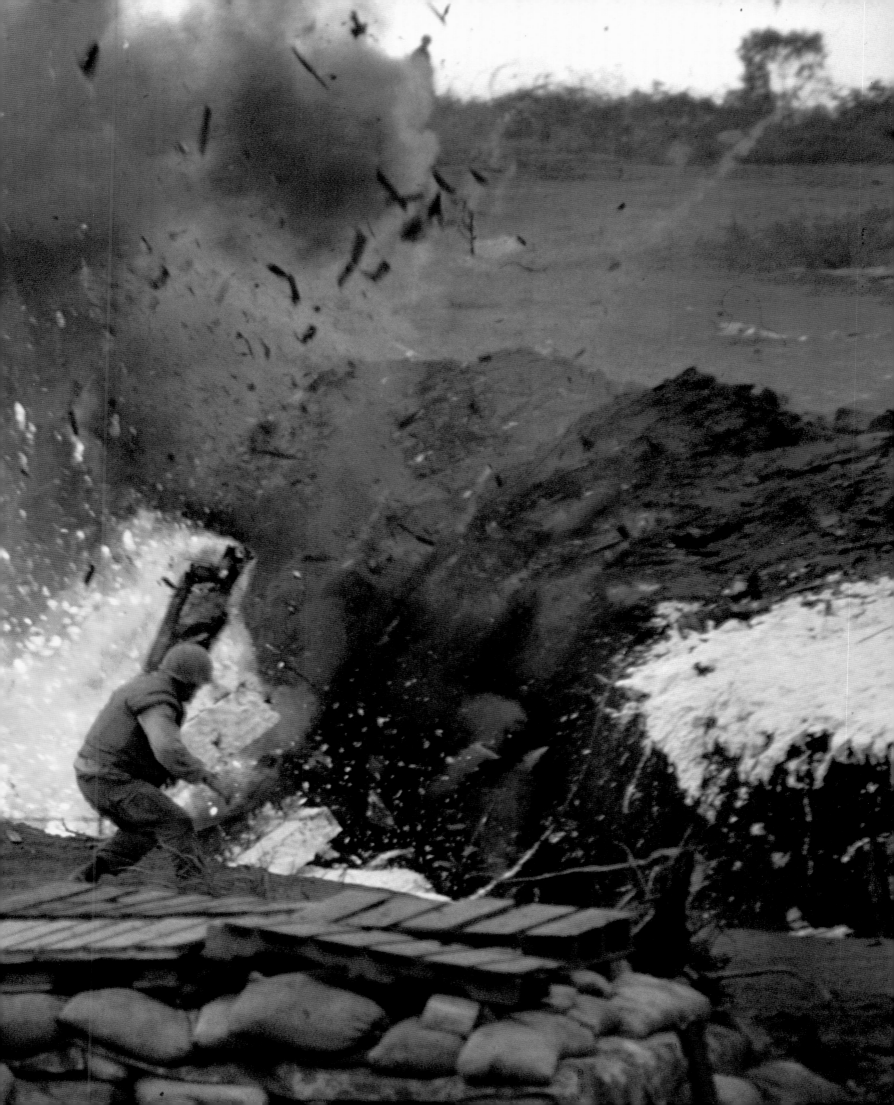

KHE SANH
Neil Sheehan

Khe Sanh was the biggest ruse of the war. General William Westmoreland was convinced that the Vietnamese Communists would attempt another Dien Bien Phu against the garrison of six thousand Marines he had placed as bait at this forlorn spot in the far northwest corner of South Vietnam. When they did, he was going to squash them in triumph. But as explained by General Hoang Phuong, the Vietnamese chief of military history, whom I met in Hanoi after the war, "General Westmoreland fell into a strategic ambush."

The Vietnamese gave every appearance of threatening Khe Sanh, surrounding the place with thousands of troops and shelling the base relentlessly. No serious attempt to seize the Marine base ever occurred. The Vietnamese purpose was to distract Westmoreland's attention from their prep-arations for the real Dien Bien Phu of the American war, the surprise nationwide offensive at Tet, the lunar New Year holiday, in January 1968, which broke the will of the Johnson administration and the American public to continue to prosecute the conflict. The ruse succeeded completely. On the first morning of the Tet Offensive, Westmoreland announced that the panorama of attacks across South Vietnam, including an assault on the U.S. embassy in the middle of Saigon, was merely a diversion from an intended main thrust at Khe Sanh and across the Demilitarized Zone.

Yet the credulity of the commanding general cannot detract from the staunchness of the Marines who held Khe Sanh, at the cost of 205 of their comrades, and the gallantry of the aviators who kept them supplied with food and ammunition.

THE DEATH OF CHARLIE EGGLESTON
(1945–1968)

United Press International radio correspondent Roger Norum was tape-recording live during street fighting in Saigon on May 6, 1968, when he witnessed the death of UPI photographer Charlie Eggleston, who was shot by a Viet Cong sniper. Norum was with a group of South Vietnamese and Korean soldiers who were confronting a platoon of Viet Cong guerrillas who had infiltrated a densely populated area on the outskirts of Saigon near the airport and were now attacking from burning buildings. Norum then spotted Eggleston. UPI's Dick Growald, back at the agency's headquarters in New York, later narrated the tape, which was broadcast the same day as Eggleston's death.

ROGER NORUM: *Charlie! [In the background single-shot automatic-rifle fire gradually increases.] Trying to make it across the road here. [Three more rounds are fired, the sound of trucks and steady rifle fire can be heard in the background.] Don't you duck, Charlie? The smoke from the heat and the fire is rather intense. What do you make of all this, Charlie?*

CHARLIE EGGLESTON: *It's just about good for a laugh.*

ROGER NORUM: *What do you think about that convoy of trucks? Why were they going into this area where all this smoke is coming from?*

CHARLIE EGGLESTON: *Oh, that's an ammo dump over in that area; that is the direct road to Cu Chi, and that was artillery ammo and they are short of it in Cu Chi. I was there over two days ago. They said they are low on 155 [millimeter artillery] rounds.*

ROGER NORUM: *There is a little bit more action than I had bargained for. Miserably hot, and the flames and fire from the burning building is just adding to it. . . . Proceeding very, very cautiously now. . . . Is it all right, Charlie? . . . Charlie has just given me the OK, right in the midst of a burning village area. Flames are all around, and the smell is of burned plastic. Looks like we are in the middle of a blacksmith shop here.*

NARRATOR: *Here, off Plantation Road, in this alley, in this garage and blacksmith shop, the firing picks up; war seems dreadfully near.*

[Very noisy bursts of automatic fire; close by, the firm loud voice of a Vietnamese woman warns of Viet Cong "over there." Grenade explosions, firing in both directions. Sound of the loading of an automatic rifle.]

ROGER NORUM: *Viet Cong are throwing rocket-propelled grenades. Eight or nine of us in here. The heat is just dripping, just dripping. Something is coming from behind us. Huh, that sound. . . . [Explosions, noise of a plane buzzing overhead.]*

CHARLIE EGGLESTON: *Do you have a match? It's Marlboro country, huh?*

ROGER NORUM: *It's coming from behind us . . . some over to the side. [Cracking explosions and single automatic rounds, very noisy, very close.] Every time I hear a volley of gunfire—[Breaks off; bullets zing past]—very close—was that a bullet? That must have been no more than a foot away. It's not funny!*

NARRATOR: *The Viet Cong are just behind the alley, up there on the second floor, and they are cornered, and they are shooting back, and we've got to keep low. The guerrillas are doing all this to try to win publicity and hope that it will impress someone, like the rest of the world. Captured Viet Cong documents proclaim that the street fighting is necessary to back up the efforts of the North Vietnamese diplomats meeting American negotiators in Paris. They talk in Paris, but here . . . here a shot . . . [Sharp noise of a single round, very close, is followed by a thumping sound. Charlie has crashed to the ground.]*

ROGER NORUM: *Oh no! No! Charlie has been shot! Oh my God, my God . . . Charlie has been killed! Oh my God, blood is streaming out of his nose and mouth. He's got it right in his head! Ooh Jesus! I saw him stand out in this alleyway . . . [Norum's heavy breathing makes it impossible for him to continue speaking; the NARRATOR takes over.]*

NARRATOR: *You hear the sound of the shock of death; the blood of a friend is seen in the heat of a day of fighting in the street of Saigon, in the battle of Saigon, in the war of Vietnam.*

KYOICHI SAWADA
Hue, Vietnam, 1968.
Tet Offensive.
(UPI)

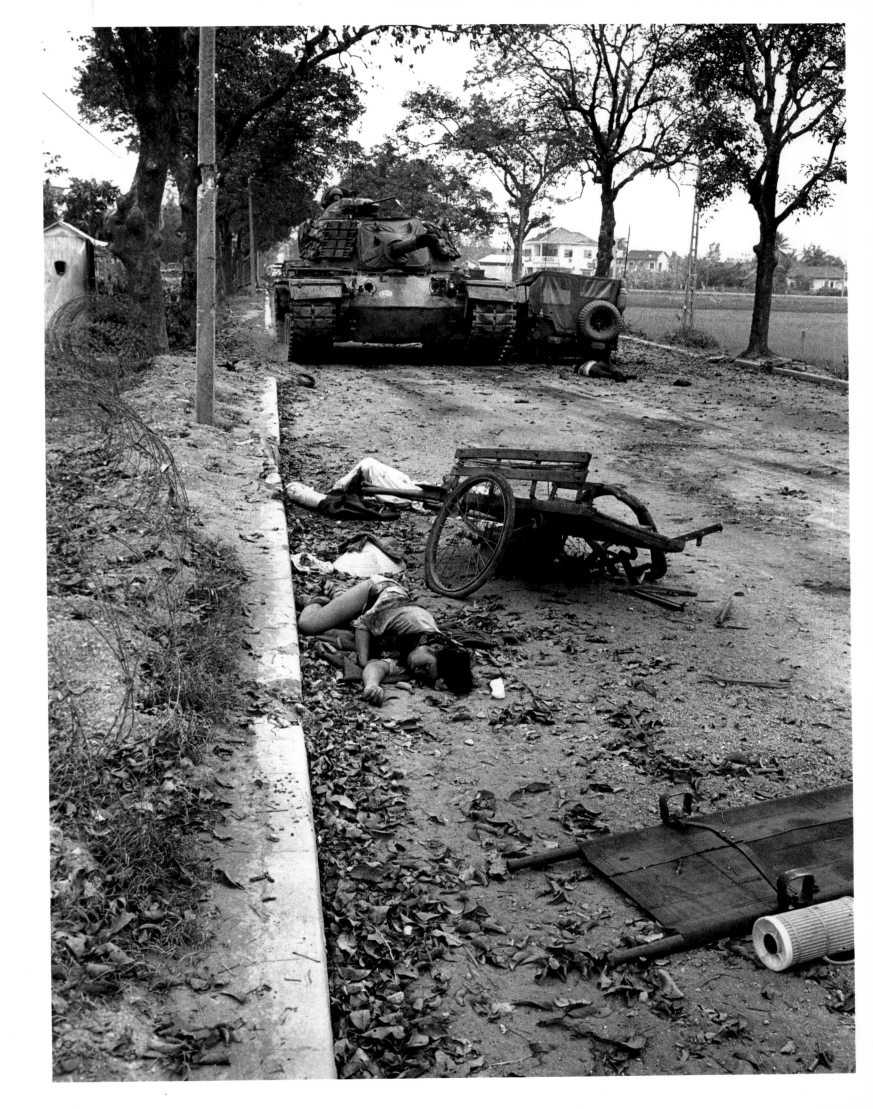

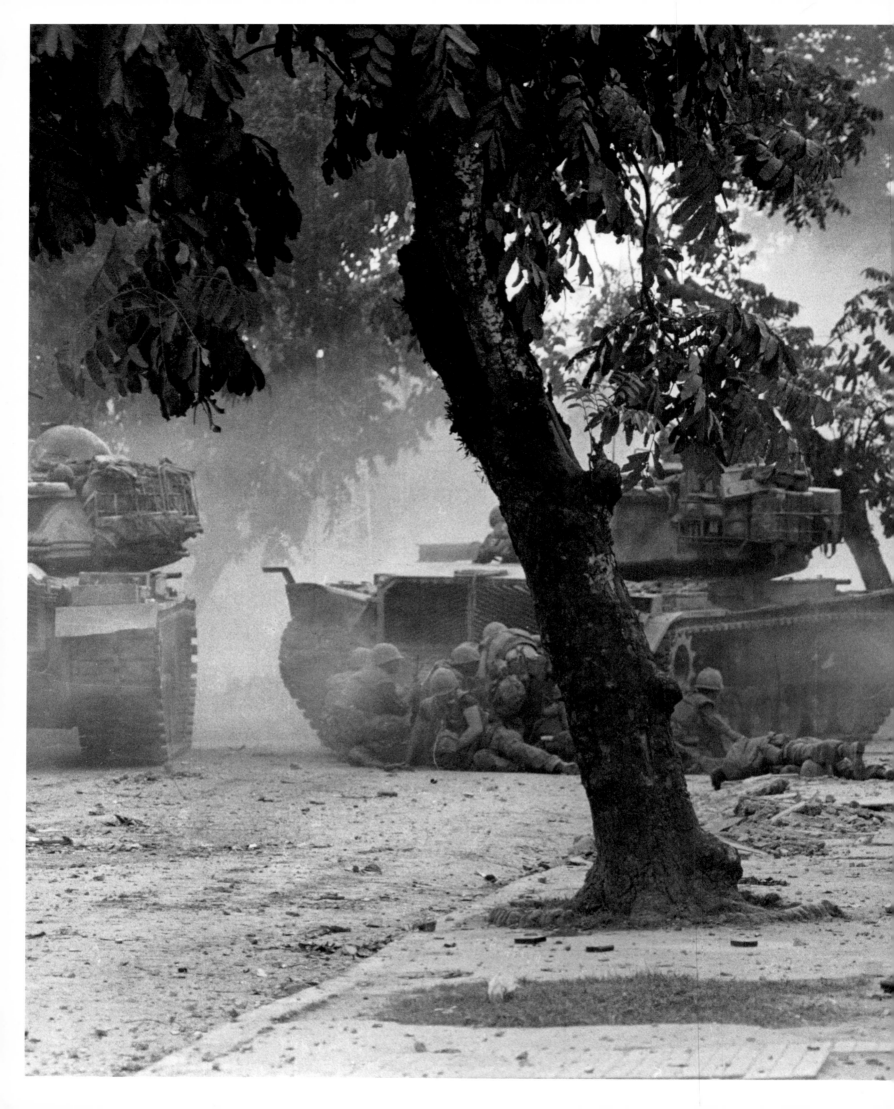

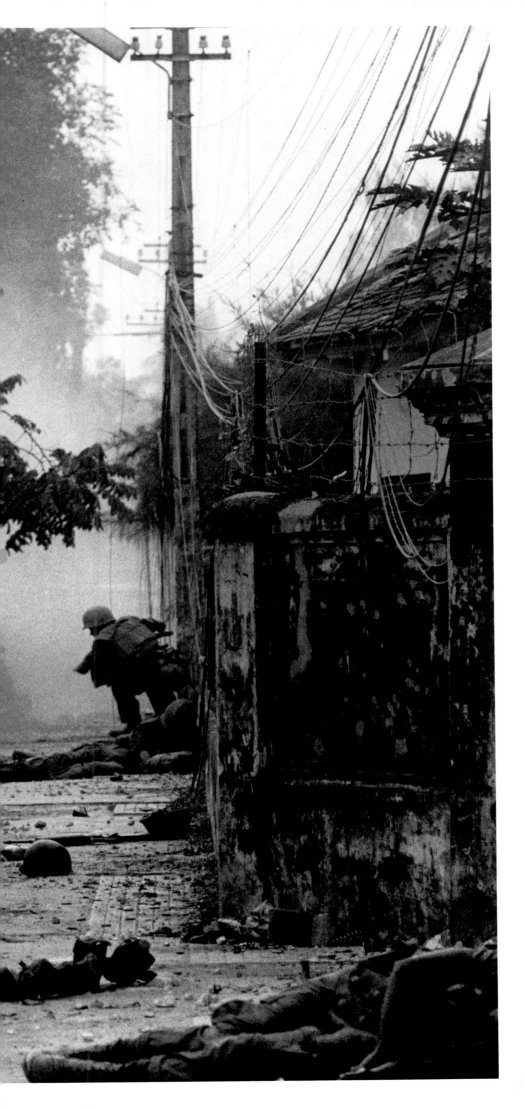

KYOICHI SAWADA
Hue, Vietnam, 1968.
*Marines use a U.S. tank for cover
during the battle in the citadel.*
(UPI)

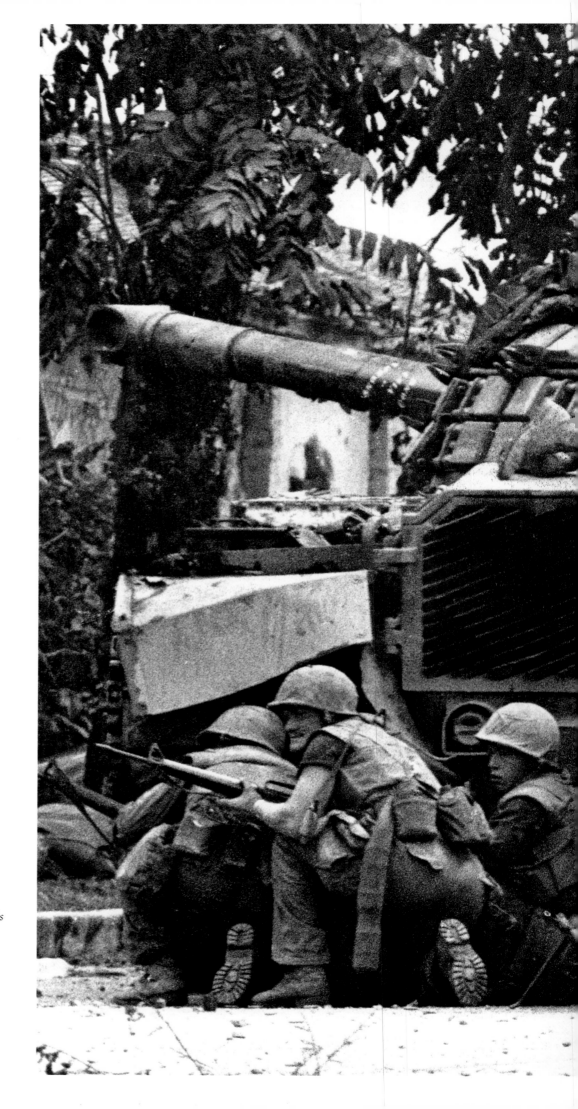

(pages 224 and 225)
KYOICHI SAWADA
Hue, Vietnam, 1968.
Inside the citadel a squad of U.S. Marines finds
cover near the ruins of the East Gate Tower.
(UPI)

KYOICHI SAWADA
Hue, Vietnam, 1968.
Marines use a U.S. tank for cover
during the battle in the citadel.
(UPI)

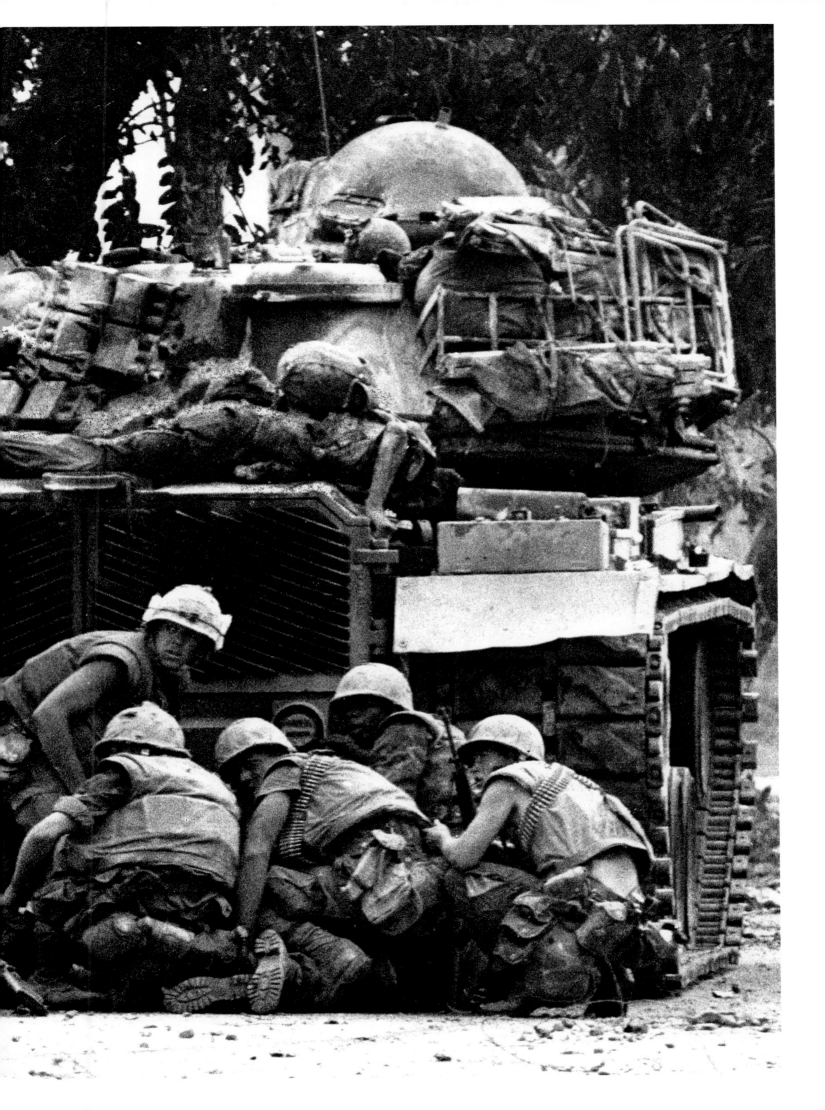

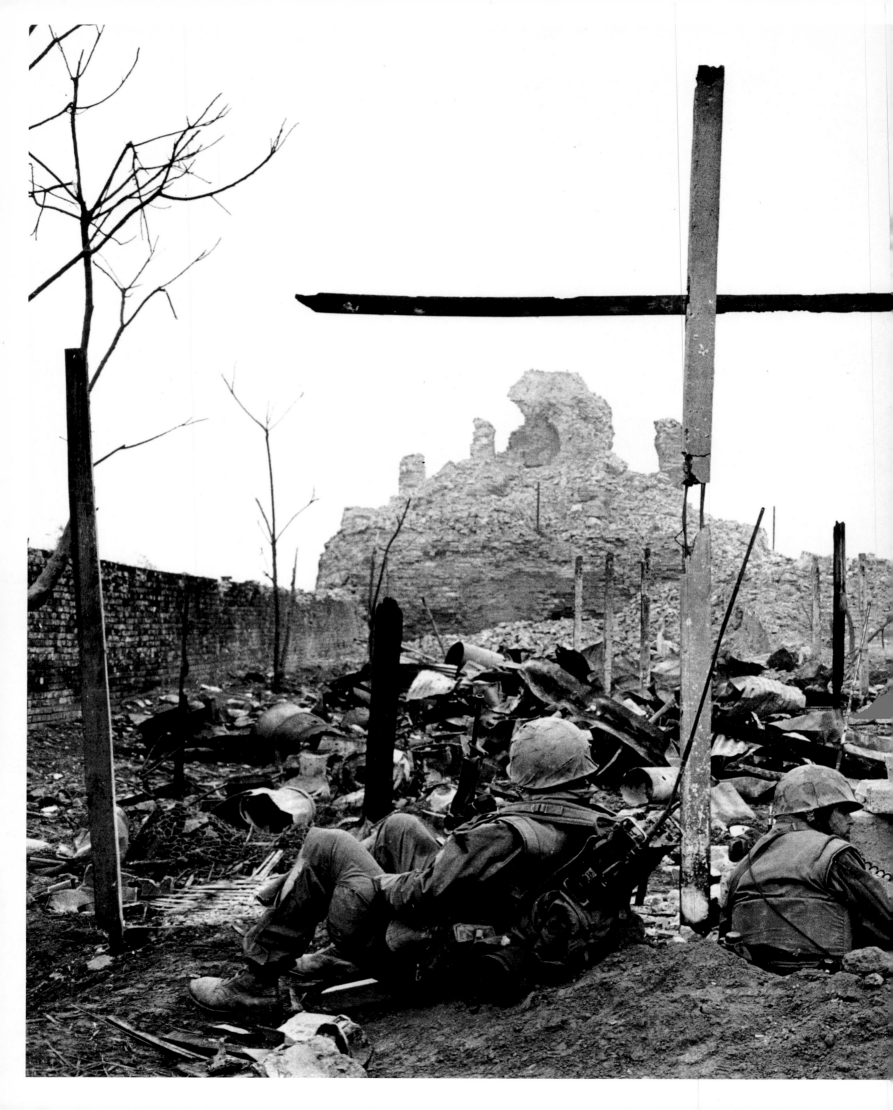

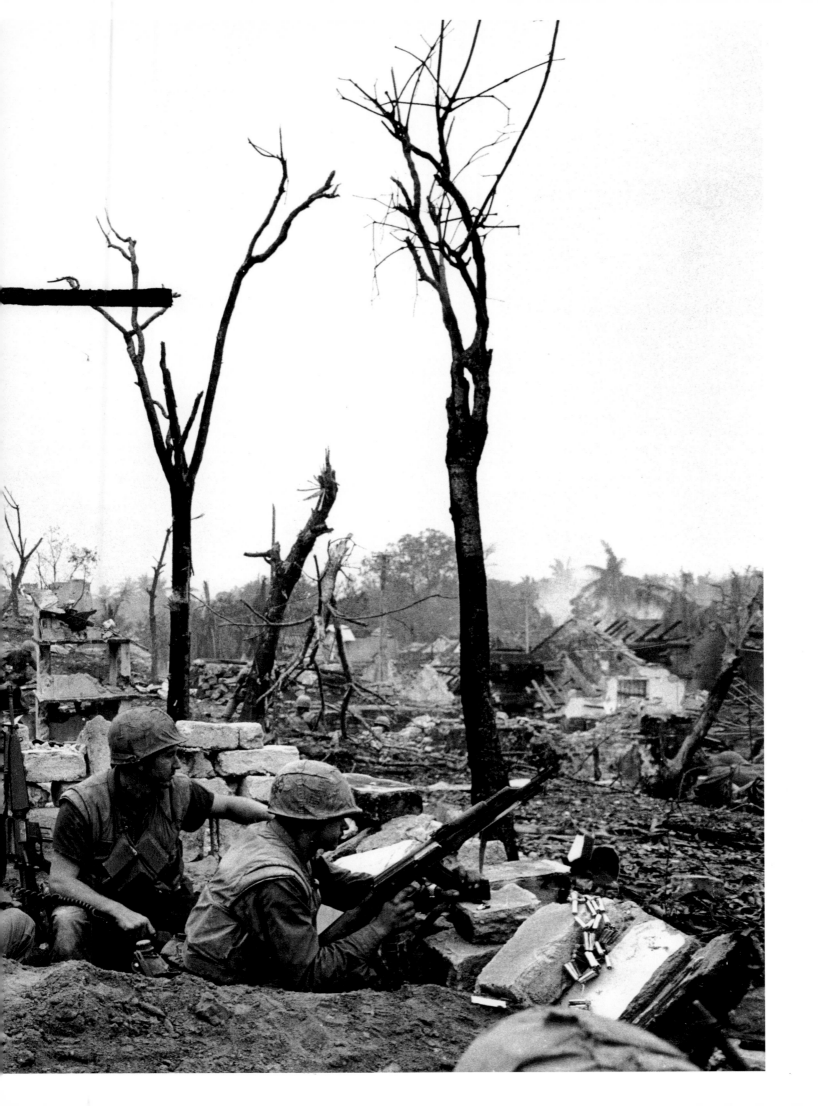

4 LAST FLIGHT

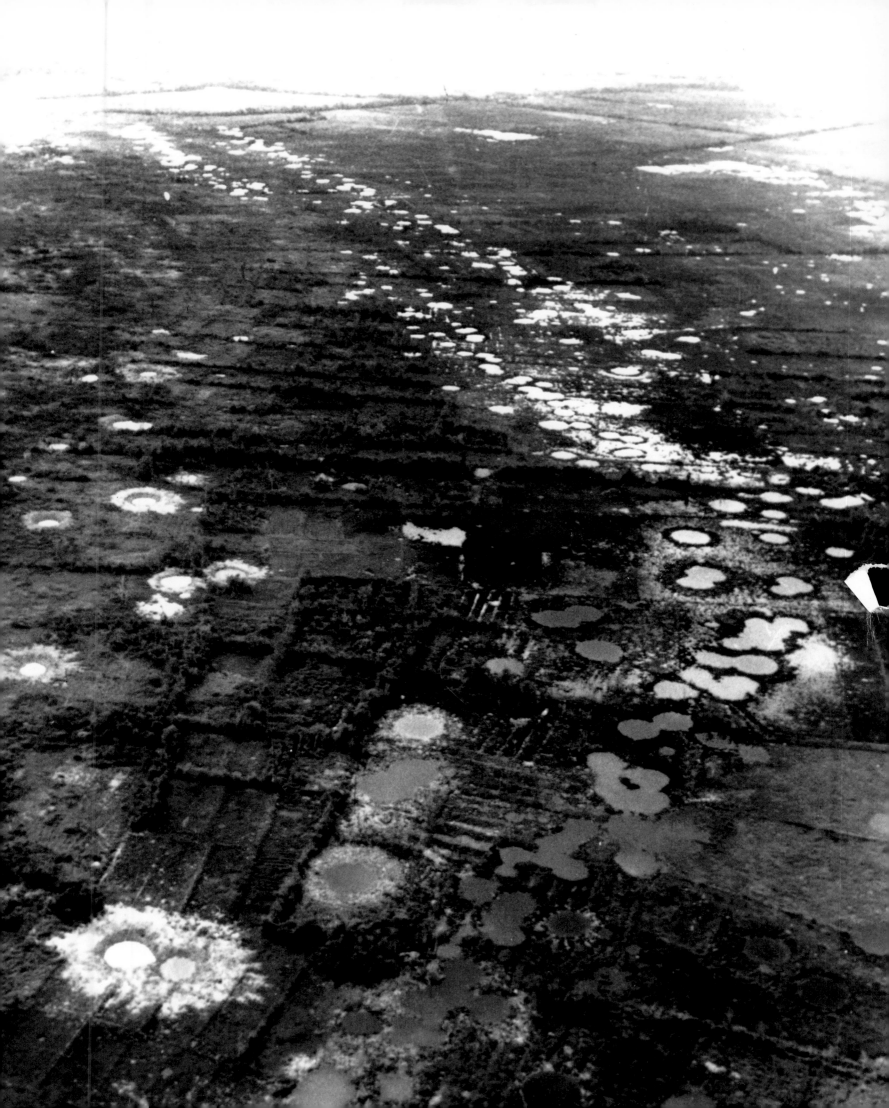

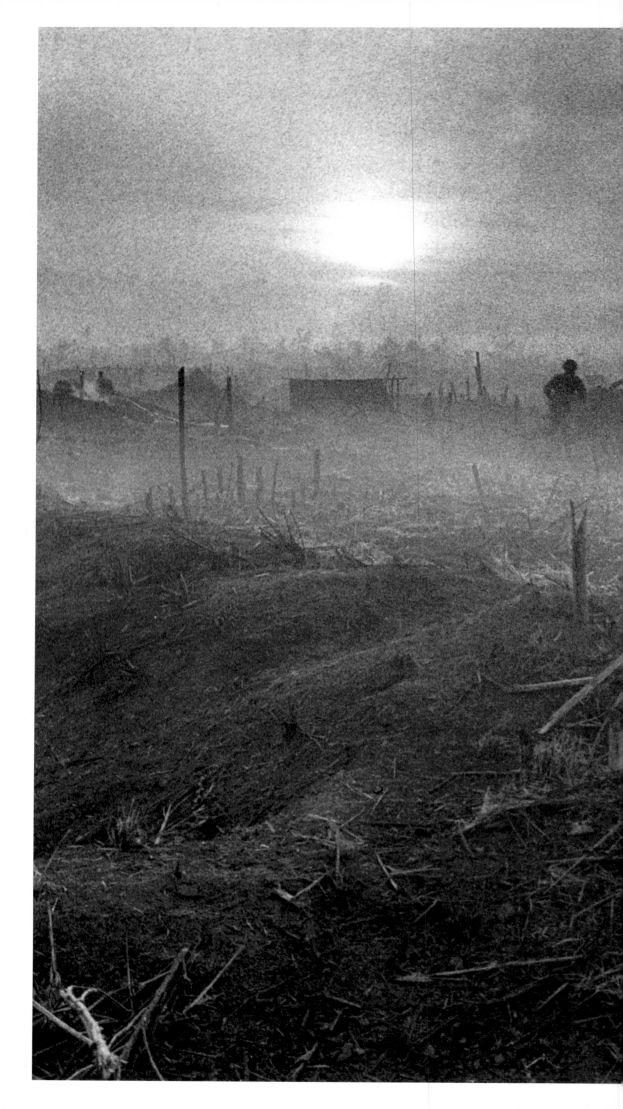

(page 227)
HENRI HUET
Near Saigon, Vietnam, 1968.
Bomb craters from B-52 strikes.
(AP)

KYOICHI SAWADA
Bu Dop, Vietnam, 1967.
North Vietnamese and Viet Cong forces have staged battles, dropped bombs, and set fires, devastating the small town on the Cambodian border.
(Cressendo)

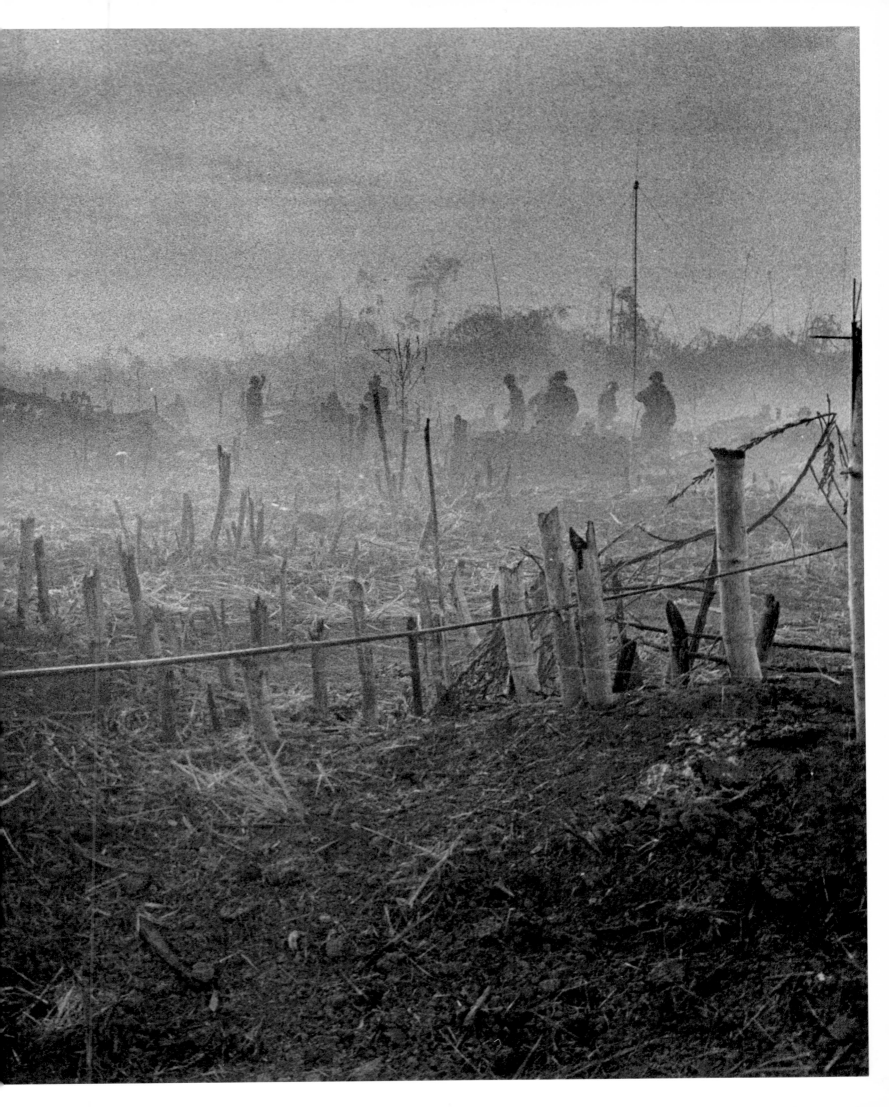

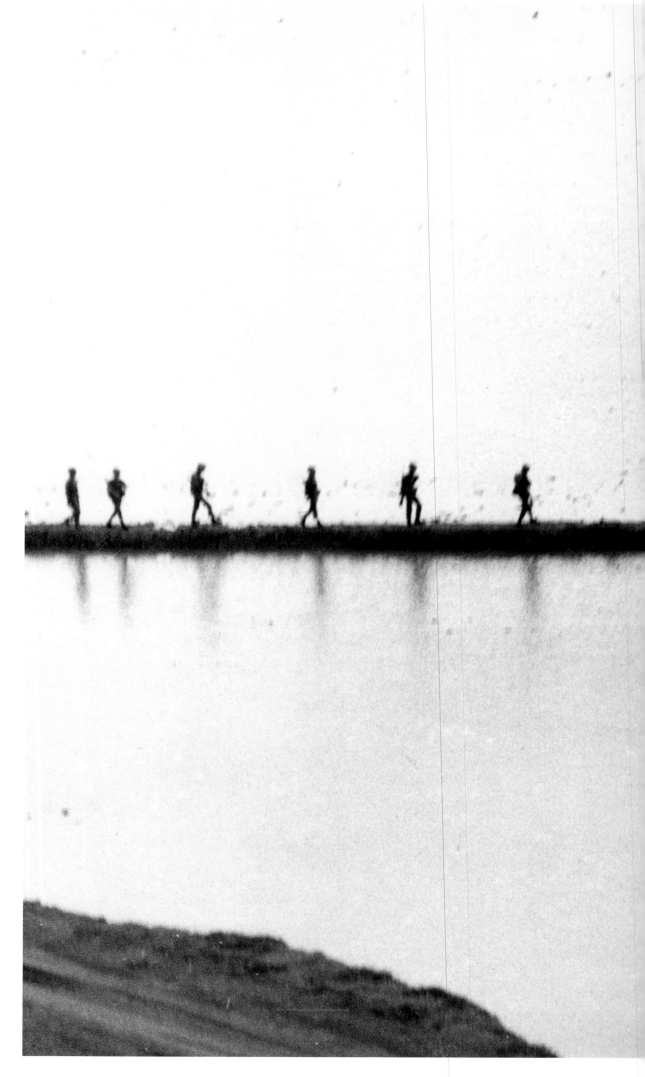

OLIVER NOONAN
Mekong Delta, Vietnam, 1969.
South Vietnamese troops move single
file along dikes during early-morning
patrol through the rice lands of
Long An Province.
(AP)

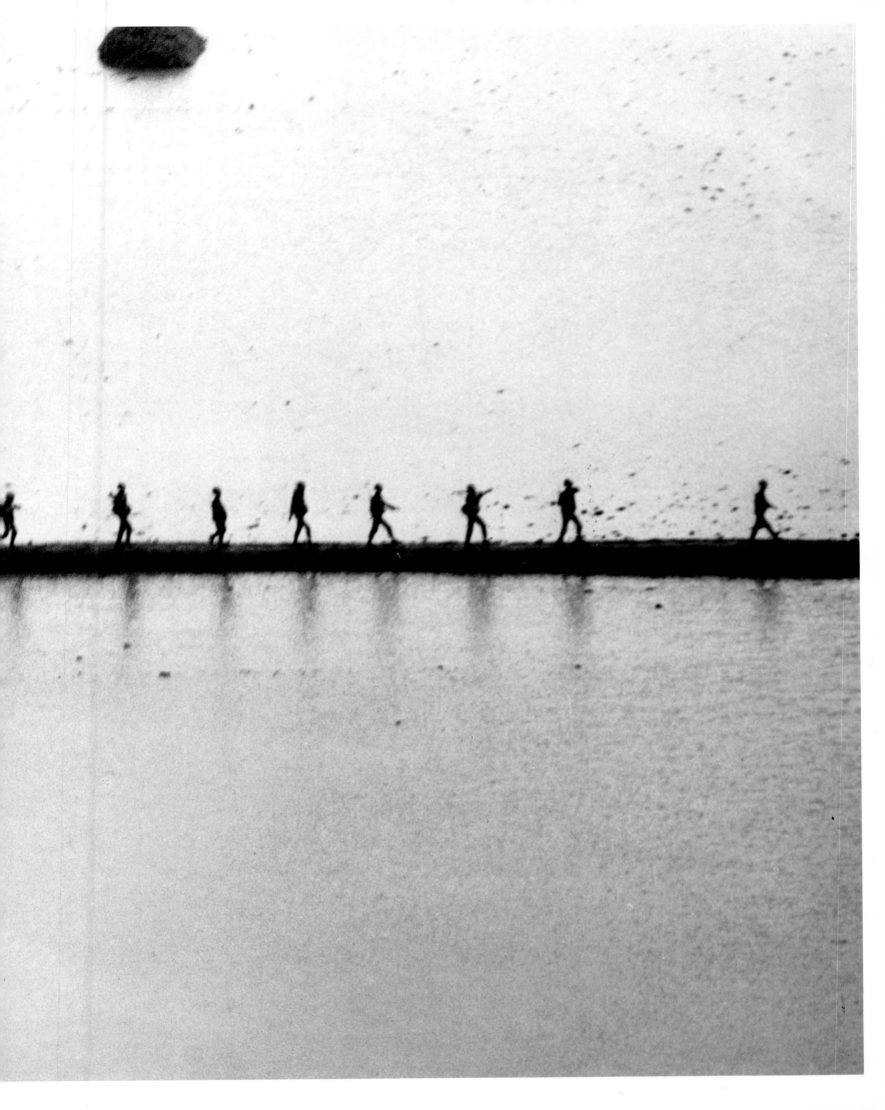

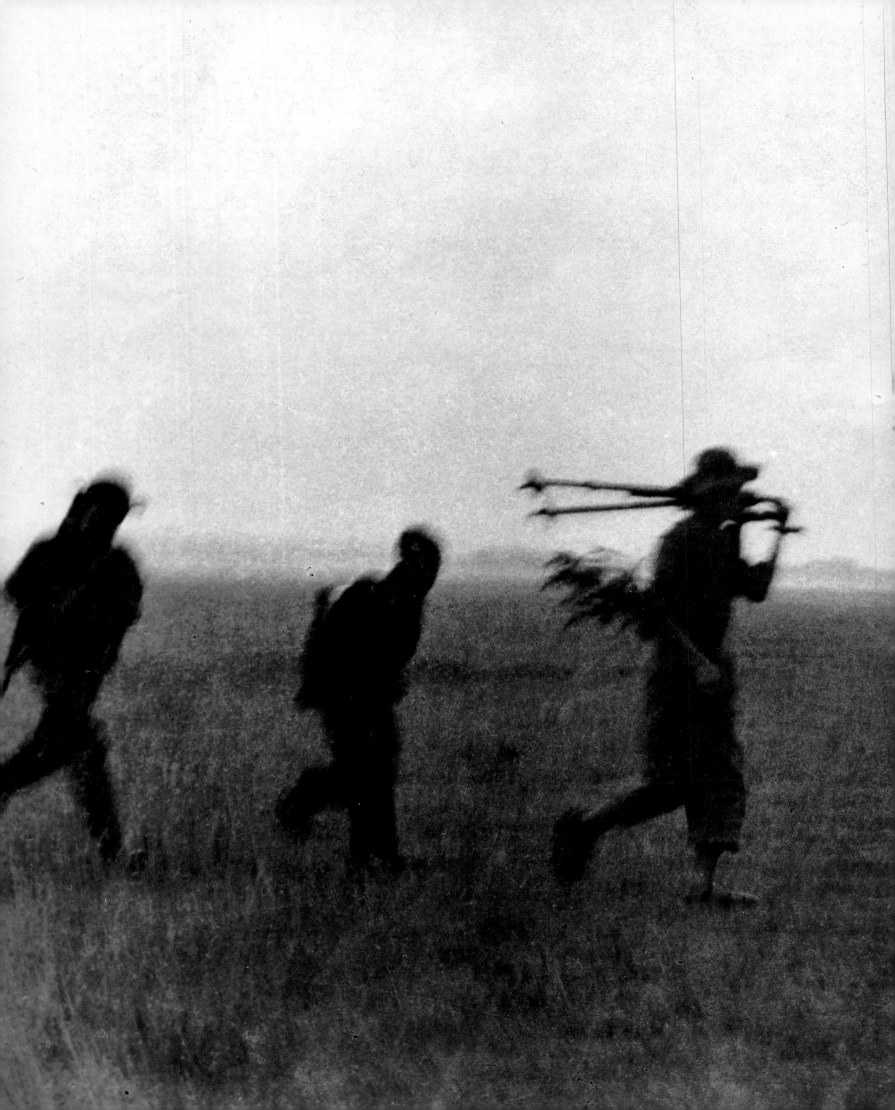

VO VAN QUY
Near Tay Ninh, Vietnam, 1969.
*Near the Cambodian border, a Viet
Cong mortar crew dashes across a
field at dawn. The first man carries
the mortar tube; the second, the
bipod; and the third, the baseplate.*
(LNA/VNA)

233

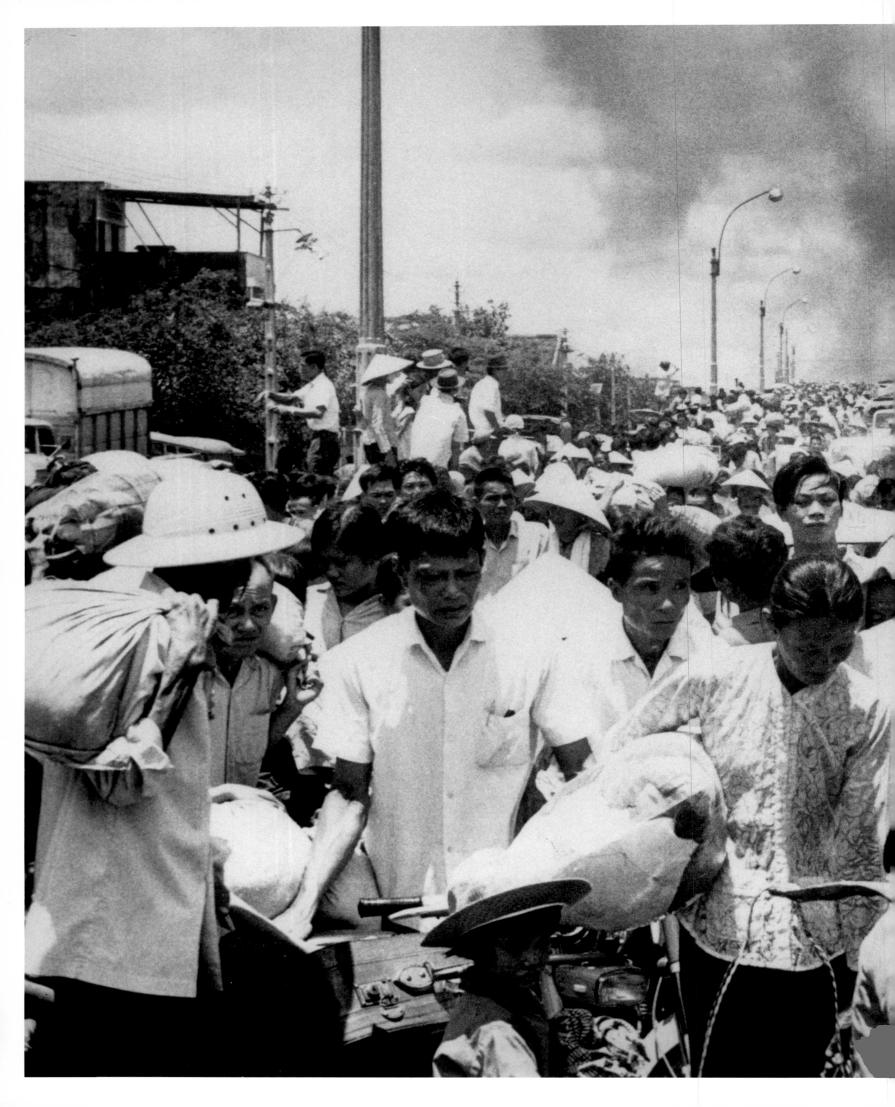

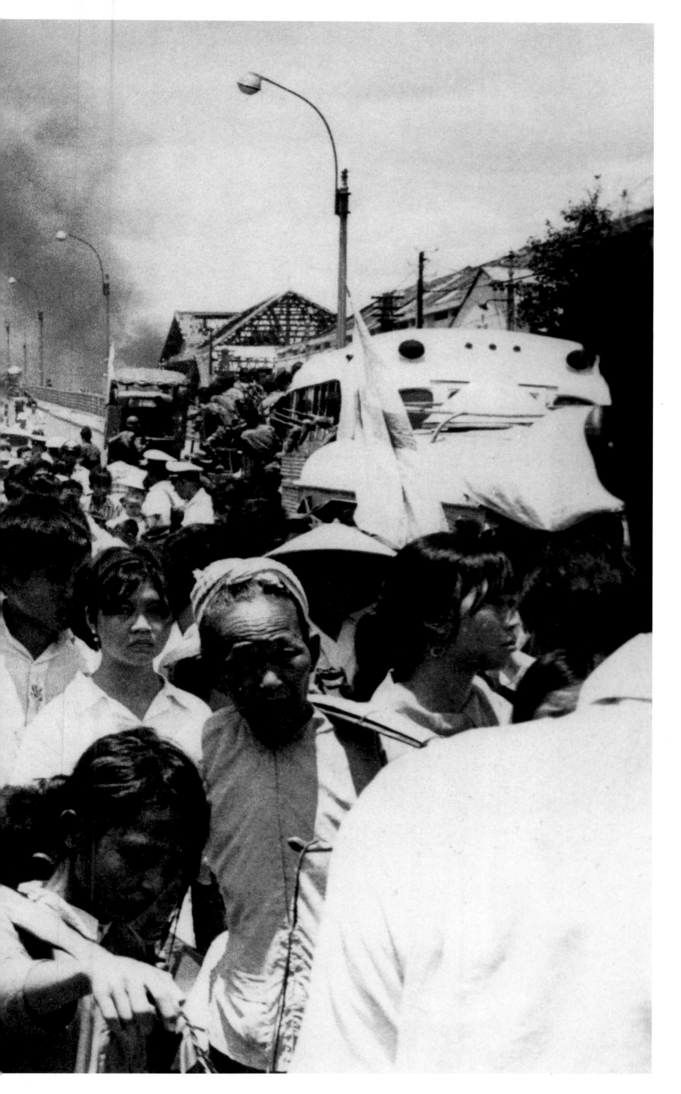

KENT POTTER
Cholon, Vietnam, 1968.
*Refugees from Saigon's Chinese
suburb cross a bridge to be
taken to refugee centers during
the second phase of the Tet
Offensive.*
(UPI)

235

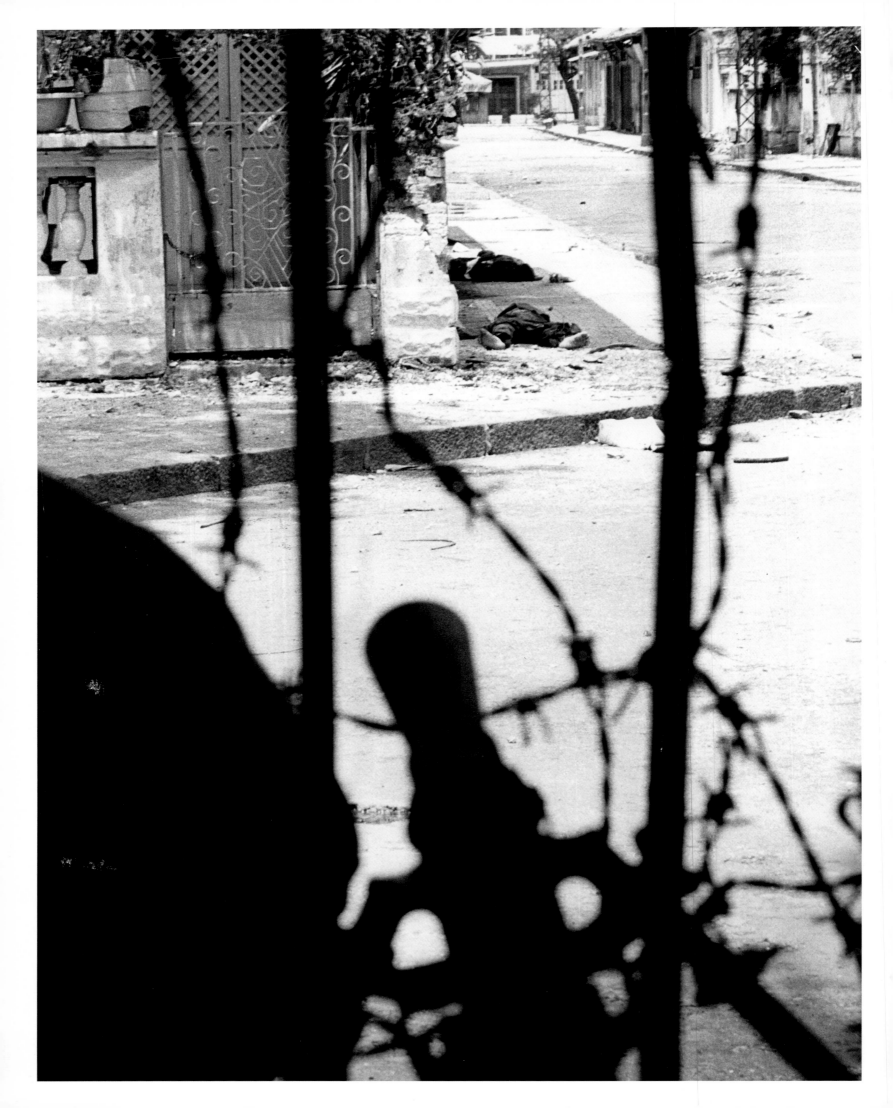

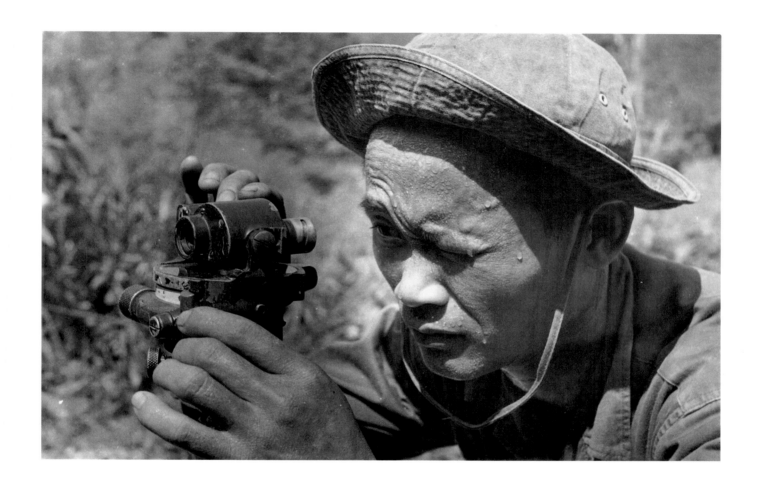

KENT POTTER
Cholon, Vietnam, 1968.
A .30-caliber machine gun points down at the bodies of two Viet Cong
who were killed during street fighting in the Chinese suburb of Saigon
during the second phase of the Tet Offensive.
(UPI)

LUONG NGHIA DUNG
Tich Truong, Vietnam, 1972.
Battery commander Tuy Duc Soi of the North Vietnamese army adjusts
the sights of a captured artillery gun. His head shows the scar of an
earlier war wound.
(VNA)

UNDER FIRE

The photographer Dana Stone gave this account from Khe Sanh on the newswire of United Press International on April 4, 1968.

The radio operator died quickly in the black, foggy night. Whatever sounds he made were drowned out by the screams of the wounded corporal and the rasping gurgle of the captain with the throat wound.

Of the five huddled figures in the bomb crater, only *Stars and Stripes* photographer John Olson and I were unhurt by the exploding shell the North Vietnamese had fired blindly Wednesday night at the ridgeline overlooking Khe Sanh town.

A few hours earlier Bravo Company of the First Air Cavalry Division had landed there without opposition.

At sundown a couple of Communist rounds landed below the ridgeline, in preparation for the night barrage. The first round of the barrage came about 10:30 P.M. It hurled out of the foggy night, exploding just below us.

Third salvo.

On the third salvo we flung ourselves into the crater. It was wet and black. The captain, a handsome, cigar-smoking West Pointer, worked the field radio with operators on either side. Repeatedly he shouted the code name for the rear battalion to report the incoming artillery. As he talked, the shell hit. The creeping barrage moved on, and the corporal began screaming for help. The captain couldn't talk.

The mortar platoon leader and a medic jumped into our refuge. Each man went to work immediately—the platoon leader attempting to call in a medical evacuation to save the lives of the radioman, the captain, and the corporal. The platoon leader shouted into the radio transmitter and frantically twisted the dials in an attempt to reach battalion headquarters, but only the wounded captain knew the correct frequency.

The medic placed the West Pointer along the side of the bomb crater on his stomach to slow the flood of blood, and the captain wrote out with a pencil stub the correct frequencies. The mortar men finally reached the rear and put in a plea for help.

Back came the reply that the fog made even the most urgent helicopter flight impossible.

Just waiting.

For the rest of that long, cold foggy night we just waited. With dawn the first gray light showed the sprawling body of the radio operator, who had died, unknown to us, from a gaping wound in his side.

Occasionally through the fog the helicopter could be heard groping for some hole in the mist.
A frantic voice broke into the helicopter circuit.

"I'm taking hits, I'm taking hits" came the cries from the pilot. "I have one man hit and I'm expecting an engine failure."

The contact broke.

By 9:00 A.M. the eyes attempting to stare away the fog saw a patch of blue sky, but then the mist swirled over the ridge again, blocking us out from the world.

An hour later there was another break, but the wind again blew the fog over the ridge. Finally the sun burned a big hole, and down through it came the olive drab helicopter, a most beautiful sight to the captain and the corporal.

DANA STONE
Con Thien, Vietnam, 1967.
A U.S. Marine under fire from North Vietnamese artillery.
(UPI)

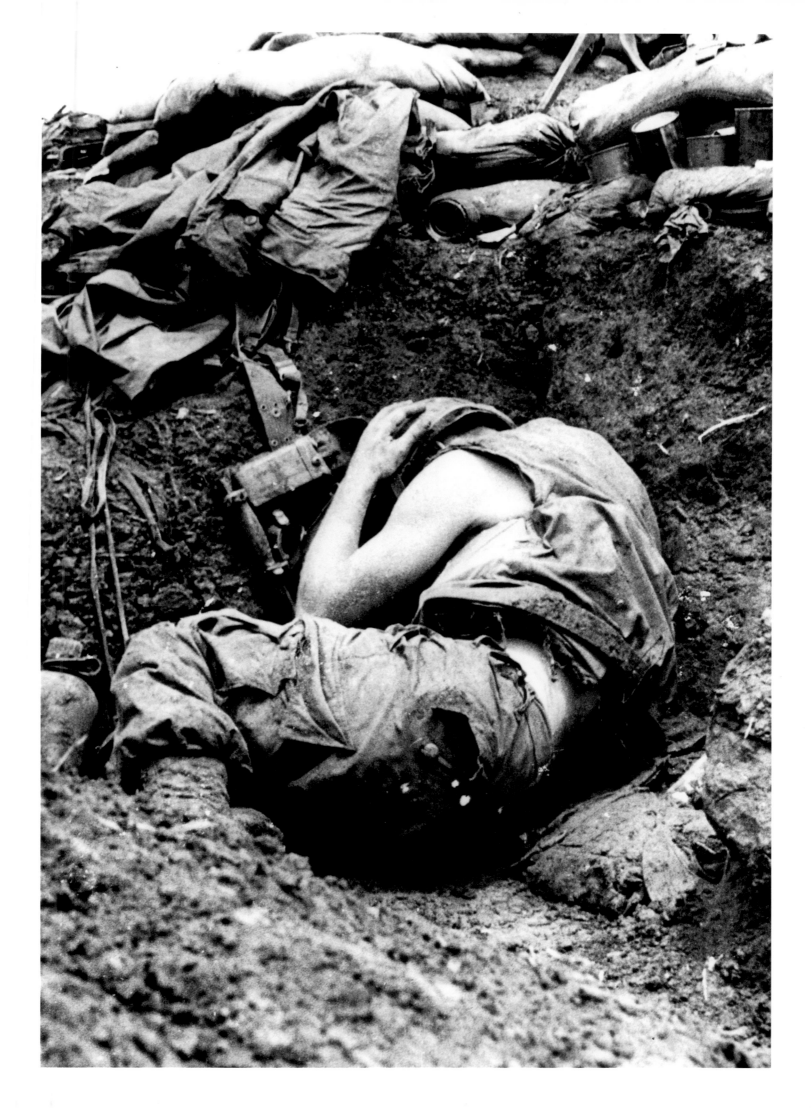

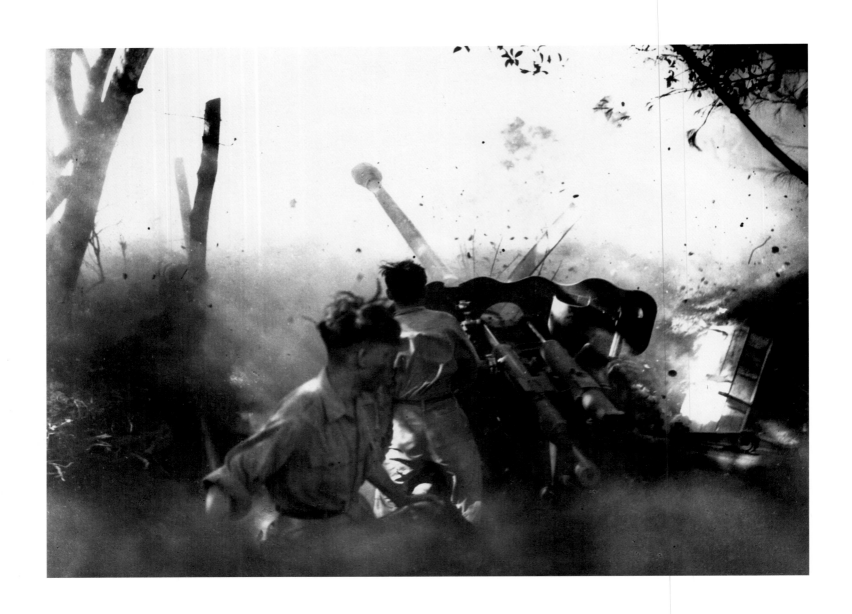

LUONG NGHIA DUNG
Vietnam, 1972.
Heavy artillery supports a North Vietnamese
offensive across the DMZ in Vinh Linh Province.
(VNA)

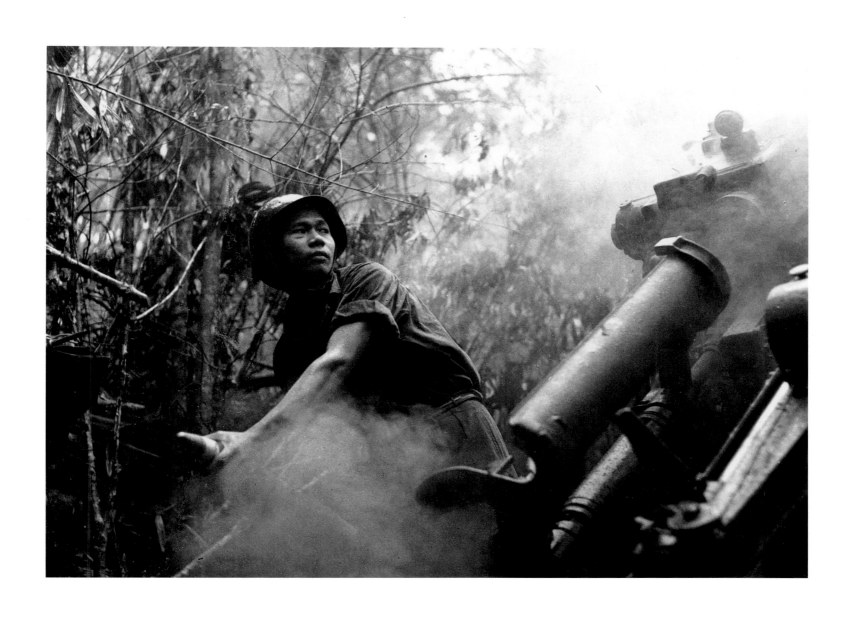

LUONG NGHIA DUNG
Vietnam, 1972.
A Soviet-made 130mm gun is loaded for action
just north of the DMZ, in Vinh Linh Province.
(VNA)

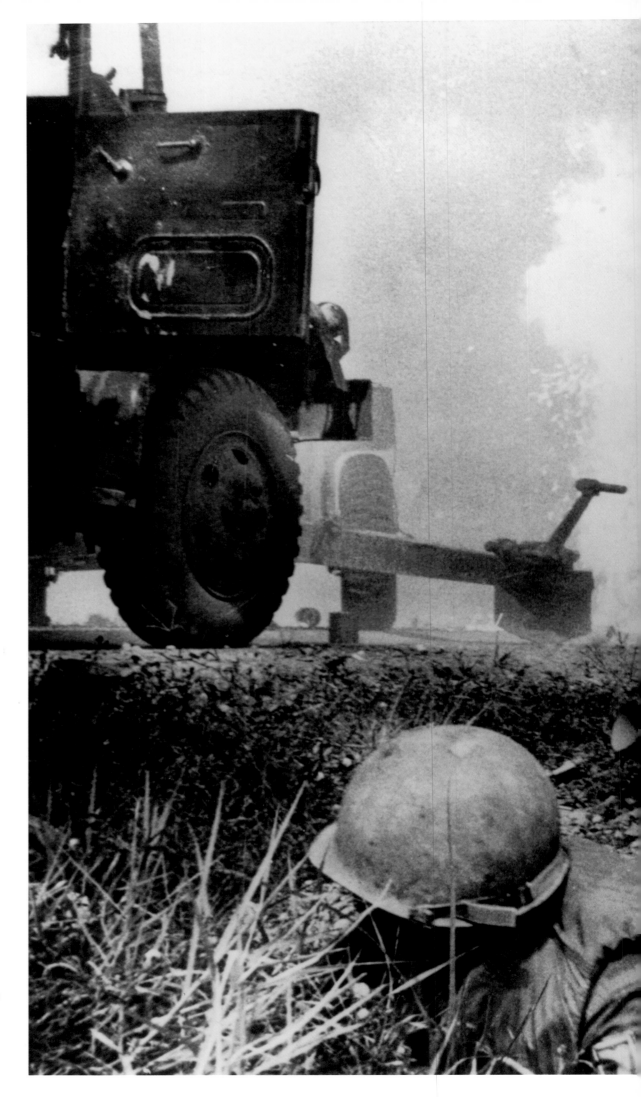

TAIZO ICHINOSE
Mekong Delta, 1972.
A South Vietnamese army convoy
ambushed by the Viet Cong southwest
of Saigon.
(UPI)

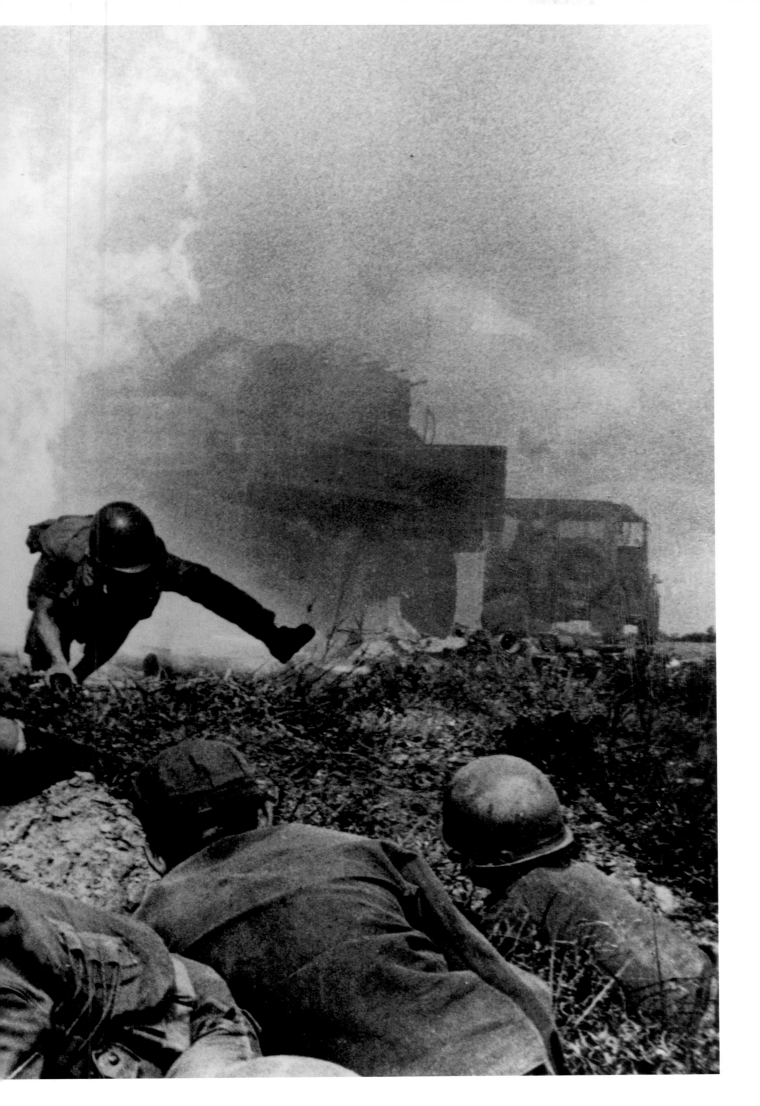

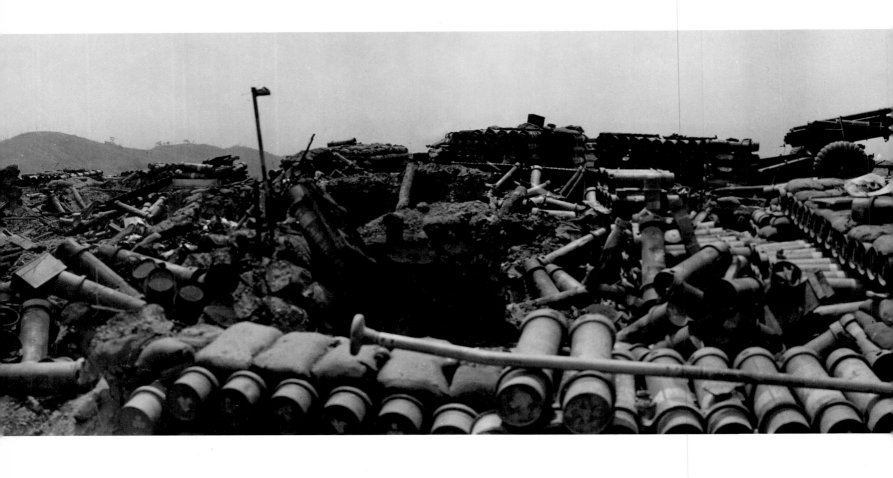

LUONG NGHIA DUNG
DMZ, Vietnam, 1972.
*This panoramic view, made up of four exposures, shows a South
Vietnamese army artillery firebase after it was overrun by soldiers of
the North Vietnamese army. The guns are still pointing northward.*
(VNA)

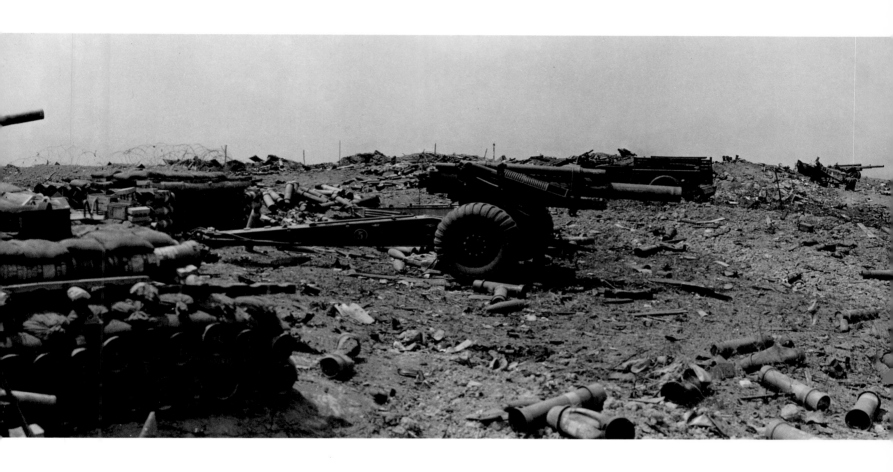

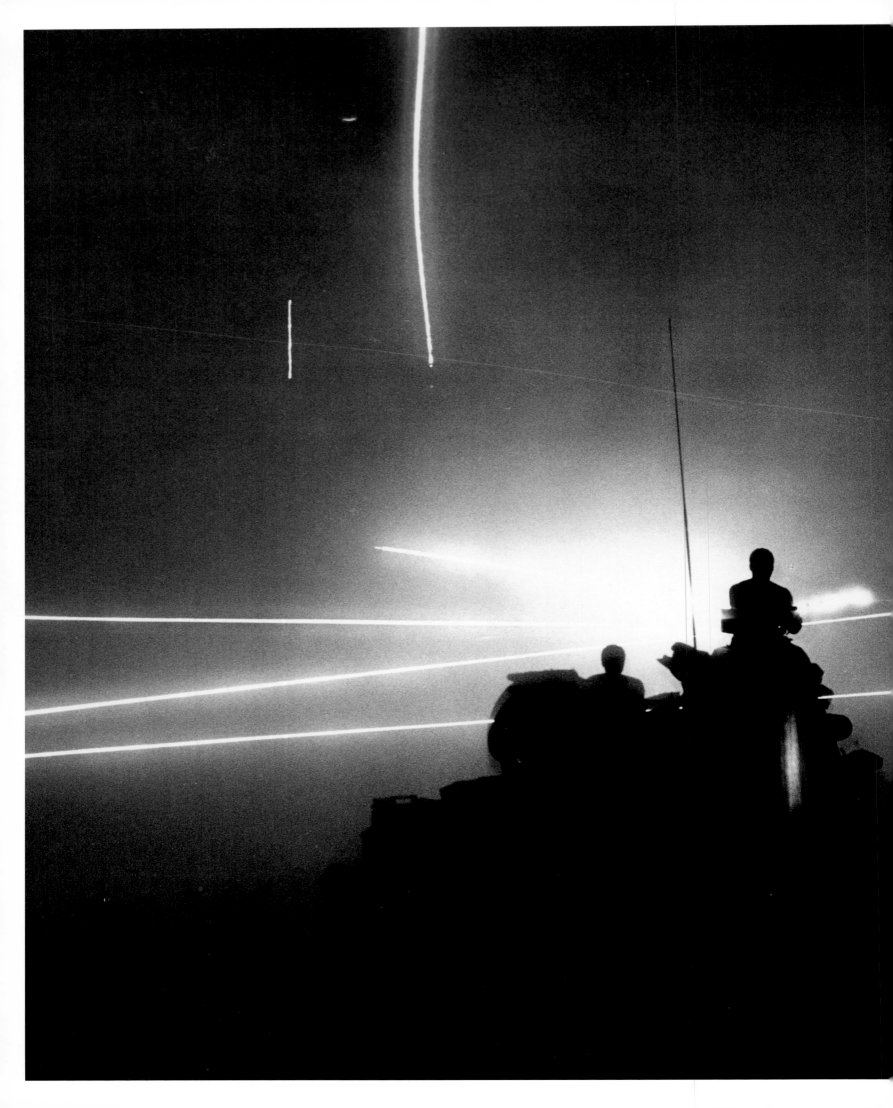

HENRI HUET
Cambodia, 1970.
*Soldiers of the U.S. Eleventh
Armored Cavalry Regiment spray
the area in an exercise known as
Mad Minute.*
(AP)

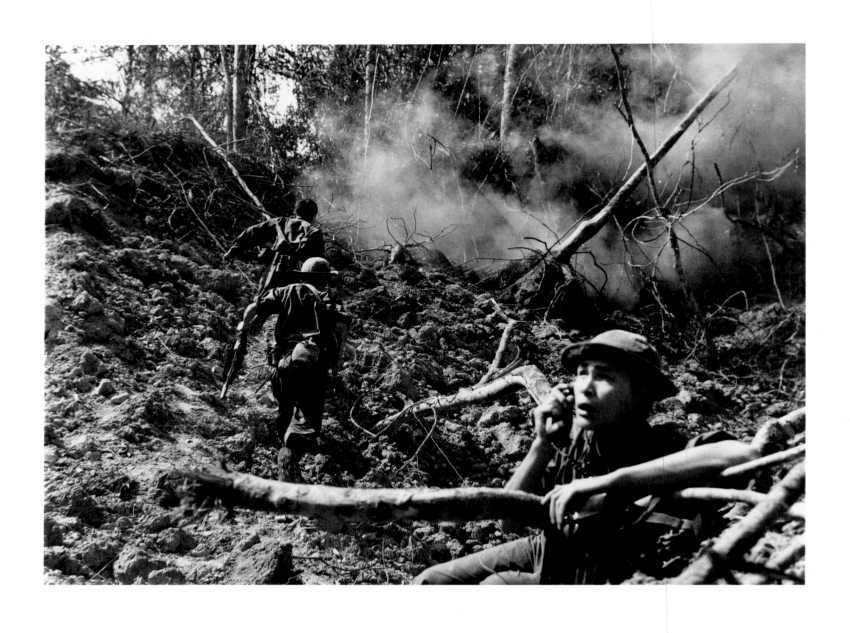

LUONG NGHIA DUNG
Vietnam, undated.
North Vietnamese radio operator.
(VNA)

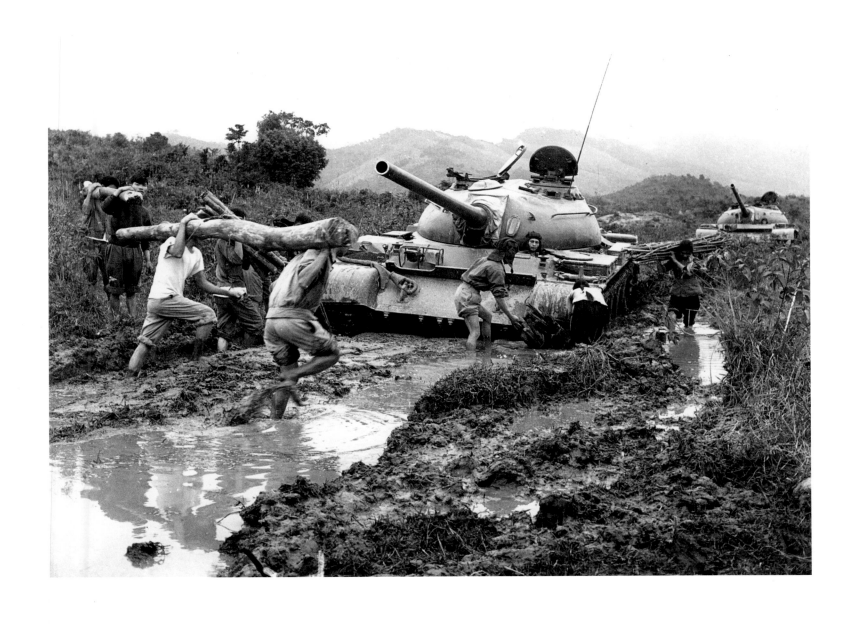

LUONG NGHIA DUNG
Ho Chi Minh Trail, Vietnam, 1972.
Soviet-made T-54 tanks bogged down in the mud.
(VNA)

LUONG NGHIA DUNG
South of the DMZ, Vietnam, 1972.
North Vietnamese infantry during
the offensive across the DMZ.
(VNA)

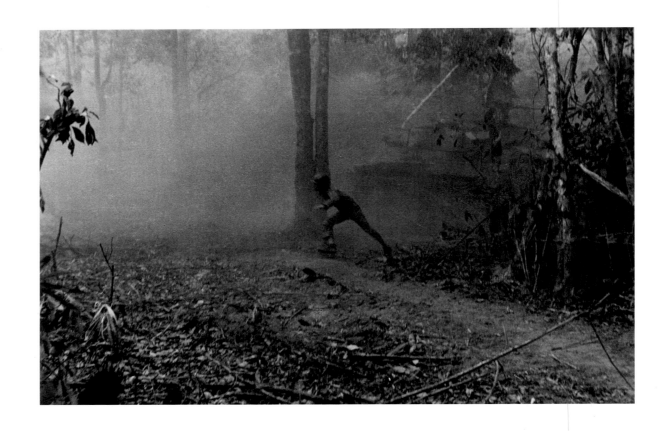

LUONG NGHIA DUNG
South of the DMZ, Vietnam, 1972.
During a battle along Route 9, a South Vietnamese soldier tries to run
away from his disabled tank, only to be caught by another explosion.
(VNA)

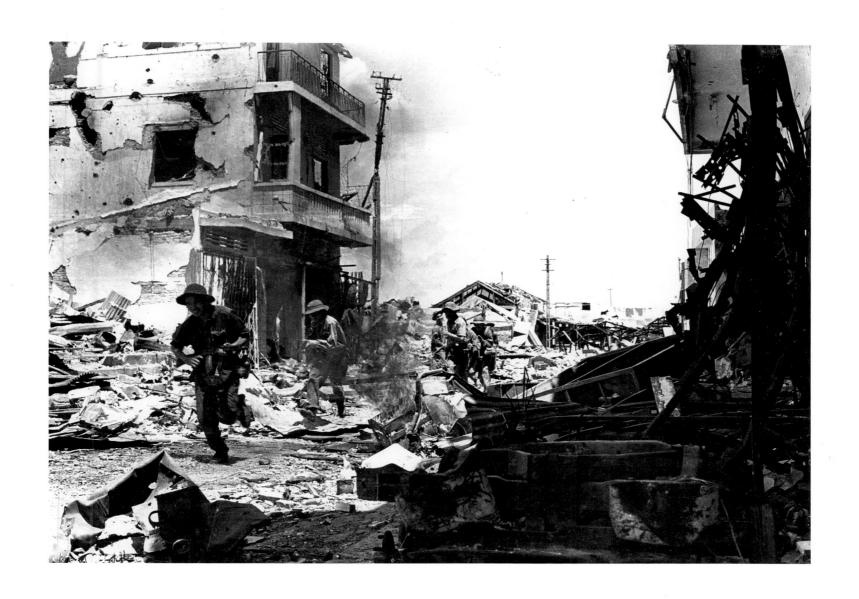

(pages 254 and 255)
LUONG NGHIA DUNG
South of the DMZ, Vietnam, 1972.
*North Vietnamese infantry capture a bridge in northern
Quang Tri Province, which retreating ARVN forces
failed to destroy during the 1972 Easter weekend.*
(VNA)

LUONG NGHIA DUNG
Quang Tri, Vietnam, 1972.
*North Vietnamese soldiers storm through the ruins of
Quang Tri, the provincial capital south of the DMZ,
which changed hands several times during a number
of attacks and counterattacks.*
(VNA)

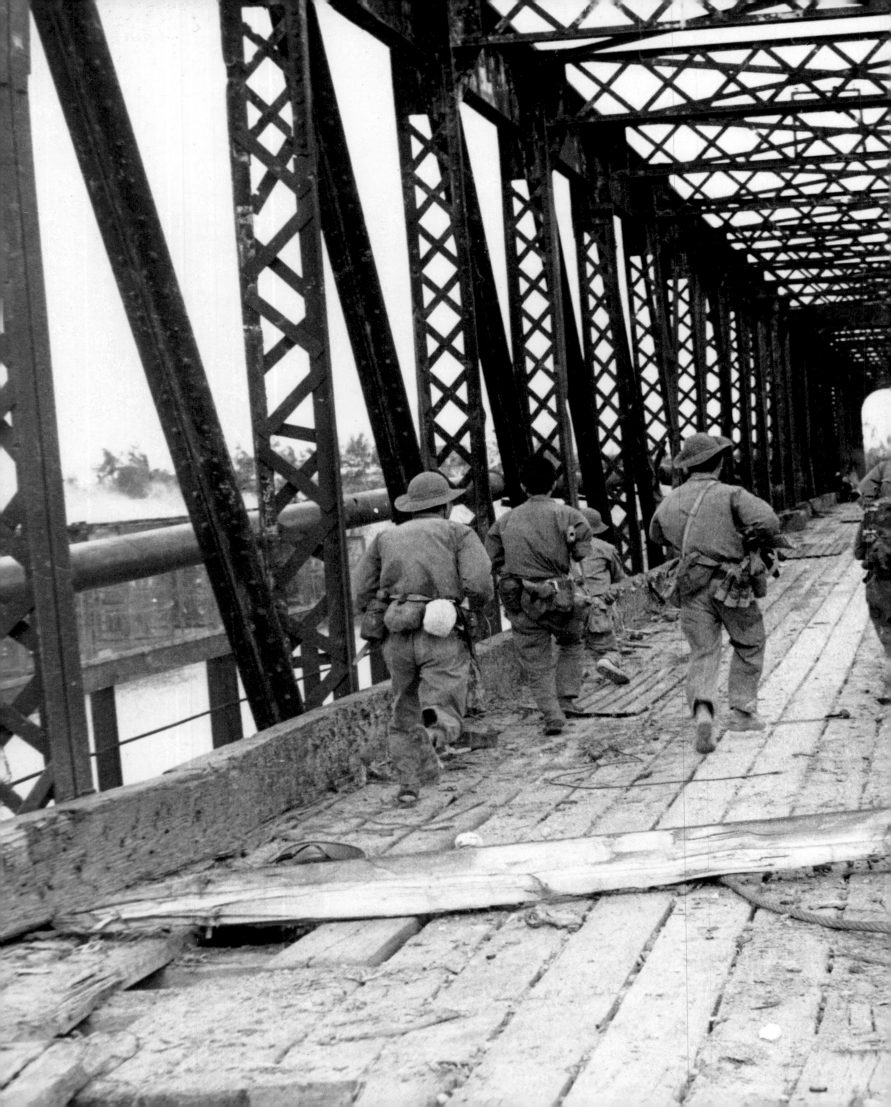

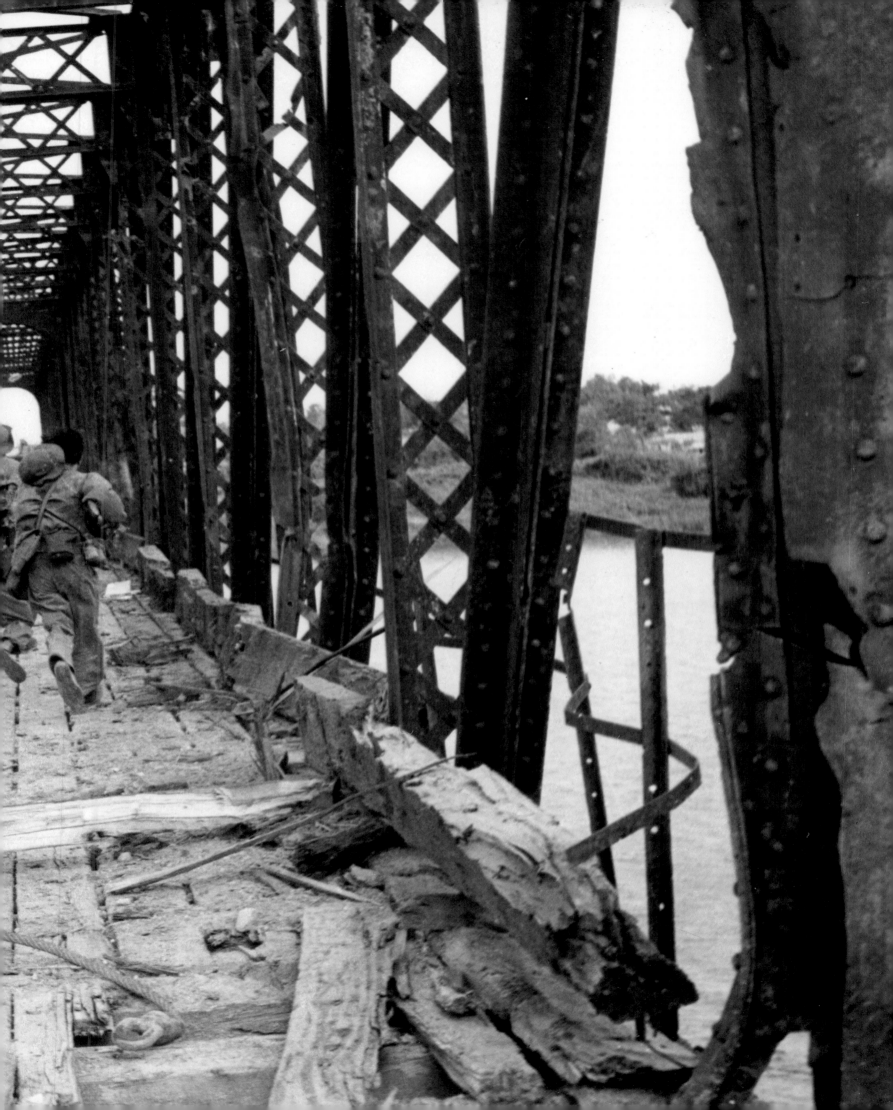

VIET CONG GUERRILLA

François Sully (1927–1971)

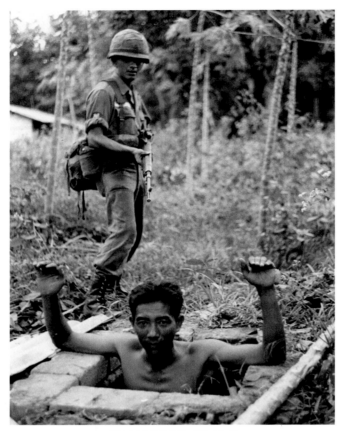

FRANÇOIS SULLY
West of Saigon, Vietnam, undated. (Sully Collection)

For eighteen-year-old Nguyen Van Loc, a guerrilla in the rugged mountains of central Vietnam, the war means hardship and hunger. His seven-man squad operates in a dense rain forest whose canopy shuts out light, leaving them in dampness and darkness.

His life is miserable, and only a deep faith in the revolutionary movement keeps him going so far removed from ordinary existence.

He joined the Liberation Front when his family was herded into a strategic hamlet to separate peasants from guerrillas. He hopes for the reunification of Vietnam under Communist rule. His morale is buoyed by daily propaganda reports that his squad hears on a transistor radio.

But Radio Hanoi's account of new factories and village cooperatives and laments by Chau Loan, who sings of the lovely Perfume River in Hue—all seem far from Loc's daily grind. For Loc suffers from chronic malaria. During the monsoon season the endless rainfall chills his fevered bones. His shivering limbs are attacked by the blood-sucking leeches.

Malarial mosquitoes are everywhere. To ward them off, his comrades smoke musty tobacco wrapped in tree leaves to form evil-odored cigars.

His dearest possession is a jute-fiber hammock and a sheet of blue plastic in which he wraps himself at night against rain and insects. So dense and dark are Loc's surroundings that his unit, housed in shacks roofed with the leathery leaves of wild banana trees, often loses track of day and night.

They move down rocky streambeds or on trails under thorny vines. One mission is to form an armed propaganda squad recruiting supporters from the primitive montagnard tribe, the Katu, so fiercely independent that French and Saigon governments have left them alone with their superstitions and sacrifices.

Loc tells them to fight against the government by planting booby traps and serving as guides, and Ho Chi Minh will grant autonomy for their tribe.

When Loc's team encounters government forces, they hide their weapons and play simple peasants looking for wild-bee honey and cinnamon bark. At night, if they hear unusual noises, they stop, squat on their heels, and slap their thighs in a prearranged code to see if the stranger returns a similar signal.

But Loc's main enemy is hunger, endless gnawing hunger. The squad subsists on green-skinned bananas and black yam roots. U.S. planes have defoliated their rare tiny rice patches. Troops keep rice from moving from coastal fields into the mountains. For six months Loc's squad lived on eight pounds of rice, carried in bags strapped across the chest.

Some days the only meal was a handful of rice spiced with red pepper or a small lime—with two grains of salt to ward off beriberi.

So to Loc's squad their most valued item, smuggled into the mountains and more precious than gold, is salt—simple sea salt.

From the papers of the François Sully Collection, Healey Library, University of Massachusetts, Boston.

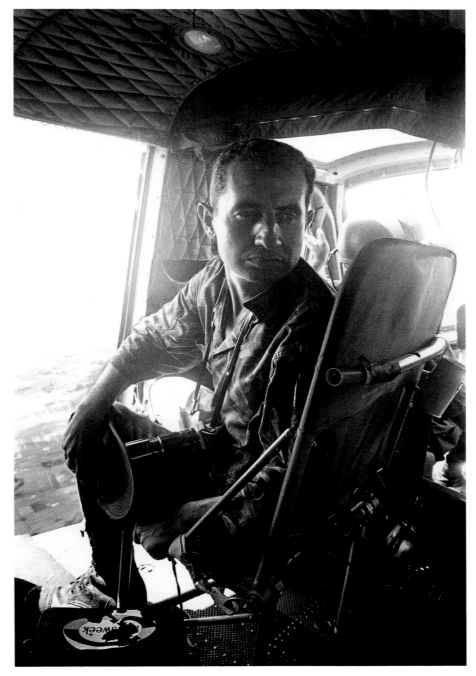

François Sully, Vietnam, undated. Unidentified photographer. (Sully Collection)

François Sully died in February 1971 near the Cambodian border when his helicopter blew up and he jumped seventy-five feet to the ground. With him died his old friend, the South Vietnamese general Do Cao Tri.

After twenty-four years in Indochina, François Sully knew all there was to know about the dangers of covering a war. Once, in a story he wrote after a bloody battle in the jungle near the Cambodian border, Sully summed up his feelings about living in the constant shadow of death. "The wounded are carried in one direction, hopefully toward recovery," went Sully's account. "The dead go another way. I walk to the

mess hall for a meal of the leftover beef. An old French war song comes back to me. '*Chacun son tour. . . . Aujourd'hui le tien, demain le mien*'—To each his turn. Today yours, tomorrow mine."

After his death, Sully's *Newsweek* colleagues went to his apartment in downtown Saigon, and there they found thirty-eight *Newsweek* cover pictures framed and hanging on his wall. Each one represented a story into which Sully had poured both gifted reporting and his love for the long-suffering people of Vietnam.

From the obituary of François Sully, Newsweek, *March 8, 1971.*

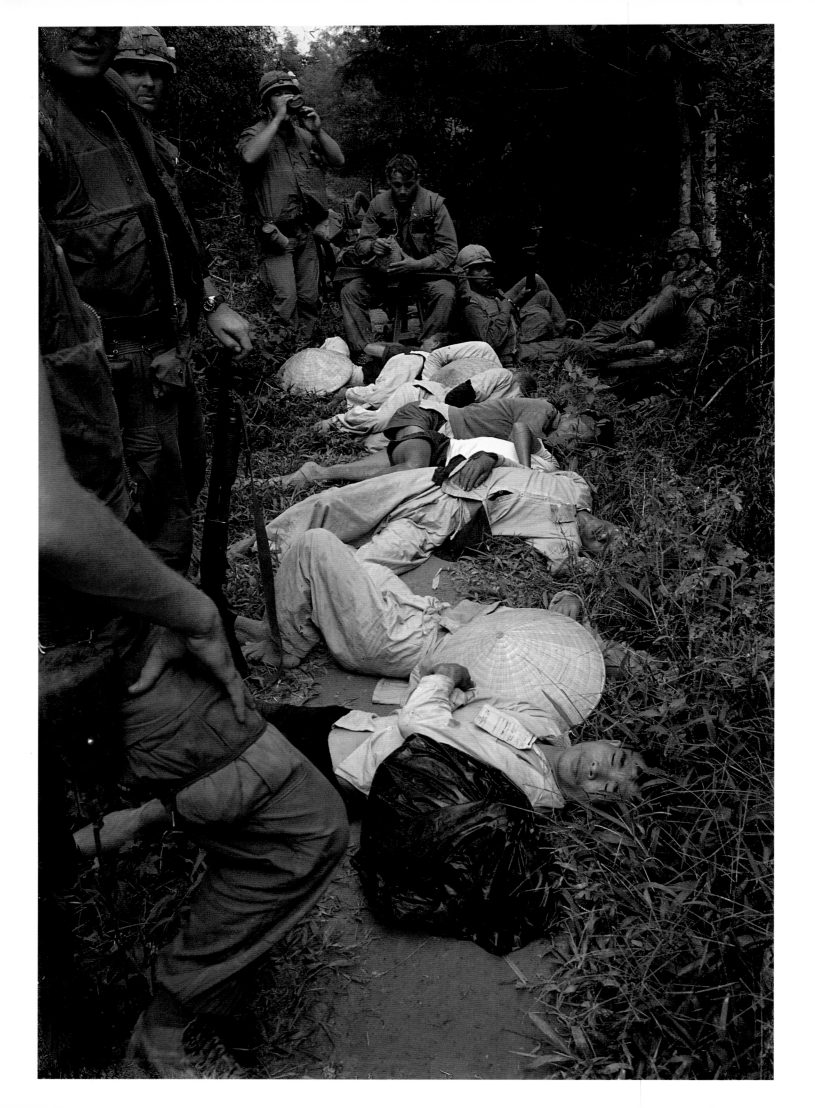

DO NOT FORGET THE MISSING

Peter Arnett

The year 1970, the worst year of the war for the international press corps.

Akira Kusaka and Yujiro Takagi of Fuji Television, missing April 5 on Cambodia Route 1 . . . the "easy riders," Sean Flynn of *Time* and Dana Stone of CBS, missing April 6 after riding their red motorcycles beyond Chipou . . . Dieter Bellendorf of NBC News, missing April 8 on Route 1 . . . Welles Hangen of NBC News, missing May 31 near Takeo—in all, seventeen journalists missing in just two months: three Americans, four French, seven Japanese, and one each Austrian, German, and Swiss.

They were victims of an eruption of hostilities in formerly hospitable Cambodia that followed the March 1970 coup d'état that ousted the government of Prince Norodom Sihanouk. Uniquely dangerous conditions for reporters and photographers sometimes made routine assignments to cover the widening war one-way trips to oblivion.

In addition to the missing, seven international journalists—three Americans, two French, one Indian, and one Japanese—died in eastern Cambodia in 1970 because of the uncertain military situation in the countryside. And there were many near misses as reporters persistently defied the odds and "ran the roads" to get the true story of the war. Roxanna Brown, an American freelancer in Cambodia, recalls talking with Kyoichi Sawada of UPI about a close shave he and reporter Bob Miller had had on May 23.

"They had been stopped at a Khmer Rouge roadblock at one-thirty in the afternoon, then put under guard in a village house for the afternoon. It was

PHAM VAN KHUONG
Vietnam, undated.
U.S. prisoners.

TERRY KHOO
Vietnam, undated.
Viet Cong prisoners.

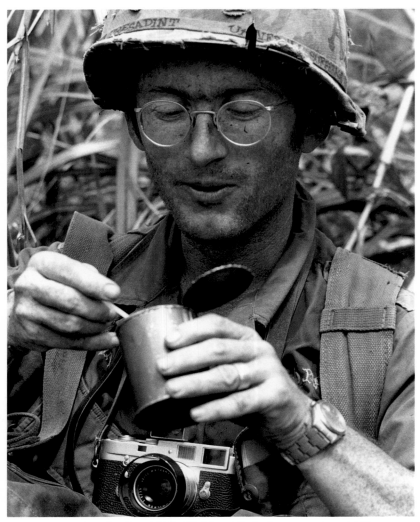

Dana Stone, Cambodia, 1970. Unidentified photographer. (AP)

Sawada who had the experience to realize that the guards had no ammunition for their guns; it was Sawada who decided simply to walk out and leave. This was the one time the normally reticent Sawada did talk. He bowed and talked and persisted. He explained they were unarmed journalists; they were there only to write about the war; they must return to Phnom Penh. Eventually, after dark, they were allowed to leave. But the next time they were not so lucky; Sawada and UPI reporter J. Frank Frosch were ambushed, captured, and shot on October twenty-sixth."

Former ABC correspondent Steve Bell says he owes his life to cameraman Terry Khoo. After their capture by Viet Cong guerrillas near Krek on April 16, a cadre offered to let Khoo and the other Asian staff leave while Bell would be kept as a "CIA agent." But Khoo refused and argued that they were all international journalists and that keeping Bell would make the Viet Cong look bad in the eyes of the world.

The argument worked. Terry Khoo was killed in Vietnam in 1972.

The catastrophic loss of journalists on Cambodia's roads galvanized relatives, news organizations, and the Phnom Penh press corps into action. Within a few days after the loss of Flynn and Stone, *Time* magazine announced that the heads of the North Vietnamese and Viet Cong delegations in Paris had pledged to investigate the disappearances of all the journalists up to that time.

Dana Stone's wife, Louise, began a tireless personal effort to free her husband, writing letters to the Vietnamese Communist liaison offices in Phnom Penh. She gave messages to officials and others traveling to Hanoi and began a long correspondence with deposed Prince Sihanouk, who was then residing in Beijing. And she traveled to Paris and India and anywhere else she could buttonhole visiting North Vietnamese and Viet Cong officials with pleas to free the journalists.

The Phnom Penh press corps organized a Committee for the Safety of Foreign Correspondents in Cambodia and conducted daily lobbying efforts with local authorities, quickly eliciting a communiqué from the Cambodian Ministry of Information that "strongly condemned before international opinion the kidnapping of foreign newsmen." Reporters made their own forays into the dangerous countryside, seeking their colleagues. Eventually, a petition signed by thirty-five committee members called on all belligerents to agree to a weeklong cease-fire in the war across all of Cambodia so that displaced people, including the seventeen missing journalists, could be allowed to return to their homes. *Newsweek* correspondent François Sully, who would die in February 1971 in a helicopter crash close to the Cambodian border, coordinated the efforts of the committee.

On September 30, 1970, the secretary-general of the United Nations, U Thant, made an official appeal on behalf of the missing journalists, which was followed by a General Assembly resolution expressing "grave concern" for the fate of reporters carrying out dangerous missions.

The international press community weighed in with unprecedented active support. An umbrella media group founded by five international associations of journalists in Geneva, the International Professional Committee for the Safety of Journalists on Dangerous Missions, announced it was seeking a visa for a delegation to visit Hanoi to "go to the help of our seventeen missing colleagues."

In France a Committee to Free Journalists Held in Southeast Asia sent a petition to Prince Sihanouk, signed by one thousand French journalists, asking him to use his good offices to free the missing.

In the United States, mainstream media organizations backed the formation of the American branch of the Committee to Free Journalists, chaired by Walter Cronkite of CBS News.

The U.S. committee concentrated on keeping the public spotlight on the issue and investigated the capture and incarceration of the missing. A booklet of photographs of the journalists with a full description of the circumstances of their capture—and efforts made to free them—was distributed to news organizations around the world.

The American committee was assisted by Zalin Grant, a freelance journalist acquainted with several of the missing, who established a liaison office in Phnom Penh and provided several detailed investigative reports that were shared with all those interested.

The American committee also made a determined attempt to involve U.S. officials in the search for the missing. Secretary of State Henry Kissinger was personally asked by Walter Cronkite to carry messages to Hanoi's Le Duc Tho and China's Chou En-lai, and he complied.

Walter Cronkite was particularly active in trying to push the U.S. government into action. In a 1973 letter to members of the committee, Cronkite complained that Kissinger had been more responsive in his private meetings with the committee than in his written communications with the Communist side. "The delicacies of diplomacy may have dictated the language in the letter, but it appears to be remarkably aloof from any real commitment to our cause. It is

Sean Flynn, Vietnam, 1968. Dana Stone.

clearly necessary for a subcommittee to call again on Dr. Kissinger at the earliest opportunity to see much stronger representation than this," Cronkite wrote.

From the beginning, hopes for the missing journalists were slim because of the brutal nature of the war in eastern Cambodia. But there were enough available clues to suggest that some of them might still be alive, reason enough to push ahead with efforts to free them all. Seven journalists—four Americans and three French—had been held for three to seven weeks in 1970 by Communist forces and then released. Widespread publicity given to the capture of journalists was believed to have played a role in their good fortune. The circumstances of most of the captures suggested that most of the missing had made it through the risky first few minutes and were handed over to regular military forces, improving their chances for survival. Various field reports over the years concerning the seventeen missing—and the several others captured later in the war—gave specific details that could not be ignored, nor could they be verified.

The North Vietnamese and the Viet Cong continued to the end of the war to deny knowing anything about the missing, even as more journalists

continued on page 263

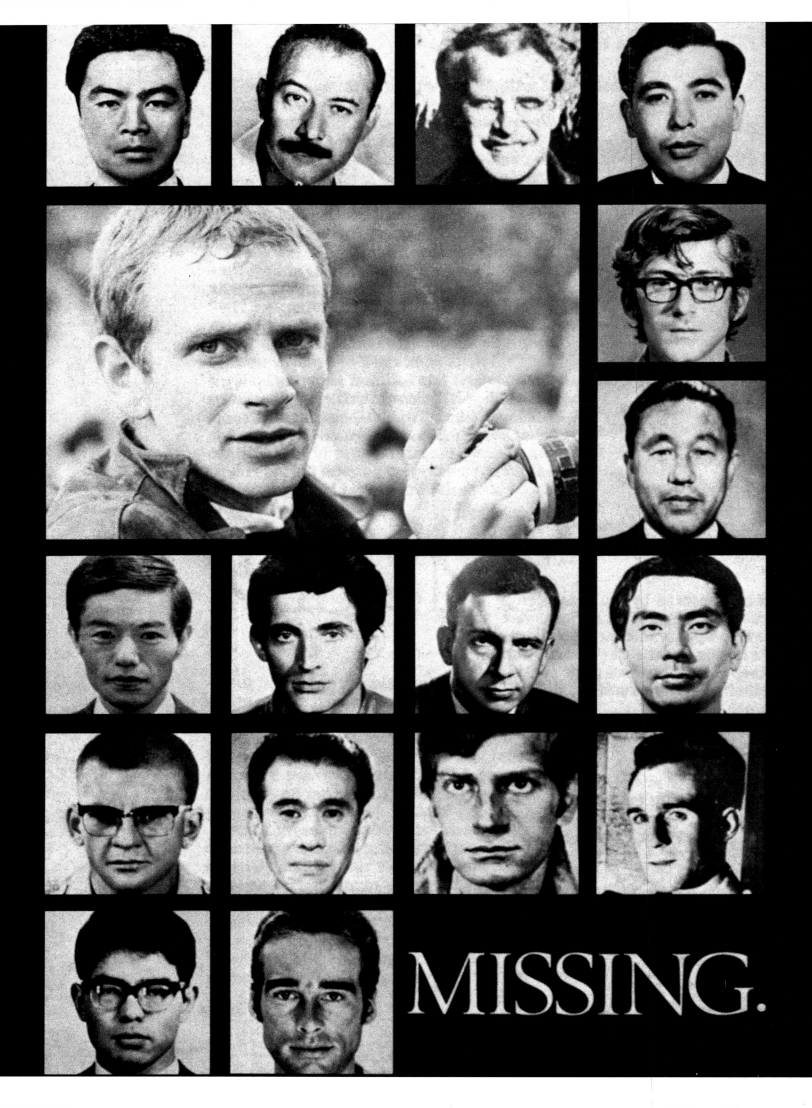

MISSING.

MISSING IN CAMBODIA

Opposite is the cover of a pamphlet published in 1970 by the American Committee to Free Journalists Held in Southeast Asia. It was dropped over Cambodia in 1970 in an effort to locate and free seventeen journalists who were missing. From top to bottom:

TAKESHI YANAGISAWA, Japanese, correspondent for *Nihon Denpa News*. Missing in southern Cambodia, April 1970.

GILLES CARON, French, photographer-reporter, Gamma agency, Paris. Captured in April 1970 on Cambodia Route 1 near Vietnam's border.

YUJIRO TAKAGI, Japanese, cameraman for Fuji Television. Captured April 5, 1970, on Cambodia Route 1 near Vietnam's border.

DIETER BELLENDORF, German, cameraman for NBC News. Captured April 8, 1970, on Cambodia Route 1.

TERUO NAKAJIMA, Japanese, on assignment for the Omari Research Institute of International Affairs. Captured April 29, 1970, place unknown.

ROGER COLNE, French, sound technician, NBC News. Captured May 31, 1970, en route to Takeo, Cambodia.

CLAUDE ARPIN, French, photographer-reporter on assignment for *Newsweek* magazine. Captured April 5, 1970, on Cambodia Route 1 near Vietnam's border.

TOMOHARU ISHII, Japanese, cameraman for CBS News. Captured May 31, 1970, en route to Takeo, Cambodia.

SEAN FLYNN, American, freelance photographer-reporter on assignment for *Time* magazine. Captured April 6, 1970, on Cambodia Route 1 near Vietnam's border.

GEORG GENSLUCKNER, Austrian, freelance photographer-reporter. Captured April 8, 1970, near Svay Rieng, Cambodia.

WELLES HANGEN, American, correspondent for NBC News. Captured May 31, 1970, en route to Takeo, Cambodia.

GUY HANNOTEAUX, French, correspondent for *l'Express*, Paris. Captured April 6, 1970, on Cambodia Route 1 near Vietnam's border.

AKIRA KUSAKA, Japanese, correspondent for Fuji Television. Captured April 5, 1970, on Cambodia Route 1 near Vietnam's border.

DANA STONE, American, freelance cameraman on assignment for CBS News. Captured April 6, 1970, on Cambodia Route 1 near Vietnam's border.

KOJIRO SAKAI, Japanese, sound technician for CBS News. Captured May 31, 1970, en route to Takeo, Cambodia.

YOSHIHIKO WAKU, Japanese, cameraman for NBC News. Captured May 31, 1970, en route to Takeo, Cambodia.

WILLY METTLER, Swiss, freelance photographer-reporter. Captured April 16, 1970, near Kampot, Cambodia.

were captured after the horrible year of 1970. Among them were Terry Reynolds, an American writer-photographer with UPI, and Alan Hirons, an Australian freelancer, both missing since April 1972, and the Japanese photographer Taizo Ichinose, who disappeared on the route to Angkor in November 1973.

The many efforts to involve Prince Sihanouk in the search on the Cambodian Khmer Rouge side brought no tangible results. In the fall of Phnom Penh in April 1975, the Western journalists in the Cambodian capital barely escaped with their lives, a fate denied the local journalists, many of whom worked for the Western agencies and television companies.

A score of photographers died in the killing fields. Only Dith Pran, a translator for *The New York Times*, was known to have survived.

Cambodia has only recently begun yielding the secrets of the missing journalists, with the bodies of some of their number uncovered from shallow graves in the vicinity of Route 1.

The brutal Cambodian conflict was a new kind of war for the world's media, with no clear line between safety and danger on the battlefield and with heightened press competition because of improved means of communication, particularly in television and photojournalism. It set the stage for nearly three decades of similarly dangerous conflicts with high press casualties, from Beirut to Central Asia to Somalia and Chechnya—nearly three more decades of running the dangerous roads to get the story.

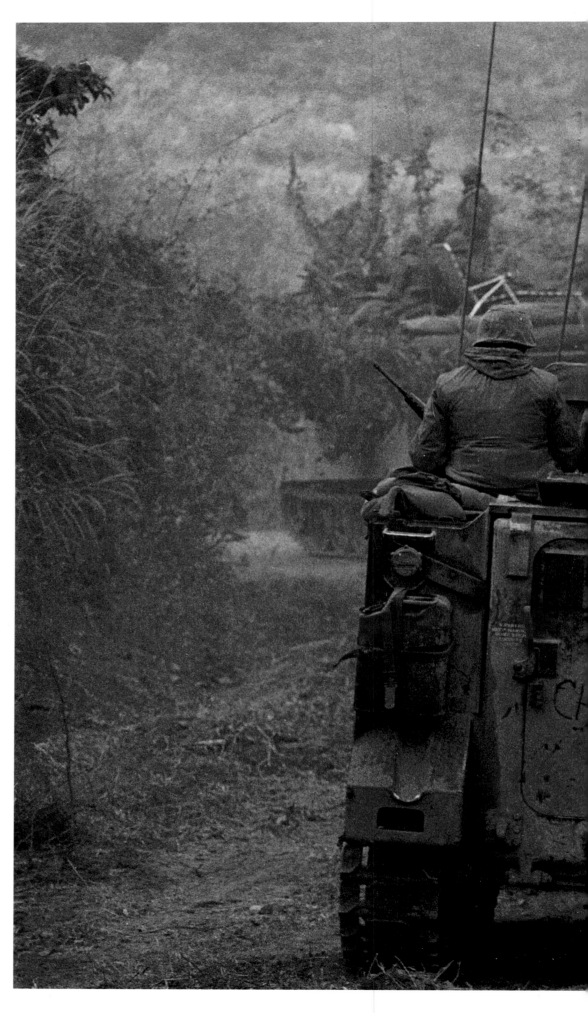

Envelope with handwritten captions
by Henri Huet. Inside were his last rolls
of film sent to Saigon in February 1971.
(AP)

HENRI HUET
Near Lang Vei, Vietnam, 1971.
*Last roll of film. U.S. soldiers ride on
armored personnel carriers toward Lang Vei
Special Forces camp, half a mile from the
Laotian border. The Americans had to clear
Route 9 to the Laotian border for the South
Vietnamese invasion into Laos.*
(AP)

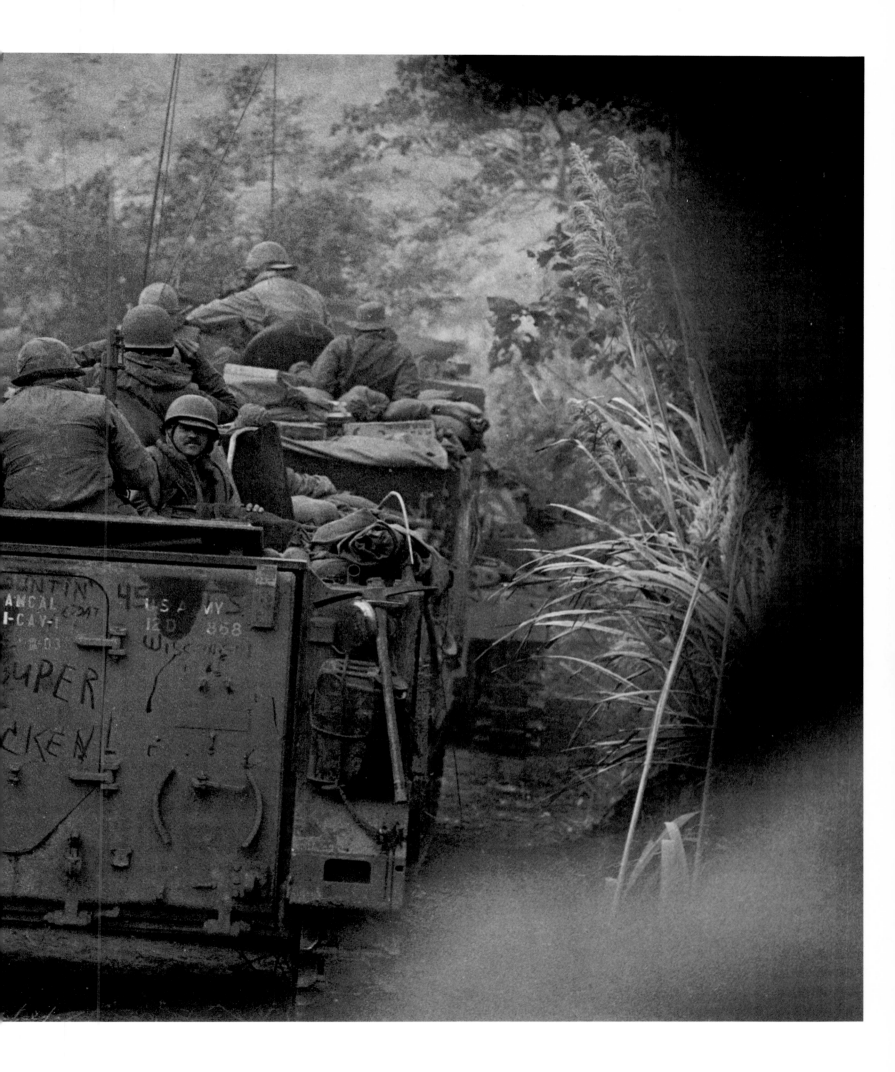

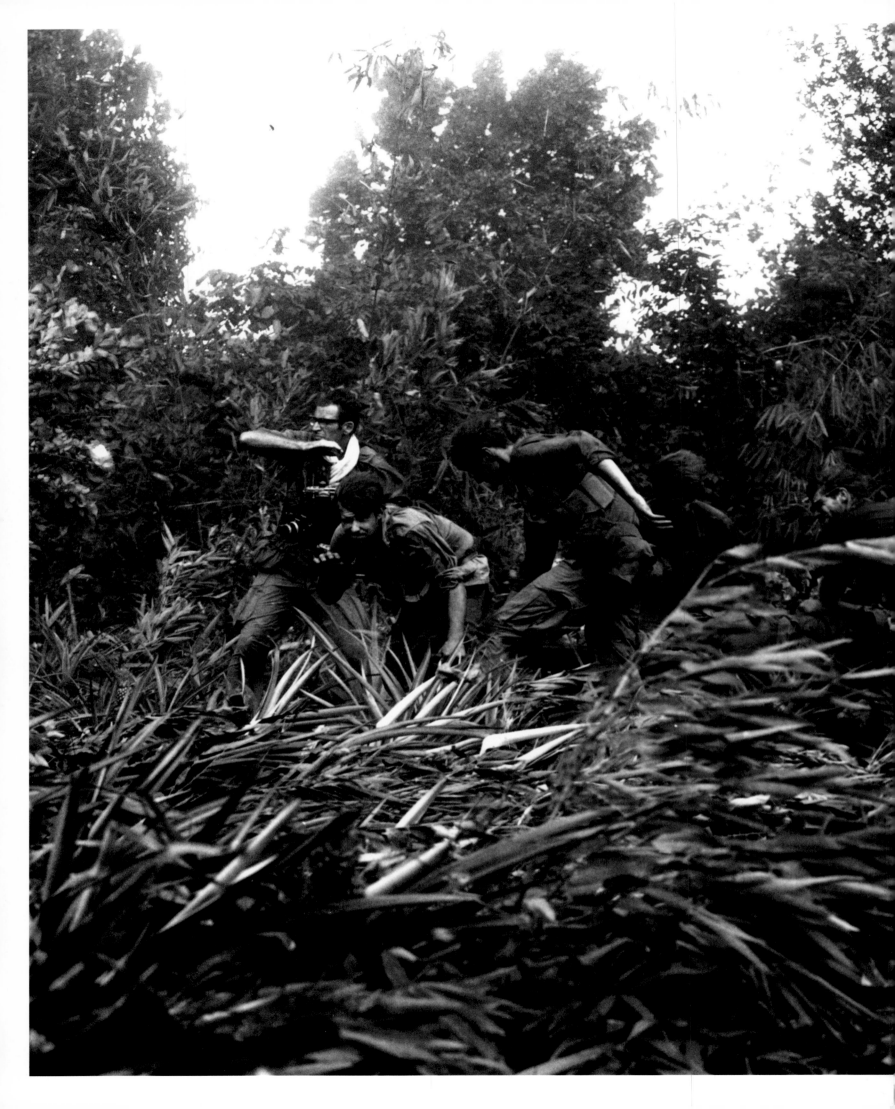

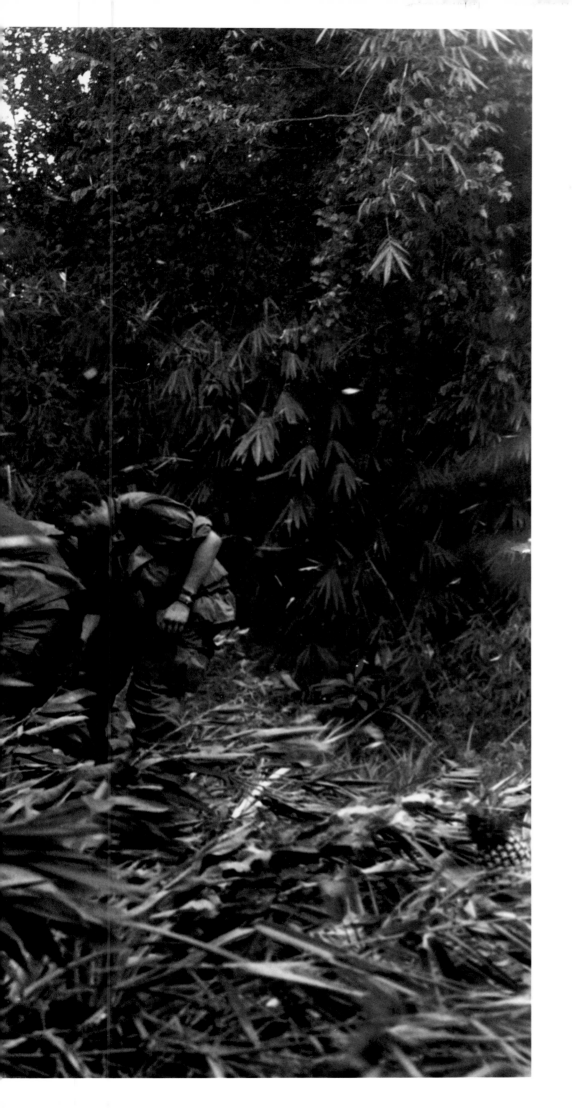

HENRI HUET
Mimot, Cambodia, 1970.
Larry Burrows helps GIs carry a wounded soldier
to an evacuation helicopter during the U.S.
incursion into Cambodia.
(AP)

sai-

new york

gallagher. following is as complete and accurate account

~~IN LAOS~~

of helicopter crash involving henri huet as we are ~~likely to get~~ ABLE (AT THIS TIME.)

is based on interview with major james a. newman, commander of [mike putzel]

c troop, 2nd battalion, 17th cavalry of 101st airborne division,

on 13 feb 1971, at khe sanh, and other information.

five arvn helicopters left forward command post inside HAM NGHI

south viet border about noon 10 feb, departure witnessed by several

other newsmen. lead chopper carried lt. gen. hoang xuan lam,

commander 1st military region, others his staff and press.

aboard one of choppers were henri huet, associated press; larry

burrows, life magazine; kent potter, upi; keisaburo shimamoto,

newsweek; sgt. tu vu, arvn photographer; col. nhat, military region

G-3, lt. col vi, G-4, and crew of four.

helicopters ~~visited~~ went first to firebase hotel, arvn firebase

and first of three firebases lam

inside laos, ~~xxxxxxxxxxxxxxxxxxxxxxxxxxxxxxxxxx~~ intended to visit.

HIM

(putzel says huet told ~~him~~ before leaving ham nghi that ~~xxx~~ he

and other photographers intended to stay aboard to go to all three

firebases, then try to be landed with advance element of arvn troops

on route 9.) ~~horse pyle~~

Telexed message sent to New York by Richard Pyle, the Saigon bureau chief for The Associated Press, February 1971.

(AP)

HELICOPTER SHOT DOWN

Richard Pyle

Richard Pyle was the chief correspondent of The Associated Press in Saigon from 1970 to 1973.

Urgent

Photographs precede, undated, Saigon (AP) – A South Vietnamese helicopter carrying four civilian news photographers was shot down over the Ho Chi Minh Trail in Laos on Wednesday, apparently killing them and seven other persons aboard.

Among those missing and presumed dead . . .

The story on The Associated Press's main newswire was dated February 10, 1971.

Over a static-filled line from Quang Tri, near the DMZ, AP reporter Mike Putzel delivered the news.

Then the names: Henri Huet, forty-three, The Associated Press; Larry Burrows, forty-four, *Life* magazine; Kent Potter, twenty-three, United Press International; Keizaburo Shimamoto, thirty-four, *Newsweek*.

As I took the call in the AP's Saigon bureau, other staff members gathered around. In silence, their faces spoke: "Oh no, please. Not Henri."

Operation Lam Son 719, Saigon's biggest military gamble of the war, was in its second week—a massive invasion of Laos aimed at cutting the jungle road network that supplied North Vietnam's armies in the south.

For the first time the Saigon press corps had been barred from the front. The Americans, now in a supporting role, refused to carry journalists, and South Vietnamese officers were reluctant to do so. But after days of waiting at the Route 9 border crossing, the quartet of determined photographers had finally won permission to accompany the operation commander on a tour of forward bases, after which they hoped to link up with the forward-most South Vietnamese troops.

The first stop was uneventful, but on the second leg, the general's helicopter made an unexpected turn. The other four continued north, soon be-

The last picture of the photographers boarding the helicopter on February 10, 1971.
Sergio Ortiz, Ham Nghi, Vietnam, 1971.

came lost, and flew into the sights of a North Vietnamese 37mm antiaircraft gun hidden on a jungle ridge.

From several miles away American pilots saw the danger and radioed warnings. But as they watched, the lead helicopter exploded in a fireball. Seconds later another lost its main rotor, "dropped like an egg," and crashed in flames.

Venturing as close to the crash site as they dared, the American fliers reported only a barren smear on a jungle hillside and "no indication of any survivors."

The loss at one stroke of four of the war's best-known combat photographers was a devastating blow—to the Vietnam press corps and to photojournalism. Nowhere was it felt more deeply than in the AP's Saigon bureau, where the portraits of three other AP photographers previously killed in Vietnam graced one wall.

Knowing it could happen again was not the same as being prepared for it.

Born in Vietnam of a French father and Vietnamese mother, Henri Gilles Huet learned photography in the French army and spent the rest of his life using it to tell Vietnam's story—first as a naval and aerial cameraman in the French Indochina War of the 1950s; between the wars, with the U.S. Information Agency; finally, with the South Vietnamese and their American allies.

Like Larry Burrows, Huet was a winner of the Robert Capa Award for courageous reporting under fire. We joked that he'd spent more time pinned down

in rice paddies than most journalists had spent in Vietnam. "Henri goes to war the way other people go to the office," a colleague once observed.

In the field Henri Huet was savvy, self-sufficient, and skilled—the quintessential Vietnam journalist. His Leica M2s and Nikon Fs recorded not just the soldier's ordeal but his humanity. He also filled his frames with the ordinary people of Vietnam and had what one editor called "a love affair with the landscape."

Among his ardent admirers was Burrows, who in 1966 urged his own *Life* editors to use a series of pictures taken by Huet during a bloody firefight. They did, putting one on the cover.

Returning from the field, his fatigues caked with the *terre rouge* of Vietnam, Huet would turn in his film, then sit at a typewriter and laboriously transcribe his notes for the news side. No other reporter was more careful to get the names and home addresses, no other photographer had more byline stories.

While friendly and cheerful, Huet was also a private man who saw little need to explain himself. Yet in rare moments of candor he spoke of having deeper emotional ties to Vietnam than to the French heritage he openly embraced, and he admitted, after years of close calls and a serious leg wound, to one great fear: helicopters.

Kent Potter, a talented and gutsy Philadelphia native, had joined UPI in 1963 at age seventeen, winning several local news-photo awards before being assigned to Vietnam in 1968. By 1971, he had been transferred to Bangkok but still spent much of his time on Vietnam assignments.

Keizaburo Shimamoto, a Japanese born in Seoul and educated at Tokyo's prestigious Waseda University, had covered Vietnam since 1965 for the Pan-Asia Newspaper Alliance of Tokyo, the Paris-based Gamma agency, and as a freelancer.

The crash also killed Sergeant Tu Vu, a Vietnamese army photographer, two staff officers, and the helicopter's four-man crew.

U.S. attack bombers destroyed the antiaircraft gun the next day, but the crash site was beyond immediate reach. It lay smack in the middle of the Ho Chi Minh Trail network, about nine miles west of the Vietnam-Laos frontier and nine miles north of Route 9.

Saigon did order a contingent of specially trained Hoc Bao jungle fighters to try to recover documents carried by the dead staff officers, and a U.S. general said it would take "at least a week" for friendly forces to reach this site in rugged, hostile territory. There were no reports that any ever got there. Whether Communist forces did is not known.

Thus for more than two decades the jungle itself remained the silent custodian of the undiscovered graveyard. In 1995 a researcher for the U.S. Joint Task Force (JTF) Full Accounting, set up in 1963 to seek the remains of some twenty-two hundred American MIAs in Indochina, contacted The Associated Press after finding the crash mentioned in old war records. The fact that one U.S. citizen was involved—even though a civilian—was legitimate grounds for adding it to the MIA list as case number 2062.

Using grid coordinates and other data dug from old AP bureau files, search teams failed to find the site on their first attempt. A later try yielded the rusted debris of an antiaircraft gun—possibly the one that had destroyed the helicopters nearly twenty-five years earlier.

During the third foray, on June 8, 1996, the village chief of Ban Tai Loi, Savannakhet Province, told members of the JTF team about a nearby crash site and then led them to it. On the ridge just north of the Xe Sa Mu River, within an area of one thousand square feet, between tall elephant grass and the hillside jungle trees, at map coordinates X-Ray Delta 559553, they reported finding "wreckage consistent with a UH-1," shards of bone, part of a multi-pocketed vest and pieces of 35mm film, its emulsion long since eroded away.

Judging that this was "probably" the site of case 2062 and that there was a "high probability" that human remains would be recovered, the site was marked for future excavation—most likely within a year.

Meanwhile, the bone shards were tagged and stored at the army's Central Identification Laboratory at Hickam Air Force Base in Hawaii, the tattered vest and film in separate plastic bags in cardboard box number 30 in a metal locker at JTF headquarters at nearby Camp Smith.

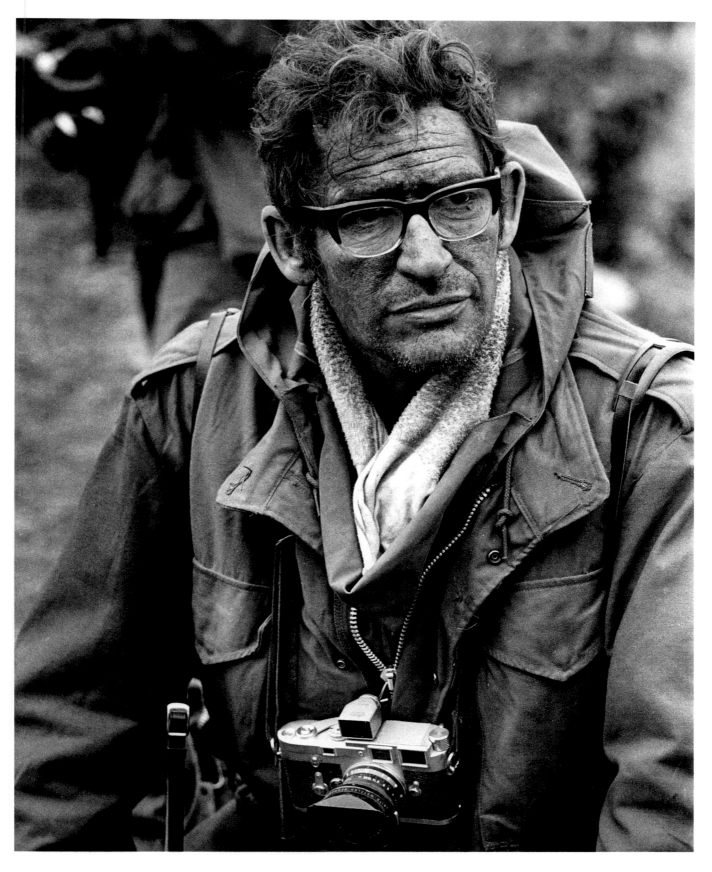

Larry Burrows covering his last story, "The Edge of Laos,"
three days before he was killed in the helicopter crash in Laos.
Roger Mattingly, Laotian border, 1971.

(pages 272 and 273)
LARRY BURROWS
Khe Sanh, Vietnam, 1968.
An ammunition airlift.
(*Life*)

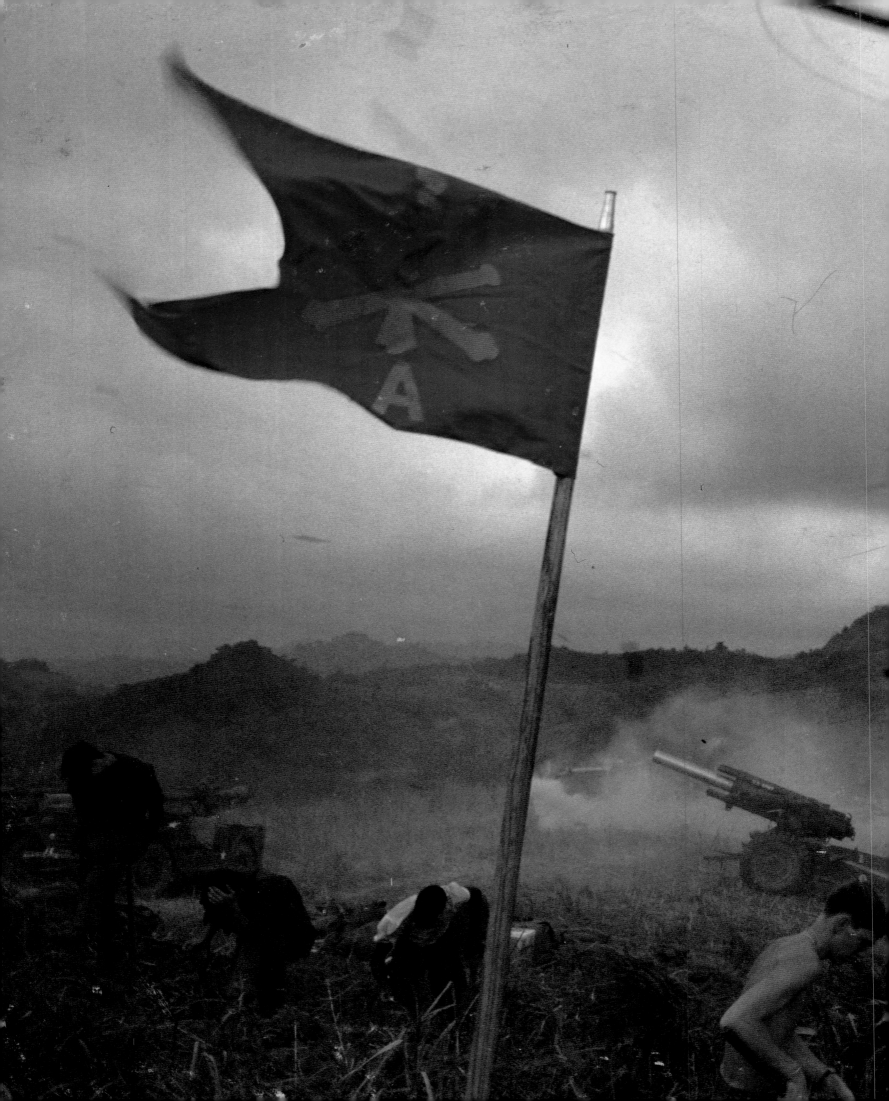

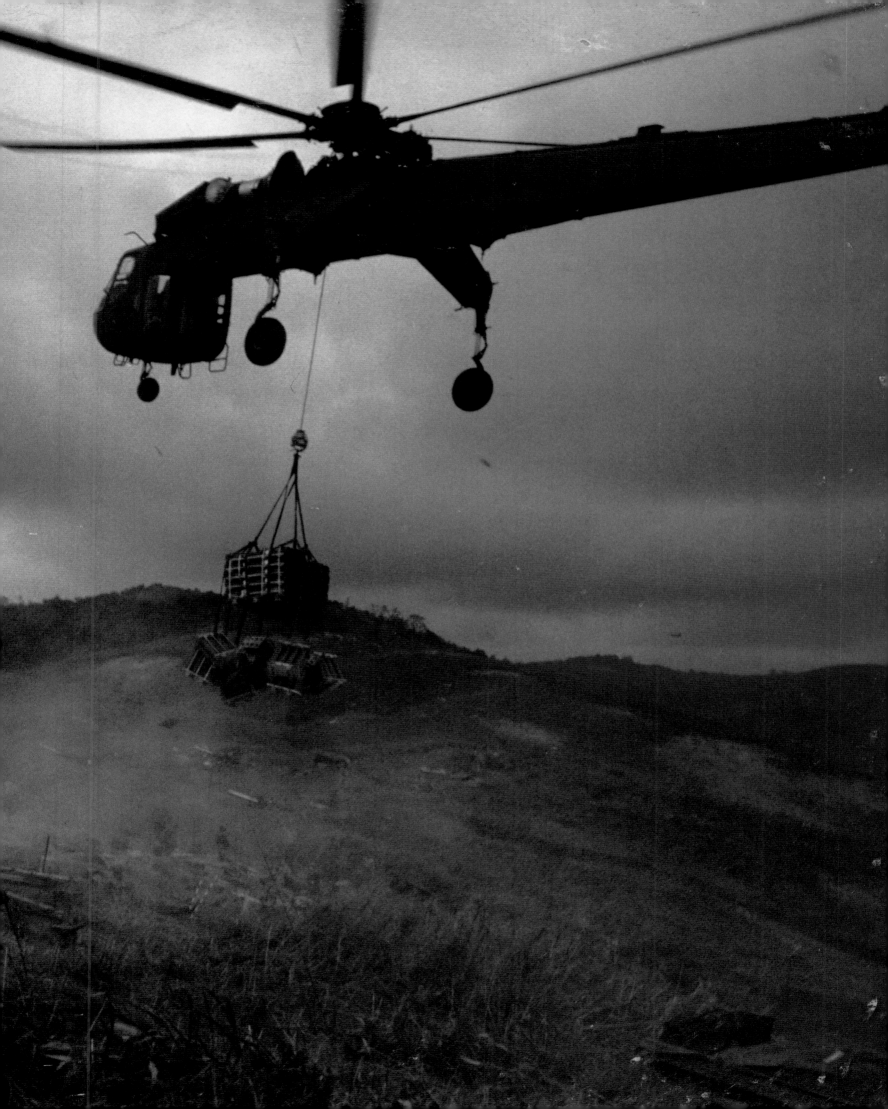

5 FINAL DAYS

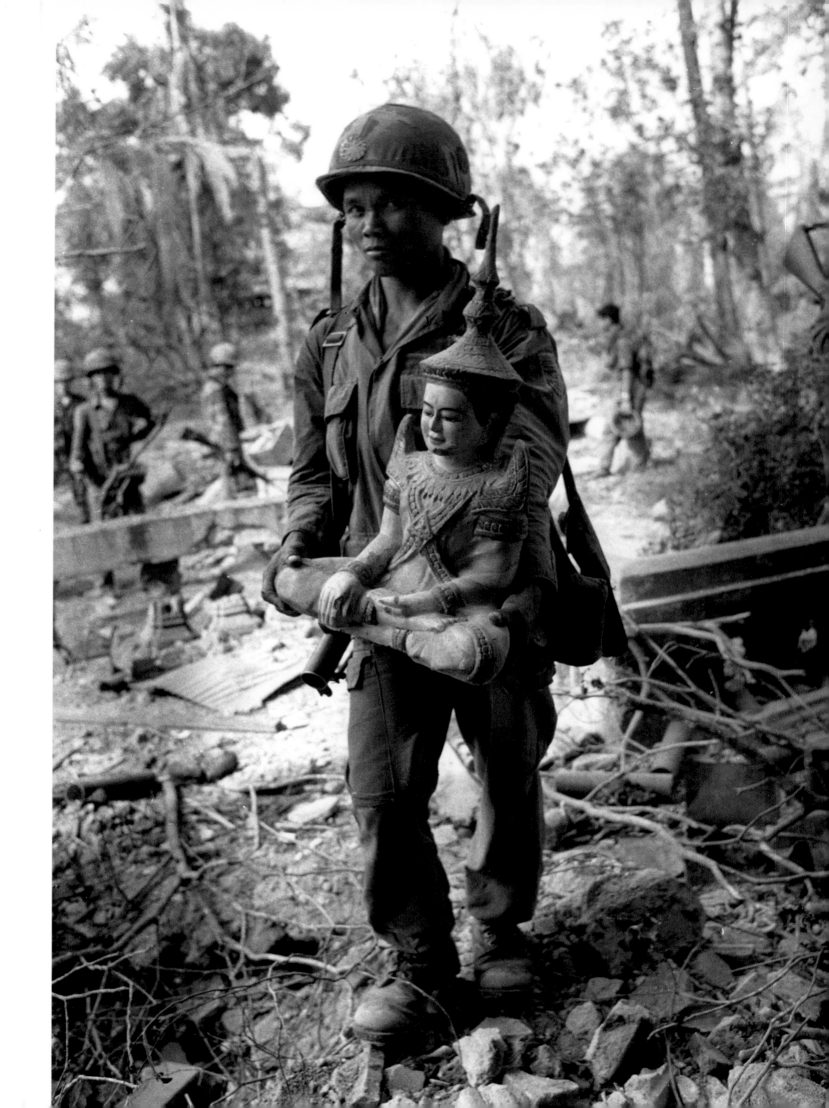

SIDESHOW—THE WAR IN CAMBODIA

Jon Swain

Jon Swain, special correspondent for The Sunday Times *(London), was in Phnom Penh when the city fell to the Khmer Rouge in April 1975.*

Cambodia during the war was the hardest and toughest of all the Indochinese countries to work and live in. The death toll for journalists and, especially, photographers was exceptional. The photographers were always prepared for the dangers inherent in their profession and often too absorbed by the war to be afraid of combat. But Cambodia was the first modern conflict where almost every journalist, photographer, television correspondent, and cameraman to fall into the hands of the Khmer Rouge was killed. The war was a sideshow to Vietnam, and there were critical differences in how it was fought and covered.

The Cambodian army was a tattered rabble from the start. It went to war in gaily painted buses. Its soldiers were often barefoot. Many were pathetically young—twelve-year-old boys who had been scooped off the streets of Phnom Penh and given three days' token training and the latest American weapons. They were capable of being insanely brave, but the officers who commanded them were incompetent, employing World War I tactics against some of the best guerrilla forces in the world.

The greatest mistake ever made about Cambodians was to believe that they were gentle. Behind the famous Khmer smile of the tourist brochures was a savagery and a cruelty that were breathtaking. Those traits showed themselves almost from the start in a pogrom against the Vietnamese.

At the beginning of the war in Cambodia, in April 1970, when old ethnic hatreds boiled over, the Cambodians massacred thousands of Vietnamese whose families had lived in the country for generations, and they cast their bodies into the Mekong to float downstream past Phnom Penh. Such a slaughter made Cambodia resemble an Asian Congo.

But Cambodia had been the last bastion of neutral independence in Indochina, an oasis of peaceful peasant existence. As the fighting in Vietnam intensified in the late 1960s, its neutrality was tragically abused. First it became the entry point for military supplies from North Vietnam to the Viet Cong, the Communist forces in South Vietnam. Then, in 1969, President Nixon authorized the savage and secret B-52 bombing of the sanctuaries of the Viet Cong and North Vietnamese Communists inside Cambodia's borders with South Vietnam.

Finally, in March 1970, Lon Nol, the rightwing defense minister, overthrew Prince Norodom Sihanouk and took Cambodia into the Vietnam War on the side of South Vietnam and the United States. Sihanouk sided with the small bands of Cambodian Communists who later became known as the Khmer Rouge and with the Communists in Hanoi.

The war was bitter and inglorious. Lon Nol's American patrons were incapable of controlling the corruption, waste, and incompetence of his army commanders. A U.S. military drive in eastern Cambodia to destroy the Communist sanctuaries and help protect the U.S. withdrawal from South Vietnam was a disaster for Cambodia.

The war spread across the land. One by one the provinces fell or became insecure, and in no time Phnom Penh was cut off from much of the rest of the

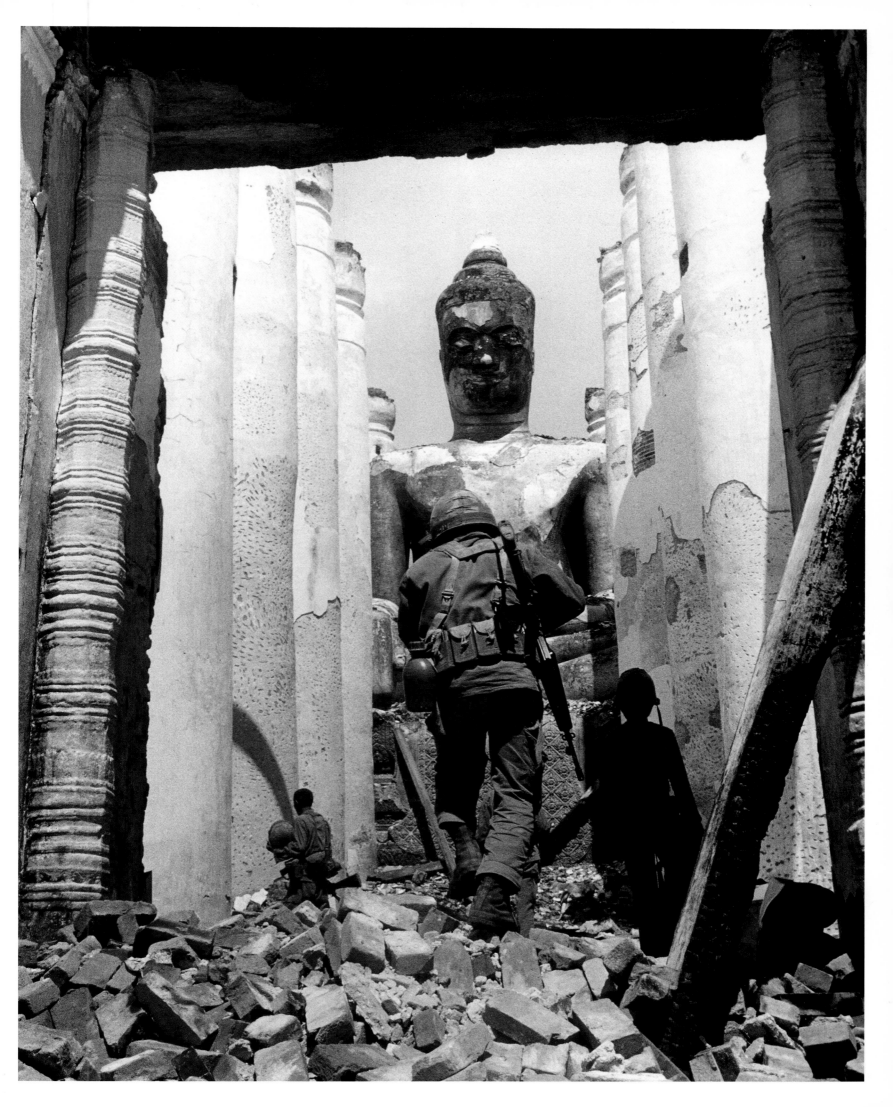

countryside, and there was often skirmishing on its outer perimeter.

The Khmer Rouge were kept at bay only by massive American bombing.

The Khmer Rouge were ragged and underfed, mostly peasants. But they spread like wildfire over Cambodia. They survived by employing mobility and ingenuity and because they were trained for guerrilla warfare. They had a ferocious determination and often fought against great odds. The massive American bombing embittered and hardened them.

By the end all that was left of Lon Nol's Cambodia was the city of Phnom Penh and a few enclaves. The lazy charm of a once abidingly pretty city on the banks of the Mekong River had vanished. Phnom Penh was wrapped in barbed wire. Overland routes were cut. The little airport at Pochentong was under rocket attack. American diplomats drove about in bulletproof limousines. There was a 9:00 P.M. curfew. One third of Cambodia's population of seven million was now living in huge shantytowns within the city's boundaries; the city was filled with a terrible hopelessness, and anyone with money or a foreign connection scrambled for a place on one of the rare planes braving falling rockets to bring supplies in and take people out.

As the perimeter shrank, the war came so close that it was possible to drive from the Hotel Le Phnom, the main journalists' hotel, early in the morning, spend a couple of hours at the battlefront, catch a whiff of cordite up the nostrils, and be back at the hotel in time for breakfast. The war also came to the streets as the Khmer Rouge lobbed rockets at short range into the city, turning Phnom Penh into the middle of hell. The rockets were the great leveler, falling on the homes of the rich and the poor alike. The wounded, gasping and groaning and stained with blood, were often cycled to hospital in pedicabs because of a chronic shortage of ambulances. Malnutrition spread like cancer.

In Vietnam the helicopter, the workhorse of the U.S. Army, was the journalists' taxi ride to the fighting; in Cambodia, where the Americans were not on the ground, the war could be covered only by car. This led to exposure to a type of danger unencoun-

tered in Vietnam. There, photographers were much more a part of the mighty American war machine, relying on the U.S. Army for transport and shelter. To accompany U.S. troops on their field operations, they were required to wear army fatigues and bore the symbolic rank of major.

In Cambodia, covering war required a more independent-minded, adventurous approach. The journalists had no choice but to fend for themselves. Few other wars offered such opportunity to the individual photographer. The unforgettable reminder of this are the many ambushed and killed by the Khmer Rouge while running the roads in search of a story. There was seldom any reliable war information to be gleaned at the press-briefing center, so the rule was to head out into the countryside and see for oneself.

The seven main roads radiated out of Phnom Penh like the spokes of a wheel; Route 1, the old colonial road that used to link Phnom Penh and Saigon, and Routes 2 and 3 to Takeo and Kampot were the ones where many journalists were lost. The rule was not to be the first to travel down the roads in the early morning because of land mines and never to be on them after 4:00 P.M., when it began to grow dark, the peasants left their fields, the government soldiers retreated to their camps, and the Khmer Rouge took over.

It became so dangerous that after a while the main Western news media forbade their staff photographers to go out into the field and paid local Cambodians to cover the fighting for them. They were called news assistants, paid low rates, and given no insurance. Prominent among them and typical of their amazing courage was Tea Kim Heang, a former film actor known to all as Moonface.

He was wounded eight times in the war and was captured in March 1971 by the Viet Cong but released a month later. He was easygoing, good-natured, and supremely loyal. But even he could not cheat death. The consequence of his loyalty was that he was murdered by the Khmer Rouge in the horrific aftermath of Phnom Penh's fall in April 1975, when they identified him as a journalist working for the Western press and killed him along with the other local photographers they caught. Sou Vichith, who

worked for The Associated Press and Gamma, perhaps the most accomplished photographer of them all, was another victim.

The Western press was a magnet to Cambodians. In a country destroyed by the war, photographing, driving, and interpreting for a Western news organization were among the best jobs going and provided a steady income. The Cambodians who got these jobs lived hard and died young. They worked right up to the last moment, when the Khmer Rouge captured Phnom Penh.

I was one of the few Westerners in Phnom Penh to witness the horrors of the Khmer Rouge takeover and its forced evacuation of the city's two million residents to the countryside.

"An unthinking madness was taking over," I wrote at the time. "In its zest for revolution the Khmer Rouge soldier-peasantry was not embarking on the bloodbath predicted by the Americans. Instead, it was emptying the city of its people. There clearly was a discipline, a cold-blooded discipline which said the Khmer Rouge new order was the only one, that anything in its way had to be eliminated. It was not a discipline which respected human life or property.

"The Khmer Rouge were tipping the patients out of hospitals like garbage into the streets. Bandaged men and women hobbled past the embassy, holding one another up. Wives pushed wounded soldier-husbands down the street on wheeled hospital beds, some with serum drips and blood-plasma bottles still attached. In five years of war this was the greatest caravan of human misery I saw. The entire city was being emptied of its people: the old, the sick, the in-firm, the hungry, the orphans, the little children, without exception. There were an estimated twenty thousand wounded in Phnom Penh's hospitals at the end of the war. The Khmer Rouge must have known that few could survive the trek into the countryside; one could only conclude that they had no humanitarian instincts."

Like other Cambodians who had been associated with Westerners during the war, many Cambodian journalists and photographers and their families sought shelter in the French embassy, among them Dith Pran, the *New York Times* interpreter, Moonface, and Sou Vichith. When they were forced to leave for the countryside, it was like a death sentence. Moonface and Sou Vichith put their belongings into the back of a Toyota pickup. We shared our food with them and with heavy hearts watched them trudge through the front gate, where the Khmer Rouge soldiers were waiting for them. It was raining. It usually was at funerals. They hoped to make it across the border to Thailand but were killed.

Tens of thousands were slaughtered or died from disease or starvation. Dith Pran, who survived the Khmer Rouge killing fields, escaping across the Thai border more than four years later, and who still works for *The New York Times*, now as a photographer in New York, said he was not surprised the Khmer Rouge murdered virtually every Cambodian journalist they came across. "They tried to destroy all those who knew what they had done because we were a witness to their atrocities against the Cambodian people. Their aim was to get rid of those people who would bring the message of what they saw to the outside world," said Pran.

(page 275)
SOU VICHITH
Cambodia, 1974.
*A soldier of the Cambodian government army removes the
wooden statue of a Buddha from a destroyed village temple.*
(Gamma)

(pages 280 and 281)
SOU VICHITH
Prek Phnou, Cambodia, 1974.
*Cambodian paratroopers defend the village of
Prek Phnou on the outskirts of Phnom Penh.*
(Gamma)

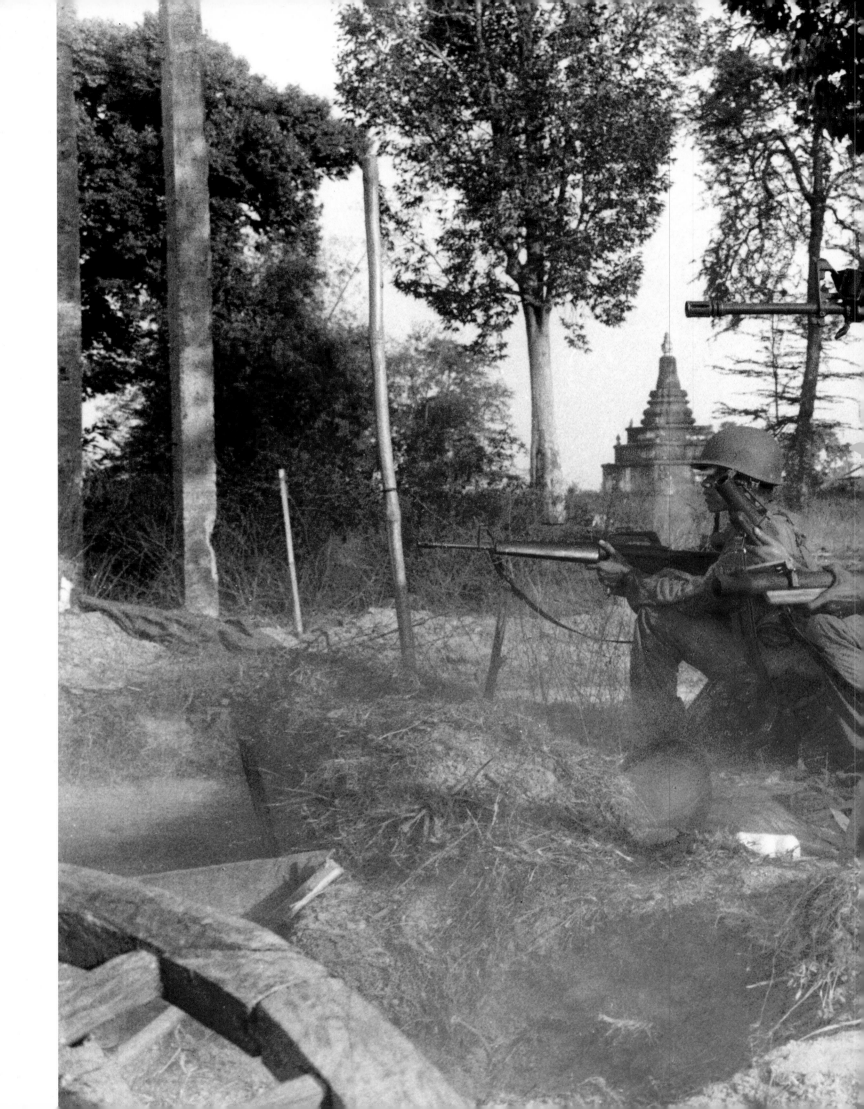

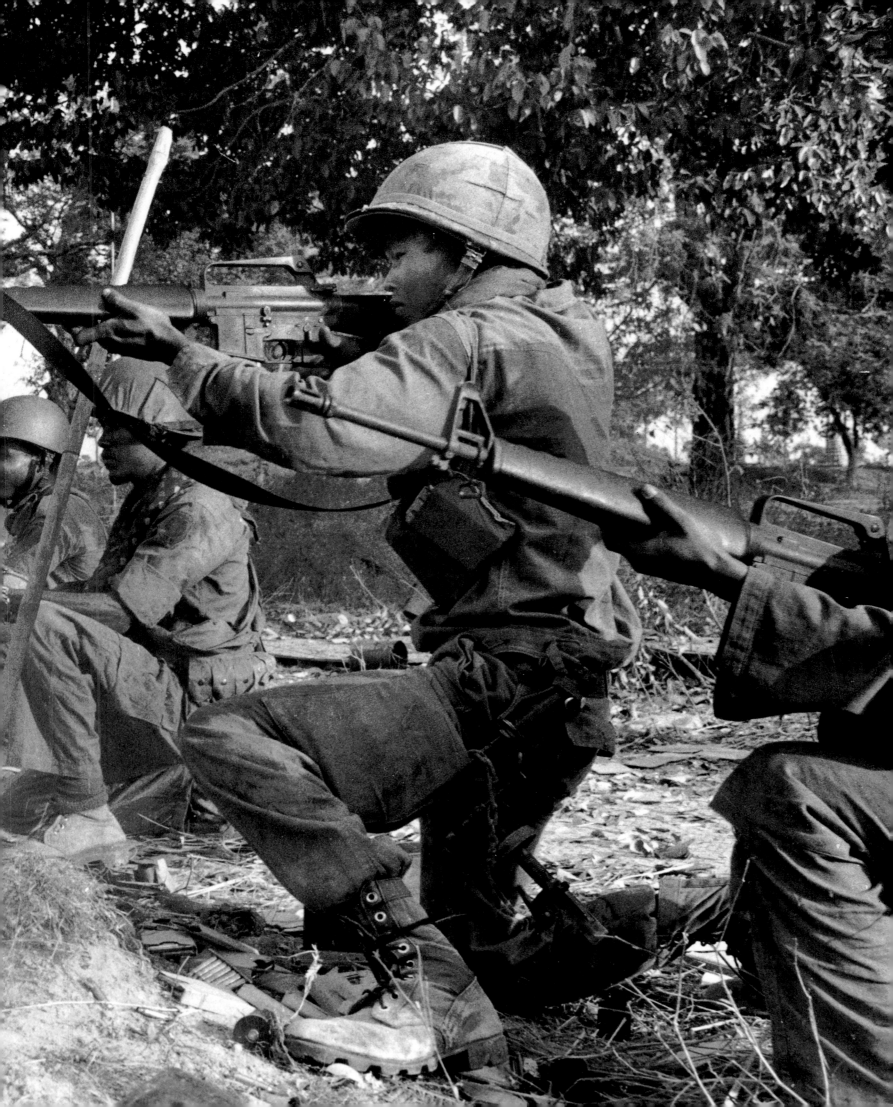

SOU VICHITH
Cambodia, 1971.
*Tea Kim Heang (Moonface) is helped to safety by a Cambodian
government soldier and the photographer Sun Heang, along Route 4.*
(Gamma)

(page 284)
TEA KIM HEANG
Siem Reap, Cambodia, 1974.
Cambodian girl with her father's rifle at a marshaling point.
(AP)

(page 285)
THONG VEASNA
Prek Phnou, Cambodia, 1975.
*A Cambodian boy traveling with his father, who is with a unit of
Cambodian government troops.*
(AP)

ON THE OTHER SIDE

Kate Webb

Kate Webb, a writer for United Press International, and photographer Tea Kim Heang were held captive by North Vietnamese troops in 1971. The following text is an extract from her book, On the Other Side *(1971), combined with details from UPI's debriefing report.*

So far it had been an uneventful day. The sun beat down unmercifully as UPI's rented car bounced along behind a Cambodian army water truck.

It was just 1:00 P.M. when the column passed Kilometer 95. The next moment the stillness of the afternoon exploded into the crackle of small-arms fire, the hammer of automatic weapons, and the crash of mortars. From all sides came the screams of the wounded.

Webb dived into a ditch as the firing erupted on both ends of the convoy. A freelance photographer joined her. Tea Kim Heang, called Moonface by his friends, had been wounded only the week before, hit in the shoulder and leg, but not badly. But now blood from his freshly stitched wounds was beginning to seep through the leg of his pants and put a brown-yellow stain on the back of his shirt.

More shots—a volley of gunfire—rang out only a few yards away. Webb and Heang looked at each other for a split second, then scrambled into the jungle. There they joined Toshiichi Suzuki, correspondent for *Nihon Denpa News*, his driver, and Eang Charoon, a Cambodian newspaper cartoonist.

The small band decided to move northwest, trying to keep between the road and the air strikes and the artillery. Thorns ripped their clothes and bodies as they ran through the jungle. As night fell, they lay on the ground, frozen in silence, watching uniformed men and women moving in columns only yards away.

The artillery began once more. Moving again, they had covered nearly a quarter of a mile when they came face-to-face with two North Vietnamese army (NVA) soldiers.

"*Bao chi, bao chi*" (press), Webb rasped. "*Nuoc, nuoc*" (water, water), Heang cried, pointing to an empty canteen.

One of the soldiers jabbed his rifle at the girl reporter. "*My?*" (American?) he asked. "*Anglaise, Anglaise*" (English), Heang replied.

Herding them together by motioning with his AK-47, one of the soldiers left the other to guard the prisoners as he disappeared up the trail. He returned not with water but with rope. It was April 8, 1971. For the next twenty-four days they would be prisoners of the North Vietnamese.

A short time after they were taken, they were herded into a bunker by two NVA soldiers, one of whom returned a few moments later with a green sack. "It's plastique—an explosive," Webb thought, and tried to scramble out, passing the word back to the others. They all thought they would be blown to bits. Luckily the sack turned out to be just that—a sack, intended to hold their cameras and personal effects.

A North Vietnamese officer told them to follow him. "We go where there is food and water," he said. "It is only a short walk."

Moonface, whose shoes had been taken, was protesting loudly. He couldn't even walk around the camp on his mushy feet. One of the Vietnamese sat him on a bunker and methodically began to "sew" the soles of his feet with needle and thread so that dark blood and puss oozed out.

It was the first of many walks that were never short, always long. Still parched with thirst, tied individually and roped together in a chain, with armed guards in front and behind them, they were pushed swiftly along a winding jungle trail.

Living guerrilla style was weakening them daily. Their captors seemed unaffected by the tough regimen. Their release was hinted at but never promised. Then suddenly they crossed from one world to another, a world of shadows in the night to the unaccustomed glare of the light. Symbolically it was at dawn when they made the crossing to freedom, a lonely, hesitant, and frightened group.

Heang took a piece of white parachute silk he had and tied it to a stick. Clad only in his torn trousers—now too large for him—he raised the white flag as they continued down the highway. They then met a unit of Cambodian government troops.

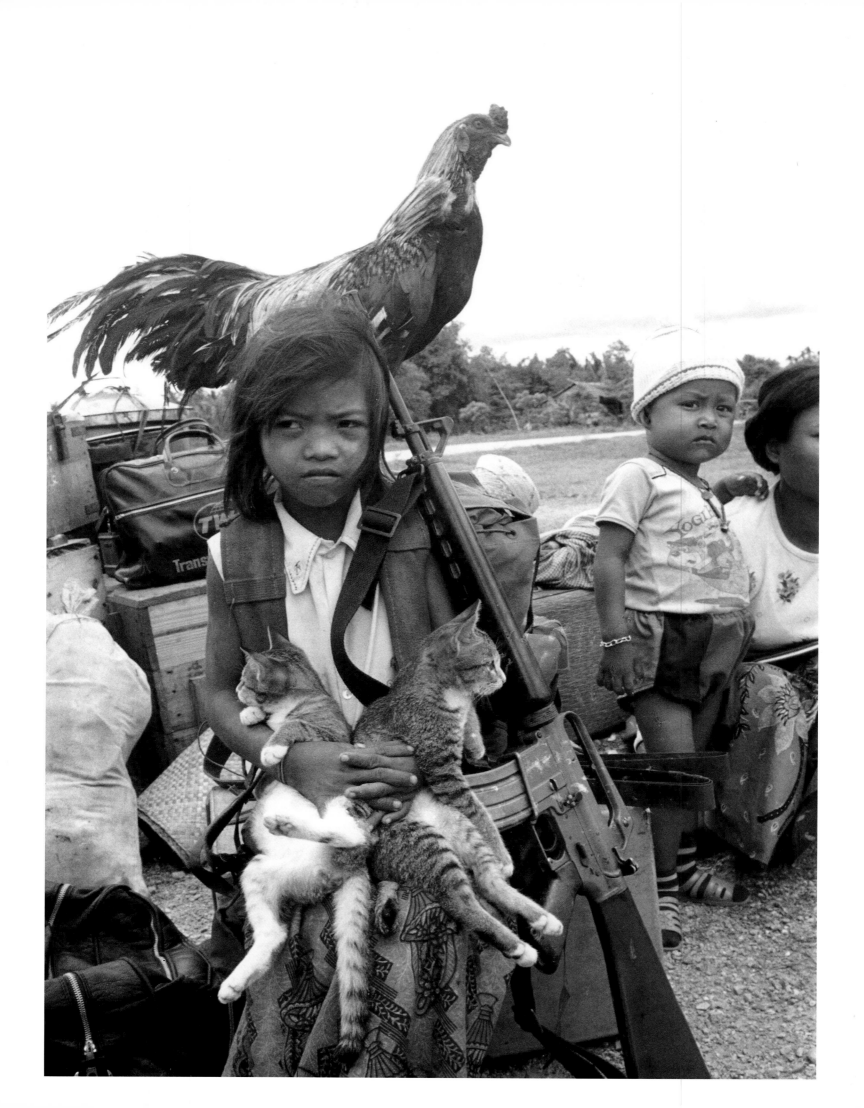

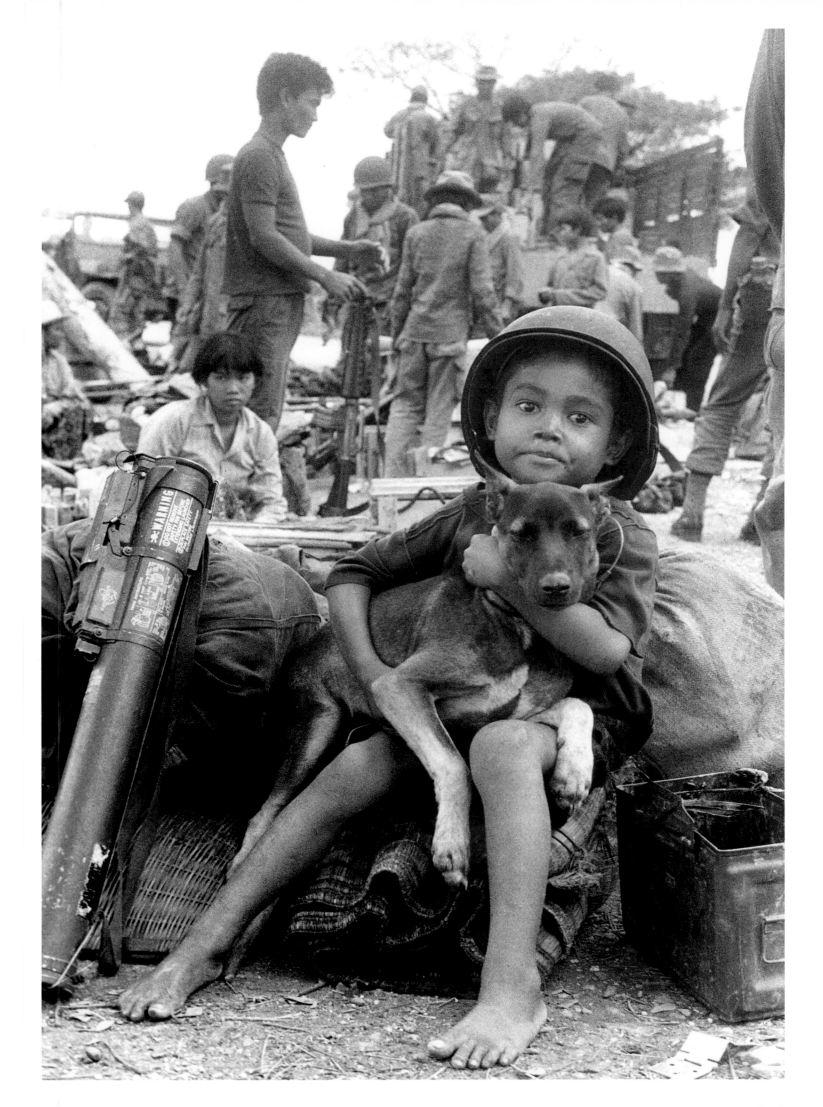

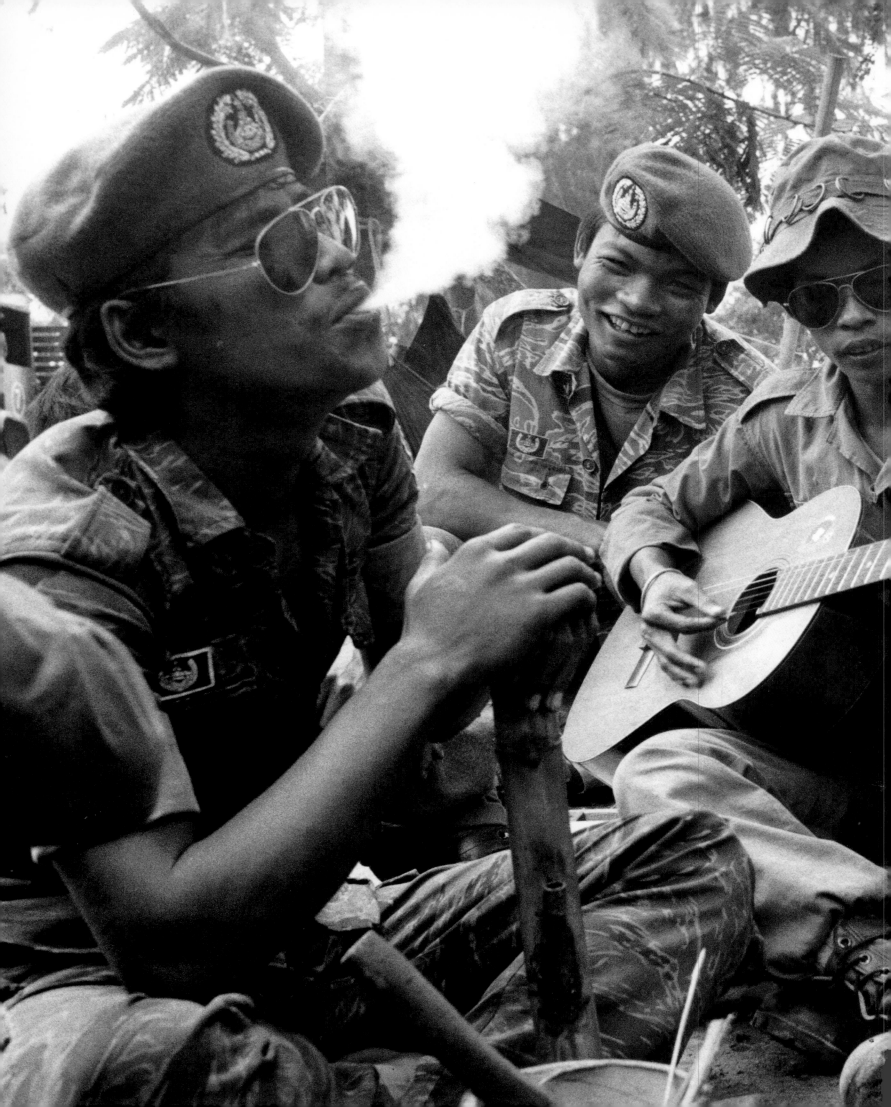

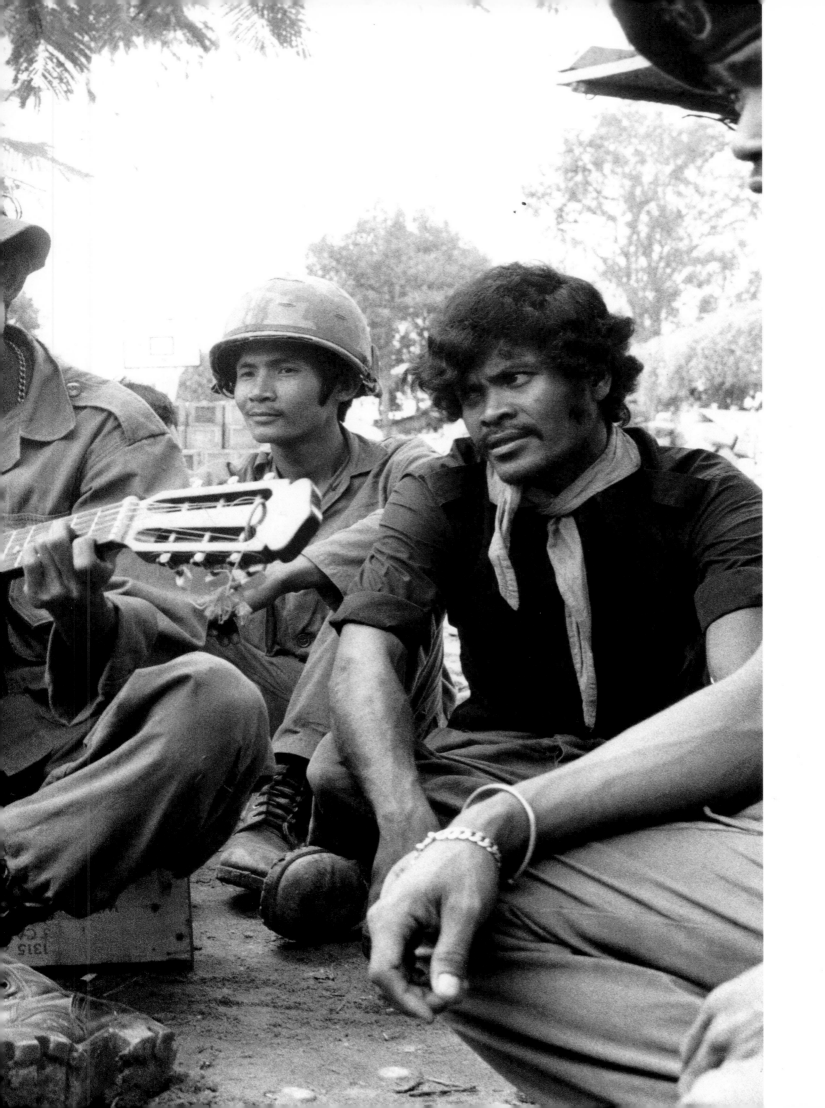

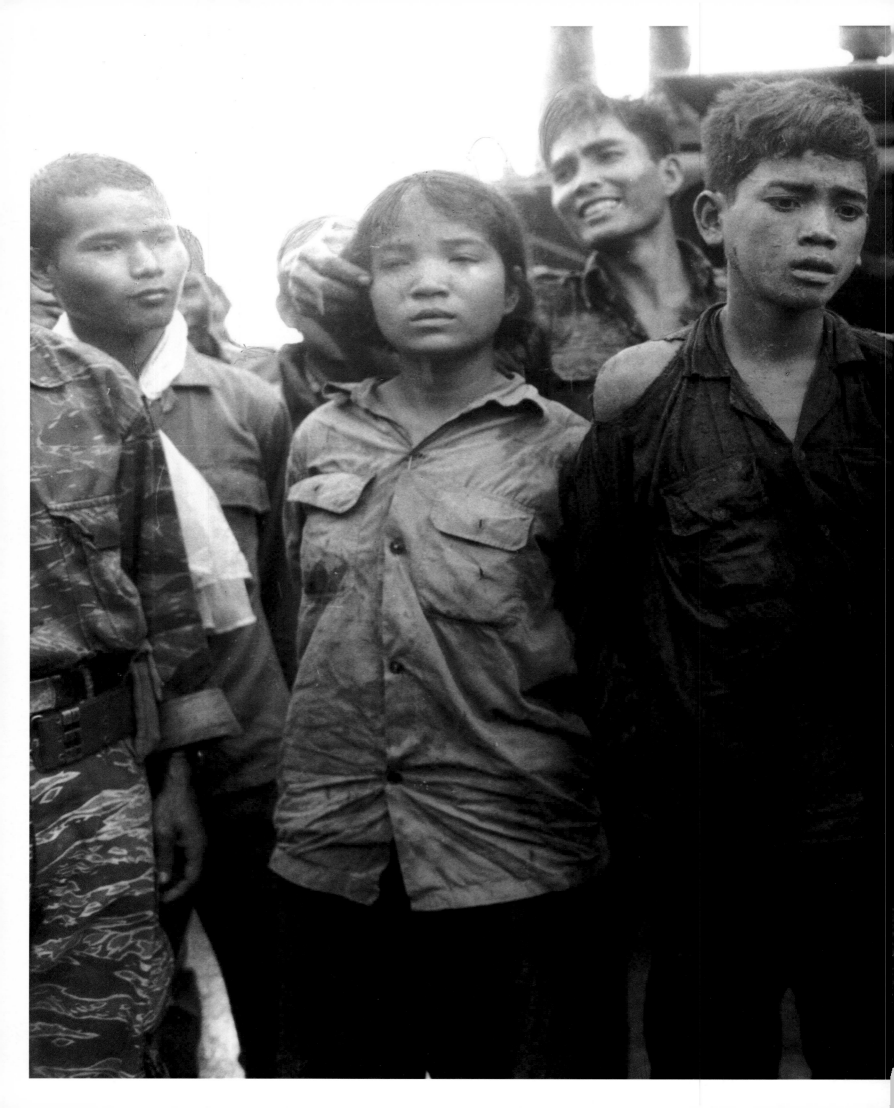

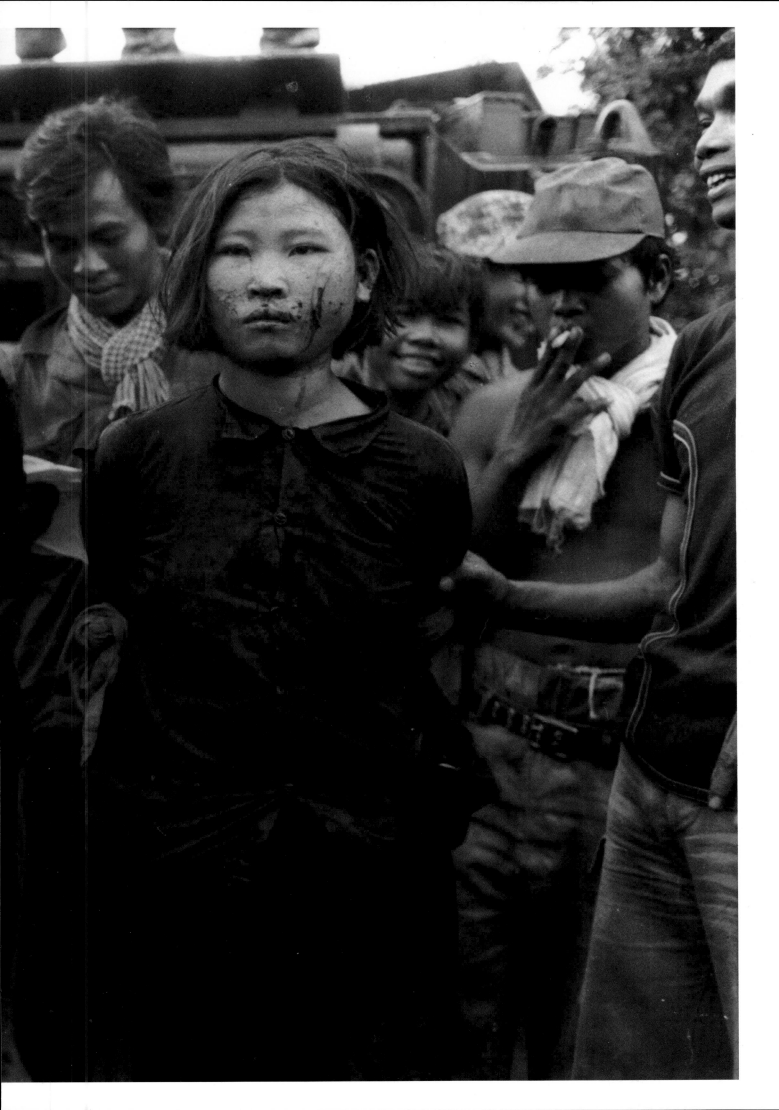

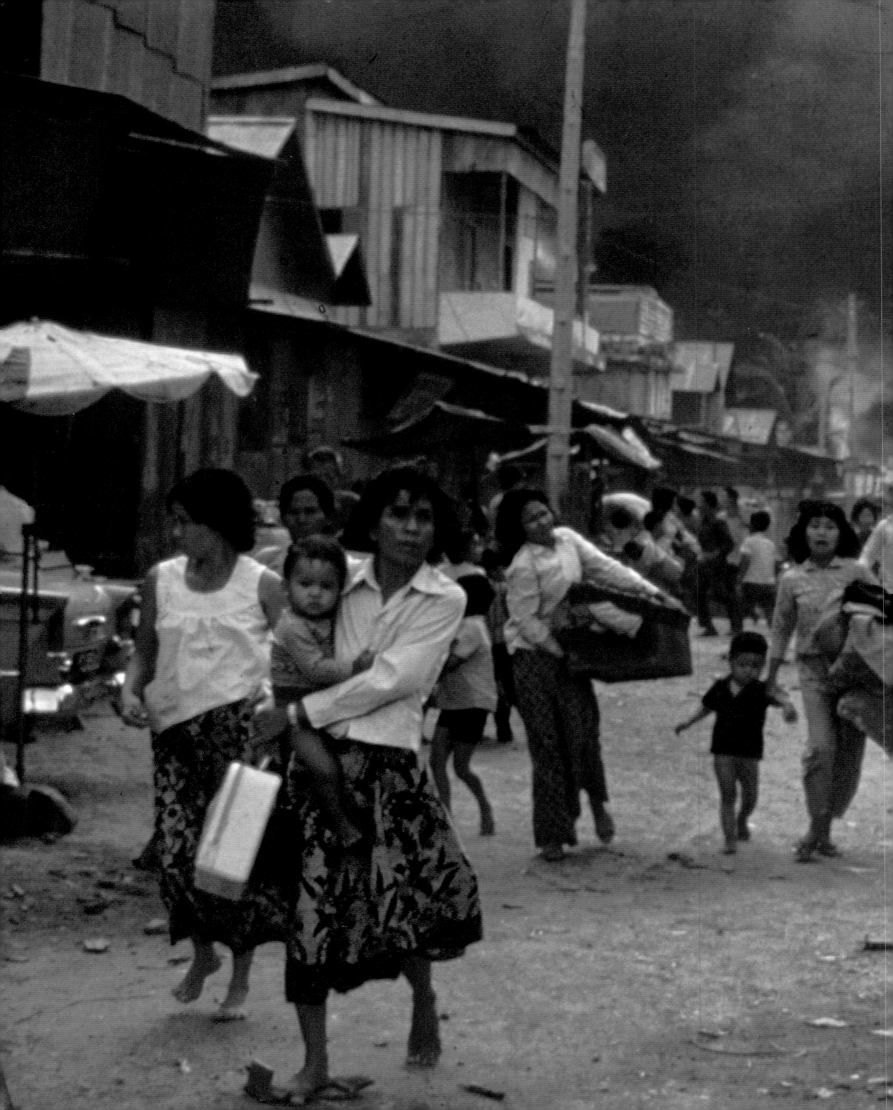

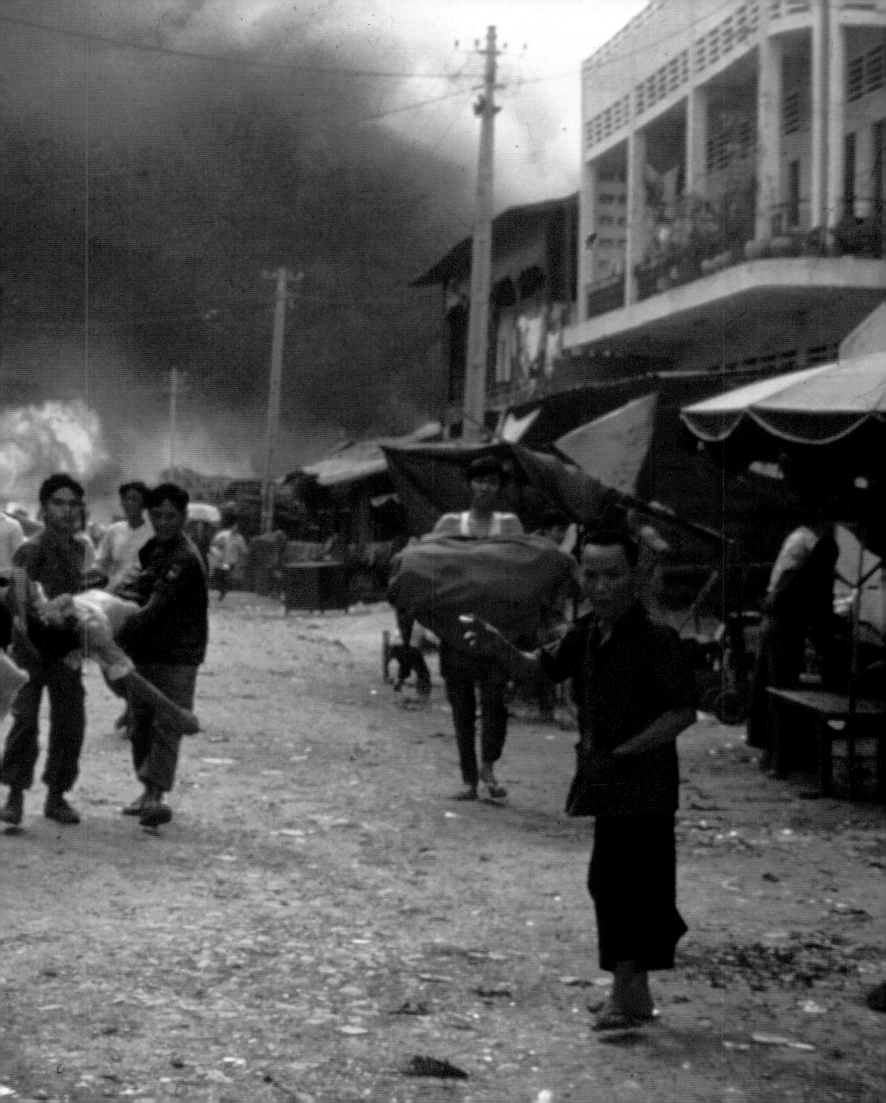

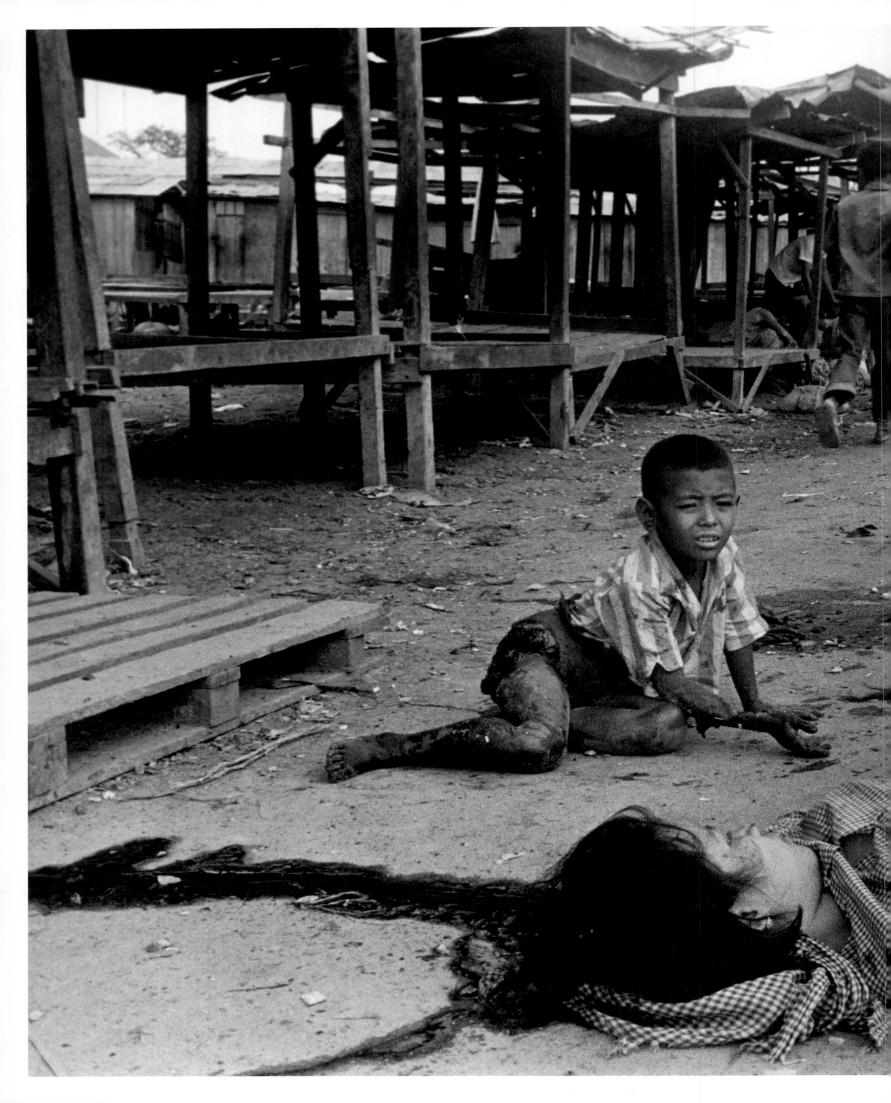

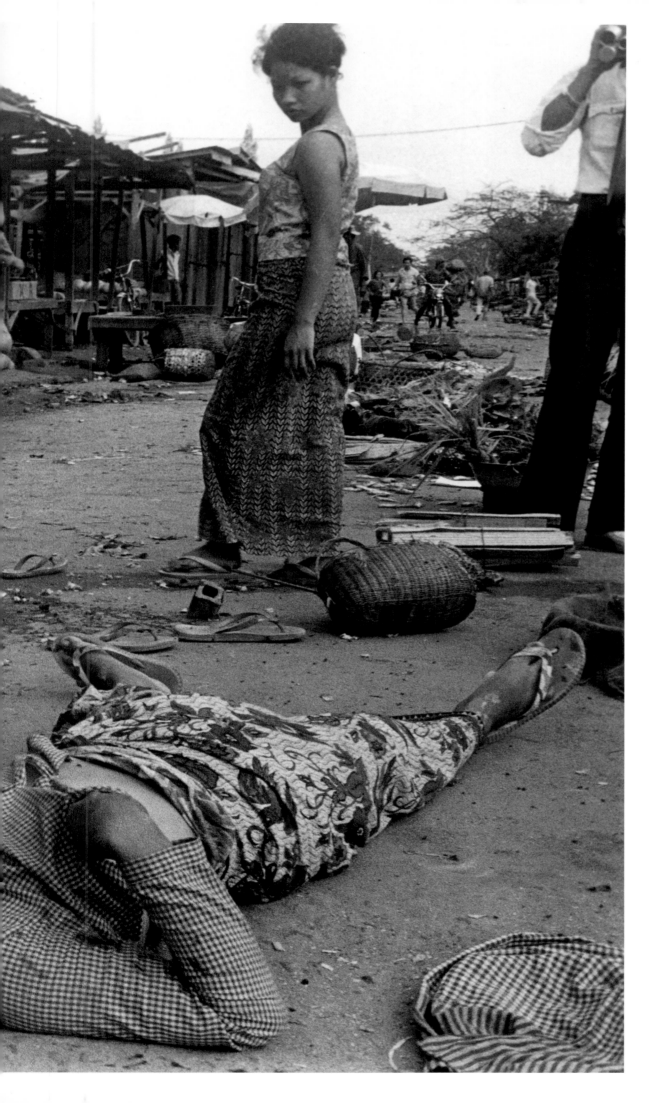

(pages 286 and 287)
CHHOR VUTHI
Phnom Penh, Cambodia, 1973.
(AP)

(pages 288 and 289)
SOU VICHITH
Cambodia, 1974.
*Terrified prisoners are paraded
by Cambodian soldiers near
Phnom Penh. The prisoners were
later stripped, violated, and
murdered.*
(Gamma)

(pages 290 and 291)
FRANCIS BAILLY
Cambodia, 1970.
*Photographs found on the body of a
dead North Vietnamese soldier.*
(Gamma)

(pages 292 and 293)
SOU VICHITH
Phnom Penh, Cambodia, 1974.
*More than a million refugees crowded
Phnom Penh from 1974, when the
Cambodian capital was under virtual
siege and rocket attack by the
Khmer Rouge.*
(Gamma)

TEA KIM HEANG
Phnom Penh, Cambodia, 1975.
*After a rocket attack on the
Pochentong central market, a boy
with severe burns looks at his dead
mother.*
(AP)

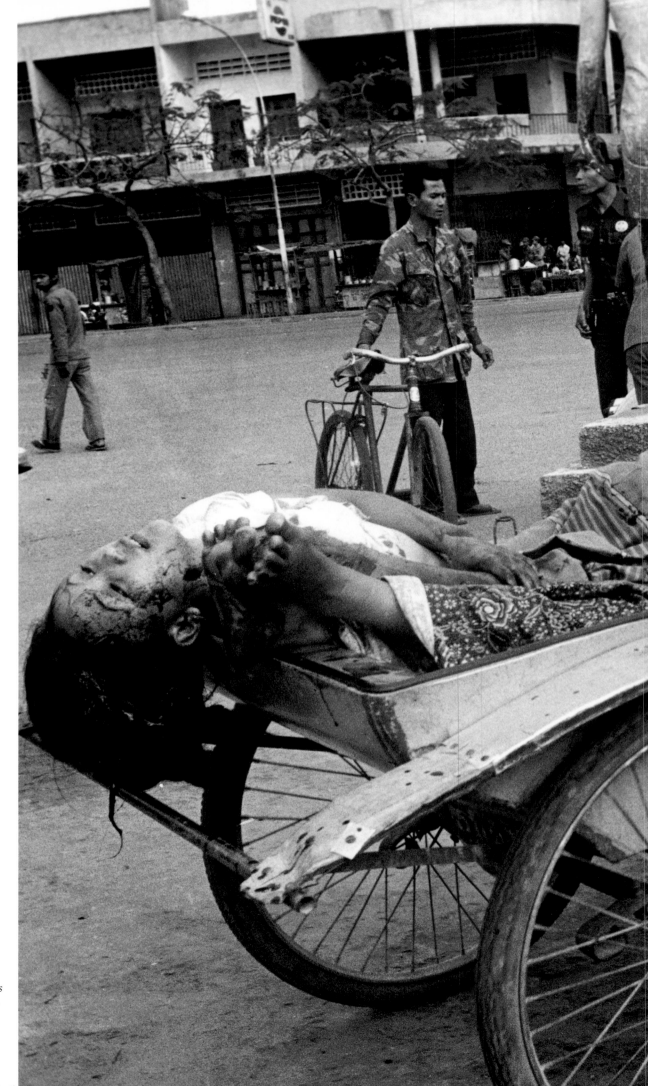

TEA KIM HEANG
Phnom Penh, Cambodia, 1975.
After a rocket attack on the
Pochentong central market, a cyclo is
used to ferry the dead and wounded.
(AP)

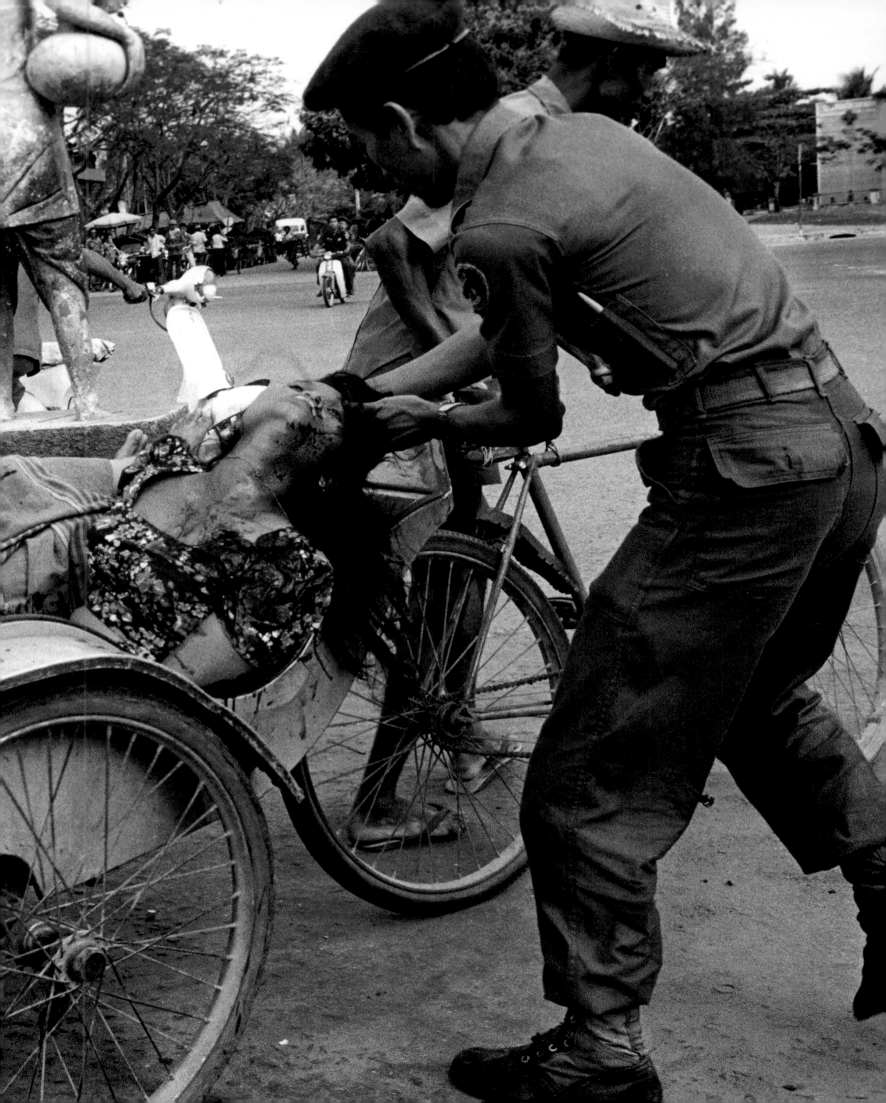

HIS FINAL MESSAGE: I FEEL SO TREMBLING

The following is the last message received by The Associated Press bureau in Hong Kong from Phnom Penh before communication lines went down a few hours after the surrender of the Cambodian government to the Khmer Rouge on April 16, 1975. The message was sent by AP reporter Mean Leang, a Cambodian, from the Phnom Penh post office, where he had been receiving reports from other Cambodian reporters. Earlier in the day these AP reporters had filed dispatches reporting the surrender of the government.

I alone in post office, losing contact with our guys. Only guy seeing me is Moonface at 13.00 [1:00 P.M.]. I have so numerous stories to cover.

Only call from Seang [an AP reporter], still at Hotel Le Phnom. Seang told me black-jacketed guys [the Khmer Rouge] want his bike.

I feel rather trembling. Do not know how to file out stories.

How quiet the streets. Every minute changes. At 13.00 local my wife came and saw me here at post office saying that Monatio [French for the National Movement, or Khmer Rouge] threatened my family out of the house. Vichith lost his camera to the black-jacketed guys.

Appreciate instructions. I not admitted to Le Phnom Hotel this morning into Red Cross security zone. Need press card. I have none. Last night they admitted me to Le Phnom.

The Red Cross ordered removal of all belongings whatsoever having military aspect.

I, with a small typewriter, shuttle between the post office and home.

May be last cable today and forever.

George Esper, chief correspondent for The Associated Press in Indochina, replied in a message to Mean Leang, telling him to leave the post office immediately and seek safety wherever he could.

SOU VICHITH
Phnom Penh, Cambodia, 1975.
After a rocket and artillery attack on Phnom Penh in April 1975, an anguished woman holding her dying child cries for help.
(Gamma)

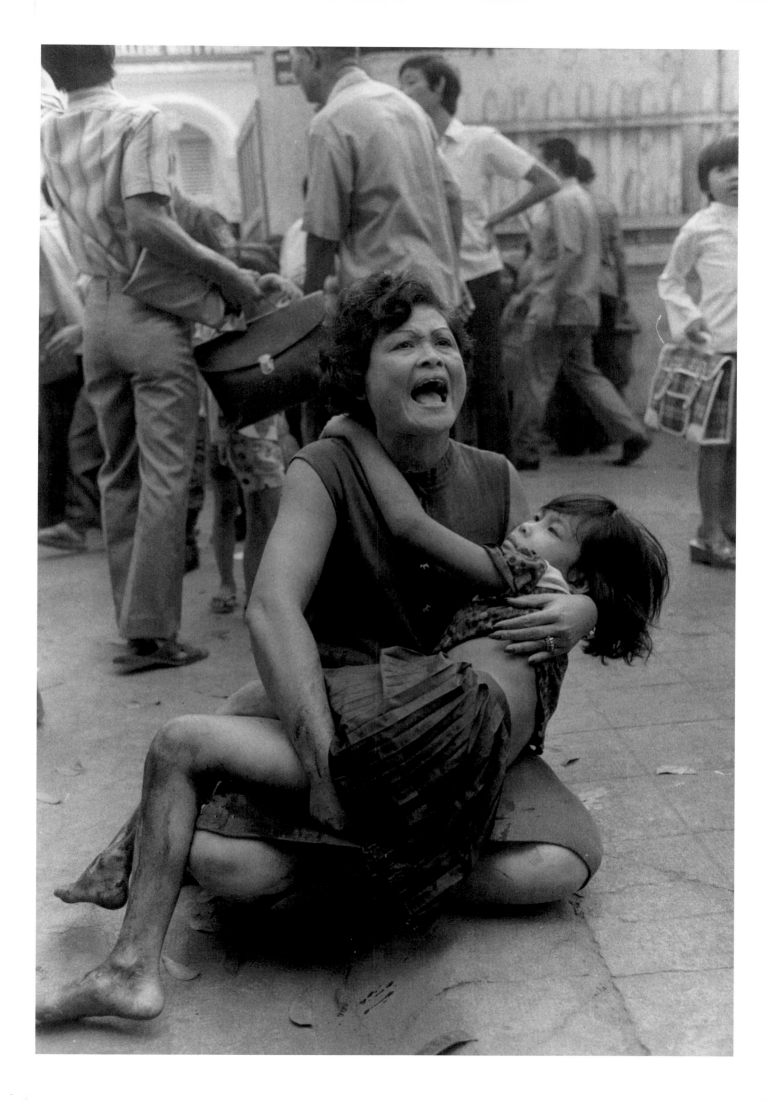

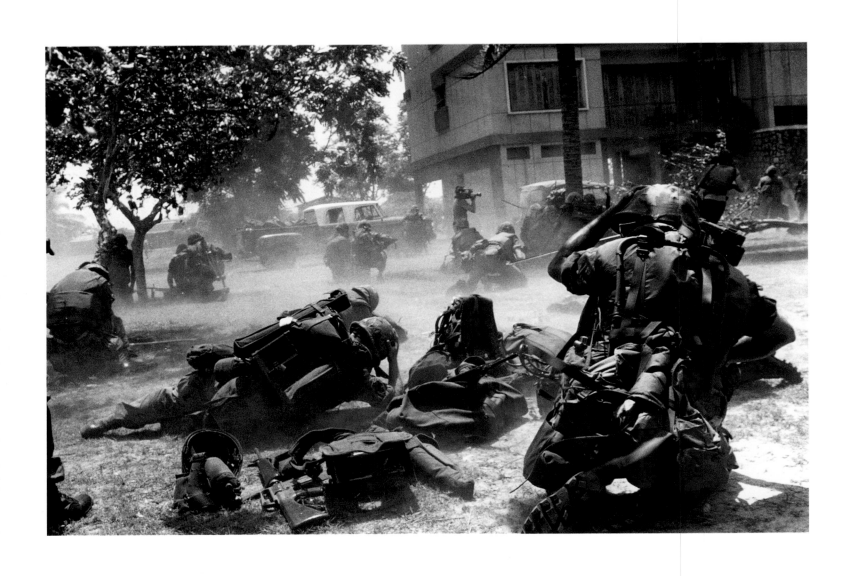

TEA KIM HEANG
Phnom Penh, Cambodia, 1975.
*On April 13, 1975, U.S. Marines evacuated U.S.
and other allied embassy personnel by helicopter.
The Marines came under Khmer Rouge fire after they
were on the ground near the U.S. embassy.*
(AP)

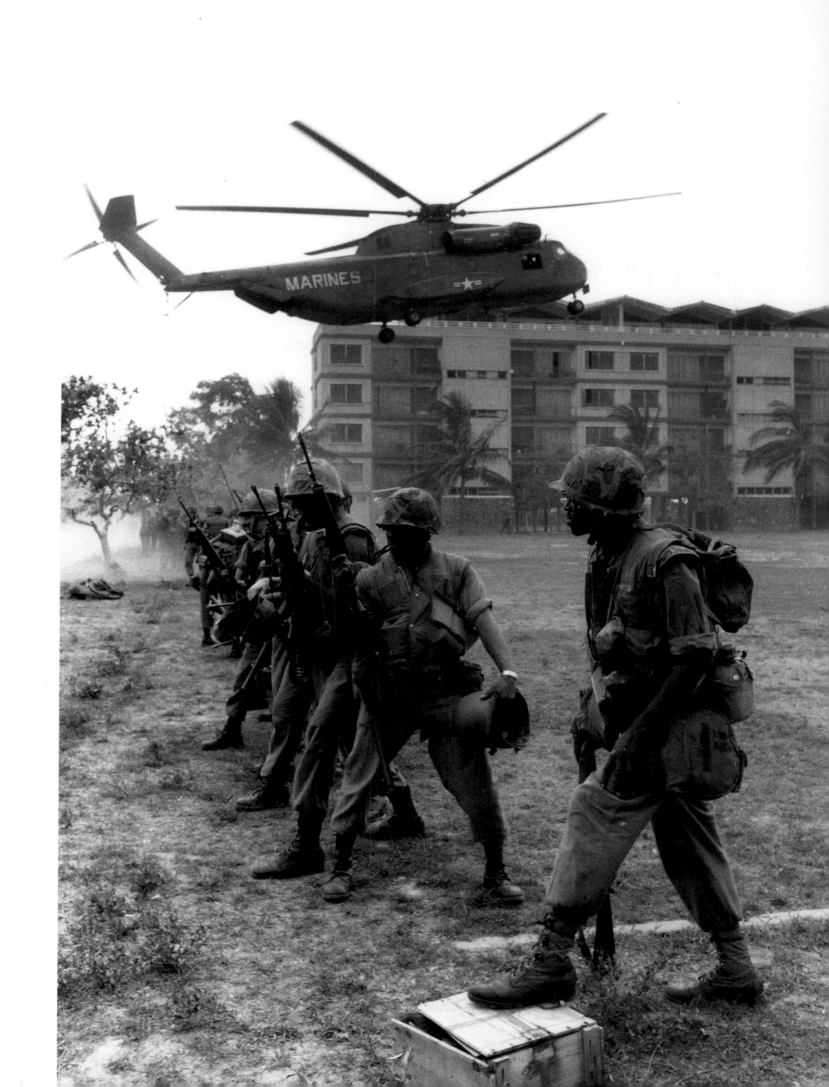

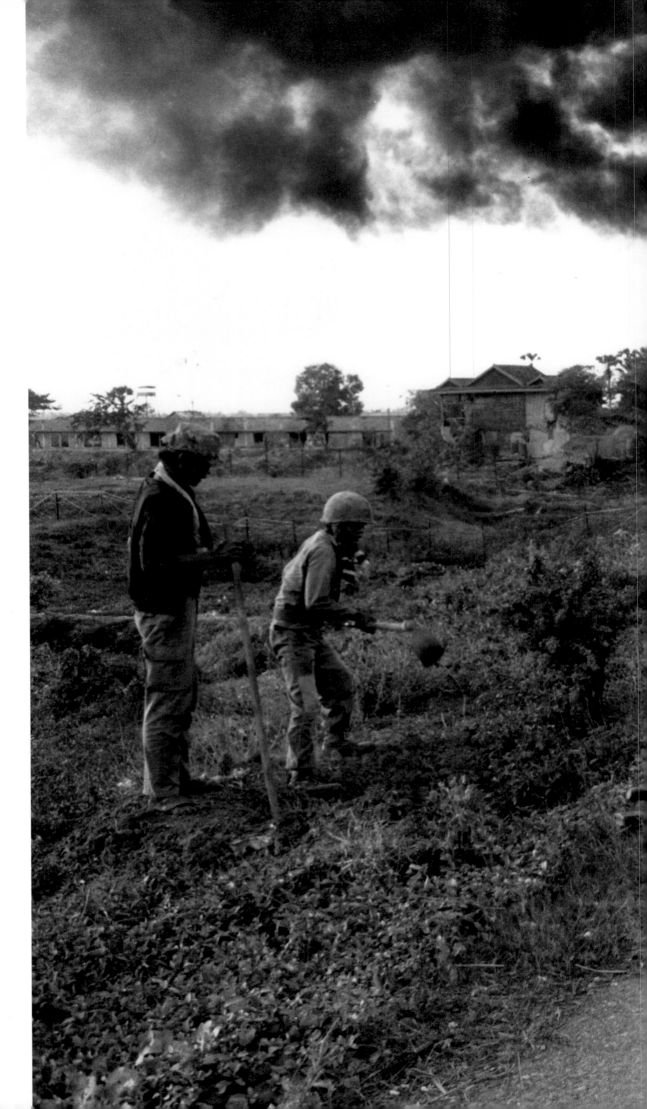

SOU VICHITH
Near Phnom Penh, Cambodia, 1975.
*Toward the end of the Cambodian
war, almost the total population of
the country was left homeless.*
(Gamma)

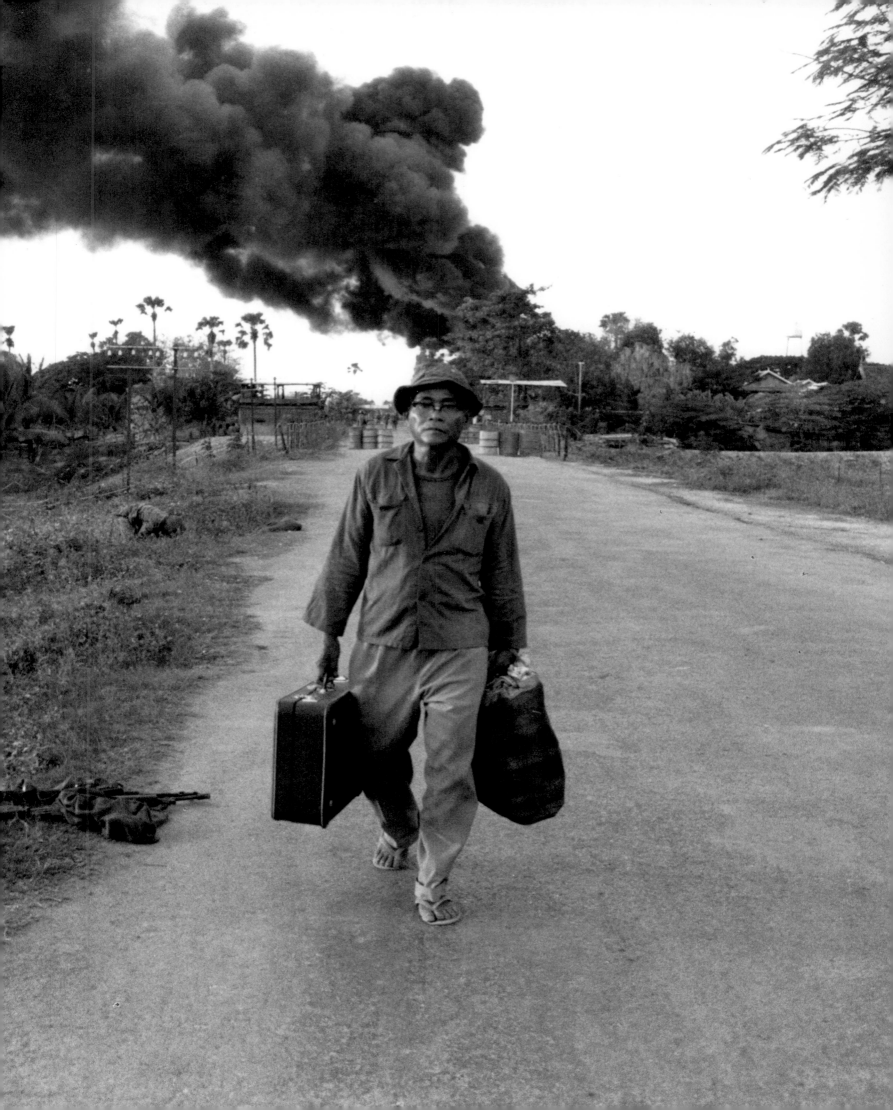

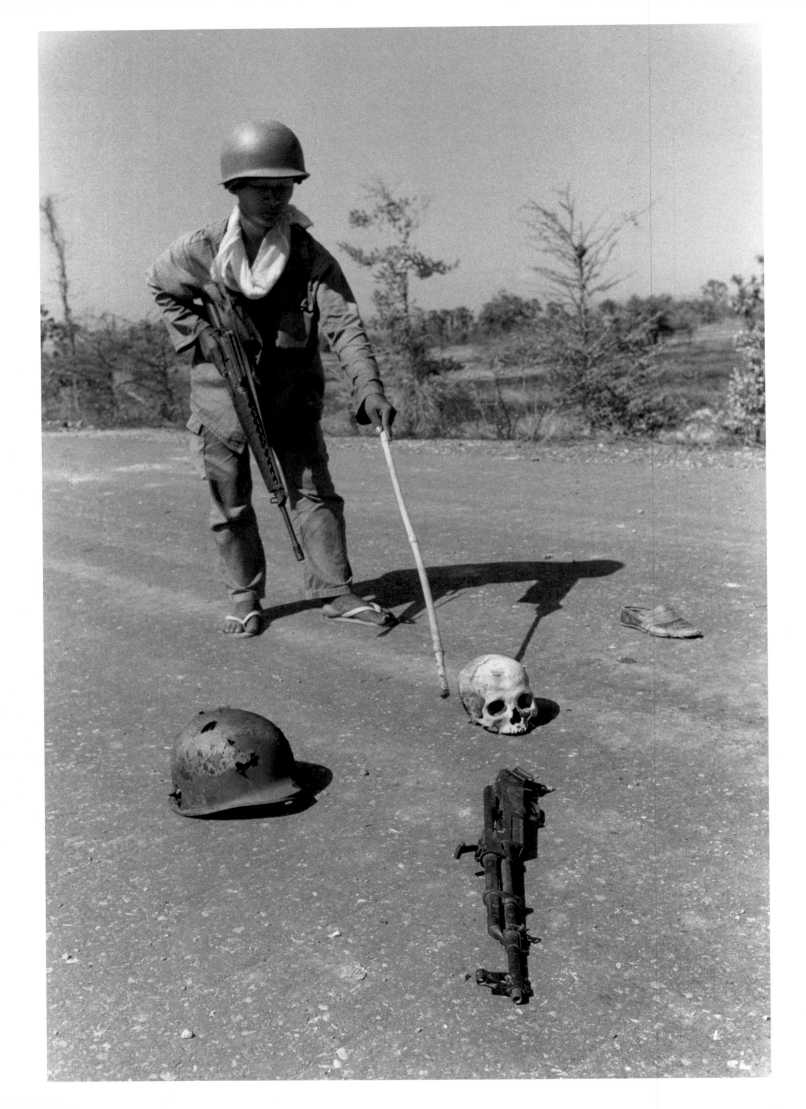

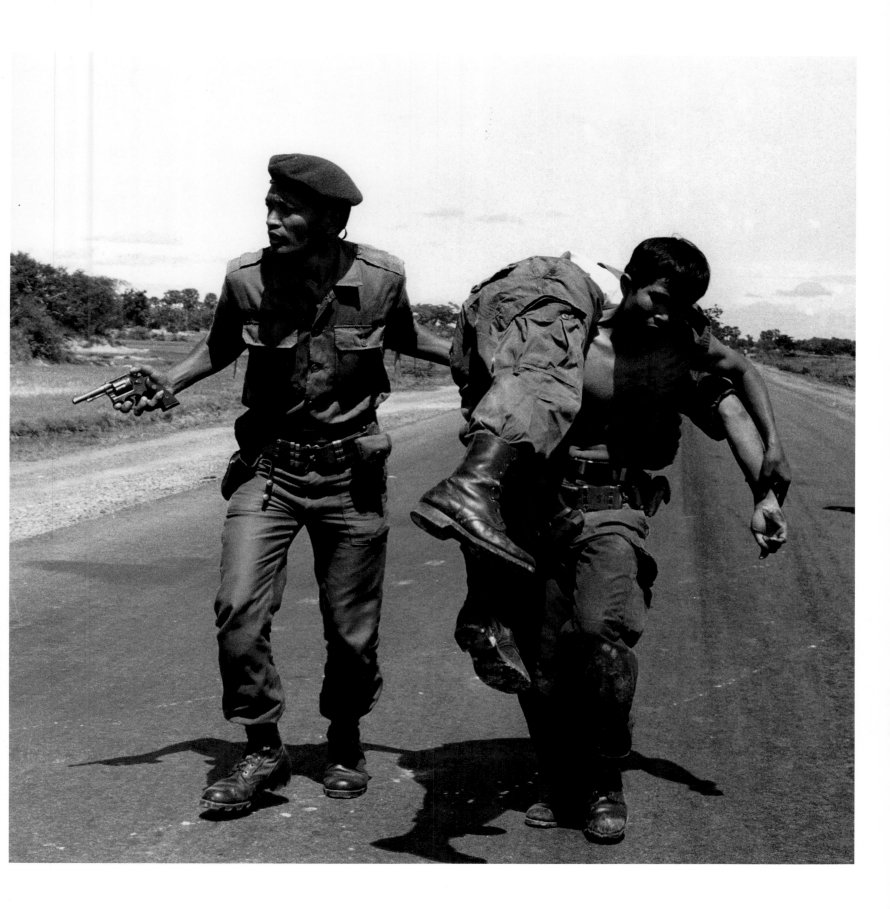

SOU VICHITH
Near Ang Snoul, Cambodia, 1973.
A Cambodian government soldier carries a
wounded comrade to an outpost.
(AP)

SOU VICHITH
Near Phnom Penh, Cambodia, 1973.
A roadblock marker along a highway near Phnom Penh.
(Gamma)

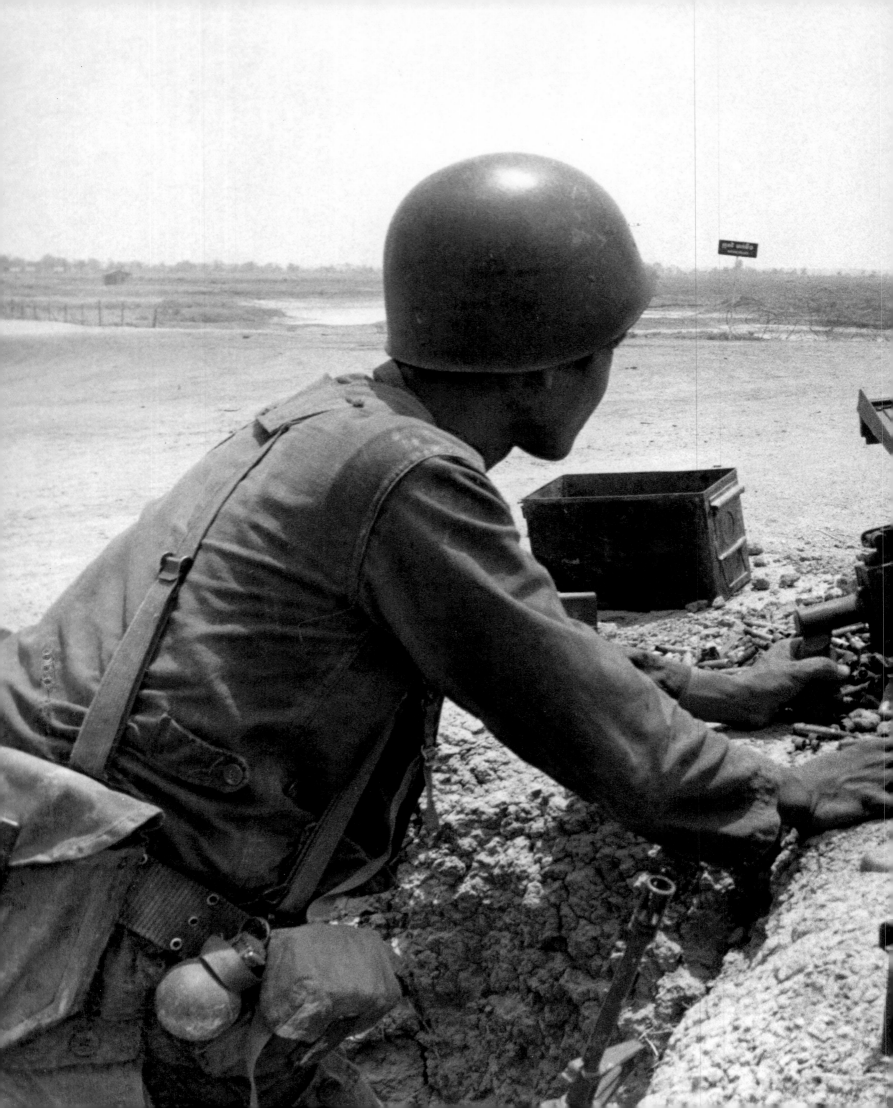

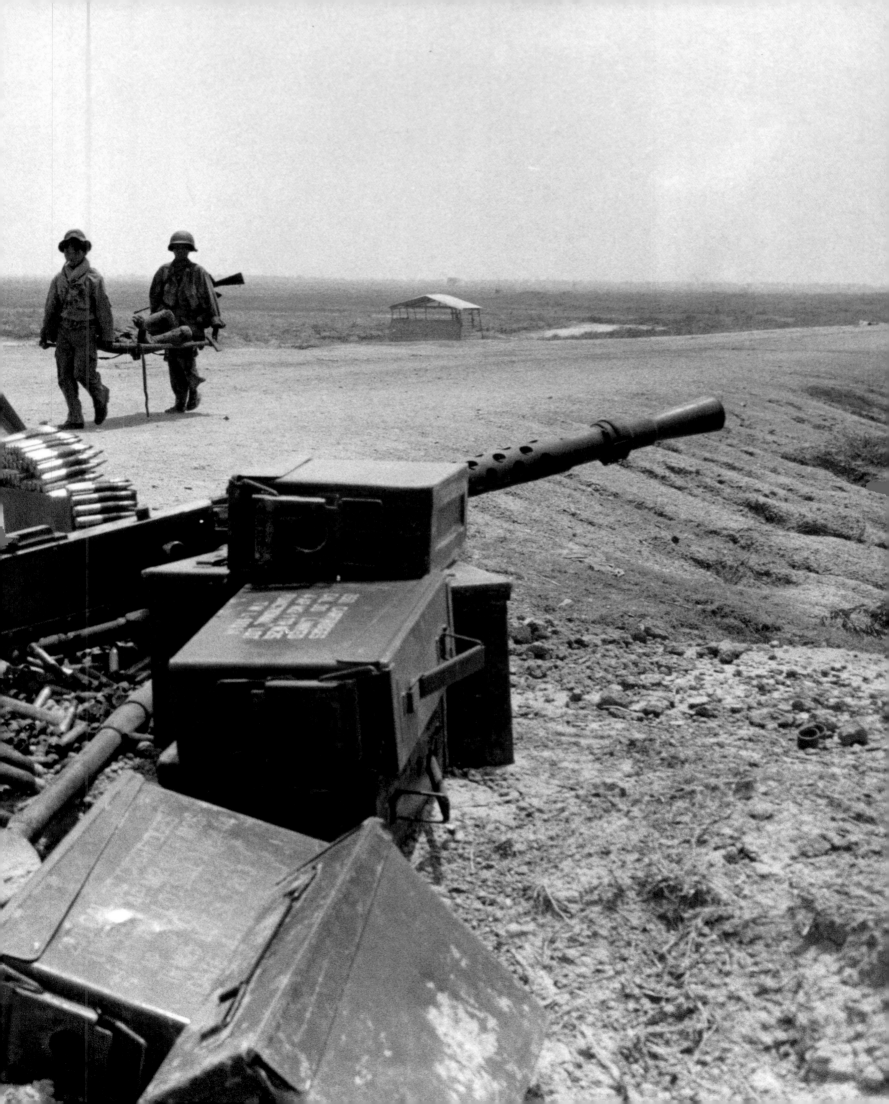

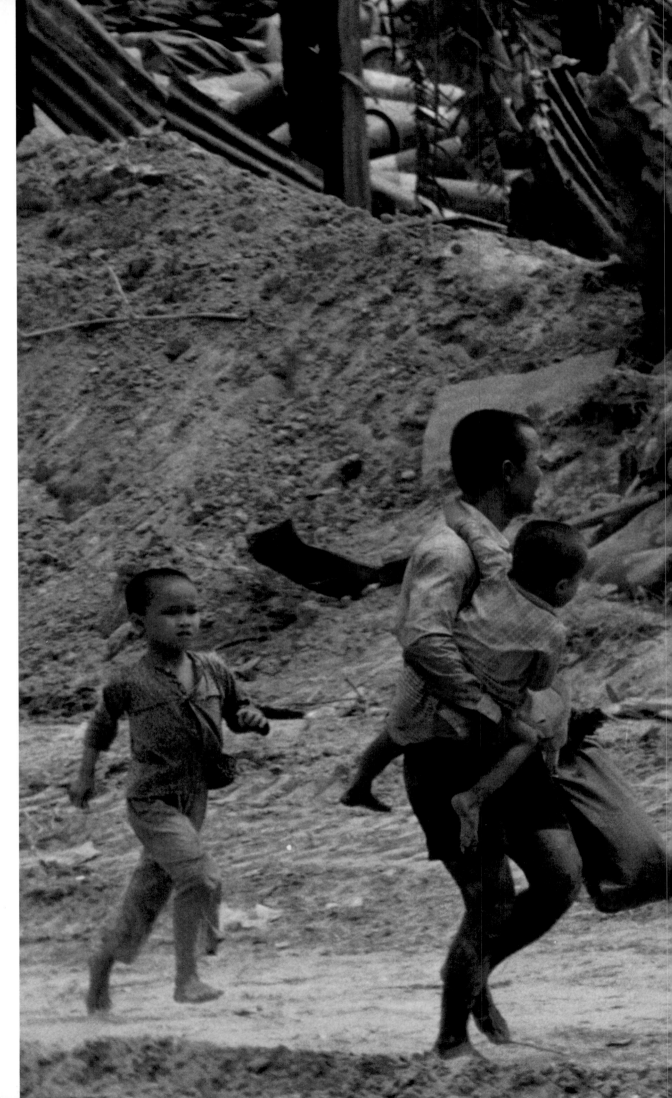

(pages 306 and 307)
KUOY SARUN
North of Phnom Penh,
Cambodia, 1975.
*Two Cambodian troopers carry
a wounded comrade past a
machine gunner's position on
Route 5.*
(AP)

MICHEL LAURENT
Quang Tri, Vietnam, 1972.
*A South Vietnamese medic and
refugees run for cover on the
outskirts of Quang Tri, the
provincial capital just south
of the DMZ.*
(AP)

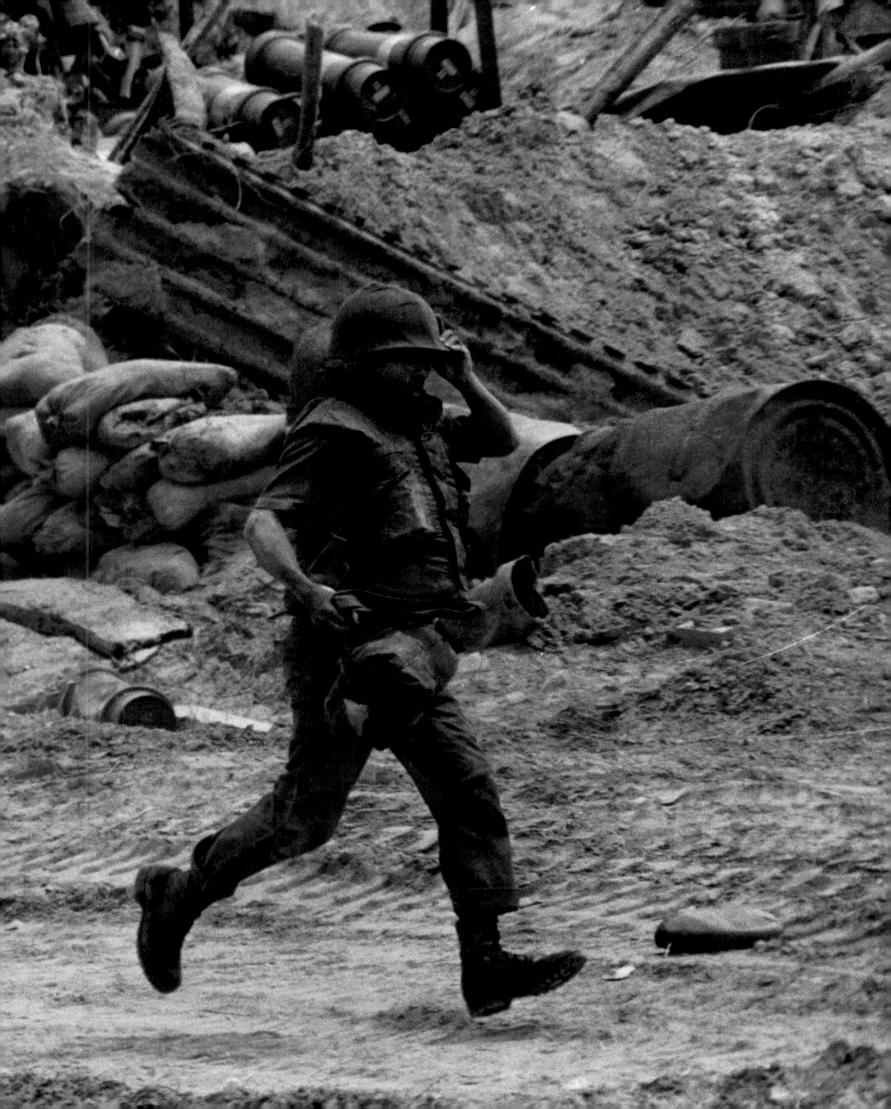

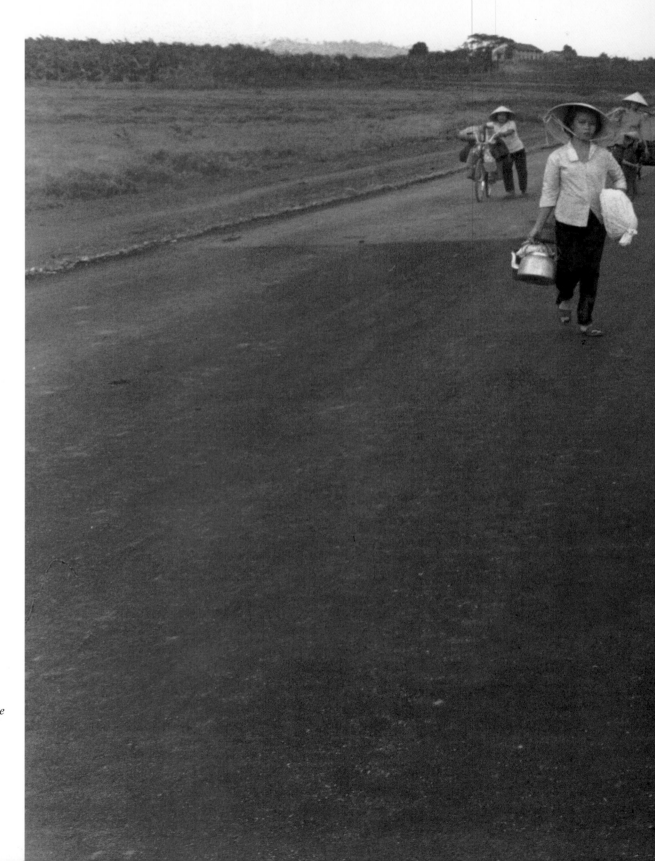

MICHEL LAURENT
Northwest of Saigon, Vietnam,
April 1975.
*Vietnamese refugees flee toward
the capital as the North Vietnamese
close in on Saigon. The wide road
was built a decade earlier
to accommodate large
American military convoys.*
(Gamma)

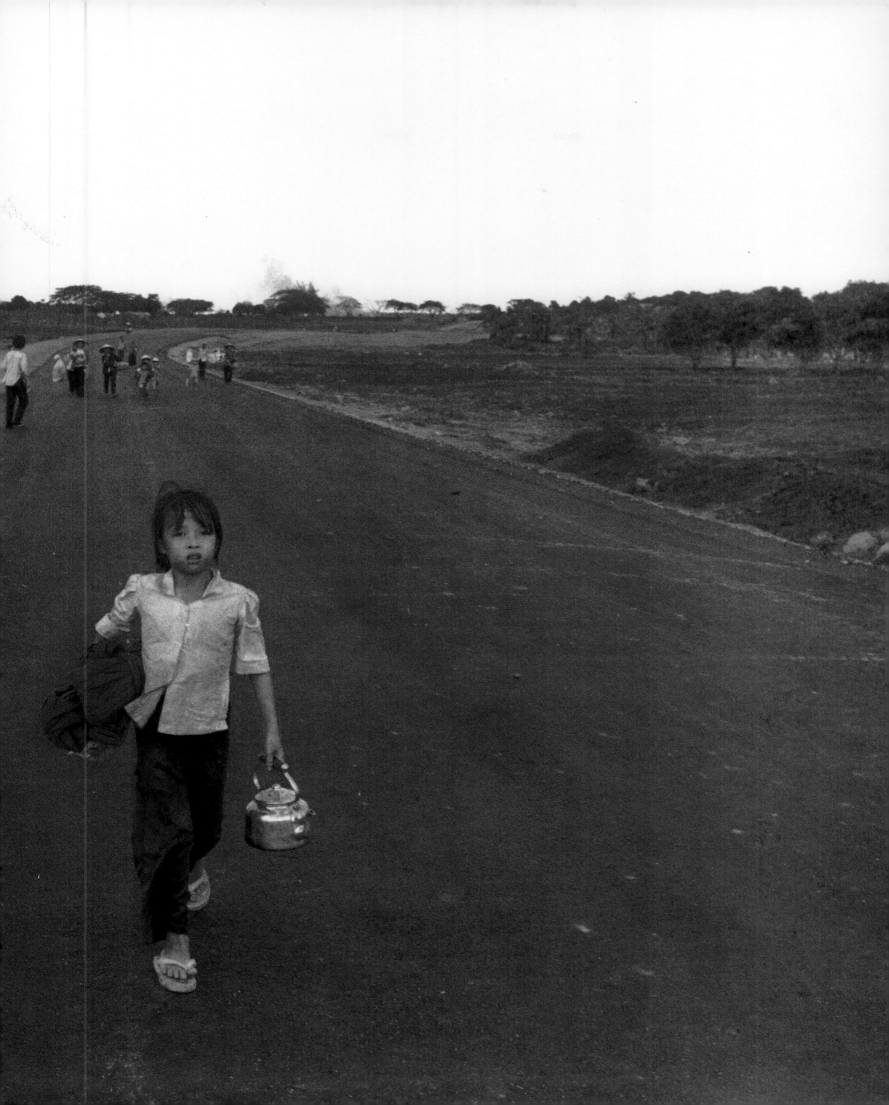

TAIZO ICHINOSE
Cambodia, undated.
*Part of a human spine on the
road to Angkor Thom bears
testimony to the slaughter. Taizo
Ichinose was captured by the
Khmer Rouge on the way
to Angkor.*

BIOGRAPHIES

ABBREVIATIONS

AP (The Associated Press) UPI (United Press International) VNA (Vietnam News Agency) LNA (Liberation News Agency, the southern branch of the Vietnam News Agency until the end of the war in April 1975) VAAP (Vietnam Association of Artistic Photographers)

NVA (North Vietnamese [People's] Army) SVN (former South Vietnam)

Alan Hirons

ALAN HIRONS. *Australia.*
Born: November 26, 1947, in Melbourne, Australia.
Missing: April 25, 1972, near Phnom Penh, Cambodia.

Alan Hirons's short career began with free-lance work for *The Sunday Observer*. In Cambodia in late 1970, he conceived the idea of his own book on the war. He returned briefly to Melbourne, promised his widowed mother, Pauline Hirons, that he would write every week, then flew back to Phnom Penh. She received one postcard. He disappeared ten days after his arrival, along with American Terry Reynolds and Cambodian Chhim Sarath.

GEORG GENSLUCKNER. *Austria.*
Born: August 16, 1943, in Salzburg, Austria.
Missing: April 8, 1970, on Route 1 near Svay Rieng, Cambodia.

After training to be a mechanical engineer in Switzerland, Georg Gensluckner wound up in Cambodia and became a freelance photographer. His main employer was UPI. He had teamed up with German photographer Dieter Bellendorf to see the war. According to peasants, their car was stopped by Khmer Rouge guerrillas. The two men were led away as prisoners.

LARRY BURROWS. *Britain.*
Born: May 29, 1926, in London.
Died: February 10, 1971, in Laos.

Larry Burrows began working in *Life* magazine's London photo lab in 1942, when he was sixteen. He was a "tea boy" whose job was to fetch steaming-hot cups of tea. It was a fascinating time for journalists—the blitz, blackouts with air-raid sirens and bombs raining down—exciting and terrifying all at once.

Burrows was born Henry Frank Leslie Burrows; "Larry" was the work of a group of U.S. servicemen. As a young man, Burrows stuttered, was skinny, wore glasses, and was always fingering a camera. His career as a photographer began in 1945. He photographed Ernest Hemingway at bullfights, Winston Churchill, Billy Graham's British crusades, other celebrities and politicians, and particularly the paintings that illustrated *Life*'s series on great art. He didn't like being called a war photographer, but he spent much of his career on the battlefield, covering the conflicts in the Congo and the Middle East as well as the Vietnam War. Three-time winner of the Overseas Press Club's Robert Capa Award for Still Photography Requiring Exceptional Courage and Enterprise, he also was named 1967 Magazine Photographer of the Year by the University of Missouri School of Journalism.

He had been photographing in Calcutta when he heard that the South Vietnamese were poised to invade Laos. He flew back to the war he knew best and did what he always did: went to the front to find the action. Just before he died, Burrows behaved in a characteristic manner, risking his life to rescue a Vietnamese soldier from a burning personnel carrier. The next morning, in bad weather, Burrows and Kent Potter of UPI, Keizaburo Shimamoto of *Newsweek*, and Henri Huet of AP were aboard a helicopter headed into Laos. The pilot lost his way, flew over enemy gun positions, and was shot down. *Life* managing editor Ralph Graves called Burrows "the single bravest and most dedicated photographer I know of."

JAMES DENIS GILL. *Britain.*
Born: 1939 in Birmingham, England.
Died: June 29, 1972, near Quang Tri, Vietnam.

On June 8, 1972, a freelance photographer claiming to be an ex–British Marine arrived in Saigon and introduced himself to the press corps as James Gill. Less than a month later, while photographing SVN Marines near Quang Tri, he apparently was killed while trying to move from one unit to another. The British embassy identified him as William H. J. Cattell, twenty-three, a Marine commando officially listed as an absentee from his unit. The British Defence Ministry said Cattell had deserted twice, the second time on April 8, 1972.

THE CAMBODIANS
The best estimate of the number of Cambodian photographers either killed in the war or missing and presumed dead is twenty. Most of them drifted into journalism from professions as diverse as acting and teaching, bringing few details of their past with them. In the time they were known to us, they were young, eager to please, and brave. Their presence was indispensable to Western journalists trying to cover Cambodia's elusive guerrilla war from the Hotel Royale, later the Hotel Le Phnom.

In the field and on the roads, they saved American, French, and other Western lives with their instincts, savvy, and knowledge of their own country. They interpreted not only the language but also the nuance of the losing government's response to the winning Khmer Rouge. They were repaid with a little money, long hours, an occasional acknowledgment of their efforts in a byline or photo credit, and friendship.

When the end came, the photo stringers, drivers, and interpreters were separated, sometimes forcibly, always heartbreakingly, from their would-be protectors, who had sought sanctuary in the French embassy. In their employers' last view of most of these loyal, fine people, they were walking west into the setting sun, toward the killing fields. No one who knew them will ever forget them.

CHEA HO
A quiet, shadowlike figure, Chea Ho worked for UPI. While photographing action on Route 4 in 1971, he was hit in the spine and almost completely paralyzed. When the Khmer Rouge emptied Phnom Penh's hospitals and forced staff and patients alike to start heading west, Chea Ho was lost.

CHHIM SARATH
A driver who worked as a photographer for UPI, Chhim Sarath was captured in 1971 but released. On April 25, 1972, he was with American Terry Reynolds and Australian Alan Hirons on Route 1 when they were captured by Khmer Rouge guerrillas.

CHHOR VUTHI
Believed to be the youngest photographer covering the war in Cambodia, Chhor Vuthi worked for AP. In 1974 he was wounded in the arm but was soon back on the job. He disappeared in Phnom Penh when it fell in April 1975.

HENG HO
A driver who worked as a photographer for UPI, Heng Ho was a Cambodian Chinese. He was in Phnom Penh when it fell in April 1975 and is presumed dead.

KIM SAVATH
An AP photographer, Kim Savath died in Kompong Chhanang Province in 1974 while photographing in combat.

KUOY SARUN
A driver, interpreter, and photographer, Kuoy Sarun worked for several international news

outlets, including *The New York Times*. He is believed to have died in 1977 in the killing fields.

LANH DAUNH RAR

A photographer for AP in 1974–1975, Lanh Daunh Rar's fate is unknown.

LEK

A freelance photographer for AP, Lek worked primarily for Prime Minister Lon Nol's Military Information Bureau. He was in Phnom Penh when it fell to the Khmer Rouge.

LENG

A freelancer with AP, Leng left no trace.

LY ENG

Editor of the Cambodian *Koh Aantipheap* newspaper, Ly Eng was an educated and well-traveled man who had also edited a book on the 1967 Arab-Israeli war. Born into a family of teachers, he wrote in French and Cambodian and was a prominent voice among the local journalists. He helped Western journalists in their assignments. In 1972, Ly Eng was accused of treason, jailed, and condemned to die by firing squad for reporting on corruption among top military officials under the command of the prime minister's brother, Lon Non. His friends arranged a jailbreak, and he fled overland to Thailand. When Lon Non was ousted, Ly Eng returned to Cambodia via Laos. He was in the capital when the Khmer Rouge took over. He is presumed dead.

LYNG NHAN

Also known as Ly Ngan, Lyng Nhan freelanced for AP in 1974–1975. He disappeared as the Khmer Rouge arrived.

PEN

Pen was another stringer for AP who left no trace.

PUT SOPHAN

A photographer and general assistant for news agencies and CBS News, Put Sophan was last seen by *New York Times* interpreter Dith Pran during the evacuation of Phnom Penh. Dith Pran was on Route 6 about twenty-five miles outside the capital. Put Sophan told him that he had contacted the Khmer Rouge and told them he worked for CBS, and he said that they had promised to bring him back to Phnom Penh, where he would work for them. "I told him that I didn't trust the Khmer Rouge," Dith Pran recalled, "and I kept moving." Dith Pran would be the lone Cambodian journalist to survive the killing fields. He escaped to Thailand and ultimately reached the United States. A rumor says that Put Sophan was with Tea Kim Heang (Moonface) and that they took their cameras with them into the countryside and initially survived but were later executed.

SAING HEL

Editor of a Cambodian newspaper, Saing Hel was a gentle, handsome man who liked fishing and romantic novels. He was highly principled and spoke out against the corruption and lies scuttling Cambodian society before the country fell to the Khmer Rouge. Government thugs nearly killed him several times in retaliation for his political views. Besides editing his newspaper, he contributed photographs to the AP report and enjoyed dubbing actors' lines in local versions of Western movies. He was in Phnom Penh at the Communist takeover.

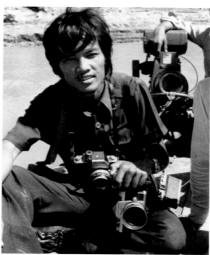

Sou Vichith

SOU VICHITH

A photographer who worked for Gamma and AP, Sou Vichith and his wife and children took refuge in the French embassy when Phnom Penh fell, but they were forced out by the Khmer Rouge. They began walking along Routes 5 and 6, where they were seen by Dith Pran headed in the direction of the killing fields. Dith Pran heard later that Sou Vichith died there.

SUN HEANG

At forty, Sun Heang was one of the oldest Cambodian journalists to work for the Western news agencies. He already had a career dubbing foreign films in Cambodian. He worked for AP and was the last person to file any AP reports out of Phnom Penh after the Khmer Rouge took over. He reportedly was executed.

TEA KIM HEANG

Known to all as Moonface, Tea Kim Heang had been an actor. When war came, he worked alternately for AP and UPI. Wounded in the shoulder and thigh on Route 4 in 1971, Moonface was captured with UPI Cambodian bureau chief Kate Webb only a month later. They were held by the Viet Cong for twenty-three days. During the forced marches and captivity, Moonface suffered agonies from gout, dehydration, and sore feet. He was wounded eight times during his career. When the Khmer Rouge entered Phnom Penh, Moonface was still shooting pictures. He reportedly was with Put Sophan during the initial deportations from the capital.

THONG VEASNA

A tall, muscular man in his mid-twenties when he was a photographer for AP, Thong Veasna is remembered by his former colleagues as a helpful newsman. There is no information about his fate.

TY MANY

When he first went to AP, Ty Many was a cyclo driver. He used his tricycle to ferry passengers and deliver messages. Soon he was learning how to use a camera and tried hard to equal the performance of the other Cambodian photographers. He was in Phnom Penh until the Khmer Rouge arrived.

VANTHA

Photos in the AP library are the only trace Vantha left.

CLAUDE ARPIN-PONT. *France.*
Born: December 31, 1940, in Montaigu, France.
Missing: April 5, 1970, on Route 1, Cambodia.

Claude Arpin-Pont quit school at sixteen. He had already been taking pictures for two years, and he continued photography while serving as an army paratrooper in Algeria. His first pictures were published in 1962. He went to Vietnam in 1967, focusing on the war in Cambodia. He was traveling with two Japanese correspondents and a Cambodian driver when stopped by the Viet Cong. Claude Arpin-Pont and his companions were marched toward Laos, according to villagers' reports, and never seen again.

FRANCIS BAILLY. *France.*
Born: 1934 in France.
Died: February 19, 1971, near Kompong Cham, Cambodia.

A freelancer for Gamma and UPI, Francis Bailly arrived in Cambodia in June 1970. He often spent long stints with troops in the field. Like all photographers and correspondents covering the war in Cambodia, he was driven to the front in a hired car. Soldiers found his body in an abandoned taxi on Route 7, where Cambodian troops had been trapped by Khmer Rouge guerrillas. He had been shot in the back of the head.

Gilles Caron

GILLES CARON. *France.*
Born: July 8, 1939, in Neuilly-sur-Seine, France.
Missing: April 4, 1970, on Route 1, near Chipou, Vietnam.

His career lasted just six years, but Gilles Caron left a legacy emulated today by young

photojournalists. In 1965, he joined the APIS agency in Paris. Two years later he helped establish Gamma and became famous when he covered the Six-Day War in the Middle East. He seemed to be everywhere at once: the horrific battle for Hill 875 in Vietnam, the war and famine in Biafra, an expedition to Chad, the students' riots in Paris, civil war in Northern Ireland, the aftermath of the Prague Spring.

For weeks every issue of *Paris Match* had a Caron photo story. Like so many of his colleagues, he disappeared in the Parrot's Beak area along the Cambodian border with South Vietnam. His widow, Marianne, has established a foundation to preserve his work. The book *Sous les pavés, la plage* (1993) showcases his May 1968 pictures of the student uprising in Paris. The Bibliothèque nationale de France has indexed and digitized Caron's photographs.

FRANZ DALMA. *France.*
Died: July 27, 1954, in Vietnam.
In the French Foreign Legion, Franz Dalma served as a photographer and covered the activities of his unit. His photos were made available through the French Press Information Service. His last assignment was the Battle of Dien Bien Phu, where he was taken prisoner along with other survivors of his unit. In the tradition of the Foreign Legion, nothing of his earlier life and the circumstances of his death have been recorded.

BERNARD B. FALL. *France.*
Born: November 19, 1926, in Vienna, Austria.
Died: February 21, 1967, on the Street Without Joy, northwest of Hue, Vietnam.
As a child Bernard Fall was caught up in the French resistance against the Nazis when his family moved from Austria to France. He became a research analyst at the Nuremberg war-crimes trials. Later he studied at the Sorbonne and the University of Maryland Overseas. In 1951, he was awarded a Fulbright Scholarship to Syracuse University, where he earned his master's and doctorate degrees. He chose the Viet Minh as the topic of his doctoral thesis and went to Indochina in 1953 for field research. Letters home to his wife, Dorothy, during the seven months he spent interviewing tax collectors, traveling with the French army, and sizing up village allegiances formed the core of his first and most famous book, *Street Without Joy.* Fall warned that Ho Chi Minh's forces would ultimately win the Indochina wars because they were wars of revolution. His prescience and meticulous research made him, by the time of his death, the leading scholar-journalist on Vietnam. Blessed with immense energy, he wrote hundreds of articles and seven books about Vietnam. Many of the illustrations accompanying his writing were his own. On his sixth trip to Vietnam, revisiting the Street Without Joy area with U.S. Marines on Operation Chinook, he was killed by a booby-trap explosion.

GERARD HEBERT. *France.*
Born: 1918 in France.
Died: July 22, 1972, near Quang Tri, Vietnam.
Gerard Hebert claimed that he was born in Quebec, Canada, during World War I and that he came to Vietnam from Montreal, where he had worked for CBC Television. In the field Hebert liked to work alone with elite units, such as the SVN Marines and paratroopers. He was wounded in 1972 while rescuing three Vietnamese paratroopers and was given a medal for his bravery.

During the battle for An Loc, he was wounded when a helicopter taking him from the combat zone was shot down. He was wounded again when the helicopter that had rescued him was shot down. Upon recovering, he went to Quang Tri to photograph the heavy fighting in that city and was killed by a 130-millimeter round.

Documents he had left for safekeeping in Saigon revealed that Gerard Hebert was not his real name, he had got his Canadian passport under false pretenses, and he was a Frenchman who had left France after serving time in prison. His mother, located by UPI, would have nothing to do with her son's remains. He was buried in the old Catholic cemetery near Tan Son Nhut Airport in Saigon, where French and Vietnamese lie side by side. Only in 1990 did it become known that Hebert's real name was Gerard Arroux.

Henri Huet

HENRI HUET. *France.*
Born: April 1927 in Da Lat, Vietnam.
Died: February 10, 1971, in Laos.
Son of a French father and a Vietnamese mother, Henri Huet moved with his family from Da Lat to France when he was five years old. Educated in Brittany, at Saint-Malo, and at an art school in Rennes, Huet started out as a painter, then went into the army, which sent him to study photography. At twenty-two, Huet returned to Vietnam as a French combat photographer and stayed on after his discharge, working as a civilian photographer for the French and American governments and then for UPI. He switched to AP in 1965. Constantly in the field, he

had numerous close calls. Wounded twice, Huet was transferred to Tokyo, but he was restless and missed the action, so he asked to return to Vietnam. In 1967, he won the Overseas Press Club's Robert Capa Award for Still Photography Requiring Exceptional Courage and Enterprise. Among his peers Huet was respected for his bravery, dignity, and skill, and he was loved for his kindness and sense of humor. Huet, Larry Burrows of *Life* magazine, UPI's Kent Potter, and Keizaburo Shimamoto, who was working for *Newsweek,* were killed when the South Vietnamese helicopter they were riding in was shot down over the Ho Chi Minh Trail in Laos.

PIERRE JAHAN. *France.*
Born: 1929 or 1930 in France.
Died: May 1954 in Dien Bien Phu, Vietnam.
Serving as a paratrooper in the French army, Pierre Jahan was transferred to Indochina in 1952, where he worked as a photographer for the French Press Information Service. After a year he was ordered back to his regular army unit, which was going to Dien Bien Phu. Jahan died in hand-to-hand combat at outpost Elaine One toward the end of the fighting. His body was never recovered, and it is not known whether he took pictures during his last battle.

MICHEL LAURENT. *France.*
Born: July 22, 1946, in Vernon, France.
Died: April 28, 1975, near Xuan Loc, Vietnam.
Skinny, freckled, and curly haired, with a jaunty handkerchief tied around his neck, Michel Laurent barely looked old enough to shave. He went to work for AP in Paris in his teens and got his big break during the 1968 student uprising. When the Russians invaded Prague in August 1968, AP sent Laurent. It was the start of nonstop travel to troublespots: Jordan for the Palestinian crisis, Cairo for Gamal Nasser's funeral, the unrest in Northern Ireland, Vietnam.

When he was expelled from Dacca in 1971, he hitchhiked and bicycled his way

Michel Laurent

back into Bangladesh from Calcutta, dodging army patrols all the way. Once there, he teamed up with Horst Faas to record Bengali guerrillas bayoneting collaborators to death. In 1972, the two AP photographers shared a Pulitzer Prize, the Overseas Press Club's George Polk Award, and the University of Missouri Award for the Bangladesh photos. Laurent joined Gamma and continued covering wars in Israel, Ethiopia, and Cyprus. He had not intended to return to Vietnam, but in 1975 the Gamma photographer in Saigon was wounded and Laurent's visa was valid. By then, Laurent had acquired a reputation as a photographer who stood up when others took cover and who held his shutter finger taut for just the right shot instead of firing a dozen frames hoping for that good one. On April 28, he drove out to meet the advancing NVA on Route 1 and was shot by automatic-rifle fire while attempting to rescue Christian Hoche, his wounded colleague from *Le Figaro*. Laurent died two days before the war ended, the last Western journalist to be killed in Vietnam.

RAYMOND MARTINOFF. *France.*
Born: 1926 in France.
Died: March 13, 1954, in Dien Bien Phu, Vietnam.
Raymond Martinoff joined the French army and became a sergeant with the Moroccan infantry sharpshooters. Sent to Indochina in 1947, he liked that part of the world so much that he served three tours. In 1953, he was handed a Rolleiflex camera and transferred to the French Press Information Service where he became a familiar figure with combat units. He was with cameraman Andre Lebon when Lebon lost his leg at Dien Bien Phu during a mortar attack; two days later Martinoff was killed by artillery shells as he took pictures of planes evacuating wounded troops from the besieged garrison.

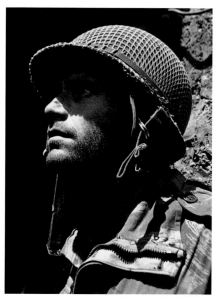

Jean Peraud

JEAN PERAUD. *France.*
Born: 1923 in Saint-Nazaire, France.
Missing: May 23–24, 1954, near Thakhoa, Dien Bien Phu, Vietnam.
Jean Peraud became a towering figure among photographers of the French

Indochina War. As a youth living next to a German submarine base in the port of Saint-Nazaire, he was a spy for the French resistance. In 1944, the Gestapo arrested and tortured him, then sent him to Buchenwald concentration camp. He survived and joined the French army after World War II.

In 1952, he went to Indochina and became a photographer for the French Press Information Service, often parachuting with troops into combat. In March 1954, he jumped into Dien Bien Phu and was there when the Viet Minh overran it on May 7. Along with French troops and his Press Service colleagues Daniel Camus and Pierre Schoendoerffer, Peraud was marched through the jungle for ten days, then driven in darkness by truck. He and Schoendoerffer tried to escape. Schoendoerffer, who was immediately recaptured, saw Peraud disappear into a dense bamboo forest as guards fired shots at him. He was never heard from again.

FRANÇOIS SULLY. *France.*
Born: August 7, 1927, in France.
Died: February 24, 1971, near Tay Ninh, Vietnam.
François Sully seemed as at ease in the jungle as he was at Harvard University, where he studied for a time. Born between the world wars, he joined the French resistance as an adolescent and was wounded on his seventeenth birthday. In 1945, he volunteered for duty in Vietnam, arriving as the Japanese surrendered. After he was discharged in Saigon, he sought his fortune in the countryside as a tea planter and sheep rancher, but panthers ate his sheep, so he turned to journalism.

He joined Time-Life in 1953, went to Dien Bien Phu, and got out before the outpost fell to the Viet Minh. After a stint at UPI, he was hired by *Newsweek* magazine in 1961. Despised by president Ngo Dinh Diem's regime for reporting information "helpful to the enemy," Sully was expelled in September 1962. He spent a year at Harvard as a Nieman fellow, then returned to Saigon to report on the coup against Diem in November 1963. He believed that field soldiers, not generals, had the answers in war, but he was riding with his longtime friend General Do Cao Tri when their helicopter burst into flames. Sully leaped from the burning craft and plunged seventy-five feet to the ground. All others were killed in the crash. Sully died of injuries from the fall and was buried in the French cemetery in Saigon.

DIETER BELLENDORF. *Germany.*
Born: March 11, 1930, in Germany.
Missing: April 8, 1970, on Route 1 near Svay Rieng, Cambodia.
A freelance photographer for AP, Dieter Bellendorf had arrived in Vietnam in 1968 at the time of the Tet Offensive. He was wounded by mortar fragments in June 1969, near Duc Pho, Vietnam, while covering the Americal Division. In 1970, he went to Cambodia to work as a cameraman for NBC News while keeping his affiliation with AP. He disclosed that he had been with the

French Foreign Legion. Austrian photographer Georg Gensluckner and Dieter Bellendorf teamed up often to drive out of Phnom Penh looking for the war. On the day they disappeared, they were about thirty-four miles south of the Cambodian capital when Khmer Rouge guerrillas captured them.

TAIZO ICHINOSE. *Japan.*
Born: November 1, 1947, in Takeo, Japan.
Missing: November 22–23, 1973, between Phnom Penh and Angkor, Cambodia.
Taizo Ichinose graduated with a degree in photography from Nihon University in 1970. As an amateur boxer, he kept in prime physical shape. He began working as a freelance photographer for UPI in Japan, then covered the India-Pakistan conflict in 1972. He traveled to Vietnam later that year and covered the fighting in the Mekong Delta. His last photo editor at UPI described him as a "free spirit" who was "willing to go anywhere." In Cambodia, Ichinose decided to ride a bicycle between Phnom Penh and the ancient temples of Angkor. He was never seen again.

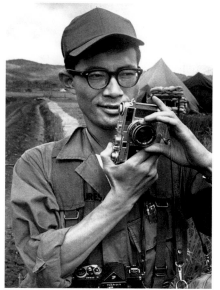

Hiromichi Mine

HIROMICHI MINE. *Japan.*
Born: October 12, 1940, in Mukden, Manchuria.
Died: March 5, 1968, near Hue, Vietnam.
A graduate of the University of Jochi (Sofia) in Tokyo, Hiromichi Mine had a degree in economics. Though he planned a career in business, his love of photography prompted him to take a low-paying job at UPI's Tokyo office. He got his chance to break into the newsphoto business in July 1964, when he was sent to Vietnam. Mine took one of the most famous shots of the war at a Special Forces camp in the central highlands: a twin-engine Caribou transport plane a second after it was hit by an artillery shell as it came in for a landing. The plane was cut in half, and all aboard died. The picture won prizes in the World Press Photo Contest at the Hague and the Picture of the Year competition, co-sponsored by the National Press Photographers Association and the *World Book Encyclopedia*.

During his second tour of Vietnam, Mine was riding in an armored personnel carrier between Hue and Phu Bai when it hit a land mine. The vehicle flipped and caught fire. Mine suffered burns over 75 percent of his body and died at a Marine aid station.

KYOICHI SAWADA. *Japan.*
Born: February 22, 1936, in Aomori Prefecture, Japan.
Died: October 28, 1970, in Laos.

Born in northern Japan, Kyoichi Sawada was orphaned as a child. He completed high school in 1954 and wanted to go to Waseda University in Tokyo but failed the entrance exam. Setting aside that dream, he got a job at a camera shop in the post exchange at the United States military base at Misawa. His aspirations led him to Tokyo, where he went to work for UPI in December 1961. Soon he was UPI's Tokyo picture editor. He asked for, but was denied, a transfer to Vietnam. In February 1965, he used his vacation to go to war. His photos from that trip persuaded UPI to send him to Saigon. Within the year he had received the Pulitzer Prize for news photography for *Flee to Safety*, his dramatic picture of a desperate mother swimming with her children across a river in search of safety. Sawada also was awarded the grand prize of the Ninth Annual World Press Photo Contest, an Overseas Press Club award, and the U.S. Camera Achievement Award for that photo.

In 1966, Sawada won first and second place in the World Press Photo Contest, and a year later won a second Overseas Press Club Award. In 1968, at the peak of his career, UPI named him news-picture editor in Hong Kong, but he didn't like desk work and returned to Vietnam as the war expanded into Laos and Cambodia.

Sawada volunteered to take the new Phnom Penh bureau chief, Frank Frosch, down the narrow Route 2 to Chambak, twenty-four miles south of Phnom Penh, to assess the war. The next day another UPI staffer found the men's bodies lying about thirty feet from their car. Each had been shot several times through the chest. Neither Sawada nor Frosch was armed, and both were dressed in civilian clothes. Sawada had been captured a few months earlier, along with outgoing UPI bureau chief Bob Miller, but after eight hours of interrogation they had managed to persuade their captors to release them.

After his death, the Overseas Press Club presented him with its Robert Capa Award.

KEIZABURO SHIMAMOTO. *Japan.*
Born: January 5, 1937, in Seoul, South Korea.
Died: February 10, 1971, in Laos.

Carefully, assignment by assignment, Keizaburo Shimamoto built a solid reputation as a photojournalist. When he graduated from Waseda University in Tokyo in 1959 with a degree in literature, he seemed destined for a more aesthetic life. But he got a job as a photographer for the Pan-Asia Newspaper Alliance. By June 1965, he had become PANA's Saigon photographer. In January 1968, he signed on with Gamma.

He went home to Tokyo for two years, but the lure of Vietnam brought him back in July 1970. From then until his death, he was often shooting for *Newsweek*. He was on assignment for *Newsweek* when he and Larry Burrows of *Life* magazine, Kent Potter of UPI, and Henri Huet of AP died in a helicopter crash in Laos. In 1972, the Overseas Press Club honored him with a posthumous citation.

CHARLES CHELLAPPAH. *Singapore.*
Born: in the East Indies.
Died: February 14, 1966, near Cu Chi, Vietnam.

It was Charlie Chellappah's dream to go to Vietnam and become a war photographer. He emigrated from the East Indies to Singapore so that he could get work as a news photographer. He arrived in Saigon in January 1966.

Freelancing for AP, he went to a place American GIs called Hell's Half Acre. Some twenty-five miles north of Saigon, it was a densely jungled rubber plantation honeycombed with Viet Cong tunnels and overrun by snipers. His dramatic close-up images of casualties and combat prompted the AP photo editor to warn Chellappah to be more cautious and take fewer chances.

Two days later he was with U.S. infantrymen when they swept a road; a claymore mine exploded, and Chellappah accompanied the company commander and a medic to help the wounded. The Viet Cong then detonated a second mine, killing them instantly. The roll of film in his camera captures the drama up until his death.

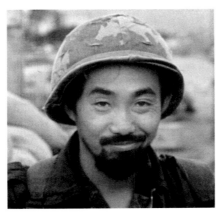

Terrence Khoo

TERRENCE KHOO. *Singapore.*
Born: November 21, 1936, in Singapore.
Died: July 20, 1972, along Highway 1 in Quang Tri Province, Vietnam.

Born of Chinese parents, Terry Khoo had a love of languages and learned English and French. When he went to Vietnam in 1962, he learned Vietnamese. His skill in talking to people in their native tongue, as well as his coolness under pressure, soon made Khoo one of the most sought-after cameramen of the war. He especially liked taking close-up portraits and photographing children. All the networks, including his employer for seven years, ABC News, used Khoo's film on the nightly news. *Asia* magazine used his photos. He covered everything—Khe Sanh, the Tet Offensive, the famous battles, and the

small firefights. He once saved the life of ABC correspondent Steve Bell, an American, by convincing his Khmer Rouge captors that Bell was Australian.

In 1972, ABC planned to transfer Khoo to Bonn. One day before his departure he and Sam Kai Faye, who was to replace him, decided to check out the fighting north of Hue. Snipers caught them in an open field, Sam Kai Faye was hit in the stomach, and Khoo said he would stay with his friend until help arrived. By the time rescuers reached them Khoo, too, had also been shot to death. His tombstone in Singapore's Chua Chu Kang Christian Cemetery is inscribed, in part, "a son so valiant and noble-hearted . . . a man with courage and soul."

SAM KAI FAYE. *Singapore.*
Born: March 10, 1924, in Penang, Malaysia.
Died: July 20, 1972, along Highway 1 in Quang Tri Province, Vietnam.

In life and death Sam Kai Faye was joined with his friend, fellow Singaporean and fellow ABC cameraman, Terry Khoo. Like Khoo, Faye was a passionate photographer. He won the British Commonwealth Photo Contest in 1958 and 1959. Even as he began filming for television, he continued to take still pictures.

On their last day, Terry Khoo wanted to have just one more look at the fighting north of Hue before moving on to a new assignment in Europe, and Sam Kai Faye, who was replacing him, went along. They were carrying heavy camera equipment across an open field near the My Chanh River when they were caught by NVA machine gunners. A single sniper zeroed in, and Faye took a round in the stomach. Khoo stayed with him, waiting for help to arrive. Before help came Khoo was also hit by the sniper. It took several days before the two bodies were recovered. Faye is buried at Peck San Teng Buddhist Cemetery in Singapore.

WILLY METTLER. *Switzerland.*
Born: January 1, 1940, in Reichenburg, Canton Schwyz, Switzerland.
Missing: April 16, 1970, near Kampot, Cambodia.

Willy Mettler, a freelance photographer and journalist, lived in Bangkok for some months, then set off for Cambodia in a Volkswagen bus in early 1970 and reportedly reached Phnom Penh. He was captured near Kampot several weeks later.

ROBERT CAPA. *United States.*
Born: October 22, 1913, in Budapest, Hungary.
Died: May 25, 1954, near Thai Binh, Vietnam.

Endre Friedmann, nicknamed Bandi, was seventeen when he was beaten and jailed by Fascist police who accused him of being a Communist. He left the Jewish quarter of Pest for Berlin, where he studied journalism and worked as a photographer's helper. Ambitious, curious, and quick, his first published picture was of Leon Trotsky in exile in Copenhagen in 1932.

The victim of anti-Semitism, Friedmann moved on to Vienna and then Paris, but his name still hampered his career. In 1936, his

photographs of the Spanish Civil War carried the credit Robert Capa. These pictures introduced to the world the courage and brilliant eye of the persona he had invented for himself.

Tall, dark, and handsome, with a suave manner women adored, he was also intellectual and intuitive. Fluent in five languages, he prowled the turbulent political landscape of the late 1930s, the 1940s, and the early 1950s looking for great pictures; he found them in eighteen wars. He photographed the Japanese-Chinese fighting in Shanghai, then went to North Africa for Rommel and Montgomery's clash in the desert. He joined up with U.S. paratroopers in Tunisia and jumped with them into Sicily. At dawn on D-day he was in the first wave to hit Omaha Beach in Normandy. He counted among his friends the foot soldiers of dozens of nations, Pablo Picasso, the founders of modern Israel, Nobel laureates, Ernie Pyle, and bartenders everywhere.

In 1947, Robert Capa devoted himself to organizing the Magnum Photos agency with Henri Cartier-Bresson, David Seymour, George Rodger, and William and Rita Vandivert. He skipped the Korean War but was assigned to Vietnam by *Life* magazine in 1954. It was his last trip: he was killed by a land mine near Thai Binh in North Vietnam.

SAM CASTAN. *United States.*
Born: May 12, 1935, in Brooklyn, New York, U.S.A.
Died: May 21, 1966, near An Khe, Vietnam.
Look magazine was Sam Castan's ticket to the world. A New Yorker who had graduated from Brooklyn College and served in the army, willingness to go anywhere landed him a job with *Look* in 1957. He wrote about the civil war in Cyprus and the uprising in the Dominican Republic. In 1964, the Society of Professional Journalists awarded him its medal of honor for his reporting from Vietnam. By age twenty-nine, he was a *Look* senior editor of Asian affairs based in Hong Kong and often covered the war as a photographer as well. He was killed reporting on Operation Crazy Horse.

The U.S. Army awarded him posthumously the Outstanding Civilian Service Medal. The citation says, in part, "On 21 May 1966, Mr. Sam Castan distinguished himself by bravery in action. . . . Voluntarily taking up arms against a numerically superior enemy force, he fired his pistol at point-blank range against an enemy machine-gun crew. Thrice wounded, he gave his life in defense of his fellow Americans. Mr. Castan's heroic action reflects great credit upon himself and the news media he represented."

DICKEY CHAPELLE. *United States.*
Born: March 14, 1918, in Shorewood, Wisconsin, U.S.A. (born Georgette Louise Meyer)
Died: November 4, 1965, near Chu Lai, Vietnam.
Whiskey-voiced and brave, Dickey Chapelle spent most of her adult life in a man's world. She knew how to parachute out of a plane as well as how to fly one, had adventures in three wars, and was remembered by nearly everyone she ever met.

In 1962, she won the Overseas Press Club's George Polk Award for the best reporting in any medium, requiring exceptional courage and enterprise abroad. Her proudest achievement was the Distinguished Service Award, presented by the U.S. Marine Corps Combat Correspondents Association. At her memorial service a representative of the Women's National Press Club said Chapelle was "the kind of reporter all women in journalism openly or secretly aspire to be. She was always where the action was."

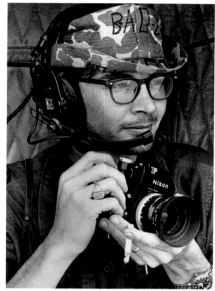

Charles Richard Eggleston

CHARLES RICHARD EGGLESTON. *United States.*
Born: November 1945 in Gouverneur, New York, U.S.A.
Died: May 6, 1968, in Saigon, Vietnam.
When Charlie Eggleston's stint as a U.S. Navy journalist ended in 1966, he had collected two bronze stars for valor and other military awards for such efforts as climbing down a helicopter hoist to rescue a U.S. pilot in North Vietnam and serving with a SVN junk-fleet patrol. Going home to Gouverneur, New York, didn't hold the same appeal as working for UPI in Saigon, so he stayed on. He was wounded twice in the 1968 Tet Offensive. He died in Rocket Alley near Saigon's Tan Son Nhut Airport, leaving his estate to Vietnamese orphans.

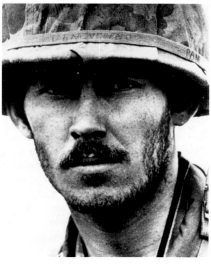

Robert Jackson Ellison

ROBERT JACKSON ELLISON. *United States.*
Born: July 6, 1944, in Ames, Iowa, U.S.A.
Died: March 6, 1968, near Khe Sanh, Vietnam.
At the University of Florida, Bob Ellison switched his major from herpetology to photography and then to journalism and soon landed a dream assignment: *Ebony* magazine hired him to photograph the march that Dr. Martin Luther King, Jr., was leading from Selma to Montgomery, Alabama. Ellison subsequently covered the civil rights movement throughout the South. The rather slight figure in a felt hat and turtleneck sweater became familiar to the thousands of marchers.

Ellison arrived in Vietnam for the 1968 Tet Offensive and spent three weeks with besieged Marines at Khe Sanh. Later, to get back to Khe Sanh, he bartered his way onto a C-123 flight with a case of Coke, a case of beer, and a box of cigars. His name was inadvertently left off the manifest, and when the plane was shot down near the Khe Sanh runway, nearly a week passed before the twenty-three-year-old photographer's fate was known.

Dr. King was assassinated a month later. *Ebony* eulogized both men in an editorial, describing Ellison as "the young white photographer who lived free of prejudice, full of understanding and respectful of the rights of all men."

His *Newsweek* photographs, published after he died, posthumously won Ellison the Overseas Press Club's award for Best Magazine Coverage from Abroad.

Bob Ellison and the Marines on that fatal flight into Khe Sanh are buried in a mass grave in a military cemetery in Missouri.

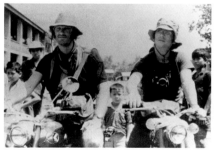

Sean Flynn (left) and Dana Stone

SEAN FLYNN. *United States.*
Born: May 31, 1941, in Palm Beach, Florida, U.S.A.
Missing: April 6, 1970, on Route 1 in the Parrot's Beak area of Cambodia.
His good looks—he was six feet one with flashing eyes and seemingly sculpted features—and his parentage—he was the son of Hollywood actor Errol Flynn and French actress Lili Damita—always preceded any consideration of his achievement when Sean Flynn was new in town or in a crowd. But in Vietnam, on the job, what mattered was whether you were good enough to get work, and Flynn got work.

A child of privilege, he dabbled in movies (*Where the Boys Are, Son of Captain Blood*), lived in Paris, hunted in Africa, and turned up in Saigon as the ringleader of a band of daring freelancers who used motor-

cycles to stay ahead of the pack. Flynn sold his photographs to the wire services, weekly news magazines, and television networks. He and his buddy Dana Stone, the pair nicknamed the Easy Riders, disappeared together in Cambodia.

RONALD D. GALLAGHER.
United States.
Born: July 19, 1939, in Fort Scott, Kansas, U.S.A.
Died: March 11, 1967, near Saigon, Vietnam.

In his lifetime, Ron Gallagher lived in only two places, Kansas and Vietnam. He was born and raised in the same town, and even stayed home to go to college there.

Unable to find a full-time job in the newspaper business, he followed his dream to Vietnam. According to his boss at the Topeka newspaper that sponsored him in Saigon, he wanted to find fame and fortune in war. He supported himself by freelancing. He was killed by friendly fire—a misdirected American artillery shell that also killed four U.S. soldiers and wounded eight others during a combat mission south of Saigon.

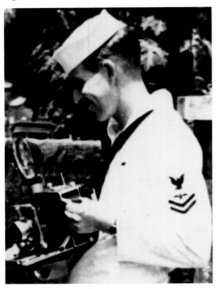
Neil K. Hulbert

NEIL K. HULBERT. *United States.*
Born: 1931.
Died: March 5, 1966, on Mount Fuji, Japan.

As a young U.S. Navy photographer, Neil Hulbert was assigned to photograph French Union forces in Vietnam in 1953–1954. He returned to civilian life after assignments in Korea and the South Pacific, where he recorded the Eniwetok hydrogen-bomb tests.

Hulbert's pictures for the *Humboldt Standard* newspaper in Eureka, California, proved to Americans that Russian trawlers were operating illegally in U.S. waters off the West Coast. Hulbert's memories of Vietnam stayed with him. As the United States became increasingly mired in its Indochina war, he asked for an assignment to return to Vietnam. En route, he and 123 other passengers were killed when the pilot of their Boeing 707 detoured to give them a better view of Mount Fuji, then crashed into it.

BERNARD KOLENBERG. *United States.*
Born: 1927 in Troy, New York, U.S.A.
Died: October 2, 1965, near Qui Nhon, Vietnam.

A veteran photographer with twenty years at the same newspaper, Bernard Kolenberg was well known to state and national politicians who frequented the capitol in Albany, New York, which he covered for the *Times-Union*. Kolenberg was adventurous: He took

Bernard Kolenberg

parachute lessons so that he could photograph skydivers and rode a motorbike so he could get to stories quickly. He chronicled the partition of Berlin and the rise of a young senator named John F. Kennedy. His seven-year album of Kennedy photographs resulted in *John F. Kennedy: A Memorial Tribute, Albany to Arlington*, published in 1964.

Kolenberg spent a few weeks in Vietnam for his newspaper in the summer of 1965, then returned in the fall as a volunteer for AP. "It's great to be back," he said. A week later he was dead, killed in the crash of an A-1E Skyraider.

Oliver E. Noonan

OLIVER E. NOONAN. *United States.*
Born: November 2, 1939, in Boston, Massachusetts, U.S.A.
Died: August 16, 1969, near Da Nang, Vietnam.

Ollie Noonan went to Vietnam on his own, paying for his ticket and putting on hold his career at *The Boston Globe* and his presidency of the Boston chapter of the National Press Photographers Association. Like so many talented shooters of his generation, he had already covered the civil rights movement in the American South and the 1963 March on Washington. He had photo-

graphed art in Europe, the Beatles, and murder and mayhem in Massachusetts. His father was also a photographer, and for a brief time they competed at different Boston newspapers.

In Vietnam, on temporary assignment for AP, Ollie Noonan didn't drink, rarely smoked, and calmed his nerves by writing poetry and listening to classical music. The day he died, he got exclusive pictures of fierce fighting, then put aside his cameras to help carry wounded. He was rushing to get his film to Da Nang when his helicopter was shot down. His cameras were later recovered, the film still intact. The pictures showed American GIs in battle and a fisherman on a beach.

Ollie Noonan was laid to rest in the family burial plot on Campobello Island, Canada. His friends at *The Boston Globe* added this poem, which he had sent from Vietnam to the newspaper's obituary files.

On the Side That's Winning

The moon hangs like a tear
And I, sensing immortality
But afraid of tomorrow, rush to greet it
Afraid to die
And keep running,
Afraid to realize it may be hopeless
To carry tears on my sleeve
While right behind me, in cloak and gown,
The man's juggling bombs
Like a circus clown
Though the bells toll
They can bomb the land
But not the soul.

KENT POTTER. *United States.*
Born: May 4, 1947, in Philadelphia, Pennsylvania, U.S.A.
Died: February 10, 1971, in Laos.

When he was just sixteen, Kent Potter went to work for UPI in his hometown of Philadelphia. By the time he was twenty-one he had won three awards from the Pennsylvania Photographers Association in the spot news category and was off to Vietnam at the height of the war. A year later he was promoted to UPI photo manager in Saigon, one of the hottest jobs in journalism. In 1971, he was transferred to Bangkok.

Potter covered Cambodia and Laos, too, and was in Phnom Penh when the UPI order came in to cover Operation Tiger's Mouth, an SVN offensive across the border into Laos. The helicopter carrying Potter and

Kent Potter

ten others lost its way and was shot down over the Ho Chi Minh Trail. It burned on impact. Searchers were unable to get to the site to recover any remains.

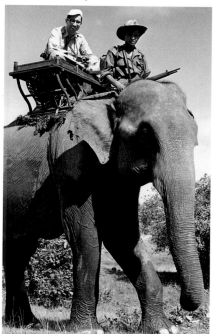

Everette Dixie Reese

EVERETTE DIXIE REESE.
United States.
Born: October 15, 1923, in Houston, Texas, U.S.A.
Died: April 29, 1955, in Cholon, Vietnam.
A U.S. Army photographer in Europe, Dixie Reese spent most of World War II under fire. Back in Texas he worked at the *Houston Post*, then returned to France as a student. He was hired by the forerunner of the United States Information Agency and was sent to Saigon in 1951. He recorded the ruins of Angkor, chronicled the early days of an outpost called Dien Bien Phu, accompanied French Union forces on patrols, and then reported the flight of hundreds of thousands of refugees from north to south when Vietnam was partitioned in 1954.

Reese fell in love with an American nurse in Saigon. Their son was just a year old when the photographer hitched a ride in a friend's light plane to get a better view of an armed rebellion against the Saigon government. The L-5 Stinson was shot down in Saigon's Chinese quarter of Cholon.

TERRY REYNOLDS. *United States.*
Missing: April 25, 1972, near Phnom Penh, Cambodia.
An American freelance photographer for UPI, Terry Reynolds borrowed a hundred dollars to go from Saigon to Phnom Penh. He and Alan Hirons, an Australian photographer, together with Cambodian photographer Chhim Sarath, were traveling south from Phnom Penh when they were forced from their car by Khmer Rouge guerrillas. Their vehicle later was found near Neak Luong, their camera equipment still inside.

JERRY A. ROSE. *United States.*
Born: 1933 in Gloversville, New York, U.S.A.
Died: September 16, 1965, near Quang Ngai, Vietnam.
A teacher with itchy feet, Jerry Rose left a steady job in his hometown in 1959 to go to Vietnam. Once there, he discovered he could make better money as a journalist than as a teacher, so he freelanced for *Time* magazine. By the end of 1961, he also contributed to *The Saturday Evening Post* and was one of only three full-time resident freelance journalists working alongside seven Western staff correspondents in Saigon. By 1965, he had mostly phased himself out of journalism to work for the SVN government, helping refugees and orphans cope with the disasters of war and teaching English at the University of Hue, where he was supported by the Asia Foundation. During that time he produced *Faces of Anguish*, a photo book about the early years of the war.

Rose, traveling to Saigon from a refugee camp in the central highlands, was one of thirty-nine passengers on an Air Vietnam C-47 flight that crashed, probably after being hit by ground fire.

DANA STONE. *United States.*
Born: April 18, 1939, in North Pomfret, Vermont, U.S.A.
Missing: April 6, 1970, on Route 1, Cambodia.
Because Dana Stone disappeared with Sean Flynn, his name is invariably linked with Flynn's. But friends remember Stone himself, a quick study who had to be taught how to use a Nikon when he hit Saigon in 1966 and ended up with his combat photos on the cover of *Time* magazine a year later.

The son of a mailman, Stone grew up in the Vermont woods and became a lumberjack, then a postal worker himself. But that wasn't enough. He bought his own ticket to Vietnam and began working as a stringer for AP. In 1968 Stone and his wife, Louise Smiser, left Saigon for Europe, then returned in 1970. Stone then worked for UPI and CBS, and some of his film was included in the award-winning documentary *Charly Company*.

It was as a CBS cameraman that Stone accompanied Flynn to the Parrot's Beak area. After they vanished, Louise Smiser Stone stayed in Indochina to search for her husband. She now lives in Kentucky and has not petitioned a court to have Dana Stone declared dead.

PETER RONALD VAN THIEL.
United States.
Born: in the Netherlands.
Died: May 1965 in the Mekong Delta, Vietnam.
About all that is known of Peter Ronald van Thiel's life are the circumstances of his death. Colleagues believed he was a naturalized U.S. citizen and that he was a freelance photographer.

He was presumed killed by the Viet Cong, but that has never been officially established. He had been with an SVN army patrol in the Mekong Delta when the troops stopped to rest in a "friendly" village. Somehow, van Thiel got separated from the soldiers, and his mutilated body was found a short time later.

DO VAN VU (alias VU PHONG).
Vietnam.
Born: 1934 in Vietnam.
Died: December 11, 1974, in the Mekong Delta, Vietnam.
Do Van Vu worked for the AP as a darkroom technician and a freelance photographer from 1968 to 1972. Suffering from asthma and stomach ulcers, he found it difficult to keep up with his colleagues and the soldiers. In 1972, military police stormed into the AP office and arrested Vu as a draft dodger. He was assigned to the Twenty-First SVN Infantry Division as a newsman, cameraman, and photographer and was soon promoted to sergeant. He often sent the AP photographs shot on military operations.

On December 11, 1974, Vietnam Press reported his death in battle southeast of the Hung Long district, Chuong Thien Province, in the Mekong Delta. He left a wife, pregnant at the time, and one child.

HUYNH THANH MY (alias HUYNH CONG LA).
Vietnam.
Born: June 1, 1937, in Long An, Vietnam.
Died: October 10, 1965, near Can Tho, Vietnam.
Although he was only five feet three and weighed just 110 pounds, Huynh Thanh My was one of the toughest photographers of the Vietnam War. He had a bachelor of arts degree and for several years he carried heavy network news equipment around the battlefield for CBS, until he was lured to AP in 1963 to work as a staff photographer.

In May 1965, he was wounded by machine-gun fire but returned to the front lines as soon as he was released from the hospital. While covering a fight between the Viet Cong and SVN Rangers in the Mekong Delta later that year, Huynh Thanh My was wounded in the chest and arm. As he waited to be evacuated by helicopter, the enemy overran the makeshift aid station and killed the wounded. Nearly the entire Saigon press corps marched in Huynh Thanh My's funeral procession to the Mac Dinh Chi Cemetery.

Huynh left behind his nineteen-year-old widow and their seven-month-old daughter. His younger brother, Huynh Cong Ut, was hired by the AP in 1965 and covered the rest of the war, winning a Pulitzer Prize in 1973. Better known as Nick Ut, he now lives in Los Angeles.

NGUYEN MAN HIEU. *Vietnam.*
Born: 1952 in Vietnam.
Died: 1974 near Saigon, Vietnam.
Vietnamese authorities in Ho Chi Minh City in 1996 provided birth and death dates for Nguyen Man Hieu and the information that he had worked as a photographer for South Vietnamese newspapers.

VU VAN GIANG (alias UOC).
Vietnam.
Died: 1974 in Thuong Duc, Quang Ngai Province, Vietnam.
A South Vietnamese photographer, Vu Van Giang worked for newspapers in Saigon. He was a freelancer for the AP for a year and a half before he died.

He was killed while photographing SVN airborne troops fighting in Quang Ngai

Province. There was some indication, but no definite evidence, that he was killed by friendly fire.

VIETNAMESE PHOTOGRAPHERS ON THE COMMUNIST SIDE

The best estimate of the number of Viet Cong and North Vietnamese photographers killed in the war or missing and presumed dead is seventy-two. All were connected with the military effort to throw the French out of Indochina, then defeat the South Vietnamese regimes and their U.S. allies. A surprising number of the casualties were in their thirties and forties, patriots who had spent nearly their entire lives documenting a cause while fighting for it. Most were men. Although hundreds of thousands of women fought for Ho Chi Minh, only a handful were journalist-soldiers.

Little is known of the lives of these chroniclers of the revolution, and details of their deaths are as bare as their bones. Often they had aliases, a custom in Indochina to obscure one's origins and thus protect one's family. The collective memory of a few old comrades and perhaps a mention or two in tattered magazines from long ago are the only references to brave colleagues who lived full lives. As for their work, much has not survived. The war, the climate, the bureaucracy—all have claimed the images for which the North Vietnamese and Viet Cong photographers made the ultimate sacrifice. Those pictures that do survive depict the suffering and appalling hardship, the camaraderie and determination of an entire people at war, giving testimony to the question, Why did they prevail?

Bui Dinh Tuy

BUI DINH TUY (alias DINH THUY)
Born: 1914 in Canh Duong, Quang Binh Province, Vietnam.
Died: September 21, 1967, in Vinh Long , Vietnam.
The highest-ranking North Vietnamese journalist killed during the war, Bui Dinh Tuy was deputy director of the LNA (the southern branch of VNA). He was sent into SVN in 1965—the same year the U.S. Marines arrived—to direct VNA's photo coverage of the war and was killed during an air raid. His official biography lists this wrenching detail: "None of his works of the war remained after the bomb." In December 1995, the VAAP presented his widow with a medal for his work.

DANG VAN HANG (alias THANH NGUYEN)
Born: 1937 in Kien Phong Province, Vietnam.
Died: November 9, 1967.
A photo-reporter with the LNA, Dang Van Hang was assigned to the Dong Thap Province Communications and Training Center.

DINH DE
Born: 1944 in Phu Cat District, Binh Dinh Province, Vietnam.
Died: February 1, 1970, near his home village of Cat Tai, Vietnam.
Dinh De was a photographer for the VNA. The circumstances of his death are not known.

DO VAN NHAN
Born: January 1934 in Nhan Ly, Nam Ha Province, Vietnam.
Died: March 8, 1969, in Phu Yen Province, Vietnam.
Do Van Nhan was a photo technician and photographer. His remains were recovered and buried in the Combatants' Cemetery in Hanoi.

DOAN PHI HUNG
Born: 1944 in Saigon, Vietnam.
Died: 1968 in Cu Chi, north of Saigon, Vietnam.
A southerner, Doan Phi Hung was a correspondent for the LNA in the Mekong Delta. He also took photographs and was affiliated with the Communications and Training Center in Tra Vinh Province in the Mekong Delta.

DUONG CONG THIEN
Died: 1971 in Tra Vinh Province, Vietnam.
No photographs of, or personal information about, Duong Cong Thien survived the war except a notation that he was a photo-reporter for the LNA's Communications and Training Center in Tra Vinh.

DUONG THANH VAN (alias BA HINH)
Born: 1940 in Ninh Hoa, Khanh Hoa Province, Vietnam.
Died: October 14, 1967, in Song Be Province, Vietnam.
Duong Thanh Van was wounded twice but survived while serving as a photo-reporter for the Saigon–Gia Dinh branch of the LNA. The first time he was hurt, shrapnel tore up his arms; the second time the shrapnel injured his legs. He was killed by machine-gun fire during a battle in the Iron Triangle of SVN, War Zone D.

HO CA
Born: 1934 in My Tai, Binh Dinh Province, Vietnam.
Died: April 26, 1972, Phu Yen Province, Vietnam.
A veteran of fierce fighting in the north, Ho Ca was transferred to the south with the LNA in February 1968, during the Tet Offensive. He was killed during a major NVA offensive in the south. Later most of his work was lost when his negatives and photos were shipped to Hanoi to be preserved in archives of the war.

HO VAN DE
Born: 1933 in Long An Province, Vietnam.
Died: November 11, 1971.
Ho Van De was an army officer who also worked as a VNA photographer.

HO VAN TU
Born: 1940 in Mang Thit, Vinh Long Province, Vietnam.
Died: December 12, 1963, in Song Be Province, Vietnam.
Ho Van Tu was a photo-reporter for the LNA.

HOANG CHAU
Born: 1927 in Duc Tho, Ha Tinh Province, Vietnam.
Died: November 1963 on the Sre Pok River in Dac Lac Province, Vietnam.
A northerner, Hoang Chau worked as a photographer in Hanoi and became an officer of the VNA. In 1960, he stood with Ho Chi Minh to welcome a Soviet astronaut and present him with a medal. Hoang Chau's son, Hoang Long, who was only two years old at the time, treasures the photograph of his father at that event. In 1963, Hoang Chau was sent across the DMZ, one of the first NVA photographers to be dispatched to the front. While crossing a river along the Ho Chi Minh Trail, he was killed in an ambush.

Hoang Long and his family maintain an ancestor's altar in their home in honor of the family hero. Inspired by the father he hardly knew, Hoang Long also is a photographer. He says that what he remembers most about his father is that he neglected his family duties to spend time developing his photographs.

HUYNH VAN DUNG
Born: 1940.
Died: 1972 in Soc Trang Province, Vietnam.
Huynh Van Dung was a photographer for the LNA, attached to the Communications and Training Center in Soc Trang Province.

HUYNH VAN HUONG
Born: in Saigon, Vietnam.
Died: 1967 in Saigon, Vietnam.
Records list Huynh Van Huong as a photographer and correspondent of the VNA.

HUYNH VAN HUU (alias HAI HUU)
Born: 1937 in Tam Binh, Vinh Long Province, Vietnam.
Died: 1968 in Hau Giang, Kien Giang Province, Vietnam.
Huynh Van Huu was a photo-reporter for the LNA and was killed during the second part of the Tet Offensive in the spring of 1968.

HUYNH VAN TRI
Born: 1937.
Died: 1961 in Ben Tre Province, Vietnam.
A photographer for the LNA assigned to the Communications and Training Center in Ben Tre in the Mekong Delta, Huynh Van Tri died in a major battle in the delta.

KIM VAN TUOC (alias HOA)
Born: 1947 in Giong Trom, Ben Tre Province, Vietnam.
Died: January 10, 1973, in Ben Tre, Vietnam.
While working as a photo-reporter for the LNA at the Communications and Training Center in Ben Tre, Kim Van Tuoc was

arrested as a member of the Viet Cong and subsequently killed.

LE DINH DU (alias HO THUA)
Died: 1968 on the Cua Viet River, Vietnam.
In the book *Fighting at the 17th Parallel*, published in Vietnam after the war, Le Dinh Du is described as a photography correspondent of *Quan Doi Nhan Dan*, the people's army newspaper. He was killed, along with colleague Ngoc Nhu, when they were attacked while crossing the Cua Viet River in 1968. The river marked the dividing line— the Demilitarized Zone—between North and South Vietnam.

LE DUY QUE
Born: 1930 in Thuy Anh, Thai Binh Province, Vietnam.
Died: July 31, 1967, in Quang Binh Province, Vietnam.
Le Duy Que was a technician and telegraphist for the VNA.

LE KHAC TAM (alias KHAC TAM)
Born: 1940 in Cuu Long, Vietnam.
Died: March 26, 1970, in Kien Giang Province, Vietnam.
Le Khac Tam was a photo-reporter for the LNA.

LE KIA (alias HAI TAM)
Born: 1948 in Thanh Tung, Minh Hai Province, Vietnam.
Died: 1964 in Kien Giang Province, Vietnam.
Le Kia worked as a photo-reporter for the LNA.

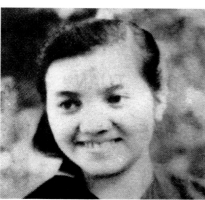
Le Thi Nang

LE THI NANG (alias UT NANG)
Born: 1949 in Thuan My, An Giang Province, Vietnam.
Died: 1972 in Kampong Cham Province, Cambodia.
An active fighter with the Viet Cong throughout her teenage years, Le Thi Nang spent nearly all her life on the front lines of the war. She was working as a photographer and expert darkroom technician for the LNA when she was killed in a B-52 air strike in Cambodia. Her body was never recovered.

LUONG NGHIA DUNG
Born: 1934 in Quang Trung, Ha Tay Province, Vietnam.
Died: 1972 near Con Thien, Quang Tri Province, Vietnam.
The most famous photographer in Vietnam, Luong Nghia Dung cheated the odds in some of the fiercest battles of the two wars. Joining the army in 1954, when the Viet Minh defeated the French, he saw action as a soldier and then went to the University of Hanoi to study to become a teacher of mathematics and physics. Still in the army, he taught those subjects to troops before he became a professional photographer. From 1965 on, he worked for the VNA, taking pictures at Khe Sanh, along Route 9, in southern Laos, and at Quang Tri. He left thousands of pictures chronicling the war effort on the North Vietnam side. His work was reprinted in Vietnamese and international publications during and after his lifetime. The VNA has eight volumes of his photographs in its collection. Luong Nghia Dung died during the spring offensive in Quang Tri in 1972. Eyewitnesses said that he was shot, then his body was incinerated in the tank in which he was riding. He was shooting pictures when he was killed.

A colleague eulogized him as "a very energetic man, always ready to die for good pictures."

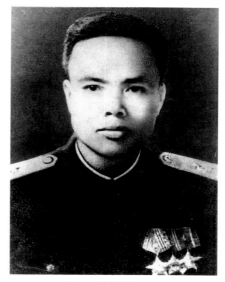
Luong Nghia Dung

LUONG TAN TUC (alias PHAM TAN PHUOC)
Born: 1939 in Vinh Kim, Kien Giang Province, Vietnam.
Died: August 25, 1968, in Cai Be, Tien Giang Province, Vietnam.
A member of the Communist Party, Luong Tan Tuc was a photographer for the LNA in the northern delta area.

LY VAN CAO (alias LY CAN)
Born: 1936 in Can Tho, Vietnam.
Died: December 31, 1967, near My Tho, Vietnam.
Ly Van Cao was a photographer with the LNA.

NGOC HUONG
Born: in Vinh Long, Vietnam.
Died: 1968 in Hau Giang, Kien Giang Province, Vietnam.
Part of a newsphoto team for the LNA in the southern Mekong Delta, Ngoc Huong was a darkroom technician. She also was a political cadre who exhorted her colleagues with revolutionary doctrine. She was killed during the Tet Offensive.

NGOC NHU
Died: 1968 on the Cua Viet River, Vietnam.
The book *Fighting at the 17th Parallel*, published in Vietnam after the war, describes how the photographer Ngoc Nhu died, along with colleague Le Dinh Du, when they were attacked in the DMZ while crossing the Cua Viet River in 1968. Like Le Dinh Du, Ngoc Nhu was a photographer for *Quan Doi Nhan Dan*, the people's army newspaper.

NGUYEN DUC THANH
Born: April 28, 1945.
Died: 1968 near Hue, Vietnam.
Nguyen Duc Thanh was accompanying a Hue-based VNA newsphoto team when he was killed.

NGUYEN DUNG (alias UT DUNG)
Born: 1940 in Cambodia.
Died: 1966 near Vinh Tuy, Kien Giang Province, Vietnam.
Nguyen Dung was a photo-reporter for the LNA.

NGUYEN HUONG NAM (alias BAY NAM)
Born: 1935 in Hoc Mon, Gia Dinh Province, Vietnam.
Died: February 1968 near Nha Be, Vietnam.
Nguyen Huong Nam was a Viet Cong who worked in and around the capital as a reporter-photographer for the LNA until he was killed in the early days of the Tet Offensive.

NGUYEN HUY
Born: 1940.
Died: 1968 in Quang Tri, Vietnam.
A photographer for the *Quan Doi Nhan Dan*, the people's army newspaper, Nguyen Huy was killed during the Battle of Quang Tri, near the DMZ.

NGUYEN KHAC TAM (alias SAU TAM)
Born: Vinh Long Province, Vietnam.
Died: 1969 in Kien Giang Province, Vietnam.
A photo-reporter for the LNA in the Rach Gia District, Nguyen Khac Tam died in battle.

NGUYEN LUONG NAM
A few photos credited to Nguyen Luong Nam have survived. Nothing else is known of him.

NGUYEN NGOC TU
Born: 1937.
Died: 1968 in Nghia Dien, Binh Dinh Province, Vietnam.
Nguyen Ngoc Tu was a photographer for *Nhan Dan*, the people's daily newspaper.

NGUYEN NHUT HOA (alias BAY THANG)
Born: 1939 in Cao Lanh, Dong Thap Province, Vietnam.
Died: December 4, 1967, near his birthplace.
Nguyen Nhut Hoa was killed at the Nguyen Van Thiep Canal while photographing the war for the LNA.

NGUYEN OANH LIET
Born: 1932 in An Tich, Dong Thap Province, Vietnam.
Died: April 5, 1968, near Lai Thieu, Vietnam.
The son of the police chief in Sa Dec Province (in the Mekong Delta) during French rule, Nguyen Oanh Liet was an early

member of the Viet Minh. Following the partition of Vietnam in 1954, he went to study in the north and graduated from the School of Technology in 1966. That same year he returned to the south to organize telephototransmission stations for the Viet Cong. Nguyen Oanh Liet was killed in 1968 while working as a photographer for the LNA near Saigon. Five years later technicians finally succeeded in transmitting a wirephoto to Hanoi from the Liberation Front headquarters northwest of Tay Ninh in War Zone C. Photos from the fall of Saigon in April 1975 were also sent from the station that Nguyen Oanh Liet began in 1966.

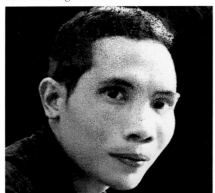

Nguyen Oanh Liet

NGUYEN THANH HIEN (alias MUOI HIEN)

Born: 1945.
Died: July 1969 in Chau Thanh, Kien Giang Province, Vietnam.

Nguyen Thanh Hien was a photo-reporter for the LNA.

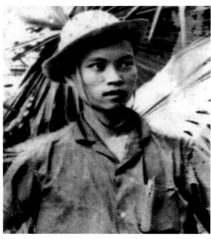

Nguyen Trung Dinh

NGUYEN TRUNG DINH

Born: 1942.
Died: 1968 in Da Nang, Vietnam.

Nguyen Trung Dinh worked for *Nhan Dan*, the people's daily newspaper.

NGUYEN VAN CHIEN (1)

Born: 1937 in Lai Thieu, Vietnam.
Died: December 1968 in Vinh Long Province, Vietnam.

NGUYEN VAN CHIEN (2)

Born: 1951 Mang Thit, in Vinh Long Province, Vietnam.
Died: 1969.

Two men named Nguyen Van Chien worked as photo-reporters for the LNA. Both were killed in Vinh Long, but in different years.

NGUYEN VAN HUONG

Born: in Vinh Long Province, Vietnam.
Died: 1970 in Kien Giang Province, Vietnam.

Nothing is known about the life and circumstances of Nguyen Van Huong's death.

NGUYEN VAN MAN

Born: 1954 in Chau Thanh, Dong Thap Province, Vietnam.
Died: 1971 in Binh Minh, Vinh Long Province, Vietnam, near his birthplace.

Nguyen Van Man was a photo-reporter for the LNA.

NGUYEN VAN NANG

Born: Thai Binh Province, Vietnam.
Died: 1968 on Nui Ba Den, near Tay Ninh, Vietnam.

Nguyen Van Nang graduated from the University of Hanoi in 1965. He then trained to be a journalist and became a photo-reporter for the VNA, which sent him south on the Ho Chi Minh Trail in 1965. He was working for the political arm of the Viet Cong when he was killed during the battle for the Black Virgin Mountain (Nui Ba Den).

NGUYEN VAN NHU (alias HOANH SON)

Born: 1942 in Chau Thanh, Dong Thap Province, Vietnam.
Died: March 16, 1968, near Mang Thit, Vinh Long Province, Vietnam.

Nguyen Van Nhu was a photo-reporter for the LNA.

NGUYEN VAN THA (alias SAU HUNG)

Born: 1941 in Cai Nhum, Vinh Long Province, Vietnam.
Died: 1968 near Binh Minh, Vinh Long Province, Vietnam.

Nguyen Van Tha was a photo-reporter for the LNA.

NGUYEN VAN THANG

Born: in Minh Hai Province, Vietnam.
Died: 1970.

Nguyen Van Thang worked for the LNA as a photo-reporter.

NGUYEN VAN THUAN

Born: in Tra Vinh Province, Vietnam.
Died: 1968 in Ba Ria, Vung Tau Province, Vietnam.

Nguyen Van Thuan worked as a photo-reporter for the LNA in Ba Ria.

NGUYEN VAN THUY

Born: in Hanoi, Vietnam.
Died: 1968 in Tay Ninh Province, Vietnam.

Noted in several books about journalists killed in the war, Nguyen Van Thuy was a photo technician with a VNA team.

NGUYEN VAN UNG (alias THANH VAN)

Born: 1939 in Tam Binh, Vinh Long Province, Vietnam.
Died: 1969 in Tra Vinh Province, Vietnam.

Nguyen Van Ung was a photo-reporter for the LNA. His remains, unlike those of most other Viet Cong journalists killed in the war, were recovered, and Nguyen Van Ung was buried in Binh Minh, a village in his home province of Vinh Long.

NGUYEN VIET HIEN

Born: 1923 in Thu Duc, Vietnam.
Died: 1972 at the Sre Pok River, Dac Lac Province, Vietnam.

Born near Saigon, Nguyen Viet Hien was a horse-coach driver when he joined the Viet Minh in 1947. He became a combat photographer. After the French Indochina War he went north but returned to the south in May 1965, assigned as a photo-reporter for the National Liberation Front's headquarters near Tay Ninh. During the 1972 offensive, he was photographing the fighting at the Sre Pok River when he was killed by a bomb; there were no remains.

PHAM CO PHAC

Born: 1945 in Long Dien, Minh Hai Province, Vietnam.
Died: 1968 in Vinh Long, Vietnam.

Pham Co Phac was a photo-reporter for the LNA in the southwestern delta region.

PHAM TRANH (alias PHAM VAN TRANH)

Born: 1922 in Phuoc Long, Ben Tre Province, Vietnam.
Died: 1965 in Song Be Province, Vietnam.

A southerner, Pham Tranh joined the Viet Minh when he was twenty-four. When Vietnam was partitioned in 1954, he went north and worked in Hanoi for nine years as a photographer for the *People's Army Magazine* and later for *Quan Doi Nhan Dan*, the people's army newspaper. He was sent back to the south on the Ho Chi Minh Trail. Pham Tranh doubled as a cameraman for the Liberation Armed Forces at the front and won several medals for his bravery. He was shot and died when his unit fought U.S. and SVN Special Forces in Song Be in 1965.

PHAM VAN KUONG (alias CHIN KHUONG)

Born: 1936 in Thanh Dong, Long An Province, Vietnam.
Died: 1969 in Chau Thanh, Ben Tre Province, Vietnam.

A photo-reporter in the Liberation Armed Forces, Pham Van Kuong was attached to the LNA at the time of his death.

PHAM VU BINH

Born: 1952.
Died: November 19, 1971, near Hue, Vietnam.

Pham Vu Binh, a photo technician for the LNA, was killed near Hue. His remains were never found.

PHUNG QUANG LIEM (alias CHIN NGHIEM)

Born: 1948 in Cu Chi, Vietnam.
Died: 1967 in Cu Chi, Vietnam.

One of the legendary tunnel rats of Cu Chi, Phung Quang Liem was a photo-reporter for the LNA. He joined the Viet Cong when he was in his mid-teens and spent his brief career photographing his fellow guerrillas who lived, worked, and fought in the maze of tunnels under Cu Chi. He died there in January 1967. Many of his photographs are exhibited at the Revolutionary Museum in Ho Chi Minh City.

Phung Quam Liem

SAU VAN (alias SAU NHO)
Born: 1948.
Died: 1967 in Cu Chi, Vietnam.
Only nineteen when he died, Sau Van was a Viet Cong officer assigned to the LNA as a photographer and photo technician.

THANH TINH
Born: Da Nang, Vietnam.
Died: 1968 in Song Be Province, Vietnam.
Thanh Tinh joined the army in 1964 as a photographer and correspondent. He worked directly for the political branch of the Viet Cong and was killed in the 1968 mini Tet Offensive in Song Be.

THE DINH
Died: 1968 in Quang Tri Province, Vietnam.
Only one of The Dinh's photos survived. It shows his shadow cast over a DMZ battle scene. The Dinh died in the DMZ in 1968.

THOI HUU
Born: 1922.
Died: 1950 in Thanh Hoa, Vietnam.
A photographer for the *Quan Doi Nhan Dan*, the people's army newspaper, Thoi Huu was killed during the Viet Minh's war against the French.

TO DINH
Only a few of To Dinh's photos remain. All that is known is that he perished in the war.

TRAN BINH KHUOL (alias HAI NHIEP)
Born: 1914 in Vinh Chau, Soc Trang Province, Vietnam.
Died: 1969 in the U-Minh Forest, Minh Hai Province, Vietnam.
A veteran combat photographer, Tran Binh Khuol was chief of the Viet Cong's photography and cinematography division in the Mekong Delta. He worked on the front lines from 1960 until his death and chronicled battles on the Camau Peninsula, in the U-Minh forest, at Rach Gia, and at Can Tho. In 1962, he fought U.S. and SVN units spraying defoliants along the riverbanks in Ca Mau. Two of his sons were photographers; his second son, Tran Oai Dung, was killed in an ambush in 1970. Tran Binh Khuol's widow was certified as a Vietnam Heroine. She received, on behalf of her late husband, the Hero of the Motherland medal and is the recipient of a VAAP award.

TRAN NGOC DANG
Born: 1945 in Cambodia.
Died: August 3, 1967, near Tay Ninh, Vietnam.
Of Vietnamese ancestry, Tran Ngoc Dang was born in Cambodia. He went to Vietnam to join the Viet Cong when he was nineteen and was a photographer and technician with an LNA photo-news team. He is said to have destroyed two American tanks before he was reportedly killed in a battle with U.S. troops.

TRAN OAI DUNG (alias TRAN DUNG)
Born: 1950 in Minh Hai Province, Vietnam.
Died: 1970 in Kien Giang Province, Vietnam.
Second son of famous Viet Cong photographer Tran Binh Khuol, Tran Oai Dung was a photo-reporter for the LNA in the Mekong Delta. He was killed in an ambush in 1970, one year after his father died in battle.

TRAN XUAN HY
Born: 1945.
Died: October 12, 1972, near Da Nang, Vietnam.
Tran Xuan Hy worked as a photo-reporter for the VNA.

TRINH DINH HY
Born: 1940 in Tam Thanh, Quang Tri Province, Vietnam.
Died: December 10, 1973, at Dien Ban near Da Nang, Vietnam.
Trinh Dinh Hy worked as a photographer for the VNA.

TRUONG PHU THIEN
Born: 1947 near Da Nang, Vietnam.
Died: 1969 in Cu Chi, Vietnam.
Truong Phu Thien worked as a technician and photo-reporter for the LNA.

VO DUC HIEP (alias SAU HIEP)
Born: 1942 in Ninh Hoa, Khanh Hoa Province, Vietnam.
Died: August 1969 in Cu Chi, Vietnam.
Vo Duc Hiep was a photo-reporter for the LNA. His pictures of the Cu Chi tunnel area, where he was killed, are exhibited at the Revolutionary Museum in Ho Chi Minh City.

VO NGOC KHANH
Born: 1945 in Long Phuoc, Vung Tau Province, Vietnam.
Died: June 3, 1969, in Vung Tau, Vietnam.
Vo Ngoc Khanh was a photo-reporter with the LNA.

VO VAN LUONG
Born: 1931 in Thu Dau Mot, north of Saigon, Vietnam.
Died: 1969 in his birthplace, Vietnam.
Vo Van Luong was a Viet Cong soldier and photo-reporter for the LNA.

VO VAN QUY
Born: 1943 in Binh Dai, Ben Tre Province, Vietnam.
Died: December 8, 1972, in Ben Tre Province, Vietnam.
The son of a Viet Minh officer, Vo Van Quy was born in the south but went north after Vietnam was partitioned in 1954. He was educated in Hanoi at a special training school for young Communists from the south, and from 1962 until 1965 he studied history at the University of Hanoi. After he graduated, he took the VNA's course in journalism, then went south in February 1966. He was a photo-reporter assigned to NVA divisions nine and seven and worked around My Tho and Ben Tre. He was photographing a firefight when he was shot to death. His father, a Viet Cong colonel, survived the war.

VU HANH
Vu Hanh's name appears on some photos, with the notation that he died in the war. Nothing else is known about him.

VU HUNG DUNG
Born: 1956 in Phung Hiep, Can Tho Province, Vietnam.
Died: 1974 at the Baka Canal near Can Tho, Vietnam.
Working as a photo-reporter with the LNA, Vu Hung Dung died in an ambush.

VU NGOC TONG
Born: 1941 in Ha Long, Vung Tau Province, Vietnam.
Died: December 10, 1969, near Vung Tau, Vietnam.
Vu Ngoc Tong's contribution to the war effort as a photo-reporter for the LNA earned him several posthumous medals.

RECIPIENTS OF MEDALS FROM
THE VIETNAMESE ASSOCIATION
OF ARTISTIC PHOTOGRAPHERS,
PRESENTED POSTHUMOUSLY
SINCE DECEMBER 1995:

BUI DINH TUY
DINH DE
DO VAN NHAN
HO CA
HO VAN DE
HUYNH VAN HUONG
HUYNH VAN TRI
KIM VAN TUOC
LE DINH DU
LE DUY QUE
LE KHAC TAM
LE KIA
LE THI NANG
LUONG NGHIA DUNG
LY VAN CAO
NGOC HUONG
NGOC NHU
NGUYEN DUC THANH
NGUYEN HUONG NAM
NGUYEN HUY
NGUYEN KHAC TAM
NGUYEN OANH LIET
NGUYEN VAN HUONG
NGUYEN VAN NANG
NGUYEN VAN THUY
PHAM TRANH
PHAM VAN KUONG
PHAM VU BINH
PHUNG QUANG LIEM
SAU VAN
THANH TINH
THE DINH
TRAN BINH KHUOL
TRAN NGOC DANG
TRAN OAI DUNG
TRAN XUAN HY
TRINH DINH HY
TRUONG PHU THIEN
VO DUC HIEP
VO VAN QUY
VU HUNG DUNG
VU NGOC TONG

EPILOGUE

Neil Sheehan

This book was meant as a tribute, but it has ended as a gift. It is the gift of those who gave their lives so that no one would ever forget what they saw and recorded through a camera's lens. Photographs are the images of history rescued from the oblivion of mortality. Long after those who died to take these photographs are gone, long after those of us who knew them and survived them and remembered their experiences are gone in our turn, the images they captured will remain to show generations to come the face of the war in Indochina.

Not that anyone was conscious of this at the time. The photographer was often too preoccupied taking the picture to think of posterity, let alone the personal danger in which he placed himself. One day in Saigon during the Buddhist crisis of 1963, the great Larry Burrows was photographing an anti-government melee. The riot police began loading their weapons. Larry was oblivious to the slamming of bolts as the policemen chambered rounds. "Larry!" I shouted at him, and shook him by the shoulders. "We've got to get out of the way. They're getting ready to open fire." He lowered his camera and looked at me as if in a trance. His trousers were torn, and his leg was bleeding from a bad cut he had not noticed. I shouted at him again. "OK," he finally said, and we both ran.

There was also a certain fatalism mixed with the courage. François Sully was too reflective a man not to understand that after twenty-four years in Indochina he would one day lose to the odds. Once, in an article for *Newsweek,* he cited an old French war song to describe his feelings on returning from battle: "*Chacun son tour. Aujourd'hui le tien, demain le mien"*—"To each his turn. Today yours, tomorrow mine." To those of us who knew François, it was a premonition.

Although Americans think of the second war in Indochina as their war, the majority of photographers who covered the American and Saigon government side were, ironically, non-American. Ten different nationalities are represented among the dead—American, Australian, Austrian, British, French, German, Japanese, Singaporean, Swiss, South Vietnamese. And in Cambodia, where the foreign photographers received the recognition and the bylines, equally courageous and frequently equally distinguished work was done by the Cambodian photographers who worked for the foreign news agencies. After the fall of Phnom Penh in 1975, many of them were murdered by the Khmer Rouge.

Nor can one fail to note the sacrifice of the seventy-two photographers, two of them women, who died on the Vietnamese Communist side. Of their work only a few thousand negatives and prints survive. Most of their effort was lost because of the unimaginably difficult conditions under which they labored. One can see, in the fine action photographs of Luong Nghia Dung or Bui Dinh Tuy of the Vietnam News Agency, how talented many of them must have been. They lie with the millions of Vietnamese who died to free their nation from the domination of foreigners in the cause of Ho Chi Minh.

Yet all these photojournalists of Indochina prevailed in the end. In a war in which so many died for illusions and foolish causes and mad dreams—58,000 Americans, a quarter of a million Vietnamese on the Saigon government side, tens of thousands of Laotians, a million Cambodians in the killing fields of the Khmer Rouge—these men and women of the camera conquered death through their immortal photographs.

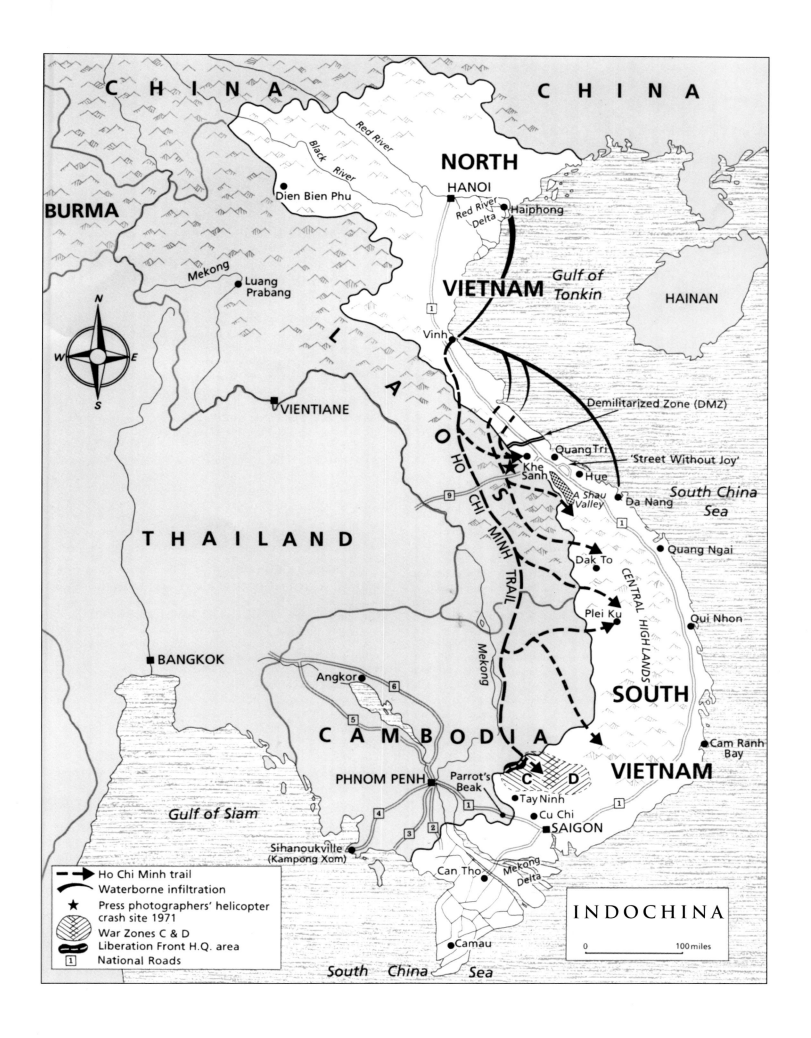

CHINA

CHINA

BURMA

Dien Bien Phu

NORTH

HANOI

Black River

Red River

Red River Delta

Haiphong

Mekong

Luang Prabang

VIETNAM

Gulf of Tonkin

HAINAN

L A O S

VIENTIANE

Vinh

THAILAND

HO CHI MINH TRAIL

Demilitarized Zone (DMZ)

Quang Tri

'Street Without Joy'

Khe Sanh

Hue

A Shau Valley

Da Nang

South China Sea

Dak To

Quang Ngai

Mekong

Plei Ku

CENTRAL HIGH LANDS

Qui Nhon

BANGKOK

Angkor

6

C A M B O D I A

5

Mekong

Cam Ranh Bay

PHNOM PENH

Parrot's Beak

C

D

SOUTH

Gulf of Siam

4

1

Tay Ninh

VIETNAM

3

2

Cu Chi

SAIGON

1

Sihanoukville (Kampong Xom)

Can Tho

Mekong Delta

Ho Chi Minh trail

Waterborne infiltration

Press photographers' helicopter crash site 1971

War Zones C & D

Liberation Front H.Q. area

National Roads

1

Camau

INDOCHINA

0 100 miles

South China Sea

PICTURE CREDITS

Photographs appear courtesy of the following organizations:
Wide World Photos (The Associated Press), New York: 70, 75, 78-79, 114-117, 119, 121-131, 138-139, 148-149, 150-151, 164-169, 174, 178-179, 181-186, 190-191, 193, 195-197, 200-203, 227, 230-231, 246-247, 260, 264-268, 277, 285-287, 294-297, 300, 305-309, 316, 320, 330-331, 334; **The Bettmann Archive (UPI)/Corbis, New York:** 2-3, 113, 118, 132-135, 152-155, 188-189, 208-209, 219-223, 234-236, 241, 315-319, 320; **Vietnam Association of Artistic Photographers (Liberation News Agency), Ho Chi Minh City:** 80-85, 104-105, 107, 110-111, 232-233, 322, 323, 332-333; **Vietnam News Agency, Hanoi:** 101-104, 106, 108-110, 204-207, 237-239, 244-245, 248-255, 259, 323, 324, 325, 336; **LIFE, @ Time Inc., New York:** 86-95, 97, 99, 142-143, 145-147, 176-177, 272-273, 315; **Larry Burrows Collection, New York:** front cover and 76-77; **Gamma Agency, Paris:** 275, 280-282, 288-293, 299, 301-304, 310-311, 315; **Magnum Photos (Cornell Capa), New York:** 52-53, 65-69, 71, 72-73; **SIRPA/ECPA, Fort d'Ivry, Paris:** 38, 42-43, 47-49, 54-59, 61-63, 317; **Black Star, New York:** 210-215; **Contact Press Images, Paris:** 162-163, 170-173, 175, 261.

We are also grateful to the following individuals and organizations for permission to reproduce photographs on the following pages:
The Indochina Media Memorial Foundation (IMMF), London: 198-199, 261; **Library of Congress (*Look* magazine), Washington, D.C.:** 160-161; **University of Massachusetts (François Sully Collection, Healey Library), Boston:** 256-257; **The State Historical Society of Wisconsin, Madison:** 137; **Peter Arnett, McLean, Virginia:** 262; **Mme. Renee Arpin-Pont, Bourg-St-Maurice, France:** 187; **Prof. Steve Bell, Muncie, Indiana:** 319; **Jim Caccavo, Los Angeles:** 269, 319; **Mrs. Dorothy Fall, Washington, D.C.:** 159; **Tony Hirashiki (ABC-TV), New York:** 258; **Mrs. Pauline Hirons, Victoria, Australia:** 314; **Mr. and Mrs. Kiyoji Ichinose, Takeo, Japan:** 240-243, 312-313; **Rikio Imajo, Tokyo:** 155, 224-225, and back cover; **Roger Mattingly, Wheeling, Illinois:** 271; **Don North, Fairfax, Virginia:** 318; **Peter E. Palmquist, Arcata, California:** 320; **Alan E. Reese, Cordova, Tennessee:** 13, 15, 17, 19, 21, 23-34, 39-41, 44-45, 51, 321, 335; **Mrs. Sata Sawada, Tokyo:** 140-141, 228-229; **Dick Swanson, Washington, D.C.:** 158; **Neal Ulevich, Denver, Colorado:** 316.

TEXT CREDITS

"The Death of Robert Capa" by John Mecklin, *Life* magazine © Time Inc., 1954.
"The End of Jean Peraud" © Dorothy Fall Executrix, 1966.
"The Last Tape" © Dorothy Fall, 1967.

CONTRIBUTORS

PETER ARNETT is an international correspondent for CNN. He was an Associated Press correspondent in Vietnam between 1962 and 1975 and won a Pulitzer Prize in 1967. His book, *Live from the Battlefield*, retraces thirty-five years as a newsman in the world's war zones.

TAD BARTIMUS reported from Vietnam for The Associated Press in 1973 and 1974. Other foreign assignments followed. She was the AP's first woman state bureau chief (Alaska) and became an award-winning AP special correspondent. She recently taught journalism at the University of Alaska. Bartimus is the co-author of *Trinity's Children* and *Mid-Life Confidential*.

DAVID HALBERSTAM won the Pulitzer Prize for his reporting from Vietnam for *The New York Times* in 1964.

JOHN LAURENCE covered the war in Vietnam for CBS News from 1965 to 1970 and was correspondent on the documentary film *The World of Charlie Company*. He was a friend of Sam Castan.

RICHARD PYLE's reporting assignments have taken him from Washington to Cuba to Tokyo to Namibia, and through six wars including Vietnam. He spent nearly five years in Indochina and was The Associated Press's Saigon bureau chief from 1970 to 1973.

PIERRE SCHOENDOERFFER is a French fimmaker, novelist, and member of the Institut de France. He enlisted in the French Expeditionary Corps in Indochina as a combat cameraman. He parachuted into Dien Bien Phu and was taken prisoner when it fell on April 7, 1954. His books and films include *Platoon 317* (1965), *Paths of the Sea* (1977), and *Dien Bien Phu* (1992).

NEIL SHEEHAN spent three years in Vietnam for United Press International and *The New York Times*. In 1971, while in Washington, he obtained the Pentagon Papers, which gained *The New York Times* a Pulitzer Prize for public service. In 1988, he published *A Bright Shining Lie: John Paul Vann and America in Vietnam*. The book won him a Pulitzer for general nonfiction, the National Book Award, and other prizes. *After the War Was Over: Hanoi and Saigon* is his account of a two-month postwar sojourn in Vietnam.

JON SWAIN was a correspondent in Indochina between 1970 and 1975. He went back to Phnom Penh on the last plane just before the fall of the city to the Khmer Rouge in April 1975 and was the only British journalist to witness its horrific aftermath. He has won several British press awards for his reporting at home and abroad. He works for *The Sunday Times* (London). He is the author of *River of Time*.

WILLIAM TUOHY covered the Vietnam War for *Newsweek* and the *Los Angeles Times* from 1965 to 1968 and was awarded the Pulitzer Prize for his reporting in 1968. He was a foreign correspondent with the *Los Angeles Times* for thirty years. He is the author of a memoir, *Dangerous Company*.

ACKNOWLEDGMENTS

Looking back over the five years it took to gather the contributions for this book and exhibition, our thanks go first to all those who urged us on, who encouraged and supported us to pursue this project to create this memorial for our dead photographer friends and colleagues lost in Indochina. Equally important were the contributions from many who shared their memories with us, who sent mementos of the dead, photographs, and old clippings. Picture research was greatly facilitated by the goodwill we received from the photo agencies and many researchers who offered their help.

We deeply appreciate the support and friendship of relatives of the dead, particularly Mme. Renee Arpin-Pont, Russell Burrows, Cornell Capa, Mme. Marianne Caron-Montely, Fran Castan, Dorothy Fall, Dr. Wolfgang Gensluckner, Arlette and Trinh Hieu Nguyen, Mrs. Pauline Hirons, Huynh Cong "Nick" Ut, Kiyoji and Nobuko Ichinose, Mme. Michele Laurent, Lorene Noonan Austin-Lubec, Judith Noonan Felone, Alan E. Reese, Mrs. Sata Sawada, Tom Stone, Louise Stone-Smyser, and Cary B. Zeiter.

The idea of the memorial only took shape after we found enthusiastic backing for it in both Hanoi and Ho Chi Minh City. The Vietnam News Agency in Hanoi opened its files to us, and many fellow photographers who once worked "on the other side" helped to trace the lives and work of their fallen colleagues.

At the Vietnam News Agency, we especially thank Mr. Phuong, general director, retired in 1996; Mr. Chu Chi Thanh and Mr. Pham Hoat, former and current directors of VNA Photos; VNA's chief photo librarian, Mr. Mai The Hung, as well as the former war photogaphers Lt. Col. Hoang Kiem and Hoang Van Sac.

In Ho Chi Minh City we are deeply grateful for the friendship and advice of Mr. Lam Tam Tai, vice secretary-general, and Mr. Nguyen Van Bao, deputy secretary-general, of the Vietnam Association of Artistic Photographers. They arranged for us to meet photographers who survived the war and who told us their stories: Duong Thanh Phong, Hoang Long, Nguyen Dang, and Vu Bai.

Many journalists who once reported from Vietnam and Cambodia have contributed generously with their expertise and information. Their names read like a participants' roster of a Vietnam war correspondents' reunion: Peter Arnett, Tad Bartimus-Wariner, Steve Bell, Paul Brinkley-Rogers, Roxanna and Fred Leo Brown, Jim Caccavo, Bob Carroll, Chai Bornlay, Tony Clifton, Dang Van Phuoc, Dith Pran, George Esper, Matt Franjola, Murray Fromson, Joe Galloway, Dennis Gray, David Halberstam, Bill Hammond, Tony Hirashiki, Hoang Van Cuong, Al Kaff, Robert Kaiser, Bernard Kalb, Jurate Kazickas, David Hume Kennerly, Donald Kirk, John Laurence, Roger Mattingly, George McArthur,

Glenn McDonald, John Nance, Nguyen Khuyen, Roger Norrum, Don North, Frank Palmos, Richard Pyle, Michel Renard, Carl Robinson, Pierre Schoendoerffer, Neil Sheehan, Colin Smith, Christine Spengler, Jon Swain, Dick and Germaine Swanson, William Tuohy, Neal Ulevich, Hugh Van Es, Kate Webb, Donald Wise, Perry Dean Young, and many others.

Research was greatly facilitated by Hal Buell, former Associated Press executive photo editor, retired; Susan Clark of AP's Corporate Communications in New York; Richard C. Clarkson, former editor of *Eureka Newspaper* (California), retired; Jean Ferrari, former military archivist of SIRPA/ECPA in Paris; Katherine Friedrich, photo editor of the *Albany Times Union;* Marianne Fulton, curator of the Eastman House International Museum of Photography; Stan Grossfeld, chief photographer of *The Boston Globe;* Alex Kessler, photo editor at *Newsweek;* Kevin Kushel, photo researcher in New York; Peter Palmquist, photo historian; C. Zoe Smith School of Journalism at the University of Missouri, Columbia; Nigel Tappin of the Omega Photo lab, London, who printed all our photos; and Chuck Zoeller, director of the AP photo library in New York.

We would also like to thank the following individuals and institutions: John Flowers, cartographer; Rikio Imajo, Wide World Photos (AP) Tokyo; Atsuo Kaneko, executive editor of Kyodo News Agency, Japan; Carol Mann, our literary agent, New York; Thomas Neurath, managing director, Thames & Hudson, London, and the staff of the AP photo library; The Bettmann Archive (UPI)/Corbis; Time-Warner (*Life* magazine); Gamma Agency; Magnum Photos; SIRPA/ECPA-Paris; Black Star; Contact Press Images; Cressendo Agency; the Healey Library, which houses the Sully Collection, at the University of Massachusetts, Boston; University of Missouri, Columbia.

It has been a demanding task to record and organize the quantity of information and photos we assembled, and we are especially grateful for the goodwill, diligence, and patience of Rose Marie Wheeler.

We would also like to thank Harry Evans and Bob Loomis of Random House, New York, for the enthusiasm with which they took on the project, and Mark Holborn, the editor and designer for Random House, for his support throughout.

Above all, we profoundly appreciate the sincere support of all on whom we relied to create this memorial to the photographers who lost their lives in the Indochina wars. We hope this homage will succeed in reminding everyone of the excellence of their work.

Horst Faas and Tim Page

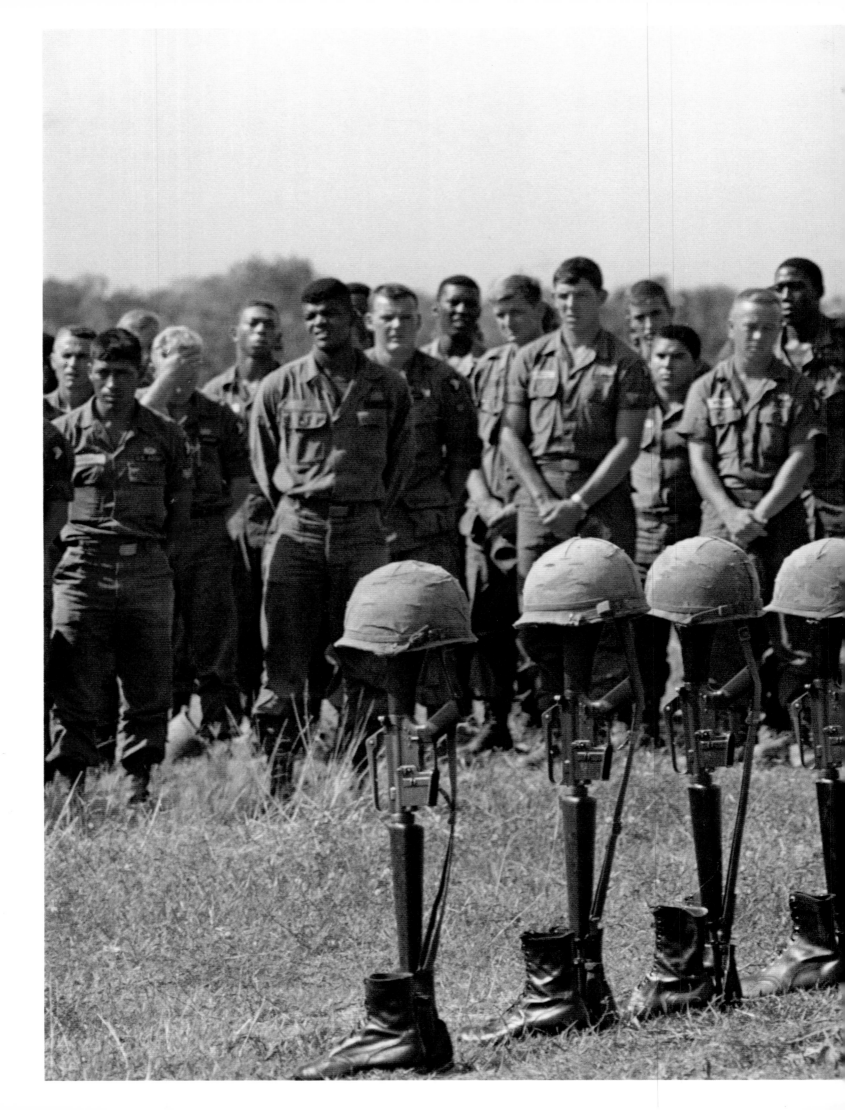

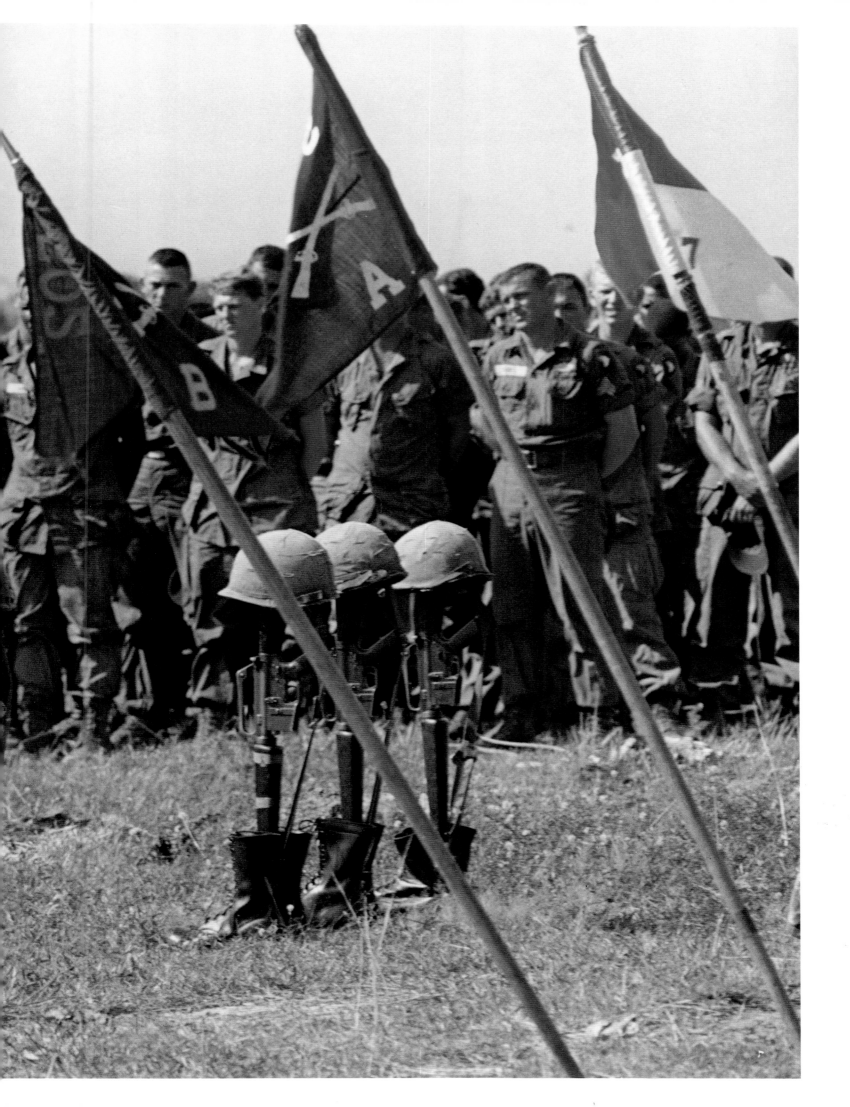

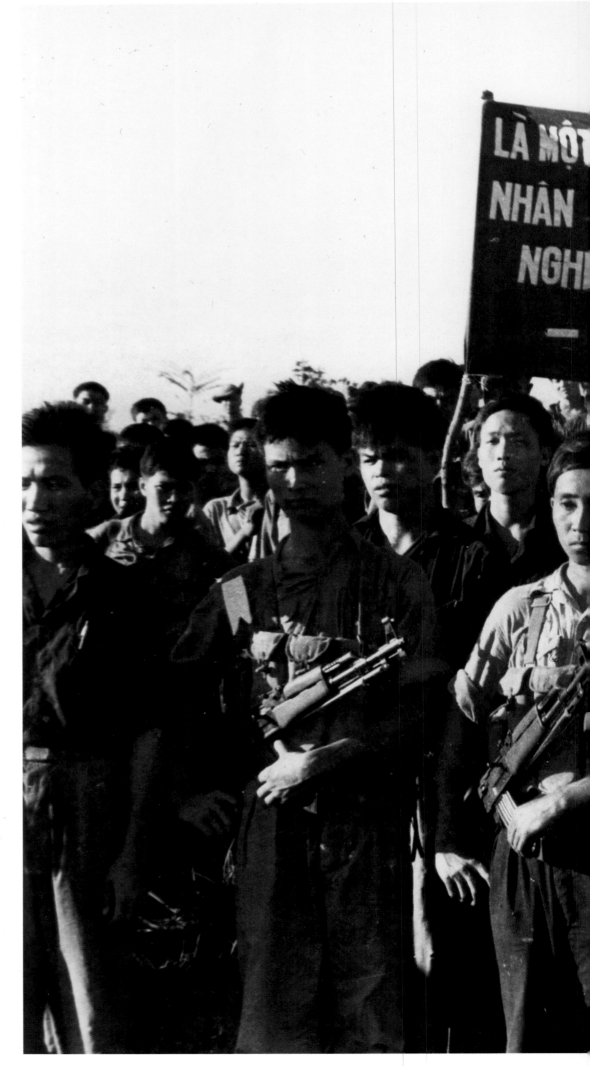

(pages 330 and 331)
HENRI HUET
Lai Khe, Vietnam, 1965.
A memorial service for seven men of the U.S.
101st Airborne Brigade.
(AP)

VO VAN QUY
Tay Ninh, Vietnam, 1969.
Viet Cong soldiers near the National
Liberation Front headquarters at the
Cambodian border northwest of Tay Ninh.
The banner reads: WE ARE THE ARMY OF THE
PEOPLE JOINING IN THE STRUGGLE OF THE
REVOLUTIONARY GOVERNMENT OF THE SOUTH.
(LNA/VNA)

EULOGY

Tim Page

It was the first and last war covered without the accustomed censorship. Sometimes you got lucky, got caught in the right place at the wrong time and came back with a camera bag brimming with exposed rolls of film. Other times it was just another long, hot plod through a hostile, demanding countryside that could grab your limb or your life.

The fall of the Berlin Wall in 1989 and the second Russian revolution heralded a change of attitude in Hanoi and a new official Vietnamese policy of *doi moi*, openness. By then the Vietnamese had liberated the Cambodians. Normalization of U.S.-Vietnamese relations hinged on the fates of those still listed as missing in action. For the Vietnamese the roll call of the dead and missing numbered in the millions. In a Buddhist world the missing suffer a fate worse than death. Their spirits are cast into a void that leaves superstitions and beliefs unassuaged. With unresolved karma there is no place of peace, and the spirits wander endlessly.

One morning in April 1970, the French photographer Claude Arpin-Pont and two Japanese colleagues were ambushed along Route 1 in eastern Cambodia. By midday Sean Flynn and Dana Stone, two freelance photographers, had been captured along the same highway. They had separated from the press in Chipou and were heading for the Vietnam border. Of Arpin-Pont's fate we know nothing. Tracing Sean and Dana's story led to the birth of this homage.

On a trip back to Indochina nearly twenty years later, in the Buddha caves of Marble Mountain, south of Da Nang, I perceived the spirit of Sean Flynn, roommate, buddy, and brother. During the period of *doi moi*, declassified CIA documents had arrived on my desk in England with reports of Sean and Dana's captivity, including place-names and map coordinates that referred to a small patch of territory on the east bank of the Mekong in Kampong Cham Province. It was still bandit country and had been an original home of the Khmer Rouge. Within months I had made both a weeklong initial reconnaissance and a return trip to try to uncover their fate.

The length of their captivity, thirteen months, is surprising. Their unwitnessed executions, Khmer Rouge–style, with a blow to the back of the head with a hoe, must have been appalling. Villagers readily identified Sean and Dana from pictures in a MIA booklet. I found folk prepared to recount their experiences of late 1970 and early 1971. An old man offered us three teeth and a filling. Dental forensics have confirmed these as coming from two Caucasians, a tall man and a short man, who met violent deaths. The story of their last days was patched together. The jigsaw puzzle now seems complete.

On leaving Phnom Penh, the chief Buddhist prelate presented us with a sacred bodhi sapling that had been planted on the seventeenth parallel to inaugurate a garden of remembrance for the three hundred media men and women from all sides who had fallen. Of those, 135 had been photographers. Most of their images had never been seen by the public, though they all seemed terribly familiar. Archives were opened up in Hanoi and Ho Chi Minh City. In the West hitherto lost caches came to light and were donated to the common cause of memory.

It has been said, "Only from a distance, or through the sanitizing filter of television, does war take on the majesty of ballet; up close it hurts, and smells of death." It was Robert Capa, during the Spanish Civil War, who said that a good photo had to be in close. The legacy of these images is unassailable. The face of death is painted in grain and chrome, locking our hopes and fears to the imponderable, making us smell that edge, tease it, pray for a certain peace.

EVERETTE DIXIE REESE
Luang Prabang, Laos, 1951.
Cave of Buddhas.

THE DINH
South of the DMZ, Vietnam, undated.
The photographer's shadow looms over an artillery position
after North Vietnamese forces overran several South Vietnamese
government artillery bases.
(VNA)

VIETNAM BUI DINH TUY · DANG VAN HANG · DINH DE ·

DUONG THANH VAN · HO CA · HO VAN DE · HO VAN TU ·

HUYNH VAN HUU · HUYNH VAN TRI · KIM VAN TUOC · LE

· LUONG NGHIA DUNG · LUONG TAN TUC · LY VAN CA

NGUYEN DUNG · NGUYEN HUONG NAM · NGUYEN HUY

TU · NGUYEN NHUT HOA · NGUYEN OANH LIET · NGUYEN

· NGUYEN VAN CHIEN · NGUYEN VAN HUONG · NGUYEN V

VAN THA · NGUYEN VAN THANG · NGUYEN VAN THUAN · I

· PHAM CO PHAC · PHAM TRANH · PHAM VAN KUONG

TINH · THE DINH · THOI HUU · TO DINH · TRAN BINH K

HY · TRINH DINH HY · TRUONG PHU THIEN · VO DUC

VU HANH · VU HUNG DUNG · VU NGOC TONG